Jacopo Bellini's *Book of Drawings* in the Louvre
and the Paduan Academy of Francesco Squarcione

Norberto Gramaccini

Jacopo Bellini's *Book of Drawings* in the Louvre and the Paduan Academy of Francesco Squarcione

DE GRUYTER

CONTENTS

PREFACE

The present book came about courtesy of my contract as Senior Professor from 2018–2021 at Renmin University (Beijing) as part of the Chinese central government's Thousand Talents Program. I thank Prof. Ding Fang, the former dean of the School of Arts, and his then assistant, Dr. Gu Shengrong, for the application, as well as Prof. Dr. LaoZhu (Peking University), Prof. Dr. Sybille Ebert Schifferer (Bibliotheca Hertziana, Rome), Prof. Dr. Alessandro Nova (Kunsthistorisches Institut, Florence) and Prof. Dr. Frank Zöllner (Universität Leipzig) for the advisory opinions. Prof. Niu Hongbao, Prof. Ma LinFei and Prof. Wang Wenjuan were in charge of setting-up the position at the School of Arts. This was preceded by a multi-year teaching engagement at Tongji University (Shanghai), made possible by the generous invitation of Prof. Hu Wei (CAUP) and Prof. Zhang Jianlong (CAUP).

I received support from the following friends and colleagues: Davide Banzato (Padua), Giulio Bodon (Venice), Frank Fehrenbach (Hamburg), Erika Hegewisch (Hamburg), Christiane L. Joost-Gaugier (Washington), Michael Krethlow (Bern), Klaus Krüger (Berlin), Kate Lowe (London), Axel Matthiessen (Hamburg), Hans Jakob Meyer (Stuttgart), Stefan Moret (Freiburg i. Br.), Ann waithira Njeri (Qatar), Ulrich Pfisterer (Munich), Barbara Steindl (Florence), Yuning Teng (Beijing), Federica Toniolo (Padua), Milène Wegmann (Bern), Karolina Zgraja (Rome), and of course Antonin Gramaccini (Berlin). I thank Dominique Cordellier (Paris) and Hugo Chapman (London) for allowing me to consult the drawing books in the Louvre and British Museum, as well as Colin Eisler (New York) for his continuous generosity and patience. A special thanks goes out to Dr. Simone Westermann (Munich) for the critical reading of the text, as well as Prof. Guy Claessen (Leuwen) for improving the classicist passages. Mathematician Georg Wick (Zürich) drew the perspectival reconstructions, published here for the first time. A big thank you to Ellen Van Benschoten (Berlin) for editing my English-language manuscript. Crucial was the support from Dr. Katja Richter, assisted by Susanne Drexler, who made it possible for the book to be published by De Gruyter as was desired.

The writing of this book took place during the prescribed lockdown in consequence of the Corona pandemic and would have been difficult to accomplish without the assistance of the library database kubikat, the digital library JSTOR, the document delivery service subito, and the document server academia.edu.

Norberto Gramaccini
Thousand Talents Professor
Renmin University, Beijing

PART 1

I. A Precious Collector's Item

The present book argues against the traditional approach of attributing the *Book of Drawings* in the Louvre (R. F. 1475–1556, figs. 1a and b) to Jacopo Bellini (circa 1400–1470), fountain-head of the Venetian school of painting that was to flourish under his sons, Gentile and Giovanni.[1] The title defines Jacopo as merely the owner of this most precious collection of early Renaissance drawings, not its author. What is instead being suggested is that the drawings were actually executed in Padua, mostly during the late 1440s. The mastermind and financier behind the book was the painter Francesco Squarcione (1394–1468), assisted by some of his pupils, the most gifted of whom was Andrea Mantegna (1431–1506).[2] Following this hypothesis, the *Book of Drawings* – valued as a precious artifact ever since – had been passed on from Squarcione's Paduan school of painting into Bellini's possession, most likely upon Mantegna's marriage to Nicolosia, Jacopo's daughter, in 1453. Jacopo certainly regarded it as precious property, since he bequeathed the drawings, among other valuable items, to his widow, not his sons. Thus, they were not considered workshop material. The album was handed down from Anna Bellini to Gentile Bellini (1429–1507), who either sold or presented it as a diplomatic gift on his official mission to Sultan Mehmed II (1432–1481) in Constantinople.[3] Over the course of this trajectory – which witnessed the ascent of the Bellinis, along with the political and economic ascent of Venice over its neighboring territory, the *terraferma* – the provenance and authorship of the *Louvre Album* were forgotten and the drawings were unanimously believed to be by Jacopo's hand.[4]

Material as well as documentary evidence speak in favor of this hypothesis. A first clue is furnished by the book's history. The *Louvre Album* contains, as is well known, parts of an older model book.[5] Its parchment surfaces bore primitive pen drawings that had partly to be coated with a grounding consisting of bone dust or chalk mixed with water before they could be used again. Altogether, seven pages (14 folio sides) can thus be reconstructed.[6] Only two of the original drawings were kept, obviously because the artist liked them: the one, (folio 77v) exhibiting six lions, and the other (folio 95v), a textile pattern (figs. 2 and 37). Thus far, no precise answer has been found for the question of where this costly material might have come from or on which grounds it was meant to be recycled. The prevailing idea is that Jacopo had discovered it on the Venetian art market or inherited from his master Gentile da Fabriano (circa 1370–1427).[7] This assumption, however, makes the use of the identical and unspoiled parchment in the "new" album difficult to understand. Another problem is posed by the drawing's autopsy. The conventionalism in form and subject matter of what can still be seen from this predecessor was believed to justify a date at the

1 Jacopo Bellini, *Book of drawings*, Musée du Louvre, Paris, R. F. 1475–1556

end of the fourteenth century.[8] Doubts, however, are appropriate since the simplicity of the design must be viewed in relation to a difference in function.[9] The fact that twelve (of fourteen) drawings show textile ornaments refers to a clientele not of artists but of artisans and businessmen as well as to a specific place of origin.[10] In the Veneto, Padua is well known for having been an important center of textile manufacturing since the late fourteenth century due to the richness of its canal systems and watermills, the sheep farming in the Oltrebrenta region, and the commitment of the Carrara Lords to engage spinners, weavers, fullers, dyers, combers, sharers and finishers.[11] It was in this business that Squarcione had started his career. His uncle Francesco da Galta was a draper and estate agent, his father-in-law, a certain Bartolomeo degli Uccelli, a draper, and he himself is recorded as having been a draper and textile designer (*sartor et recamator*) from circa 1415 to 1425.[12] This means that he had access to large-size parchments commonly used for textile designs and could easily have taken the sheets from his own stock when he decided to turn his back on this business and become a teacher in the arts instead. Following this hypothesis, the preserved models document the tradition in which Squarcione used to work. They may well represent the starting position for his new academic entreprise, which is why he would have kept them.

A document discovered and published by Clifford Brown in 1973 lends credit to the idea that the *Louvre Album* had come into Jacopo Bellini's possession through a prominent member of Squarcione's Paduan academy. On October 24, 1476, the Florentine art dealer Angelo Tovaglia inquired in a letter addressed to the Margrave of Mantua, Ludovico III Gonzaga (1412–1478), about a book of drawings that he had been seeking for a long time.[13] All he could determine about this book was that it contained, for the most part, copies of antiquities, battles between centaurs, satyrs and fauns, as well as images of men and women on horseback and foot (*la più parte sono battaglie di centauri, di fauni et di satiri, così ancora d'uomini et di femine accavallo et appié, et altre cose simili*).[14] A connoisseur himself, Tovaglia was aware that this was a precious collector's item (*io so che queste cose si tengono cari*), not likely to be shared casually (*che gli originali non se mandano atorno*), which is why he suggested making a copy (*me lo facesse copiare*) at his own expense (*et io pagherei la spesa*). Ludovico replied to the letter one month later. He had asked Luca (Fancelli?), who

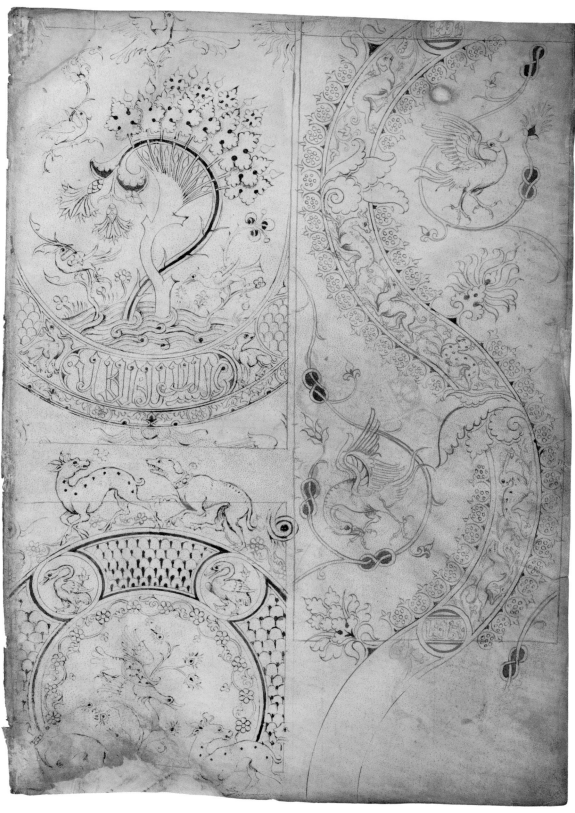

2 *Folio 95v*, Musée du Louvre, Paris

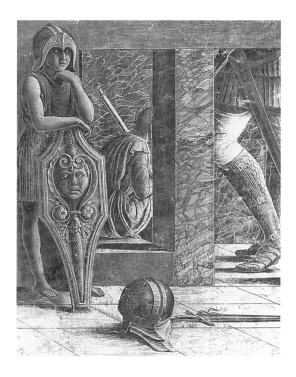

3 Andrea Mantegna, *Saint James before Herod Agrippa* (det.), Chiesa degli Eremitani, Padua

discovered that the person to ask was his court painter Andrea Mantegna. Upon inquiry, Mantegna remained elusive (*monstra non sapere quello ne fosse facto*). Fancelli, however, believed that the book had been handed over to some other painter.[15] This was all Ludovico could confirm, though he promised to keep Tovaglia informed should additional information surface. However, Ludovico's illness and premature death in 1478 unfortunately put an end to the search.[16]

The *libro del retracto* mentioned in the 1476 letter was never identified as the *Book of Drawings* in the Louvre. Nevertheless, it may be concluded that a relationship exists. For one, the subjects that Tovaglia could list by hearsay – copies of antiquarian subjects, mythological battles, and contemporary scenes – do match the contents of the *Louvre Album* quite precisely.[17] Tovaglia's preference for the term *libro*, instead of the more common *quaderno*, confirms Elen's analysis that the Louvre drawings had been bound together from the outset to form a book and were not intended to be kept as loose sheets within a folder.[18] A book of such extravagant size (427 × 290 mm), almost twice as large as other comparative albums and consisting of more than a hundred exquisite drawings all on parchment of the highest quality, for which the skins from fifty-one goats were required, was indeed a unique treasure in terms of both artistic and material value, unlikely to escape the attention of a professional art dealer like Tovaglia.[19] His emphasis on its uniqueness – too important to be entrusted to any courier – betrays an economic perspective. Tovaglia would have realized that the original might be unobtainable, which is why he suggested a copy be made for him. It might have been the preoccupation with these details that prevented him, unfortunately, from being more explicit on other points. As to the author of the drawings, nothing emerges. Tovaglia probably knew from the beginning that the trail would lead to Mantegna, which is

4 Giovanni Bellini, *Resurrection of Christ* (det.),
Gemäldegalerie, Berlin

why he contacted his employer. But the passage itself does not supply any information that Mantegna actually owned the drawing book, as has been asserted in the wake of Clifford Brown's publication of the Gonzaga documents.[20] Neither does the name of the painter, who finally came to own this treasure, surface. All that can be ascertained is that the pronoun *questa*, related to *terra*, refers to Mantegna's place of origin, the Veneto, rather than to Mantua or Tuscany, Tovaglia's local identity, in which case Ludovico would have adressed the artist in question as *nostro* or, respectively, *di vostra terra*. There are, therefore, good reasons to believe that the album came from Padua or Venice, where Mantegna had been living before accepting Ludovico's invitation in 1459, and that it was now in the possession of a nearby painter, whether directly through him or at least with his knowledge. Given the book's value, this person must have been somebody of high standing. With all probability, it was, indeed, Jacopo Bellini, Mantegna's most important relative in the art world and, furthermore, a collector of precious items of this kind (see p. 15), whose family firm in Venice was to supersede Squarcione's Paduan academy.[21]

Adding weight to this hypothesis is the extensive plundering of Mantegnesque motifs by the Bellinis, which allowed Jacopo's sons to rise to the leading workshop in the Veneto. Recent exhibitions in London and Berlin have demonstrated the extent to which the transfusion of Mantegna's genius enabled Gentile and Giovanni Bellini to not only appropriate Mantegna's inventions but also access his work tools.[22] The shield with Medusa's head in Mantegna's fresco *Saint James before Herod Agrippa* (circa 1451) at the Eremitani Chapel in Padua is a case in point.[23] The motif is invoked again in Giovanni's *Resurrection of Christ*, painted for the church of San Michele in Isola some twenty years later (figs. 3 and 4).[24] The shield's provenance may well be traced back to Francesco Squarcione, widely known as a

collector of suchlike rarities.[25] The same holds true for some antique sculptures in marble and reproductions in plaster, listed in Jacopo's estate in 1471 (see below). Similar objects are known to have been on display in the "house of reliefs" to be used in Squarcione's academy (see page 24). There is, therefore, reason to believe that Jacopo Bellini had profited from the disintegration of the Paduan studio and that his new son-in-law played a part in these transactions. This might have taken place in the late 1450s, after Mantegna had become independent from Squarcione, or else in the early 1460s, after the latter took up permanent residence with his entire household (*chon tuta la ffamegnia*) in Venice.[26] The documents relating to Mantegna's legal disputes with his former master reveal that their quarrels concerned material indemnification.[27] In his second trial, from 1455 to 1456, Mantegna had asked to be compensated for works carried out for Squarcione estimated at 400 ducats, a considerable amount, of which he petitioned half of the sum.[28] The documents do not specify what happened afterwards – all that can be deduced from similar lawsuits between Squarcione and his belligerent apprentices is that if the former consented to pay, which was likely, he would have cleared his debts not with money but in kind.[29] It is noteworthy that the six years for which Mantegna sought recompense in this trial, from 1443 to 1448, coincide with the assumed genesis of the *Louvre Album*.[30] Since no other important work is documented for this period of time, the precious book could have been part of his indemnification.[31]

The next noted instance to mention the *Book of Drawings* is the testament of Anna Rinversi, Jacopo's widow, dated November 25, 1471. To her eldest son, Gentile, Anna bequeathed not only the *Louvre Album* but also other books of drawings (*omnes libros de dessigniis*), together with Jacopo's collection of classical sculptures and reliefs in marble or plaster (*omnia laborerie de zessio, de marmore et de relevijs*).[32] It is significant that none of these valuable items were ever included in the inventory of Jacopo's workshop, in which case they would have been left to his sons. Instead, they were part of his private estate that went first to his widow. Upon their coming into his possession, Gentile was well aware of their value and saw to increase it with the help of humanist friends (see page 40). The next step was to sell them altogether. It is not clear what happened to a statue or statuette of Venus "with naked breasts" – perhaps identical with the statue of the goddess "colla testa rotta e colle braccia" that Ghiberti had seen upon his visit to Padua[33] – but Niccolò and Giovanni Bellini had offered the bust of Plato "with the point of the nose in wax" to Isabella d'Este in 1512.[34] The re-working of the images in the *Louvre Album* in pen and ink by an apprentice in Gentile's workshop was undertaken with a similar intent to increase their visibility and value once it was decided to sell or donate the book to Sultan Mehmed II during Gentile's 1479 trip to Constantinople.[35] Likewise, the second book of drawings "in leadpoint on rag paper" from Jacopo's inheritance (*fuit praedati quondam patris nostri*) that Gentile had bequeathed to his half-brother, Giovanni Bellini, on February 18, 1507, was considered a collector's item and therefore intended to be sold.[36] Though similar in size and content, it was less valuable than the *Louvre Album*, having been executed on paper rather than parchment. The buyer was with great likelihood the Venetian collector Gabriele Vendramin (1484–1552) in whose *Palazzo Santa Fosca* Marcantonio Michiel saw the book and subsequently described it in 1530 as: "The large book of drawings in bombazine paper in leadpoint from the hand of Jacopo Bellini."[37] For the first time, Jacopo is referred to not as a previous owner but as the author of the drawings

(*de man de Jacopo Bellino*).[38] The cover page of this book of drawings, which later came into the possession of the British Museum (BM 1855.0811.1), bears the same attribution to the father of the Bellini dynasty (*de mano de ms. iacobo bellino veneto 1430 in venetia*), perhaps in Vendramin's handwriting.[39] The addition of Jacopo's name and the predating of the text to the year 1430 – the start of his career – must have occurred out of a desire to raise the book's fame and to establish Jacopo's role as the founder of the modern school of painting – *padre di tutta la pittura narrativa veneziana* (Fiocco).[40] This referred to Venice's dominant position as "most triumphant city" at that time.[41] Accordingly, Padua's artistic contribution was marginalized.

Despite the importance attached to the books of drawings as they were being handed down – which finds a parallel in the upgrading of the antiquities by attributing the marble 'Venus' to the famous Greek sculptor Praxiteles (circa 395–330 BC) and restoring the so-called 'Plato' – the family documents of the late fifteenth century (Anna's testament and Gentile's donation to Giovanni) name Jacopo Bellini simply as the owner and not the creator of the books of drawings. They are listed in one row, along with the other *laborerie de zessio, de marmore et de releviis* in Jacopo's collection, for which his authorship must be excluded (as fn. 32). From here emerges an aspect not adequately addressed by scholars: Jacopo's interest in the art market and his personal collection of artworks related to the painter's study (*pertinentia pictorie et ad dipingendum*).[42] As early as 1440, he had intended to form, together with Donato Bragadin (1438–1470), a five-year partnership (*societas*) directed at selling and buying paintings and other works of art (*picturarum cuiuscumque sortis et conditionis*), in Venice as well as abroad, and to share the profit made from this business.[43] The plan failed, perhaps because Bragadin was the wrong partner, but it can safely be assumed that this did not deter Jacopo from putting together a collection of valuable items.[44] Apart from the influence of Venice as Europe's foremost center of trade, the idea to extend his artistic practice into professional entrepreneurship and, at the same time, merchandize paintings and drawings produced in his workshop, might have been encouraged by Squarcione in nearby Padua who had been building up an impressive collection since the 1420s. Therefore, there are plausible reasons to believe that the arrangement to have Mantegna marry into his family was part of Bellini's plan to become heir to the Paduan heritage.[45]

One documented instance indicates the type of objects that were of interest to Jacopo. On December 6, 1439, he bought a *tavola intarsiada* (a picture composed of illusionistic wooden inlays in contrasting colors) from the estate of the painter Jacobello del Fiore (circa 1370–1439).[46] No longer in existence and not even necessarily made by Jacobello himself, this piece of marquetry was anyhow a rare and valuable art object for which Jacopo Bellini was willing to pay a considerable price.[47] What mattered here, with all probability, was less the work of art in itself, as far as style and iconography were concerned, than the perspectival games in design which *intarsie* were famous for at that time. Filippo Brunelleschi (1377–1446) and Leon Battista Alberti (1404–1472), the early investigators into painterly perspective, were attracted to specialists working in *intarsia* for the same reason. Vice versa, the influence of Brunelleschi's *tavolette prospettiche* can also be seen in the wooden panels that Antonio Manetti and Agnolo di Lazzaro created for the sacristy of the Florence Cathedral (1436) (fig. 5).[48] At an even earlier date, Arduino da Baiso, a carpenter (*magistrum lignarium*

5 Antonio Manetti and Agnolo di Lazzaro, *Intarsia*, S. Maria del Fiore, Florence

subtilissimum) from the Appenine region who joined Ghiberti's workshop in the 1420s, was famed for his *intarsie* in Lucca, Ferrara, and Mantua.[49] Squarcione, himself a specialist in linear perspective (see page 26), made designs for the *intarsie* of the sacristy of the Basilica di San Antonio (the Santo) in Padua in 1462, to be executed ten years later by Lorenzo Canozi da Lendinara for the price of 250 gold ducats.[50] As was the case with the two books of drawings, the abovementioned shield, and ancient sculptures, this *intarsia* was not just a valuable object but an exemplary artwork that went beyond Jacopo's style and expertise. Instead of being conditioned aesthetically, the interest in this and similar items of his collection was steered by the modern ambition to transform the traditional workshop (*bottega*), restricted as it was to the accomplishment of the master – the *capo bottega* – into a study (*studio*) of more universal academic standing.[51]

The *Louvre Album* is the first example of what may be called a proto-academic "database."[52] It differs considerably in both size and scope from the large group of earlier pattern books dating from around 1400 that were studied by Robert W. Scheller and Joseph Rushton.[53] These were mostly travel sketchbooks or *taccuini*, that is, a collection of specific motifs in small format, such as animals, designs for fabrics or parts of the human figure – a "no-man's land between one work and another" (Scheller) – but not an album in the proper sense of the word.[54] This is also true for drawings based on antiquities that were begun by Gentile da Fabriano and subsequently handed down to Pisanello to be completed by him and his studio in the early 1430s. They document specific gestures and attitudes meant to be used in the form of a "repertoire" (Casu) rather than to display truly antiquarian or archeological interests.[55] By contrast, the drawings under discussion here are not at all concerned

with the fragmentation of motifs for the sake of collecting artistic material but rather present accomplished compositions that reflect upon intellectual and historical dimensions.[56] They are final and self-sufficient in the sense that they exemplify solutions to specific theoretical challenges that were meant to be not simply copied but studied as a way to understand the underlying principle.[57] Conceptually, the *Louvre Album* resembles, therefore, a precious scientific treatise rather than a catalogue or figurative archive.[58] The form of its presentation as a leather-bound book as well as the volume's content, manifesting a variety of subject matter that necessitated a table of contents, mark the difference. The fields of reference, presented almost systematically, are as follows: perspective and anatomy, archeology and architecture, botany and zoology, mythology and religion, contemporary chronicle and fashion, landscape and portrait. Finally, it is, therefore, not so much the visualization of artistic skill but rather that of theoretical knowledge – nourished by the want to partake in discussions traditionally reserved for a different strata of society by establishing a superior intellectual and, ultimately, social status within the figurative arts – that distinguishes the *Louvre Album*.[59] The impulse for this reform did not originate in Venice, nor was it brought about by Jacopo Bellini, the son of a tinworker or plumber, who had not received any humanist education.[60] Instead, the development was rooted in Padua, the most progressive center of academic teaching in Europe at the time.

II. The Paduan Tradition of Scientific Painting

The recovery of the long-forgotten sciences of the ancients – *scienze non udite e mai vedute* (Alberti) – was an essential impetus for the renaissance of the arts.[61] Before both the approach to learning in the arts and the novel interest in antiquity could migrate to Florence and then to Venice, Padua was singular among Italian cities for its endeavors, documented since the Middle Ages, to ascertain its roots in Roman history and revivify its glorious past. Local men of letters were influential in establishing the *preumanesimo Padovano*, based on literary erudition and visual recreation.[62] The first in a long row of *literati* was the Paduan native Lovato Lovati (circa 1241–1309), considered the "father of Humanism" by no less than Francesco Petrarch himself.[63] Lovato succeeded in retrieving three chapters (*decades*) of the *Ab urbe condita* by his "compatriot," the Roman historian Titus Livy (59 BC–17 AD), and in getting his fellow citizens enthused about ancient history.[64] Padua's venerable ancestry is recalled through the Trojan Antenor, said to have founded the city in 1183 BC and to have chosen it as his burial site.[65] From this testimony, which was based on the authority of the Roman poet Virgil (*Aeneid*, I, 246-8), Lovato, along with his followers like Albertino Mussato (1261–1329), inferred that Padua was owed a primary position in the Veneto and equaled (if not surpassed) Rome itself.[66] To lend visible proof to the strong link between past and present, two public monuments were erected side by side: one to contain the bones of the Trojan hero (1283) and the other dedicated to his modern re-discoverer, Lovato Lovati (circa 1300) (fig. 6).[67] A similar monument was planned, though never fully realized, to commemorate Titus Livy on the occasion of finding an antique tombstone in Santa Giustina that bore the inscription VF / T LIVIVS / LIVIAE F / QUARTAE L / HALYS / CONCORDALIS /

PATAVI / SIBI ET SVIS / OMNIBVS.[68] The mausoleum next to the Santo church (circa 1325), built from Roman remains and dedicated to Lovato's pupil Rolando da Piazzola, testifies to the continuity of this tradition into the fourteenth century, as do Altichiero's frescoes in the *Sala Virorum Illustrium* of the Carrara palace (1368ff.), which are based on Petrarch's biographies of heroes from Greek and Roman history (*De viris illustribus*) as well as on his collection of Roman coins.[69]

The University of Padua, founded in 1222, but believed to date back to as far as the time of ancient Egypt, actively took part in this discourse.[70] Its Faculty of Medicine and Philosophy, together with the Sorbonne in Paris and the University of Oxford, became a leading center for the study of Aristotle, regarded as the foremost philosopher in Paduan history.[71] Available in Latin translations from Arabic, his writings facilitated the investigation of phenomena of the external world and subsequently the emergence of empiricism and natural sciences, which had been neglected under the rule of theology and Neoplatonic philosophy during the preceding centuries.[72] This gave rise, in particular, to two important disciplines, which likewise were to play a role in the *Louvre Album*: anatomy (the science of the human body) and optics (the science of vision and space).[73] Pietro d'Abano (1257–1316), who devised a synthesis of medicine and philosophy, Jacopo Dondi (circa 1290–1359) and Giovanni Dondi dell'Orologio (1318–1388), father and son, who were physicians, astronomers and constructors of an astronomical clock set up in public, and, eventually, Biagio Pelacani (1355–1416), who explored the relationship between optics and perspective, were lumineers in their respective disciplines and are widely recognized as the leading authorities of the time.[74] They were all active in Padua and it was from here that the minor arts, to which painting belonged, were able to partake in the exploration of the visible world.

Accessing the subjects of science and philosophy and surmounting the rigid barrier which separated the liberal arts (*artes liberales*) from the mechanical arts (*artes mecchanicae*), to which painters and sculptors were confined, required another intermediary discipline. Poetry, not philosophy, set the paradigm into motion, the primary initiator of which was Francesco Petrarca (Petrarch, 1304–1374).[75] In 1349, he moved to the Court of Giacomo II da Carrara and was to serve the Carrara Lords in Padua until his death.[76] It was due to Petrarch's conviction about interdisciplinary study, nourished by the reading of Pliny the Elder's *Natural History* (circa 77 AD), that painting was afforded a prominent position within the acknowledged sciences.[77] This conviction of Europe's foremost intellectual was echoed in the first comprehensive manual on art, which aspired to the rank of a treatise of the early modern era, written in Padua at the end of the fourteenth century by the Tuscan painter Cennino Cennini (circa 1370–1440), another member at the Carrara court. His "Craftsman's Handbook" (*Il Libro dell'arte*) served two aims: on the one hand, it explained certain technical innovations related to Giotto (circa 1276–1337) and his school, and, on the other, addressed the newly acquired dignity of the figurative arts. Painting was no longer considered a mere craft but an intellectual discipline, as it embraced practice and theory.[78] In his preface, Cennini argues that it befits the painter to be of equal rank as the poet, the reason being that his imagination (*fantasia*) makes him free to illuminate whatever is hidden under the surface appearance of things (*cacciandosi sotto ombra di naturali*).[79] The idea of the sisterhood of the arts and their common foundation in science was crucial for the concept of modernity in Early Renaissance Italy.[80]

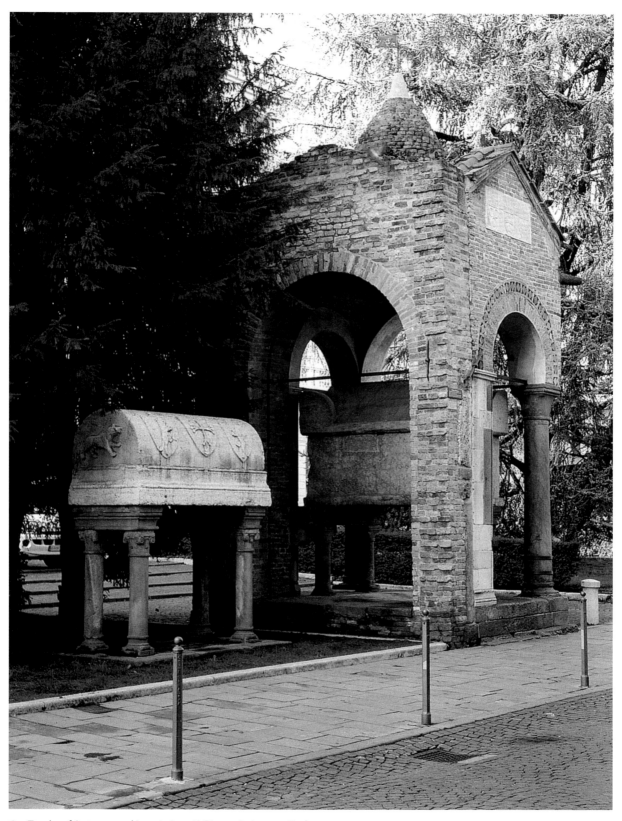

6 *Tombs of Antenor and Lovato Lovati*, Piazza Antenore, Padua

Petrarch and Cennini only confirmed what a group of painters active in Padua during the 1370s had already put into practice. The Veronese painter Altichiero da Zevio (circa 1330–1390), having worked in the Carrara palace under Petrarch's and Lombardo della Seta's direction in around 1368, may well have been aware of the high expectations imposed upon him by the intellectual ambiance he was working in.[81] In his subsequent frescoes of the *Oratorio di S. Giorgio* (1378–1384), Altichiero increased the illusionism of his settings by creating a unified architectonic space whose orthogonals meet at the vertical axis in the middle of the painting and by relating the proportions of his figures to the scale of this painted architecture, thereby establishing a symbiosis between the reality of the depicted scene and the rationality of perception – a concept that Giotto had only started to approach in the frescoes of the Arena Chapel (1305).[82] The fresco decoration of the baptistery in the Duomo by the Florence-born artist Giusto de Menabuoi (1320–1391), created almost concurrently to Altichiero's frescoes (1375–1378), displays a similar knowledge of basic geometric perspective (fig. 7).[83] They both refer, as recent studies by Peter Scholz and Simone Westermann confirm, to a theory about optics developed by Euclid's *Optica* in ancient Greece (third century BC) and expanded upon in Alhazen's eleventh-century Arabic *Book of Optics* (*Kitab al-Manazir*) that had been brought to new conclusions by the physician Biagio Pelacani, professor at the University of Padua from 1384 to 1388 and 1407 to 1411.[84] Graziella Federici Vescovini and Hans Belting were among the first to have highlighted the impact of Pelacani's teachings for a new understanding of the dialectics of space and visual perception in terms of a rational system of information that was to be decoded on purely mathematical terms by the human intellect (*potentiam activam quam intelletiva dicitur*).[85] Pelacani's treatise dedicated to this problem, the *Quaestiones super perspectiva comuni*, thus became relevant not only for the Paduan school of painters but for the *Studio Fiorentino* as well, where he had continued to teach from May to September 1388, and where copies of the *Quaestiones* are attested for as late as 1428.[86] He is the first to have extended the purely mathematical theory of sight to a model of graphic representation, even if rudimentary in its definition.[87] The *punctus centricus*, the pivotal point of the Albertian construction, however, was yet unknown to him (see p. 44). This is the reason why Pelacani can be called a precursor of Alberti's *costruzione legittima* only in a very limited sense (Appendix II). Nevertheless, he seems to have incited painters, and probably patrons in his surroundings as well, to reflect further on the application of his theory, which explains the precocity of the Paduan school in comparison to any other in Europe.[88] Altichiero's fresco *Saint George Baptizing of the Pagan King* (circa 1380) foreshadows similar experiments in Florentine fifteenth-century when viewed in relation to, for example, Lorenzo Ghiberti's relief *The Meeting of King Salomon and the Queen of Sheba* (circa 1435) in the *Gates of Paradise* (figs. 8 and 9).[89]

The sophistication of the painters in late-fourteenth century Padua did not go unnoticed. Michele Savonarola (1385–1468), in his *Report Concerning the Magnificent Decorations of the Royal City of Padua* (circa 1466), praised the local school (*pictorum schola*) starting with Giotto (circa 1300), regarded as their prince (*princeps*), and including Guariento, Giusto de Menabuoi, Jacopo Avanzo, Altichiero, and Stefano da Ferrara.[90] The superiority of these painters in comparison to other schools, Savonarola argues, was based on the university environment that led to their advancement through their use of certain theoretical prin-

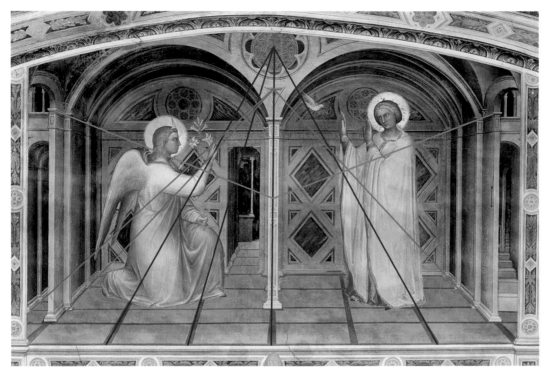

7 Giusto de Menabuoi, *Annunciation*, Baptistry, Padua

ciples for their own needs.[91] Due to the appropriation of science, painting was no longer considered a mechanical craft based on manual experience but could be classed among the liberal arts that were based on theory.[92] A renowned physician himself, Savonarola confirmed Cennini's assessment concerning the modern relationship between theory (*scienza*) and practice (*operazione di mano*) yet was more germane in determining the result of this impact, which established the fame of Padua as a national center of studies:

> And I do not belittle the university (*studium*) of painting, which is a singular ornament to our city, since it is associated to the study of letters and the liberal arts more than the other arts are, as it is a part of perspective, which deals with the projection of rays. This indeed is a part of philosophy. For Giotto, prince of painters, lives in our city through his many glorious and beautiful pictures, many of which are worthy of admiration, and so too the other four [painters], about whom we spoke earlier. Painters assemble from all of Italy in order to see them, and youths come, eager to study in this area, in order that they may then return to their own homes having been made more learned by them.[93]

What establishes the link between the painter's studio and the lofty sphere of academia is no longer the force of imagination that painters shared with poets, as noted in Cennini's *Libro dell'arte* (see above). Rather, it is the science of perspective which is considered part of philosophy and which is based on mathematics:

> I turn at last to the glorious skilled craftsmen, and the men illustrious in their art, whose knowledge is not remote from philosophy, and is the application of the mathematical arts. These are the painters, to whom it is given to know the outlines of the figures and the projections of the rays; as their knowledge of perspective is famous, so too it may be demonstrated by them as practitioners.[94]

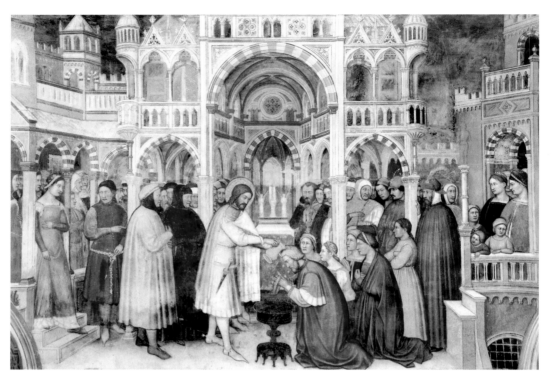

8 Altichiero, *St. George Baptizes the Pagan King*, Oratorio di S. Giorgio, Padua

Savonarola does not mention Pelacani's groundbreaking research in this context, yet there is little doubt that he was well aware of this affiliation, having been a member of the Paduan Faculty of Medicine and Philosophy in 1434 and perhaps due to his having met Pelacani personally upon his return from Florence to Padua in the years from 1407 to 1411.

Thus, Padua, not Venice, gave birth to modern painting. This development led from Giotto's *Arena Chapel* (1305) via Altichiero's *Oratorio di S. Giorgio* to Mantegna's frescoes in the *Ovetari Chapel* at the Eremitani Church (1448–1457). In the beginning, it was a small group of painters attracted to Pelacani's theories. Building upon Menabuoi's and Altichiero's experiments, a more systematical investigation of optical phenomena and the projections of lines in an empty space led to the establishment of an apparatus of rules that formed the basis of what may be called the first academy of painters – a modest yet efficient forerunner of Giorgio Vasari's *Accademia del Disegno*, founded in 1563. A figure of prime interest in this respect is the painter Francesco Squarcione (1397–1468), whom Savonarola does not mention as he seems to refuse to discuss *quattrocento* art in general.[95] However, Squarcione is discussed at length in Bernardino Scardeone's (1482–1574) book on Padua and its famous citizens.[96] Among other sources, Scardeone could rely upon Squarcione's autobiography written down in his (*libellum*), which is lost today.[97]

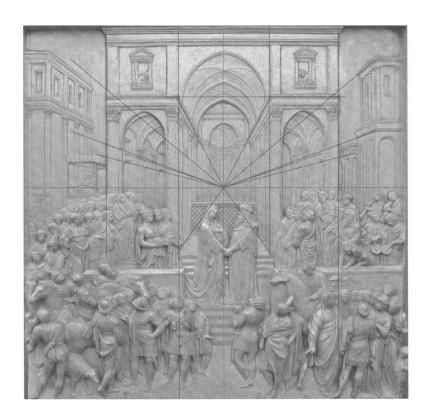

9 Lorenzo Ghiberti, *The Meeting of King Salomo and the Queen of Sheba*, Doors of Paradise, Baptistry, Florence

III. Squarcione's Academy

Squarcione came from an affluent background. The family originated from Bovolenta, a small municipality 15 kilometers away from Padua. His father Giovanni had been secretary (*officialis, scriba*) to Francesco Novello da Carrara (1359–1405) and later notary.[98] In the early 1420s, together with his father-in-law, Francesco had started in the textile business in Padua, deciding to become a painter only somewhat later (as fn. 12). Writing about his early years, Scardeone conveys an impression of a carefree and privileged life:

> From boyhood, he had taken the greatest delight in the study of painting, and shortly – as he writes of himself (*sic*) – on emerging from adolescence and being able from his age to live for himself after his own fashion, he determined to see the world and travel to distant cities and through different peoples and nations. Wherefore, he sailed to Greece and wandered all over that country, whence he brought home with him, both in his mind and in drawings, many things worthy of note that seemed likely to promote skill in his art. He journeyed in similar fashion all over Italy and won the friendship of many noblemen by his affability and virtuous disposition.[99]

This odyssey, paralleling Ciriaco d'Ancona's (1391–1452) career as a tradesman and antiquarian, lasted from about 1424 to circa 1426 when Squarcione decided to settle down and devote himself to the arts.[100] Abounding in theory and judgement – *humanitatis plenus*, as Scardeone has it – and without ever having obtained thorough training in any painter's studio and therefore possessing few practical skills (*non multae exercitationis*), he nevertheless wanted to pass his knowledge down to the next generation and instruct as many as possible (*delec-*

tabatur eam ipsam quam callebat artem posteris tradere, et docere quamplurimos).[101] He was the first to realize (*primus omnium sui temporis*) that in order to promote modern painting (*pingere in recenti*) it was no longer enough to follow the style of one single master; instead, a critical assessment of objective standards was required.[102] This is why he declared himself a professor of painting (*pictorum gymnasiarcha*) rather than the head of a workshop in the traditional sense (Scardeone). This could only be achieved, to make use of Cennini's terminology, by extending the realm of practice (*operazione di mano*) into that of theory (*teorica*) and science (*scienza*).[103] Recognized for its innovative potential, the success of his academy was immediate. Students came from all over Italy as well as from Germany, Dalmatia and Slavonia, confirming once again the international atmosphere of Padua at this time.[104]

One of the first to join the Paduan *studio* in 1431 was a certain Michele di Bartolomeo from Vicenza.[105] Mantegna, who was to become the greatest beneficiary of Squarcione's teaching method, had entered the Paduan painters' guild between 1441–1445, after being formally adopted by his master.[106] By that date, Squarcione had enlarged his house in *contrata Bersagli* towards Ponte Corvo and in the vicinity of the Santo church by adding a new building to accommodate his collections and the growing number of students.[107] Coming from different towns, these amounted altogether to 137, an astonishing number if one is to believe Scardeone.[108] Among them were Dario da Pordenone, Niccolò Pizolo, Matteo dal Pozzo, Marco Zoppo, Giorgio Schiavone [Ciulinovich], Carlo Crivelli, Agnolo di Silvestro, Dario da Udine, Michele Pannonio, Giovanni Vendramin da Padua (1466) and Giovan Francesco di Uguccione (1467).[109] With the help of Squarcione's most gifted apprentices, the Paduan school of painting was to take the lead in Lombardy and the Veneto, if only for a brief period.[110] Squarcione's ambition and greed, however, undermined his capacity as an academician. It soon became evident that he was less knowledgeable than he pretended to be and was exploiting his most talented students to compensate for his own artistic shortcomings.[111]

Squarcione's innovative teaching method needs, nevertheless, to be set apart from his character.[112] Instead of confronting his students with what "he had executed himself or worked up from modern examples provided for copying" (Scardeone), considered common practice in the fifteenth-century painters' guilds in Padua and elsewhere, he wanted them to study models of different types and origins.[113] These may be divided into two groups: accomplished works of art mostly intended to be copied by the novices, as opposed to drawings and diagrams of a more theoretical and didactic character that were studied by advanced pupils.[114] The first group consisted of Squarcione's personal collection and the models derived herefrom that he had amassed and copied during his extensive travels in Italy and Greece.[115] These were modern paintings and engravings as well as classical sculptures (for the most part reliefs in marble as well as reproductions in plaster), medals and icons.[116] Placed at the disposal (*commoditatem*) of his pupils, they were meant to be studied following Squarcione's directions, who wanted his pupils – as is to be derived from his criticism of Mantegna's Ovetari frescoes – to maintain a critical stance between classicist forms and a naturalistic coloring.[117] The idea behind his method and the displayed teaching models that constituted the academy's major attraction might well have been derived from literary studies, as scholars have speculated before.[118] Gasparino Barzizza (circa 1360–1431), a professor of rhetoric and philology at the University of Padua from 1407 to 1421 and the highest authority on

Cicero in his time, was of particular importance in this regard.[119] He taught grammar and rhetoric in Padua and Venice (1407–1421) and had opened a private gymnasium for Latin and various liberal studies in Padua that was frequented by the contemporary *jeunesse dorée*: soon-to-be renowned humanists like Guarino da Verona (1374–1450), Vittorino da Feltre (1378–1446) and Pier Paolo Vergerio (1370–1444) counted among his most gifted pupils.[120] It is known that the young Leon Battista Alberti also studied under Barzizza between 1416 and 1421 as he made his way to Bologna.[121] The ancient model of a household company, where the master presides over a student family – as practiced by Squarcione one generation later – clearly originated in Barzizza's *contubernium* in the contrada del Pozzo del Campion.[122] The same is true for his teaching method, the "fomulario barzizziano" (Révest), based as it was on a collection of oratory prototypes as well as exemplary letters that had been carefully emended and adapted for the students to study, copy, and imitate (*ad exercitationem accomodatae*).[123] Spreading throughout the universities of Italy and Europe since the 1420s and greatly successful in purifying the Latin language in a neo-Ciceronian sense, it could not fail to impress Squarcione.[124] Squarcione's painters' academy was challenged, furthermore, by the accomplishments of Giotto's Paduan followers, including Cennini, and their recognition by Savonarola and other contemporaries (see above). Barzizza himself is reported to have occasionally made reference to this school – the teaching standards of "good painters" (*boni pictores*) who confront their apprentices with chosen figures and images (*quasdam egregias figuras, atque imagines, velut quaedam artis exemplaria*).[125] Comparison with the figurative arts is indeed an ancient topos in literature and does not necessarily document the philologist's familiarity with contemporary artistic practices.[126] Nevertheless, Barzizza seems to have invited painters and writers into a dialogue, and it was left to Squarcione to define his academy on similar terms.

The sequence of drawing first from drawings or prints, then from casts and originals and finally from the living model, in addition to lectures on perspective, geometry and anatomy, was to remain the standard program of academic curricula from Vasari's Florentine *Accademia del disegno* (1563) onwards.[127] Nicolaus Pevsner rightly pointed out that "theorists such as Félibien, in the fourth of his *Conversations on the Lives and Works of the Most Excellent Painters* (1666), also pleaded for it, conscious or unconscious of its being the old program of Squarcione."[128] The novelty of his method for artistic learning was based on the authority of objective norms instead of personal style. It can best be illustrated by comparison with the experience that Michelangelo (1474–1564), at the age of fourteen, had upon entering Domenico Ghirlandaio's workshop in Florence in 1488. Unsatisfied with what his master had to offer, Michelangelo decided to abandon the workshop and study models as wide-ranging as Giotto, Masaccio, and Schongauer, from whom he had bought a print at the market in Florence on his own. It was up to Lorenzo de Medici (1449–1492) to provide a remedy for this dilemma by founding an academy and inviting Michelangelo to become a part of it.[129] Bertoldo di Giovanni (circa 1425–1491), the school's elected headmaster, was to challenge his pupils with the best of what was available in art – in great part classical models supplied by Lorenzo's personal collection.[130] Lorenzo may indeed have had some knowledge of the Paduan academy, even more so since Squarcione's *museum* was a point of general interest for distinguished visitors – Emperor Frederick III (1415–1493) having been one of them.[131]

It is, however, the second of the above-mentioned groups of academic tools that is of particular interest here. Scardeone refers to them as "prototypes edited by Squarcione himself" (*archetypis a se editis*) – the word *archetype* itself being common in literary discourse as well.[132] Distinct from the aforementioned *exempla*, which mainly consisted of ancient as well as modern sculptures and paintings, this group consisted of drawings and diagrams produced by Squarcione himself and his studio.[133] They were probably used for individual instruction in small classes in the second of the two ateliers – the *studium parvum* – and were not meant to be copied but studied so as to understand the underlying principles.[134] This is also what defines their difference to early model books, as the demonstration of theoretical issues concerning perspective, anatomy, and proportion was of prime importance here. Squarcione would eventually address these fields of knowledge as his personal revelation (*docere mysterium suum*).[135]

Squarcione was the only artist at that time to produce models of this second type, which he rightly considered the epitome of his academic teaching. In order to understand their nature, a contract from October 30, 1467, concluded with Giovanni Francesco, son of the Paduan painter Uguccione di Enrico, is of most value.[136] Francesco's contract does not describe a full apprenticeship but rather a four-month crash course, during which time he was expected to learn the rules of perspective and proportion. This may be the reason why the document is more explicit than contracts with pupils that extended over a long-term commitment. The learning objectives were explained in detail: a) how to design a well-delineated plane following Squarcione's method (*le raxon d'un piano lineato ben segondo el mio modo*); b) how to place the figures, one after the other, in different points on said plane (*meter figure sul dicto piano una in zà l'altra in là in diversi luoghi del dicto piano*); c) how to fill in different pieces of furniture (*metere masarizie, zoé chariega, bancha, chasa*) and understand their placement on said plane (*e darge intendere queste cose sul dicto piano*); d) how to show the human head isometrically foreshortened (*intendere una testa d'omo in schurzo per figura de isomatria, zoé d'un quadro perfecto con el soto quadro in scorzo*); e) how to understand certain anatomical and proportional principles regarding the nude body, measured from the front and back (*le raxon de uno corpo nudo mexurado de driedo e denanzi*); and f) how to measure the proper placement for the eyes, nose, mouth, and ears upon a man's head (*e metere ochi, naxo, bocha, rechie in una testa d'omo ai suoi luogi mexuradi*). Apart from the drawings that united different learning materials in one single composition, an extra set of model drawings (*carta d'asenpio*), probably much smaller, was used to call attention to specific problems that were then elaborated on by correcting the figures one by one with the help of white lead so as to instruct the pupil about his mistakes in succession (*e darge intendere tute queste cose a parte a parte, e tegnirge senpre una carta d'asenpio in man una dopo l'altra de diverse figure toche de biacha, e corezerge dicti asenpi, dirge i fali*). The contract ensured that the success of such a meticulous instruction depended upon the pupil's intelligence, and, furthermore, that the model drawings were to be guarded with great care. Giovanni Francesco is cautioned not to damage them, otherwise he would have to pay dearly for every drawing (*sel me guastasse algun mio desegno che dicto Guzon sia tenuto a pagarmelo a bon discrezione*).

The following chapters will supply ample evidence that the *Louvre Album* may indeed be considered the output of this academy from the 1440s onwards. It should be regarded as the first academic "treatise" in the arts based exclusively on pictures – a most precious showpiece not be used in daily workshop routine but referred to as a prototype that treasured the academy's most advanced accomplishments.[137] The provision of large folios, in parchment to enhance durability and authority, has been explained in the context of a textile pattern book that had been recycled for the *Louvre Album* (see p. 10). Squarcione's point of reference, however, was the modern humanists' reduplication of the newfound texts of the classics in beautifully designed manuscripts of authoritative standing. These master copies eventually incorporated archaeological information as well, such as the illustrated *syllogai* (compilations of ancient inscriptions) that were fashionable in humanist Padua at the time (see p. 56). The wish to become a member of this erudite society may have fostered certain structural analogies in the production of the *Louvre Album*, a main one being the division between the editing mastermind on the one side and specialised draftsmen on the other,[138] which harks back to the division between the humanist editor and professional scribes (*librarii* or *amanuenses*) at his command who were responsible for transferring the text onto parchment.[139] The aim in both cases was to create a reliable and purified *capostipit* from which all further knowledge was to be drawn. This effort to make human wisdom accessible to the intellectual community seemed to revive the noble spirit of the ancients, much in contrast to the illuminated books of the preceeding Gothic period that served only the interests of the few.[140]

PART 2

IV. Anatomy

Folio 13 of the *Book of Drawings* demonstrates a lesson in anatomy (fig. 10). The bier in the upper half of the drawing exhibits a male cadaver in a state of progressive putrefaction. Covering almost the entire width of the page, the naked body displays an elaborate realism that may be regarded as revolting even today. The skin and flesh of the face and penis are almost gone; what remains visible are the bones underneath decaying cell tissue. Never before, and certainly not in the French *transi-* or cadaver-tombs of the fourteenth century, has the effect of death been unveiled so radically, lacking any idealization or consoling attitude.[1] Seen below this image of human transience, and occupying as much space, appears a relief imitating the front side of a catafalque. Organized with the help of linear perspective, the depicted scene displays an interior space: a lecture hall of the medical faculty with Gothic windows and an entrance door on the left in the background. The central position is occupied by a professor at his lectern and a scribe at his feet.[2] The students' benches – four to the left and four to the right, each holding ten students – extend diagonally on both sides, leaving space for the latecomers in the background on the left. Altogether, more than one hundred people are assembled in this room. As was the case with the cadaver, the architecture of the lecture hall seems to rely, to a certain extent, upon visual experience. As a matter of fact, anatomical lectures taking place in the *Palazzo del Bo* were made public by decree in Padua in 1446.[3] These impressions from reality are, however, combined with conventional iconographical elements, such as the relief depicting a medical lecture that adorns the tomb monument of the famous physician Mondino de Liuzzi (circa 1270–1326) in the churchyard of San Vitale e Agricola in Bologna. Similarly, regarding the dead body in the upper part of the drawing, a proximity to the scientific woodcuts that decorate the frontispiece of medical treatises can be detected: the woodcut in Johannes de Ketham's *Fasciculus Medicinae*, referring to Liuzzi's *Anathomia corporis humani* (written 1316, first printed edition, Padua 1475), considered the first modern dissection manual, serves as an example (fig. 11).[4]

While these references help to establish the context, the deviation of folio 13 from standardized medical illustrations is considerable in terms of both form and content. To begin with, what is shown here, is not the dissection itself, which would require – apart from the *lector* (lecturer) – the *ostensor* (demonstrator) pointing at the parts of the body to be dissected, and the *sector* (surgeon) performing the dissection on the corpse. The subject matter of the Louvre drawing is considerably less technical. The lecture probably addresses the relationship between body and soul, a philosophical argument rather than an anatomical demonstration, thereby making reference to the venerated authorities of Plato (427–347 BC), Aristotle (364–322 BC), and Galen (129–210 AD). The validity for this hypothesis is suggested by a detail: the book lying under the

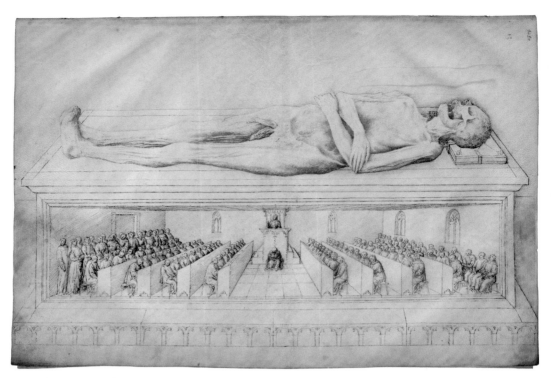

10 *Folio 13*, Musée du Louvre, Paris

dead man's skull hints at the learned context in which this image is intended to be understood. The crude depiction of decaying flesh, as a matter of fact, would seem obsolete unless it were juxtaposed against the expectancies of the human soul. Plato's *Timaeus* (translated into Latin by Cicero in 45 BC) is based on this distinction between the eternal world of the soul, indivisible and unchangeable and therefore apprehended by reason alone, and the physical world that changes and perishes. It is this dialectic that the professor at his lectern, who with all probability represents a renowned member of the Faculty of Medicine and Philosophy, is about to address.[5] The putrefaction of the flesh, described in detail, could well have justified its graphic representation:

> [82e] For whenever the flesh is decomposed and sends its decomposed matter back again into the veins, then, uniting with the air, the blood in the veins, which is large in volume and of every variety, is diversified by colors and bitter flavors, as well as by sharp and saline properties, and contains bile and serum and phlegm of every sort. For when all substances become reversed and corrupted, they begin by destroying the blood itself, and then they themselves cease to supply [83a] any nourishment to the body; for they move through the veins in all directions and no longer preserve the order of their natural revolutions, being at enmity with themselves because they have no enjoyment of themselves, and being at war also with the established and regular constitution of the body, which they corrupt and dissolve. Therefore, all the oldest part of the flesh that is decomposed becomes tough and it blackened by the continued combustion; and because it is eaten away on every side it is bitter, and therefore dangerous [83b] in its attack on any part of the body that is not as yet corrupted. And at one time the black matter acquires a sharpness in place of its bitterness, when the bitter substance becomes more diluted; and at another time the bitter substance acquires a redder color through being dipped in blood, while if the black matter is blended with this, it turns greenish; and again, whenever new flesh also is decomposed by the fire of the inflammation, a yellow matter is commingled with the bitter substance.[6]

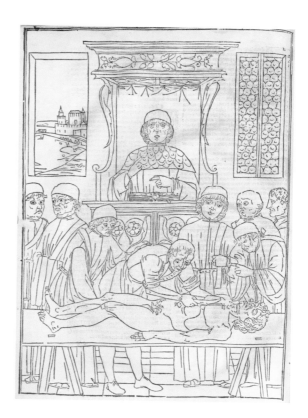

11 Johannes de Ketham, *Anothomia Mundini,*
in: Fasciculus Medicinae, 1495

The first authority, credited for having effected a synthesis between medicine and philoso-
phy, is the physician, philosopher, astrologer, mathematician, and anatomist Pietro d'Abano
(1257–1315), a contemporary of Giotto with whom he collaborated on the frescoes in the
Paduan *Palazzo della Ragione.*[7] D'Abano was the author of the widely read book *Conciliator
of the Differences Debated between Philosophers and Physicians,* which set out to reconcile
modern Arabic medicine with the classical tradition of Aristotle and Galen.[8] Occupying
the chair of medicine in Padua from 1306 to 1315, he is known for having been the first to
perform a medical autopsy for which records exist.[9] Noted anatomists to succeed d'Abano
were Niccolò di Santa Sofia (professor from 1311–1350), Giovanni Dondi (circa 1330–1388),
Niccolo da Monselice (appointed to the chair of anatomy in 1392), Leonardo Buffi da Ber-
tipaglia (active from 1420 to 1429), Cristoforo Barzizza (1431–1444) up to Andreas Vesalius
(1514–1564).[10] Similar to developments in perspective, the birth of modern anatomy conso-
lidated the Aristotelian turn in fourteenth-century Europe. With natural phenomena having
become the foundation of thought, practitioners of the manual crafts were allowed a certain
level of participation and eagerly learned from the philosophical discourse by enlivening its
principles.[11] Michele Savonarola, whose revaluation of painting as a liberal art has already
been mentioned (see p. 21), had fought a similar battle on behalf of the medical practitioners,
their vile exercise (*illiberale et vile exercitium*) having been ennobled by the succor of phi-
losophy (*merito dignitatis philosophie sibi vendicaverint*).[12] A connection between the two
disciplines of medicine and painting found its justification here. Long before Leonardo and
Michelangelo attended anatomical lectures in the late fifteenth century and Andreas Vesalius

published his richly illustrated *De humani corporis fabrica* ("On the Fabric of the Human Body") in seven volumes (Padua 1543), Cennini was to write about how to take plaster casts from both a dead and living body and make them available in the painters' workshop.[13]

The lower part of the Louvre drawing deliberately offers a different aesthetic approach to the problem of realism than the cadaver in the upper part. Of concern here, where scientific scrutiny is the subject, is the realism of perception, whereas in the case of the corpse this was the realism of depiction. Two different linear systems externalize this dichotomy. While the destructive forces of nature are translated into a *chiaroscuro* of minuscule hachures, the arcane order of the intellect, in the lower part of folio 13, finds expression in straight lines drawn with a ruler. The extension of space is painstakingly marked with the chessboard in front and the alignment of the students on their benches. Each diagonal is meant to converge with the head of the professor so as to underscore his supreme authority. The representation of inalterable reason, not the fortuity of nature, is at stake. Apart from referring to the platonic distinction between the sensible and the intelligible world, the empirical meaning of the image thus aims at demonstrating the implementation of academic rules that are superimposed onto the mere appearance of things. The contrast could not be greater, revealing a personality undismayed by questions of style while, on the contrary, deeply involved in the didactics of academic instruction. Instead of designing a tomb for somebody specific, a member of the Este or Gattamelata families as has been previously supposed, the artist wanted to show that he was in full command of both aesthetics, the distinction of which, in a nutshell, underlays the educational purpose of the *Louvre Album*.

V. Perspective

Jacopo Bellini: aerial versus linear perspective

Departing from folio 13 and Padua's longstanding tradition in anatomy and perspective, it is difficult, if not impossible, to establish any link between such drawings and Jacopo Bellini's artistic practice and theory. It is fair to say that he was unfamiliar with the kind of scientific approach exposed in the *Louvre Album*.[14] This judgment may seem fortuitous, as his documented œuvre reveals great lacunae and as there are no drawings known to have been made by him beyond the books in Paris and London.[15] However, from secured works such as the *Annunciation* in Brescia (early 1430s) and the signed *Madonna and Child* in Lovere (late 1440s), which are among Jacopo's most exquisite paintings, it can be deduced that his artistic personality was embedded in an altogether different tradition.[16] Stylistically, it adheres to the International Style of the Late Gothic period, the richness of which appealed to the mercantile elites in Venice through the use of gold and tone. This was quite distinct from the scientific approach originating in the intellectual centers of the Po Valley. One of the prominent masters of this Late-Gothic tradition is the painter Gentile da Fabriano, who is recorded as having worked in the *Sala del Maggior Consiglio* of the Doge's Palace in Venice from 1409 to 1413, when Jacopo probably became his pupil.[17] This relationship was to be determinative, and Jacopo was to remain "the proud yet humble pupil of that great artist" (Eisler) even afterwards when he probably followed his master to Brescia (1418/1419) and then to Florence (1420).[18] His indebtedness is documented in the inscription on a lost painting for the high altar of San Michele in Padua in 1430 where he calls himself Gentile's disciple (*jacobus de venetiis discipulus gentile da fabriano pinxit*) and in the dedication of the 1436 fresco of the *Crucifixion* for the Chapel of San Niccolò (Verona, Cathedral), likewise lost, in which Gentile is given the attribute of *praeceptor*.[19] Yet Jacopo was aware that a modern school had emerged in Florence, manifest in the works of Ghiberti, Donatello and Masaccio since the 1420s, which sought to deviate from Gentile's standards of refinement for the sake of naturalism and perspective.[20] Squarcione's flourishing academy in nearby Padua, which had thoroughly responded to the changing times, must have been a thorn in his side.[21] This explains why Jacopo's association with Mantegna played an important role. Both to have him become a member of his family and to come into possession of Squarcione's collection of archetypes and examples were part of the same scheme. This sought to establish the supremacy of his family workshop in a way that could have have responded quickly to the new expectations in art and been thereby commensurate with Venice's political and economic ascent.

Jacopo's own efforts to achieve mastery in what were considered the "miracles in art" (Vasari) are confirmed by the physician Giovanni Fontana (1395–1455) in his no-longer-extant treatise on painting (to be dated before 1440) in which Jacopo is counted among the innovators of "the very noble science of perspective."[22] The reference has been taken as a confirmation that the linear constructions abundant in the *Louvre Album* must certainly be his.[23] The apparent inconsistency between the drawings and his paintings have led art historians to assume that, in his official works, Jacopo was compelled to suppress his advanced capacities for the sake of convention. A split personality emerges – ahead of its time within his private exercises, yet restricted by the conservatism of his clientele.[24] This assumption is, however,

based on a misinterpretation of Fontana's text, which was about aerial not linear perspective: the clash between folio 13 and Jacopo's understanding of perspective could not be greater.[25]

The drawings related to perspective in the *Louvre Album* are organized around one central point at which all lines converge and to which all reductions in space and size relate in mathematical order. For Jacopo, however, the effect of near and far is associated with light and shadow and expressed through the gradation of color. His system is based upon the sensual perception of natural phenomena and aims to deceive rather than persuade the spectator – the *potentia visiva*, as Pelacani would have said, and not the *potentia cognosciti-va* which is based upon precise knowledge and negotiable in mathematical measures.[26] As Bellini's painterly practice relies on the artist's visual judgement (*giudizio dell' occhio*), not on his mathematical skills, so does Fontana's theory rely upon the concept of natural experience.[27] Consequently, he does not define perspective in the sense of *perspectiva artificialis* or *legittima costruzione*, as understood by Pelacani and his Florentine followers, which applies the rules of geometry in order to establish the proportions of figures and objects in correct relation to their position within space (*porre bene e con ragione le diminuizioni e accrescimenti [...] di quella misura che s'apartiene a quella distanza che le si mostrano di lungi*),[28] but defines it rather in the sense of the foregoing scholastic discussions related to light and dark through the shading of color as means to suggest proximity or distance:[29] "Truly, the art of painting teaches that objects that are near have to be painted with light colors, whereas those who are distant with dark colors and those in the middle with mixed colors."[30] Both systems coexisted in the fifteenth century. Leonardo da Vinci (1452–1519) exemplifies this point by contrasting aerial with linear perspective:

> There is a kind of perspective which I call aerial perspective, because by the atmosphere, we are able to distinguish the variations in distance of different buildings, which appear placed on a single line; as, for instance, when we see several buildings beyond a wall, all of which, as they appear above the top of the wall look of the same size, while you wish to represent them in a picture as more remote one than another and give the effect of a somewhat dense atmosphere. You know that in an atmosphere of equal density, the remotest objects seen through it, as mountains, in consequence of the great quantity of atmosphere between your eye and them – appear blue and almost of the same hue as the atmosphere itself. Hence, you must make the nearest building above the wall of its real color, but the more distant ones less defined and bluer. Those you wish should look farthest away you must make proportionately bluer; thus, if one is to be five times as distant, make it five times bluer. And by this rule, the buildings which above a given line appear of the same size, will plainly be distinguished as to which are the most remote and which larger than the others.[31]

Jacopo's precious *Virgin with Child and Donor* in the Louvre is traditional in the sense that the proportion of the Virgin and child stands in no relation to either the donor (Lionello d'Este?) or to the painting's background (fig. 12).[32] The line of horizon is situated far too high to allow a natural orchestration of space in the receding landscape, which results in its being "nicht bildeinwärts, sondern bildaufwärts orientiert" (Degenhart and Schmitt). The single parts of the composition are orchestreted by light and shade – a system clearly bound to aerial perspective as formulated by Fontana and indebted to Gentile da Fabriano.[33] Similarly to him, Jacopo applies dots of gold in different size in order to enhance not only the privileged status of his main figures – being "miles away from the other animals, men, and mountains situated on the same painted surface" (Fontana) – but also the relative vicinity

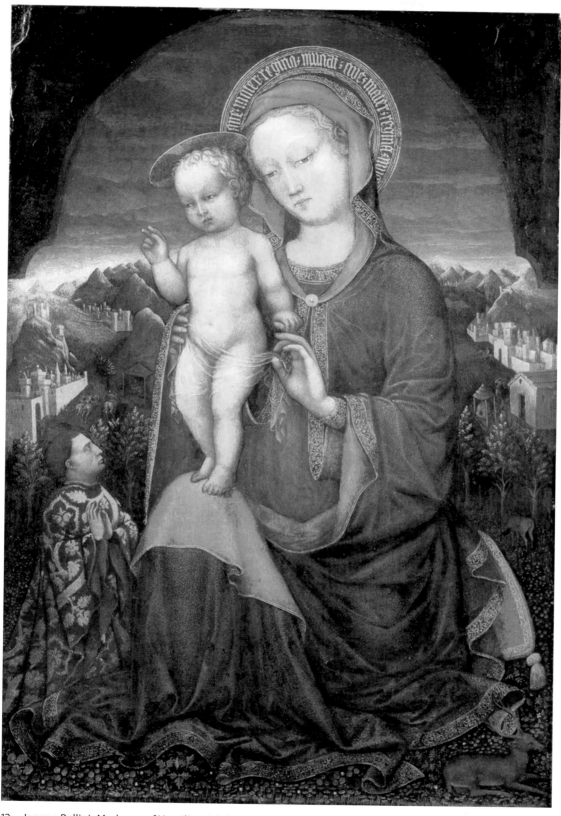

12 Jacopo Bellini, *Madonna of Humility with Donor*, Musée du Louvre, Paris

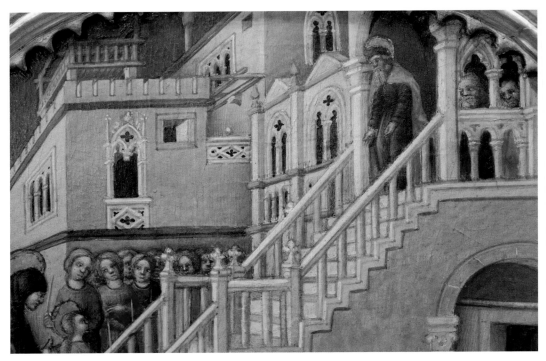

13 Jacopo Bellini, *Presentation of the Virgin in the Temple* (det.), Sant' Alessandro, Brescia

or distance of each element in his composition: lateral city views, trees and mountains.[34] By contrast, in folios 17, 26, 28, 31 or 39, the distance of the objects is measured by the projection of orthogonal lines converging into one vanishing point that meets the eye of the observer. This corresponds to Alberti's definition not only in a technical sense but also with regards to his assessment, based on the authority of the ancient painter Pamphilius, that knowledge of mathematical sciences is a prerequisite in the process of ennobled painting:

> Furthermore, I wish that the painter be expert, as far as possible, in all liberal arts, but above all I desire in him the knowledge of geometry. I certainly agree with Pamphilus, a very ancient and very famous painter, from whom the young nobles learnt painting for the first time. His opinion, in fact, was that no one by ignoring geometry would have been a good painter. Certainly, our rudiments, from which one extracts a whole, complete, and precise technique of painting, are easily assimilable by a geometrician. I also believe that for those who ignore this science neither rudiments nor some procedures of painting can be sufficiently comprehensible. I, therefore, claim that geometry absolutely must not be neglected by painters.[35]

It must be conceded, however, that Jacopo Bellini was aware of the alternative and would make reference to it in his later paintings. Given the double existence of the method and Jacopo's intensified contacts with Squarcione and Mantegna, this changed approach comes as no surprise.[36] Instead of relying on *chiaroscuro* effects, he made use of linear systems in the *predella* panels of the altarpiece for the Sant'Alessandro church in Brescia (1444) and later on in the panels for the Gattamelata Chapel in the Santo.[37] The architecture of the palace in *The Presentation of the Virgin in the Temple* (fig. 13), whose fifteen steps Mary ascends, is clearly constructed with the help of lines, not shading.[38] A comparison with the same sub-

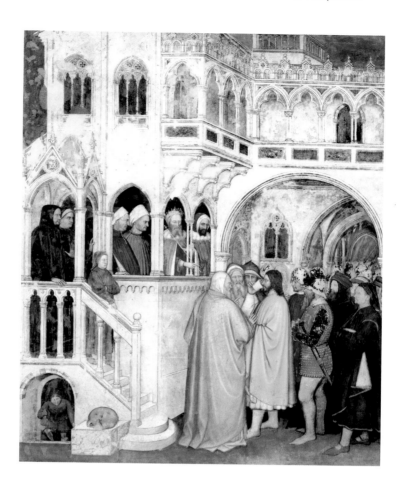

14 Altichiero, *Poisoning of Saint George*, Oratorio di S. Giorgio, Padua

ject in the *Louvre Album* (folios 24 and 30), from about the same time, nevertheless reveals fundamental differences as to the mathematical precision of the construction (Appendix IV). In Bellini's painting, the architectural setting is subjected to the story. The orthogonals of the architecture converge at the head of the Virgin only to emphasize the main figure, without being part of a rationale regarding the composition as such.[39] In the Louvre drawings, on the contrary, the subject matter is but the pretext for the consequent application of perspective and the staging of the open space.[40] Bellini's kind of simulative perspective, "welche die Dreidimensionalität durch die Schrägstellung der Baukörper und nicht durch einen lückenlosen räumlichen Zusammenhang aller Bildteile zum Ausdruck brachte" (Degenhart and Schmitt), was already known to Giotto and his school: Altichiero's frescoes of the *Poisoning of Saint George*, the *Baptism of King Sevio* and *Saint Lucy before Judge Pascadius* may serve as comparisons (fig. 14).[41] It was outdated, even in official paintings, by the middle of the fifteenth century, as is confirmed by Andrea del Castagno's mosaic of the *Dormition of the Virgin* in the Mascoli Chapel (Venice, San Marco).[42] Mantegna, while making use of Squarcione's system up to a certain degree, as the comparison between the perspectival construction of the *Flagellation* (folio 29) and the *Baptism of Hermogenes* in the Ovetari Chapel demonstrates (Appendix VIII), clearly opted for Alberti's licence when orienting the *Trial of St. James* and other frescoes of the same chapel to the changing position of the

distant spectator (Appendix IX).[43] Jacopo, in view of these recent developments within the Paduan school of painting, must have realized himself the backwardness of his own workshop, which is most probably why the mathematician Girolamo Malatini was invited to join his studio to give courses in modern perspective.[44] It is tempting to speculate that Malatini's teachings were based upon the *Louvre Album*, which, by that time, had already passed into Jacopo's possession.[45] Turning the argument around, one could claim that the employment of a specialist in geometrical perspective would have been unnecessary had Bellini himself executed the very set of drawings that is to be discussed in the next chapter.

Folio 45

Several drawings in the *Louvre Album* present scholastic exercises in perspective in order to achieve an illusion of reality on a two-dimensional surface (Appendix III–VII). Objects appear to be smaller or larger as they move farther away from or closer to one single point, upon which all diagonal lines converge in the form of a cone or pyramid. The vanishing point (or centric point) is meant to correspond to the eye of the beholder at a prescribed distance. If this point lies below the horizon line, he will be looking at the scenery from above; if, on the contrary, it is higher, he will be looking at it from below. The ultimate aim of linear perspective is to achieve a coincidence of vision and representation. Alberti, who had written on perspective in *De pictura* only slightly earlier (1435), compares the canvas to an open window "through which the *historia* is observed," and the painting itself – demonstrating the illusion of the outside world – to the cut through the visual pyramid, a method similar to the construction principle of several drawings in the *Louvre Album* (see p. 44).[46]

Squarcione's canon of teaching, as deduced from the directions given to Giovanni Francesco in 1467 (see p. 26), can easily be traced throughout the *Louvre Album*. Folios 28, 30 and 57 exemplify the layout of a plan subdivided into orthogonal and diagonal lines, folios 27 and 76 display bodies geometrically foreshortened, folios 40 and 43 show nudes in different postures, and, finally, folios 13 and 57 illustrate perspectival projections of figures and objects. Folio 45 is of particular interest, insofar as it combines different technical steps in one composition (fig. 15). The architecture of a palace with a loggia in the *piano nobile* defines the base of the visual pyramid. Occupying two-thirds of the overall height, the hall has its lower façade removed so as to allow the spectator to look inside. Here, a room is displayed, divided by two floors and connected via a staircase. All diagonals converge on the centrally positioned vanishing point (see Appendix I, fig. 18). They are cut by horizontals that establish the gradual diminution in space. Key components are the checkerboard of the ground floor, the beamed ceiling, the window with its grille, and the loggia.

The rational space thus created is inhabited by figures as well as animals. On the gallery, a bearded ruler is sitting on a throne; nine people surrounding him occupy different spatial levels and differ correspondingly in height. A man kneels on the floor in front of the ruler and presents a decapitated head. They are all clad in ancient armor or togas. Seen from behind, a modernly dressed young man is about to climb the staircase from the floor below. This is a key figure for understanding the construction.[47] He represents the viewer, whose eye-level, converging with the horizontal line, meets the central vanishing point, The figure's height is

15　*Folio 45*, Musée du Louvre, Paris

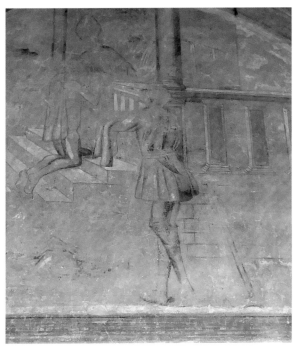

16 *Folio 45* (det.), Musée du Louvre, Paris

17 Squarcione, *Legend of Saint Francis* (det.),
San Francesco, Padua

calculated by multiplying the distance between the crown of the head and its chin by nine, as defined in contemporary Padua by Michele Savonarola.[48] A wooden mannequin (*figuretta di legno*), like the one that Squarcione used in the second of the lunettes of the Church of San Francesco in Padua (circa 1452), may have served as prototype (figs. 16 and 17).[49] Next to this ascending figure are two children positioned on the same staircase, with one standing on step one and the other sitting on step four, thereby exemplifying changes in proportion and diminution of space. They are both peering through the railing at two cheetahs in the yard. The two animals are chained to a ring fixed on the middle pier of a vaulted backroom and occupy exactly three rectangles in the second row of the pavement's checkerboard. Next to their feeding bowl (accomodated within a separate rectangle), a room opens to the right which is inhabited by a horse, seen from the back, and a stableman. Positioned above its entrance stands a nude sculpture on a pedestal. More references to the Roman past are displayed in niches and roundels in the loggia above. The two toga-clad men next to the balustrade – one seen from the rear and the other from the front – are meant to indicate by their relative height the distance in space as perceived from the youth ascending the staircase. Another man, standing in the middle of the gallery and holding a lance, who is aligned with the central beam of the ceiling and the ring above in which two garlands meet, fulfills a similar task. He upholds the construction, not the narrative. The vanishing point is situated in his axis, and the fact that he is holding a lance – as if it were a measuring tool – makes one wonder if he is meant to personify the artist himself functioning as a geometrician in the sense of Alberti. This is the first and indispensable feature required for a composition in

which nothing is fortuitous or constrained to the narrative. The *ultima ratio* is mathematical. It is compelling to note that overlapping of any kind has carefully been avoided to maintain the absolute clarity of the construction. To heighten the intelligibility of his method, the artist has inserted the basic matrix in the form of an octagon into the center of the pavement's first row of rectangles, according to which the foreshortenings (*in schurzo per figura de isomatria*) may be calculated.

The table of contents of the *Louvre Album* states the title for this drawing as: *uno chaxamento come le apresenta la testa d'Anibal*.[50] This explanation, which alludes to the tragic end of the Carthaginian general during the Second Punic War against Rome (218–201 BC), is, however, difficult to accept.[51] No literary report of his decapitation exists, nor has it ever been illustrated.[52] It is the standing hypothesis that the table of contents was written long after the completion of the *Louvre Album*, at a date when the original intent of the drawings was no longer relevant. Furthermore, it is significant that, instead of identifying the scene with a more common subject, such as the presentation of St. John's head to Herod, an event of Roman history was invented. This especially made sense for heightening its market value in view of rising antiquarian and literary interests during the later fifteenth century. Thus, the invention of an antique narrative may have seemed useful when Gentile decided to liquidate the book in 1479. The poet Raffaele Zovenzoni (1434–circa 1485), who had assisted him in the role of antiquarian expert when it came to the selling of a Venus attributed to the Greek sculptor Praxiteles from Jacopo's collection, may again have played a part in this invention.[53] Sultan Mehmed II, the future owner of the *Louvre Album*, would certainly have been more attracted by a story from Roman history than by an exercise in linear perspective or a biblical story. One is reminded that the drawings' antiquarian content was also highly praised in Tovaglia's letter to Ludovico Gonzaga (see p. 10).

The truth concerning folio 45 may well be that it was not primarily conceived to stage a remote legend, but rather to demonstrate the stereoscopic effect of space and figures on a two-dimensional surface.[54] This means that iconographical fragments from different sources (history, zoology, and archeology) were assembled at random, purely for the sake of pictorial representation. The spectator is expected to "read" the construction upon which the composition is based and understand its design from a technical point of view. It is the skillful performance and its underlying theory that counts, not the representation of an historical event. Symptomatically, no contextual relationship exists between the judgment scene above and what is represented below. More than anything, it is a box filled with different types of objects that is meant to confirm an abstract, geometric principle.[55] Squarcione's terminology is appropriate for reconstructing the procedure (see p. 26): The pupil must learn first to construct the architecture (*le raxon d'un piano lineato*) and then to populate the space with figures at different intervals (*meter figure sul dicto piano una in zà l'altra in là in diversi luoghi del dicto piano*) or whatever inventory might otherwise be fitting (*metere masarizie, zoé chariega, bancha, chasa, e darge intendere queste cose sul dicto piano*). Understanding how "to position one figure following the place for which it is designated" (Lomazzo) was to remain the basic rule for "universal perspective" in the centuries to come.[56]

Beginning
Define the framing square with its diagonals. The intersection of the diagonals establishes the center point. Draw the horizon line passing through the center point and parallel to the base line; also draw the vertical midline through the center point.

Pavement
Divide the base line with equidistant points into six parts and connect these points of division with the center point; the resulting lines are perspective lines of the pavement.
Choose one of the vanishing points of pavement's diagonals [in this case, the left intersection of the frame and the horizon line]. Connect this vanishing point with the frame corner at the bottom right. This connecting line has six points of intersection with the perspective lines.
Draw lines parallel to the base line through these six points of intersection; these are the transversals 1 to 6 of the pavement. With the help of a second diagonal, establish transversals 7, 8, and 9.

Rear Wall & Upper Floor
Draw the rear wall.
Draw the front plane, the perspective lines and the back edge of the upper floor.

Staircase
Draw the perspective line in the floor, a vertical line in the front plane of the upper room and one in the rear wall.
Draw the staircase's slope.

Octagon
Draw the original octagon and construct its perspective image in the middle of the pavement's first strip.

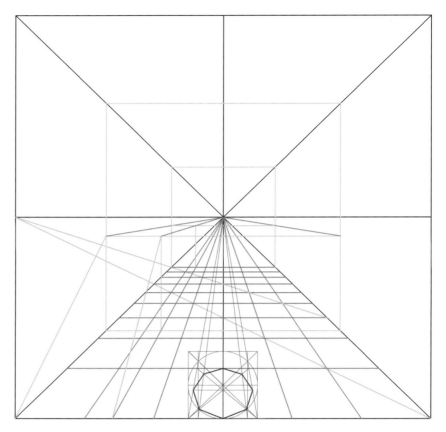

18

Folio 45 and similar drawings in the *Louvre Album* (folios 5, 6, 13, 16, 17, 24, 26, 25, 28, 29, 30, 331, 34, 57, 76) are to be understood as illustrations for a lecture on perspective, the text for which is lost today.[57] The situation appears to be the opposite when compared to the lectures on "artificial perspective" by the Salernitan scholar Pomponio Gaurico (1482–1530), a former student at the University of Padua (since 1501).[58] All that remains of these, is a chapter in Gaurico's treatise *De sculptura*, published in Padua in 1504 but without the illustrations referenced in the text and required for understanding it. Not a specialist himself, Gaurico must have turned elsewhere for help with this lost *apparato grafico* (Divenuto), for instance, to visual material or documents related to Squarcione's academy that were still available at the time.[59] This would underscore that Padua remained, next to emergent Florence, a privileged place for the reception of natural sciences in the figurative arts. Similarities in method – that the perspective depends on the spectator's position (*quacunque ratione spectamur*), and the composition's clarity (*perspicuitas*) relies on the intervals between a certain number of figures within a given space – support the assumption that Squarcione's teachings continued to be heard.[60] Gaurico also mentions the construction of circular forms (*rotundas formas*), intersected by lines and meeting in the middle (*de lateribus et de angulis ducantur, quae intersecantur in centro lineae*), which he used in order to calculate the foreshortenings of the figures (*decurtationes*) and which may find a parallel in the geometrical diagrams of the *Louvre Album*.[61] An *archetype* like the drawing in question synergized the

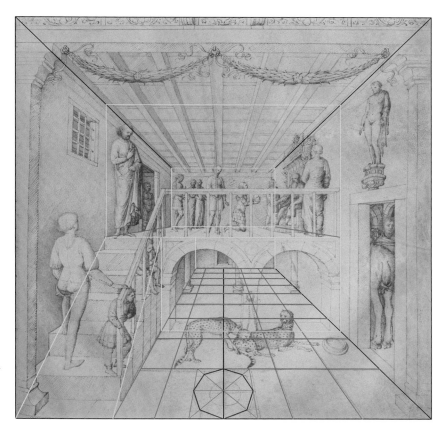

Beginning
Define the framing square with its diagonals. The intersection of the diagonals establishes the center point. Draw the horizon line passing through the center point and parallel to the base line; also draw the vertical midline through the center point.

Pavement
Divide the base line with equidistant points into six parts and connect these points of division with the center point; the resulting lines are perspective lines of the pavement.
Choose one of the vanishing points of pavement's diagonals [in this case, the left intersection of the frame and the horizon line]. Connect this vanishing point with the frame corner at the bottom right. This connecting line has six points of intersection with the perspective lines.
Draw lines parallel to the base line through these six points of intersection; these are the transversals 1 to 6 of the pavement. With the help of a second diagonal, establish transversals 7, 8, and 9.

Rear Wall & Upper Floor
Draw the rear wall.
Draw the front plane, the perspective lines and the back edge of the upper floor.

Staircase
Draw the perspective line in the floor, a vertical line in the front plane of the upper room and one in the rear wall.
Draw the staircase's slope.

Octagon
Draw the original octagon and construct its perspective image in the middle of the pavement's first strip.

Finally
Erase the construction lines
and show the folio as background.

19

complexity of rules the student of perspective needed to keep in mind. To disentangle this composite, one is reminded that Squarcione himself made use of auxiliary drawings (*carta d'asenpio*) in which the individual steps were highlighted in white lead (*diverse figure toche de biacha*) and shown one by one (*una dopo l'altra*). Folio 45 required at least thirteen single steps (fig. 18, 19 and Appendix I):

1. Define the framing square.
2. The intersection of the diagonals establishes the center point.
3. Draw the horizon line passing through the center point and parallel to the base line.
4. Divide the base line into six equidistant points and connect these with the center point; the resulting lines are the depth lines of the pavement.
5. Choose the eye point to establish the distance of the beholder [in this case, at the intersection of the frame and the horizon].
6. Draw diagonals from the eye point to the intersections on the base line.
7. Draw lines parallel to the base line and through intersections 1–6 of the diagonal of the eye point with the depth lines; these are the transversals of the pavement.
8. With the help of a second diagonal, establish transversals 7, 8, and 9.
9. Draw the rear wall.
10. Draw the upper floor (in three steps).
11. Draw the staircase (in six steps).
12. Draw the octagon or basic matrix (in two steps).
13. Erase the construction lines.

The main reference for evaluating the method as indicated in folio 45, however, is not the chapter in Gaurico's treatise which, after all, is more relevant to the context of the Paduan academy's legacy, but Alberti's *De pictura*.[62] Dedicated to the architect Filippo Brunelleschi in the mid-1430s, about ten years earlier than the presumable date of the drawings attributed to Jacopo Bellini, it was to become the major text on the subject of linear perspective.[63] The similarity in technique has led to the assumption that the author of the *Louvre Album* must have been indebted to the Florentine discovery of linear perspective.[64] As a matter of fact, the coincidences between the basic perspectival rules are striking enough to reject the notion that the kind of geometrical expertise (*geometriae peritiam*) advocated by Alberti on the one hand, and what Squarcione understood under the term *isomatria* on the other, existed altogether independently. Pelacani's and earlier theories on optics and perspective might have been a connecting link.[65] Following Alberti, a construction in perspective required at least ten steps (see Appendix II):

1. First I trace as large a quadrangle as I wish, with right angles, on the surface to be painted; in this place, it [the rectangular quadrangle] certainly functions to me as an open window through which the *historia* is observed, and there I determine how large I want the human figures in the painting to be.
2. I divide the height of this very man into three parts that for me are certainly proportional to the measure commonly called a *braccio* [an arm's length = about 58 cm]. That [measure] of the three *braccia*, in fact, as it results from the symmetry of the limbs of a man, is precisely the height of an average human body.
3. According to this measure, then, I divide the base line of the drawn [rectangular] quadrangle into as many parts of this kind as [the line] contains. Moreover, for me this very same base line of the [rectangular] quadrangle is certainly proportional to the nearest transverse and equidistant quantity seen on the pavement.
4. After these [steps], I place only one point inside the [rectangular] quadrangle. In that place let there be the [point of] sight; for me, that point, as it occupies the place itself toward which the centric ray strikes, let it, therefore, be called the centric point. The appropriate position of this centric point is not to be higher from the base line than the height of the man to be represented in the painting. On this condition, in fact, both the viewers and the painted things appear to be on a uniform plane.
5. Having placed the centric point, I draw straight lines from the centric point itself to the single subdivisions of the base line, which lines certainly show me how the transverse quantities narrow down to sight, if I wish to advance by interval up to an almost infinite distance.
6. I have a small surface on which I trace one single straight line alone, which I divide into those parts according to which the base line of the [rectangular] quadrangle is divided.
7. Hence, I place a single point above, in respect to this line, as far up as the centric point in the [rectangular] quadrangle is distant from the subdivided base line.
8. And, from this point, I trace the single lines to the single subdivisions of this exact line.
9. I then establish how much I want the distance between the viewer's eye and the painting to be.
10. And, having fixed there the position of the cut, I obtain, by means of a perpendicular line, as mathematicians say, the cut of all the lines that this [perpendicular] will have met.

Despite a general congruence of the objective and essentials of the construction – the definition of the centric point, the calculation of the checkerboard pattern, and the taking as a basis the Vitruvian canon of human proportions – Alberti presents a modernized version in contrast to the construction of perspective in the Louvre drawings.[66] He was conscious of the difference between his version and other existing systems of perspective – *their* way of

proceeding, as he calls it, that would inevitably encounter serious mistakes.[67] With respect to folio 45, the main difference consists in the fixing of the eye point on the perimeter of the square, whereas, with Alberti, the painter is free to decide the angle and the distance from which the painting is being observed. The position of the viewer, upon which the ratio of the geometrical construction depends, can be moved outside the picture frame at will. In order to achieve this, Alberti employs a device that was unfamiliar to the draftsman of the *Louvre Album*.[68] It consists in placing the view-point on a separate sheet of paper (*areolam*) that can be physically shifted at will.[69] Alberti may have learned this trick from Brunelleschi.[70] It is a significant improvement, since stretching the visual pyramid further out renders the illusion of space and the shape of the figures more pleasant to the eye of the beholder and, at the same time, allows the artist more freedom in his compositions. In folio 45, on the contrary, this liberty has been sacrificed to the dogma of geometry. The result is a *cyclopean vision* (Collins), "caused by what would appear to be a viewing of the scene or object from too close a station point or with a visual angle that is too wide, thus producing a peripheral distortion or, more accurately, perceptions which are not consistent with those normally experienced in human vision."[71]

The predominance of geometrical theory over the logic of art seems to confirm contemporary verdicts on Squarcione.[72] Scardeone reports that he was abounding in theory, yet lacking in artistic practice (*fuit profecto vir maximi in ea parte iudicii: sed (ut fertur) non multae exercitationis*); following Vasari, who relied upon a letter written to Leonico Tomeo by the Paduan painter Girolamo Campagnola (circa 1435–1522), Squarcione was universally known as an artist of discrete standing (*perché si conosceva lo Squarcione non esser il più valente dipintore del mondo*).[73] The amateurish rendering of figurative details in folio 45 and many other drawings attest to Squarcione's incapacities in this artistic domain. He himself was probably convinced that what counted was theory and that the salvation of the arts depended on science alone. Quite on the contrary, the Florentine theoreticians Alberti and Paolo dal Pozzo Toscanelli (1397–1482), notwithstanding their studies in Padua where they had entered the orbit of Pelacani, Barzizza and Vittorino da Feltre, paid more respect to the artist's judgement and what Cennini had called *operazione di mano*.[74] This may be due to the authority of the early *quattrocento* painters and sculptors, Masaccio and Donatello, to whom Alberti makes explicit reference in his prologue addressed to Brunelleschi.[75] The ultimate reason, however, for the artist's adherence to Alberti's more flexible perspectival construction in contrast to the rigid method operated by Squarcione has to be seen in terms of different ideological, rather than aesthetical, preconditions. As distinguished from conservative and elitist Padua, the political climate within the young Florentine state was dedicated to libertarian concepts. Leonardo Bruni (1370–1444) was addressing a class of nouveau-riche merchants when expounding on the principle of meritocracy, "where men are given the hope of attaining honor in the state" and, therefore, "take courage and raise themselves to a higher plane."[76] The arts in Florence, as those of Athens in the age of Pericles (d. 429 BC) to whom Bruni is paying homage, were encouraged to overcome the old class system and the authoritarian rules of the aristocracy of blood connected to them which continued to be in force in Renaissance Padua.[77]

The sculptor Donatello (1385–1466), a friend of both Brunelleschi and Alberti, matches the type of emancipated artist that would put more trust in his own creative faculties and demonstrate a certain ambivalence to "science." His presence in Padua from 1443 to 1453, on the occasion of his commission of the equestrian statue of *Gattamelata* and the high altar of the Santo church, profoundly shook the antiquated tenor of Squarcione's academy. Donatello's resistance to the artist's subordination to the laws of geometry can be deduced from his criticism of Paolo Uccello whom he reproached for abandoning "the certain for the uncertain."[78] Even more to the point is an anecdote noted by Gaurico in 1504. It reports a visit to Donatello's Paduan atelier by a certain Marco Balbo who requested that the master let him see his stencil (*Donatelli abaco*). Balbo probably had Squarcione's matrixes in mind. However, Donatello replied to him that he did not need any kind of format (*nullus est mihi, Balbe, alius abacus*), since all he relied upon was his visual judgement. Asking for paper and pencil, he thereupon designed a freehand composition (*quancumque historiam*) to prove the veracity of his argument.[79] This demonstration of artistic autonomy, which was made public in Donatello's bronze reliefs of the Santo high altar (since 1447), was almost an insult to the dogmatic spirit of the Paduan academy and capable of causing considerable damage to Squarcione's reputation. The aging patriarch, resistant to any type of reform, was not spared any heavy criticism. What was worse, his most talented pupils took leave: Niccolo Pizolo became a member of Donatello's workshop in 1447;[80] Mantegna, after having converted to Alberti's system in the frescoes for the Eremitani Chapel, sued Squarcione in public (1448, 1455); Zoppo, after a dispute with his master, left and went to Venice in 1455.[81] There is little doubt that, by this date, the kind of geometrical perspective that had been the pride of Squarcione's academy had fallen out of fashion.[82] Maestro Agnolo di Marco Silvestro, whom Squarcione had tried to lure in with his method in 1465, was explicit on this point: "It is ever his custom that he seeks to delude with his promises, boasting about things he does not have and about knowledge he does not have [...]."[83] The fact that this kind of scientific drawing plays no part in the later album of the British Museum speaks for itself.[84] Other topics, listed by Tovaglia in 1476, that suited contemporary humanist interest far better, such as archeology ("copies after the antique"), mythology ("battles of fauns and satyrs"), and genre ("images of men and women on horseback or foot"), were to supersede the exact sciences and the early spirit of academia.

VI. Archeology

Folios 48 and 49

Two pages in the Louvre book (folios 48, 49) are devoted to the subject of archeology (figs. 20 and 21): the table of contents refers to them as many Roman epitaphs (*molti Epitafii romani*) and many other ancient epitaphs (*molti altri Epitafij antichi*) respectively.[85] Altogether, seven funeral monuments (four in folio 48 and three in folio 49) are depicted. They rely upon genuine tombstones (*cippi*) from classical Roman times whose inscriptions have been copied with great care.[86] The first modern scholar to draw attention to this compilation was the German historian and archeologist Theodor Mommsen (1817–1903) in his ground-breaking sixteen-volume *Corpus of Latin Inscriptions*.[87] Thanks to his research, which other scholars subsequently completed, it is now possible to determine the locations of the insciptions at that time, most of which no longer exist. With respect to their placement in the *Louvre Album*, the monuments are listed as follows:

a) METELLIA PRIMA XXI(48, no. 1 = CIL, V, 4653): tomb of Metellia and her family in the Church of San Salvatore / Monastery of Santa Giulia, in Brescia (lost)
b) T. PVLLIO/T. LLINO (48, no. 2 = CIL, V, 2528): grave stele of Titus Pullius Linus in Baone, Monte Buso (Este) near Padua (lost)
c) T. POMPONENVS (48, no. 3a = CIL V, 2669): cippus for Titus Pomponenus Gratus situated originally in Carmignano (Monselice, S. Giacomo), in the province of Padua; the base with the inscription CLODIAE. C. ARCH /TF (48, no. 3b) has been conserved in Vienna (Neue Burg / Kunsthistorisches Museum)
d) M. ACVTIO (48, no. 4 = CIL, V, 22553): tomb altar for Marcus Acutius Marcellus, formed part of collection of Alessandro da Bassano *senior* in Padua (lost)
e) MANIBVS M. EPPI RVFI (49, no. 1 = CIL, V, 2623): base of a funerary monument for Marcus Eppius Rufus in San Fidanzio (Megliadino, San Fidenzio) near Padua (lost)
f) LVCRETIAE (49, no. 2 = CIL, V, 2542): base of a funerary monument to the dressmaker (sarcinatrix) Lucretia, formerly in Este, near Padua (lost)
g1) DIVO CAESAR (49, no. 3a = CIL, VI, 882): inscription of the Vatican obelisk (Rome, Piazza S. Pietro)
g2) C. GAVIO (49, no. 3b = CIL, V, 3464/3663): statue of Caius Gavio Strabo, Arch of the Gavii in Verona (Verona, Corso Cavour)

Additionally, the upper part of folio 48 displays three coins: the front and back of a *sestertius* dedicated to emperor Domitian, commemorating the Roman conquest of Germany (GERMANIA CAPTA) in the year 87, plus a blank verso. They formed part of a collection of ancient coins that were intended to be fully illustrated. Circles meant to include their *rectos* and *versos* (*tondi per far medaje per imperadori*, as the table of contents lists them) had already been drawn at the end of the album (folios 93v, 94); yet for reasons unknown, the plan never materialized.[88] In the case of the *cippi* and their inscriptions, it can be presupposed that a similar collection or inventory existed from which these specimens had been copied with great accuracy, showing not only the texts themselves and their divisions but also the script in Roman *capitalis*. However, in contrast to the medals, whose placement throughout the *Louvre Album* is restricted to architectural ornamentation, the tomb slabs are presented in an altered state: they combine the modest, domestic inscriptions, which refer, as a rule, to the lives and achievements of unknown and relatively ordinary people, with sculptures from different sources.[89] The artist had to respect the rules of propriety by adding elements that

20 *Folio 48*, Musée du Louvre, Paris

were compatible.[90] This re-composition may have involved the advice of experts – perhaps the same people responsible for collecting and editing the archeological material in the first place. The most striking alterations are:

a) The group of two dancing women on top of the Acutius altar (folio 48, no. 4) is derived from the relief of maenads on a Roman cippus (Padua, Musei Civici, no. 248), translated here into a freestanding sculpture.[91] The round base with the two festoons and the suspended mask is itself reminiscent of a type to be traced back to Este (Museo Atestino).[92]

b) The equestrian statue on top of the Rufus base (folio 49, no. 1) refers either to one of the Roman bronze horses from San Marco in Venice (as far as the horse is concerned) or the equestrian monument designed in 1443 by the Florentine Niccolo Baroncelli (active in Padua 1434 to 1443) for Niccolo III d'Este in Ferrara.[93]

c) The statue of Perseus with the head of Medusa surrounded by winged *erotes* holding festoons in their hands (folio 49, no. 2), added to the Lucretia base (folio 49, 2), is probably a modern invention.[94]

d) The monument on folio 49 (no. 3) combines three sources: 1) on top, the famous *titulus* of the Vatican obelisk next to St. Peter's that Caligola had brought to Rome in 37 AD; 2) below, the inscription from a niche in Arco dei Gavi in Verona; 3) the framing border decorated with griffins is derived from a relief forming part of the decoration of Ponte Nuovo in Verona (now located in the Museo Archeologico).[95]

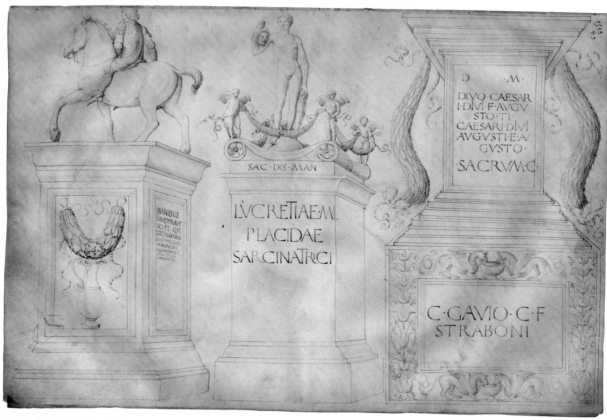

21 *Folio 49*, Musée du Louvre, Paris

This survey offers ample evidence that, with the notable exception of the inscription on the Vatican obelisk (folio 49, no. 3a), most of the Roman tomb slabs are of North Italian origin: five of a total of eight inscriptions (folio 48, nos. 2, 3, 4; folio 49, nos. 1, 2) derived from monuments situated in Padua and its province, while two others come from the nearby cities of Brescia and Verona (folio 48, no. 1 and folio 49, no. 3b). A similar preference for domestic, ancient monuments holds true for the additions: two are Paduan (a and b) and two originate from Verona (d). Pride in the ancestry of these two cities may have been the motivation for this choice, which in turn suggests the involvement of local scholars. It has been pointed out already that Padua's research into epigraphies dates back to the times of Lovato Lovati and his followers, who referred to them in terms of civic pride (see p. 17).[96] This would also explain why the transcriptions from local tomb slabs are definitely more accurate than those taken from distant monuments such as the *Arco dei Gavi* in Verona and the obelisk that originally stood in front of S. Andrea next to St. Peter's, which are ultimately derived from secondary sources.[97] In the case of the latter, presenting an exception to the rule altogether, the artist was obviously unaware of both the obelisk itself and the urn on top (at that time believed to bear the ashes of Julius Cesar).[98] The base of his drawing is composed of non-Roman elements, perhaps intended to accentuate the organic connection between Rome's greatness and the substantial support it received from the northern provinces.[99]

Neither the stones themselves nor their inscriptions betray any signs of decay. They are not meant to function as ruins, evoking nostalgic sentiments with regard to a distant past, nor are they, as with the aforementioned sketches by Pisanello and his studio, reduced to a simple repertoire of motifs "betraying the classical original" (Casu).[100] Instead, they accentuate the sterling integrity of the classic era, exemplified as a model for the present. In the case of the POMPONENVS stele, the only instance where a detailed comparison with the original is possible, the accuracy of its reproduction, including the subtle restoration of the crack at the base of the monument, is astonishing.[101] It is an indication of the presence of the classical monument itself, whose integrity was to be respected at all costs. Here lies the key to Paduan classicism, so different in its conservative attitude from the modernist vernacular of both Florentines and Venetians.[102] All the artist was permitted to do – on condition of sufficient competence – was combine the classical prototype with sculptural or decorative elements chosen from a similar antiquarian context so that its value was enhanced. This forms the basis for the compositions in the *Louvre Album* in which paradoxical monuments are constructed that are both fictional and archeological. The method is reminiscent of Barzizza's instructions with respect to literature. In his treatise *De imitatione*, he distinguishes between the capacity to add, subtract, transform, transfer, or innovate. "Adding," he writes, "is, for example, if I have found some short piece of Latin in Cicero or some other learned orator, and I add some words to it, so that this Latinity (*illam latinitas*) is seen to take on a form that is new and different from before."[103] This transformation postulates a complete familiarity with the literary archetype in regard to style, syntax, and orthography.

A new classicist purism became the characteristic trait of the Northern Renaissance. Style was all that mattered, and its accuracy was to not only emerge from the wording but be reflected in the visualization of the script itself. This is the reason why Latin inscriptions were to become a touchstone for both the figurative and literary arts. It was the shape of the letters which made a distinction possible. Whenever Jacopo Bellini applied texts to his images, the letters were scripted in Gothic style. A high regard for Roman script, on the contrary, lies at the heart of the Paduan community. Squarcione himself might have had a part in promoting the humanists' passion for epigraphy since the Roman reliefs displayed in his *domus a relevis* must have been exemplary for iconographical and typographical studies. It was, however, the rising book industry, orbiting Padua's university, which promoted the authority of Roman *capitalis* and *minuscule* alongside augmenting the reputation of calligraphy in terms of academic competence.[104] Biagio Saraceno, an employee at the chancellery of Bishop Fantino Dandolo's (1379–1459) and *commensalis continuus* at his table, may be regarded as prominent representative of this new type of scholarly scribe (*librarius*). His transcription of Eusebius of Caesarea's early fourth-century *Chronicle* from a Carolingian manuscript located today in Oxford (Merton College, ms. 315) – bought in 1434 at the Council of Basel by Dandolo's predecessor, Bishop Donato, and brought back to Padua in 1436 – expounds the consistent use of the humanistic *lettera antica* that was to become a standard from the 1460s onwards.[105] Saraceno's manuscript, now in Venice (Biblioteca Nazionale Marciana, Cod. lat. IX, I, 3496), is also indicative of the link to the painter's studio.[106] On folio 133v, one single miniature painting is inserted which shows *Christ in the Manger* (fig. 22). The picture, along with the circumscription in classical *capitalis,* is credited to Mantegna with universal consensus.[107]

22 Attributed to Andrea Mantegna, Christ in the manger, from: *Eusebii Pamphilii temporum liber seuchronicon ab Adamo ad annum Christi 326*, Biblioteca Nazionale Marciana, ms.Lat. IX, 1 (= 3496), Folio 133v

It adds support to the belief, among other testimonies from this same period, that he was not only a member in this circle of humanist reformers but actually the main promoter of the *paleographic change* (Meiss) itself and a model to be followed by Bartolomeo Sanvito (1433–1511) and others.[108] Moreover, Mantegna is the only artist, except the draftsman of the *Louvre Album*, to have used three of the Roman inscriptions and painted them in a monumental scale in his frescoes in the Eremitani Church in Padua (see p. 57).[109]

Marcanova – The Paduan *silloge*

Fortunately, it is possible to determine the initiator of the Paduan revival in classical epigraphy. Businessman and humanist Ciriaco d'Ancona copied, recomposed, and sometimes also invented on his own classical inscriptions, which he was able to produce during his extended travels in Italy, Dalmatia, Greece, and the Middle East.[110] Ciriaco would transcribe these texts, be they Latin or Greek, sometimes illustrated with his sketches and accompanied by personal comments, in his notebooks (*commentaria*) – a type of mobile museum (*galleria portatile*) in six volumes that he would carry with him.[111] Then, the materials would be transferred into luxurious manuscripts that would be sold or given to Ciriaco's patrons.[112] One was Pietro Donato (1380–1447), the bishop of Padua, a humanist, fervent collector and a former student of Barzizza, in whose house Ciriaco stayed during the years 1442

and 1443.[113] The anthology dedicated to him (Staatsbibliothek Berlin, Codex Hamilton 254) is the richest and most impressive with regard to the archeological information conferred to us.[114] While a large portion of the material was taken from Ciriaco's earlier books as well as the *syllogai* of Poggio Bracciolini (1403) and Niccola Signorili (1409) that concentrated on monuments in Rome, it is noteworthy that a smaller section related to Roman inscriptions from Padua, Brescia, and Verona had been supplemented by local friends and followers.[115] This was thanks to Giovanni Marcanova (1418–1467), who later became a leading scholar of Roman history.[116] Similar in this respect to Ciriaco, Marcanova was an ardent "investigator of antiquity" (*inquisitor vetustatis*), as he called himself, to whom the recovery of the "holy antiquity" (*sancta vetustas*) in the form of its visual relics was of prime importance as a way to gain access to the long-gone civilization.[117] His career in humanist Padua, in the footsteps of Giovanni Dondi and Petrarch, was bound to be successful from the very beginning; it is well documented throughout the 1440s and early 1450s when Marcanova was appointed to the prestigious Faculty of Medicine and Philosophy. His close relationship to the episcopal see started under Jaopo Zeno (1460–1481), in whose doctoral examination he took part in 1439; in the late 1440s he held an official position in the bishop's household, was living in the episcopal palace and guest at the bishop's table next to Biagio Saraceno, the aforementioned copyist of Donato's Eusebius manuscript (see above).[118] It was due to his competence that Marcanova could have acted as Ciriaco's assistant in the early 1440s, supported by a circle of local collectors of antiquities interested in epigraphy in particular, such as Alessandro Maggi Bassano and Arcoano Buzzaccarini.[119] His recognition as a specialist in epigraphy was attested to in 1447 when he took part in the commission for the inscriptions to be added to Donatello's monument of *Gattamelata* – the first having been composed by Francesco Barbaro and the second by Ciriaco himself.[120] The sponsor was Giacoma della Leonessa (died 1466), Gattamelata's widow, who, some years later, was to commission Mantegna for a series of frescoes for her palace.[121]

Incited by Ciriaco's example, Marcanova started research on his own. The manuscript into which he transcribed the inscriptions is referenced by him as "my great book of epitaphs" (*meo libro magno epitaphiorum*).[122] This prototype, no longer extant, must have resembled Ciriaco's *commentaries*, from which most of the information had been gathered, yet been enriched with Marcanova's personal discoveries. But it was only since he left Padua in 1453, after having accepted the chair of philosophy at the University of Bologna, that Marcanova started to edit his sylloge "Some Pieces of Antiquity" (*Antiquitatum quaedam fragmenta*).[123] The first edition, dated October 1457, is the one in Bern (Burgerbibliothek, Cod. B. 42) whose title page bears the reference that work on it had already started in Padua and was continued in Bologna: OPVS PATAVII INOCEPTVM BONO[NIA] ABSOLVTVM (fig. 23). The second and most precious, known in several copies, is the Modena edition from 1465 (Biblioteca estense, alfa 1.5.1.5).[124] Both *syllogai* are dedicated to Domenico Novello Malatesta (1413–1465), the Lord of Cesena and founder of the Biblioteca Malatestiana, a notable patron of the arts and letters who obviously had encouraged Marcanova in his work. The Modena sylloge follows Ciriaco's model in content and the general layout: the inscriptions are organized in topographical order, written in inks of different colors, and several indices have been added to highlight the book's scientific function. Yet it by far surpasses the *Codex Hamilton* in the quality of its illustrations.[125] Incited by the state of the

23 Johannes Marcanova,
Antiquitatum quaedam fragmenta,
Ms. Bern, Burgerbibliothek,
Cod. B. 42, title page

arts and the high level of book illumination of his hometown of Padua, Marcanova had decided to engage two specialists: Giovanni Antonio Zupone from Padua and Felice Feliciano (1433–1479) from Verona, the latter not only having been responsible for the illustrations but also having contributed some of the monuments himself, such as the *Porta dei Borsari* in Verona.[126] Similar to the *librarii* in the service of the humanist book authors, both lived in Marcanova's house at his own cost (*sua pecunia in hanc formam redigere fecit*).[127] In addition, an artist from the school of Francesco Squarcione, to be identified with Marco Zoppo, was asked to add a set of eighteen full-page pen drawings (folios 23-41) that were meant to visually recreate life in ancient Rome.[128] The idea might well trace back to Feliciano himself, "a friend of the artists" (Giuseeppe Fiocco), who was to assume a similar position with respect to Marcanova as had the latter with respect to Ciriaco. Starting as assistant and scribe, Feliciano was to compose his own sylloge; he would later become a leading member of the circle of antiquarians to which Andrea Mantegna also belonged.[129]

The circle of devoted antiquarians interested in epigraphy had become considerably larger, *pari passu* with a growing commerce in primary antiquarian information.[130] This explains why Marcanova's collection of inscriptions was already accessible to Padua's in-

tellectual community in the late 1440s as is confirmed by Johannes Hasenbeyn, a German student at Padua who was to compose his own *Epygramata illustrium virorum* and copy some seventeen inscriptions (nos. 1, 2, 7, 14, 16-21, 23, 25, 35, 40, 41, 43, 55) from Marcanova's manuscript before 1450.[131] The reason for this rising interest, as pointed out by Eisler, must be seen in the peculiarity of the classical inscriptions themselves: "Their messages from the deities and from the dead, beautifully carved, seemed to erase intervening time, and humanists seeking out ancient inscriptions believed themselves to be agents of resurrection."[132] It was the simultaneity of experiencing a specific constellation of signs in both ways – as historic information and aesthetic pleasure, satisfying the intellect as well as the senses – that became decisive in fostering the Renaissance.[133] The demand of the literati for the artist's skills, as a way to visualize their information and make it accessible to a larger audience, allowed the artists to in turn make use of the same material for their own objectives.[134] The book as a medium of erudite information became the priviledged scene of their interaction.[135] There is therefore little doubt that it was the draftsman who followed the scholar and not vice versa.[136] Another person, besides Hasenbeyn, allowed to consult Marcanova's book of epitaphs in Padua at that early period, was preseumably the artist in charge of the two drawings here under discussion.

Each inscription in the *Louvre Album*, with the exception of CLODIAE (folio 48, no. 3a), likewise appears in his *Antiquitatum quaedam fragmenta*, a coincidence that can hardly be called accidental.[137] The correspondences between folios 48 and 49 of the *Louvre Album* and Marcanova's two *syllogai* are as follows:

a) METELLIA (Louvre folio 48, no 1) = Modena folio 141{138v} [full-page colored drawing]
b) PVLLIO (Louvre folio 48.no. 2) = Bern folio 108 {109r}, Modena folio 159 {156v}
c) POMPONENVS (Louvre folio 48, no. 3) = Bern folio 108 {109},
 Modena folio 160 {157r} [CLODIAE C. ARCH TF missing]
d) ACVTIUS (Louvre folio 48, no 4) = Modena folio 156 {153}
e) EPPIVS (Louvre folio 49, no 1) = Bern folio 110v, Modena folio 161 {158r}
f) LVCRETIA (Louvre folio 49, no. 2) = Bern folio 110r, Modena folio 160 {157v}
g) DIVO CAESAR (Louvre folio 49, no. 3a) = Bern fol 61r, Modena folio 62 {60v and 61r}
h) GAVIVS (Louvre folio 49, no. 3b) = Modena folio 118.

A close comparison reveals minor aberrations, which are listed below. Allowance must be made for slight inconsistencies, which can be explained by the fact that the draftsman most likely copied from Marcanova's "great book of epitaphs," created during the 1440s (lost today), and not from Marcanova's *Antiquitatum quaedam fragmenta*, which is from a much later date and used here only for comparison. Despite some differences between these versions, the analogies are, nevertheless, close enough to permit the conclusion that the draftsman was eager to follow Marcanova's model as closely as possible:

a) The PVLLIO inscription is identical with Bern, folio 108.
b) The POMPENVS inscription is identical with Bern, folio 109.
c) The LVCRETIA inscription is identical with Bern folio 110 (except the
 erroneous P. VALERIO instead of L. VALERIO, folio 48, no. 1, line 8).
d) The METELLIA inscription is identical with Modena folio 138v (rendered in a full-page drawing,
 probably by Feliciano, and with the same division of lines). The Louvre drawing differs in
 the architectural and figurative parts that were obviously not known to the artist.[138]
e) The GAVIO inscription (folio 49, no. 3b) is identical with Modena folio 116.

f) The RVFVS inscription (folio 49, no. 1) is identical with Bern folio 110; errors regarding the date and lines 5 and 6 in the Louvre drawing may have been caused by rendering the script in perspective.

g) Concerning the epitaph of the Vatican obelisk, folio 49 (no. 3a) follows the Bern and Modena *silloge* – both of whom could depend on Ciriaco's transcription (Ms. Hamilton 254, folio 51r) – but prefers CAESAR instead of CAES, perhaps due to the available space.

h) In folio 48 (no 3), the lower part of the inscription (CLODIAE) seems to have been unknown to Marcanova (Modena folio 157).

The fact that none of the inscriptions originating from Marcanova's collection of epitaphs appear in Ciriaco's sylloge for Bishop Donato strongly suggests that these were part of Marcanova's personal discoveries and thus intended for a separate publication. He had indeed organized field trips while still living in Padua and ensured that any discoveries were carefully examined and documented. This is confirmed by an entry in his own handwriting related to a *cippus* of M. AVRELIUS ROMANVS (Bern, folio 147v). It states that Marcanova had discovered the original marble epitaph (*epitaphium in marmore lapidem*) near the village of Buvolenta and ordered the transfer to its present location, the house of his friend and admirer, Arcoano Buzzacarini in Padua (*Paduae in domo d. archoani de buzzacarinis*).[139]

Mantegna

Roberto Weiss, Giuseppe Billanovich, and many others have shown that Padua's contribution since the times of the *preumanesimo padovano* in the late thirteenth century was essential for the evolution of the Italian Renaissance. The recovery and reinterpretation of literary as well as artistic documents related to the Roman past – with numismatics and epigraphy receiving particular attention next to the recovery of ancient manuscripts – constituted its driving force. The tombs of Antenor or Lovato and Altichiero's frescoes of illustrious men in the Carrara palace give ample evidence, among other testimonies, that a collaboration between the scholar and the artist had been encouraged from early times, with the latter becoming a necessary assistant to the former (see p. 18). In the fifteenth century, the outcome of this was the Paduan publishing industry, which combined classical texts in newly revised humanist transcriptions with a set of illustrations that matched the antiquarian spirit of content and script.[140] When Marcanova planned to edit his collection of epitaphs, the same demand for adequate visualization became relevant. It was Marco Zoppo (1433–1478), Squarcione's former pupil, who was most likely entrusted with breathing life into the historical research through a purely fantastic rendering of daily life in republican Rome.[141]

Mantegna, appreciated as much for his artistic skills as he was for his humanist learnedness, was to become the central figure in this community.[142] Similar to the scientific draftsmen who were to assist the naturalist explorers on their missions to the South Seas throughout the late eighteenth and early nineteenth centuries, he would accompany Marcanova and Feliciano on their archeological field trips.[143] However, Mantegna's role was more important than that of a simple illustrator as he not only copied the monuments that had been newly discovered but also played a part in their artistic interpretation and visual reconstruction. His facility for design must have been of great assistance to the amateur archeologists.[144] The recognition and gratitude he generated took form in Feliciano's sylloge dedicated to him on

January 13, 1463 (Venice, Biblioteca Marciana, Lat. X, 196, folio 26v), in which he is called a formidable man, an incomparable painter, and a comet of his time.[145] This tribute, previously reserved for patrons of much higher social standing, was the reward for what Mantegna had actually contributed to the Renaissance of the Arts.

In his *Life of Ciriaco*, Feliciano poetically describes a two-day excursion to Lake Garda that took place on September 23 and 24 in 1464.[146] Two texts that record this event, the *Memoratu digna* and the *Jubilatio* (Treviso, cod. I, 138, cc. 201v, 205v), are considered to be "the best biographical evidence for Mantegna's passion for Roman remains" (Creighton E. Gilbert).[147] The description also details that the Paduan circle was still active in the 1460s, though by that point Mantegna had left for Mantua (in 1459) and Marcanova was based in Bologna (since 1452). It nevertheless becomes obvious that the years spent together in Padua, be it in the *scriptorium* of Bishop Fantino Dandolo or on previous excursions in search of local antiquities concerning the above-mentioned tombstones, had strengthened this camaraderie. In the text rendered below, Feliciano calls Mantegna his "Paduan friend" (*patavo amico*) and praises Marcanova's "antenorean," meaning Paduan, origin (*Ioanne Antenoreo*). As a new member, the Mantuan painter Samuele da Tradate (d. 1466) had been included and asked to preside over the exploration in the role of *imperator*, whereas Mantegna and Marcanova called themselves *consules* and Feliciano *procurator*, obviously because he was responsible for the organization. The result of their search, which lasted two entire days, was twenty-two latin inscriptions that were copied in their books.[148]

On the 23rd of October 1464. Starting out together with Mantegna, the incomparable Paduan friend, and myself Feliciano of Verona, for the sake of relaxing our thoughts, we came from a field as lovely as the Tusculan, by way of Lake of Garda, to greenwards like heavenly gardens in the most delicious dwelling places of the Muses. […] There, we saw a number of remains of antiquity, and first, on the island of the monks, one [epitaph] with highly ornamental letters on a marble pillar [follow inscriptions then copied]. /Celebration./ On the 24th of October, under the rule of the merry man Samuel da Tradate, the consuls being the distinguished Andrea Mantegna of Padua and Giovanni the Antenorean [Giovanni Marcanova], with myself in charge with the bright troop following through dark laurels taking our ease. […] Entering the ancient precincts of Saint Dominic, we found a most worthy memorial of Antoninus Pius Germanicus surnamed Sarmaticus [Emperor 138–161]. Steering then towards the home of the holy protomartyr [Saint Stephen] not far from the said precincts, we found in the portico an excellent memorial of Antoninus Pius the God, nephew of Hadrian the God, resident of that region. Going on then to the house of the first pontiff nearby, we found a huge memorial of Marcus Aurelius the Emperor [161–180]; all of these are recorded in the present notebooks. I will not omit from what is worthy of record that we found the lodging of Diana the quiver bearer, which, for many reasons, we knew could be no other. Having seen all these things, we circled Lake Garda, the field of Neptune, in a skiff properly packed with carpets and all kind of comforts, which we strewed with laurels and other noble leaves, while our ruler Samuel [da Tradate] played the zither, and celebrated all the while. – At length, having gloriously crossed over the lake, we sought safe harbor and disembarked. Then, entering the temple of the blessed Virgin [Mary] on the Garda, and rendering the highest praises to the most high thunderer [the Christian God] and his glorious mother, most devoutly, for having illuminated our hearts to assemble together and opened our minds to seek and investigate such outstanding places, and caused us to see such worthy and varied diversions of objects, some of them antiquities (*antiquitatesque nonullas*), and allowed us such a happy and prosperous day, and given us fortunate sailing and good harbor, and our wished-for conclusion. Especially for seeing such great wonders of antiquities (*tam magna antiquitatum mirabilia*); anyone of great soul should on just that account take the road to see them. Follow more inscriptions brought home from this field trip.

Folios 48 and 49 are of particular importance in the context of this record, regardless of whether it is real or fictitious, since they add to the evidence that this kind of antiquarian research obviously occurred. That Marcanova was the leading spirit of the Paduan circle of antiquarians in the tradition of Ciriaco is amply proved by his *librum magnum epitaphium*, which was composed at the same date as the drawings. But who was the associated artist? Squarcione is a possible guess based on the evidence that his father had been a scribe (as fn. 98) and he himself was an avid collector of ancient reliefs, using this material for the sake of instruction; yet, no mention is made of him. If he had been involved, he would have presumably delegated the drawing to someone in his workshop. It is in this context that Mantegna's presence can be ascertained.[149] In his frescoes in the Ovetari chapel of the Eremitani Church, he makes reference to four Roman inscriptions, two of which likewise appear in the *Louvre Album*: a) Titus Pullius Lino and b) Titus Ponenus.[150] The very fact that archeological monuments of relatively minor importance and discovered only recently in the province of Padua had been reproduced almost simultaneously, bearing only few deviations, is a strong argument in favor of the hypothesis that this must have happened in a specific, local context and within a narrow community of artists and scholars.[151]

Moschetti has meticulously compared the inscription dedicated to Pullius Titus Linus and his companion, Albia Mirine, from the cippus of Montebuso as it appears in folio 48, no. 2 (see p. 54), with the one that is written on the triumphal arch in the middle ground of Mantegna's fresco *Saint James before Herod Agrippa* (circa 1451) (fig. 24).[152] Mantegna's spelling is T . PVLLIO / T. L. LINO / IIIIIII VI …/ AVG / ALBI … /. S. ET…, whereas the inscription in folio 48, no. 2 reads: T. PVLLIO / T. L. LINO / IIIIII VIRO. / AVG / ALBIA. L. L. / MIRINE / SIBI. ET. VIRO /V. F. The similarity is striking at first sight, up to the identical division of lines, yet there are minimal differences: apart from the fact that the word MIRINE is missing and the letter S in line six appears to be inverted in the fresco, a curious error has occurred in line three, where the number of strokes before VIRO is seven in Mantegna's painting and six in the drawing.[153] This incongruity may seem negligible, yet, according to Moschini, it betrays a significant misinterpretation.[154] The number of strokes refers to a class of priests, the *Augustales*, that Emperor Augustus had institutionalized so that they could attend to the religious rites. The principal members of this college were called *Seviri* due to the fact that their number amounted to six and not seven (in which case they would have been called *Septemviri*). This allows one to conclude that the inscription on folio 48 bearing six strokes is correct, whereas it is wrong in Mantegna's writing. In Marcanova's *silloge* (folio 108), conversely, the PVLLIO inscription is identical to folio 48: MIRINE is not omitted and the first letter in SIBI is correct, as is the number of six instead of seven strokes before VIRO (fig. 25). A possible conclusion from this would be that Mantegna cannot be considered identical to the artist responsible for folio 48 and that he used a different transcription. This, however, is based upon another presumption that is impossible to prove: that he did take care of these paleographic details and would have recognized the mistake. The very fact that Mantegna abstained from rendering the inscription in its complete form in the fresco, subordinating it to the figures and the decoration of the triumphal arc as such, speaks in favor of the hypothesis that he was less precise than modern archeologists such as Moschetti and Gallerani expected him to be. This does not contradict the fact that he had access to the inscription in one way or another, which he was proud enough to insert in a prominent place.[155]

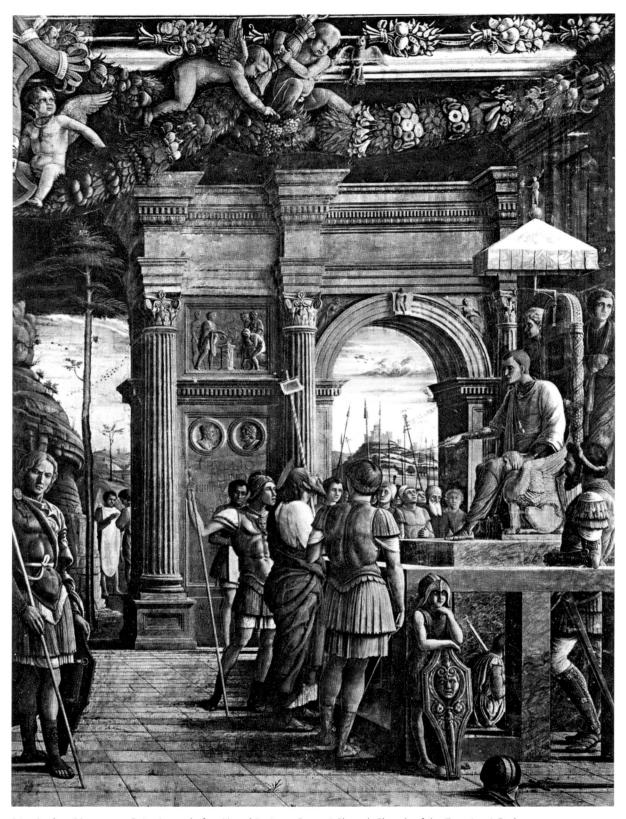

24 Andrea Mantegna, *Saint James before Herod Agrippa*, Ovetari Chapel, Church of the Eremitani, Padua

Cxtra padiuā ubi dr̄ monte buſo. MON•BVSI
·T·PVLLIO T·L·LINO ꜱꜱꜱꜱꜱ·VI
RO·AVG·ALBIA·L·L·MŸRINE.
SIBI ET VIRO· ·V· F.

25 Johannes Marcanova, *Antiquitatum quaedam fragmenta*, Ms. Bern, Burgerbibliothek, Cod. B. 42, fol. 105 (det.)

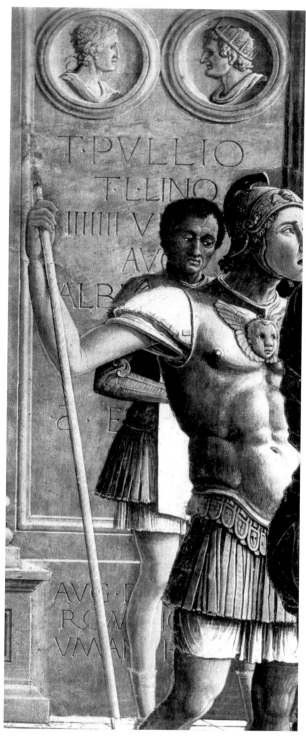

26 Andrea Mantegna, *Saint James before Herod Agrippa* (det.), Chiesa degli Eremitani, Padua

All that matters here is that the play of references can be restricted to a circle of Paduan scholars and artists in which Jacopo Bellini did not partake. Neither did he show any interest in archeology, numismatics or paleography, nor was he directly connected with the three syllogists of North Italian antiquarianism, that is, Ciriaco d'Ancona, Giovanni Marcanova and Felice Feliciano.[156] It can certainly be assumed that it was on a field trip years earlier, like the one to Lake Garda, that Mantegna made his personal transcription without caring about or being aware of the importance of the number of strokes. That one of his Paduan friends played a key part in the discovery of the PVLLIO inscription may be inferred from a detail. Paradoxically, the text is partly hidden by a soldier posted in front of the triumphal arch whose presence affects the script's visibility (fig. 26).[157] What reason lies behind his placement? Though wearing Roman armor, the physiognomy and haircut identify this person beyond doubt as a contemporary. Girolamo Campagnola's lost letter to Leonico Tomeo, quoted by Vasari in his biography of Mantegna, indicates that the latter did in fact include "portraits from life" representing "good friends of his" in the Ovetari frescoes.[158] Mantegna's friend Feliciano would have been the appropriate candidate for being immortalized in this particular position. This hypothesis gains further support by the monument that serves as a foil for the inscription, the *Arco dei Gavi* in Verona, which at this time served as city gate and was part of Castelvecchio.[159] Mantegna referred to the same monument for a second time in the subsequent fresco, *Saint James led to Martyrdom*, this time quoting the inscription that originally decorated the arch: . L . VITRVVIVS / CERDO ARC/ HITETVS (fig. 27).[160] He obviously believed this to be a reference to the famous Roman Marcus Vitruvius Pollio (circa 80–10 BC), best known for his treatise on architecture as well as the proportions of the human body, believed to have originated from Verona.[161] Feliciano, Verona-born himself, is a likely candidate to have divulged the inscription to friends and close associates.[162] The focus on Paduan or Veronese antiquities in Mantegna's frescoes and the two pages of the *Louvre Album*, as well as a notable disregard for the arguably more famous Roman monuments, corresponds fully with the local patriotism that was characteristic of this group and their archeological interests.[163]

27 Andrea Mantegna, *Saint James led to Martyrdom*, Ovetari Chapel, Church of the Eremitani, Padua

VII. Antiquity Reinterpreted

Folio 40

As far as design and subject matter are concerned, folios 40 and 43 have to be ranked among the most impressive drawings within the *Louvre Album* (figs. 28 and 30). They are related neither to history nor archeology but to poetry and philosophy. It is an entirely fictitious world that the spectator is invited to enter, inhabited not by humans but figures of gods and minor deities that embody the obscure domain of love, pleasure, and frenzy. Contrary to the perspective studies (see above), these drawings look almost flat, similar to a frieze. They may have been intended as equivalents to Roman reliefs. Closest in style and subject matter are Mantegna's large folio engravings from the 1470s depicting subjects from ancient mythology: the *Bacchanal with Silenus* (305 × 438 mm), the *Bacchanal with a Wine Vat* (299 × 437 mm), and the *Battle of the Sea Gods* (286 × 994 mm) (fig. 30).[164] Similar to the drawings, the engravings resist duplicating any well-known iconography. They rely upon Mantegna's personal interpretation of the myth, establishing his fame not only as draftsman but also inventor.[165] The similarity between the prints and folios 40 and 43 is so pronounced that Mantegna's authorship (at least in terms of the execution of preliminary drawings) may be postulated for both.[166] His contemporaries – artists, art critics, and humanists alike – must have recognized the difference between these demonstrations of his genius and the altogether more scholarly tenor of the rest of the *Louvre Album*, which probably encouraged Mantegna, as soon as the technical means were available, to transfer his mastery to the new medium of engravings – "printed drawings" (*disegni stampati*) as Vasari called them much later – which were destined to promote the development of the arts.[167]

The protagonist of folio 40 is the triumphant *Bacchus* (Greek *Dionysus*).[168] He is represented naked, adorned with grapes around his head and chest and a garland of vine leaves hanging from his shoulders. The god of fertility and wine holds a brimming bowl in his uplifted hand that is overflowing with fruits. Surrounding the god are eight cloven-hooved satyrs sporting erections who drink, dance, and play music. One of them, lowering his pipe, is about to partake of the gifts that Bacchus offers. A satyr on horseback drinks from one end of a wineskin, while another satyr holds the other end, standing on a low rock formation at the back. Below the horse, which is pulling the chariot, lies a drunken satyr deep asleep, his mouth agape. Three young satyrs bearing more fruit follow the chariot from behind. Ovid's description of Bacchus' triumphant return from India (*Metamorphoses* IV, 11–30), accompanied by female Bacchantes, matches the iconography of the drawing only slightly.[169] The same holds true for the Roman poet Catullus' lyrical account of an ancient tapestry displaying the youthful Bacchus in search of Ariadne (LXIV), or Livy's denunciation (XXXIX, 8–9) of the debaucheries committed during the spread of the Bacchic rites in Rome in the year 186 BC.[170] As no text covers the representation of folio 40, there is thus no equivalent in classic art.[171] It is a reenactment of the pagan world that one could imagine on a modern stage rather than in classical art. During Padua's carnival festivities, called *baccanaliorum vacationes*, students at the Faculty of Law would eventually stage a *comœdiam Bacchanalibus* at the mayor's palace featuring chariots of Bacchus accompanied by satyrs and fauns.[172] This may be the explanation as to why essential iconographic elements displayed on Roman

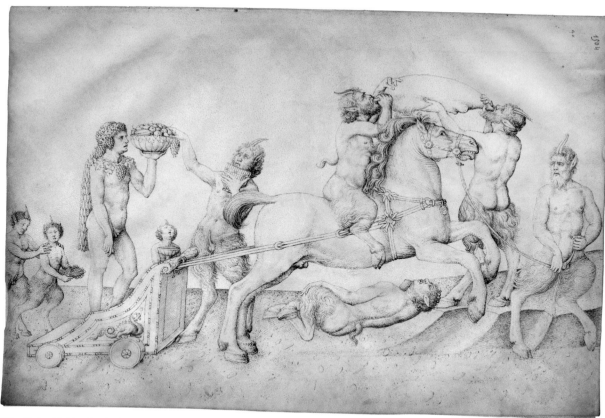

28 *Folio 40*, Musée du Louvre, Paris

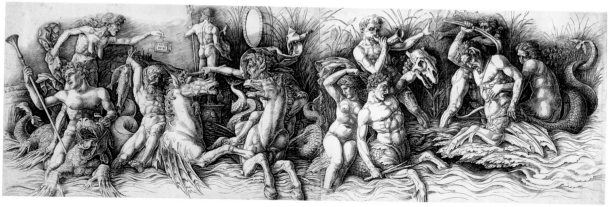

29 Andrea Mantegna, *Battle of the Sea Gods*, Devonshire Collection, Chatsworth

sarcophagi, such as the centaurs, dancing maenads, panthers, lynxes, or elephants pulling the chariot, have been eliminated or substituted by more available motifs. But not only the accessory has changed, it is the drama itself – the atmosphere of pagan abandon and orgiastic frenzy generally associated with this subject – that underwent a reinterpretation: "Statt verwirrenden Treibens, orgiastischen Taumels, eine geradezu geordnete Gesellschaft heiter dem Genuss Ergebener."[173] Bacchus is seen standing instead of sitting, he is neither drunk nor lying in Ariadne's arms, and he is hoisting the vessel of fruit instead of the traditional

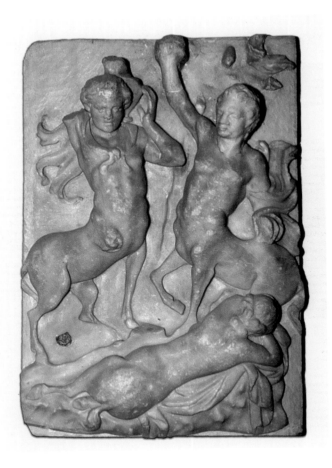

30 *Family of Centaurs*, Museo
Archeologico Venice

thyrsus – a staff tipped with a pinecone and entwined with ivy or grape leaves. The fact that a horse is pulling the god's chariot – the same beast that reappears in several other drawings (folios 52, 67, 90) related to Christian, not pagan, iconography (see p. 102) – clearly demonstrates that, despite the proximity in style, this composition is not copying any classic model. The draftsman seems familiar enough with the story to impose his own version.[174]

Excursus: The sleeping satyr

One single detail, however, proves that, despite his autonomy with respect to iconography and iconology, the artist responsible for folio 40 was embedded in a local idiom of references. This concerns the recumbent figure of the sleeping satyr viewed from behind. The motif was familiar in the Veneto, as can be deduced from a similar, small-scale wooden relief in the Kunsthistorisches Museum (Vienna).[175] The prototype being alluded to in both cases is a marble relief from the Museo Archeologico in Venice (fig. 31).[176] It was considered to be Roman (dated to the second century AD) until quite recently, when, upon uncovering stylistic and iconographic evidence, Matz, Favaretto, and others ascribed the work to the Early Renaissance period.[177] The *Family of Satyrs*, which depicts two centaurs and a sleeping *satyressa*, enjoyed a certain celebrity in Renaissance Padua, as can be deduced from the fact

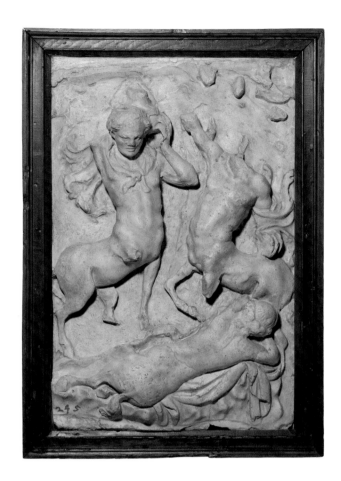

31 *Family of Centaurs*, Museo di Scienze
Archeologiche e d'Arte del Liviano,
Padua

that Marco Mantova Benavides (1489–1582), a famous Paduan lawyer and collector in his
time, possessed a plaster copy that has subsequently been passed on to the Museo di Scienze
Archeologiche e d'Arte (Padua University, *Liviano*) (fig. 30).[178] The original is known to have
belonged to Niccolò Leonico Tomeo (1456–1531), a professor of Greek studies at Padua Uni-
versity and a lover of sculptures in particular (*statuariae amantissimum*), in whose house in
Padua Marcantonio Michiel (1484–1552) noted it in the years between 1525 and 1528: "In the
quarter of Saint Francis, in the house of the philosopher M. Leonico Tomeo – A half relief
in marble with two Centaurs upright and a Satyressa lying down who sleeps and shows her
back – is an antique work of art."[179] Shortly thereafter, the *Family of Satyrs* was sold to the
Venetian classical art collector Giovanni Grimani (1506–1593), who then relinquished the
piece to the Biblioteca Marciana.

Despite simulating a Roman origin, not in the least apparent from its fragmentary state
of conservation, the *Family of Satyrs* is not to be considered a fake, but rather a subtle re-
creation of an antique sculpture. The point of reference is the detailed description (*ekphrasis*)
by the Greek author Lucian of Samosata (120–192) of a once famous painting by Zeuxis (fifth
century BC) of which no trace is left. Particularly the central passage makes reference to the
recumbent figure in question:

On the fresh green sward appears the mother Centaur, the whole equine part of her stretched on the
ground, her hoofs extended backwards; the human part is slightly raised on the elbows; the fore feet
are not extended like the others, for she is only partially on her side, one of them is bent as in the act
of kneeling with her hoofs tucked in, while the other is beginning to straighten and take a hold on the
ground – the action of a horse rising. […] In the upper part of the picture, as on higher ground, is a
Centaur who is clearly the husband of the nursing mother; he leans over laughing, visible only down
to the middle of his horse body.[180]

Tomeo, himself an expert in Greek literature, must have been attracted to the subject. He
probably believed the *Family of Satyrs* to be antique, as Michiel and Grimani certainly did
(see above). However, the original context that gave life to the sculpture is academic and may
bear a reference to Alberti's treatise *On painting*. Having exhorted contemporary artists to
provide proof of their literacy, Alberti suggested the *Calumny of Apelles* – the subject of a
painting from the Greek painter Apelles (fourth century BC) transmitted by Lucian of Samo-
sata– as an appropriate model for painting.[181] Since Lucian's text also formed the basis for the
Family of Satyrs, it is likely that the relief was conceived from the very outset in the spirit of a
modern *paragone*.[182] One may speculate as to whether this exercise in inventiveness – simi-
lar to the humanist's invention of pseudo-antique inscriptions – had been achieved within
Squarcione's academy and if the *Family of Satyrs* thus initially belonged to the collection of
classical archetypes assembled in his "house of reliefs" before it was sold to Tomeo.[183]

The moral message

We are left asking what message, if any, the *Triumph of Bacchus* intended to convey to the
contemporary viewer. What the drawing wanted to preclude at all costs, was the image of
the lascivious god in the midst of his orgiastic followers, as transmitted by Livy, Orosius,
and Giovanni Boccaccio (1313–1375) in turn.[184] The deliberate omission of female *bacchantes*
emphasizes this point. A different approach is based on Diodorus' *Bibliotheca historica* (circa
60–30 BC), a Greek text translated in parts into Latin by Poggio Bracciolini in 1449.[185] In
order to present a morally justifiable god, Diodorus distinguishes altogether three different
incarnations of Bacchus: one Egyptian, one Indian, and one Hellenic.[186] The latter is most
compelling since it succeeds in representing Bacchus as a promoter of cultural values and
a friend of the muses. Apart from preventing wars and litigations, he is said to have helped
spread the religious cult among faithful and honest citizens. The satyrs no longer emblemize
his debaucheries but represent his love of musical and theatrical performance; he is even said
to have been the first organizer of arts competitions.[187] Most importantly though, Bacchus
is held to be the originator of the institution of triumph that was to spread from ancient
Greece (Thebes) to Rome. Diodorus (III 65, 7–8) calls him "the very first who entered his
native city in triumph"; Pliny (*Historia Naturalis*) and Marcus Terentius Varro (*Antiquitates
rerum humanarum et divinarum*, before 46 BC) shared this opinion.[188] The latter explains in
De lingua latina (VI, 68) that the word *triumphare* derives from *io triumphe*, an exclamation
issued by Roman soldiers on their way to the Capitoline Hill in the company of their of
victorious generals,[189] which is turn derived from the term *thriambos,* the Greek epithet of
Bacchus.[190] From Varro, the Renaissance historian Flavio Biondo (1392–1463) deduced that
the Triumph of Bacchus was the model imitated by the Roman emperors in their triumphs.[191]

No trace of these thoughts displayed in the *Triumph of Bacchus* can be detected in the œuvre of Jacopo Bellini.[192] Despite desperate attempts by generations of scholars to demonstrate his humanist inclination, up to the point of making him appear as "the first forerunner of that most imaginative of all re-inventors of Greco-Roman art, his fellow Venetian Giovanni Battista Piranesi" (Eisler) – this combination of classicist style with a self-contained interpretation, as exemplified by folio 40, operated beyond Jacopo's artistic and intellectual capacities.[193] The only artist in the Veneto around 1450 capable of combining invention and imitation to this degree was Andrea Mantegna.[194] Similar to his later engravings, the drawings were intended as *archetypae* – created for the use of students and connoisseurs alike. The enhancement with regard to folios 48 and 49 is remarkable. Combined with antiquarian information, these too manifested a certain freedom of composition, governed by the device of appropriateness. Mantegna's *Trial of Saint James* displays a similar capacity. Yet, there is a neat shift in quality between copying and imitating. For the Latinists in the orbit of Squarcione's academy, Barzizza in particular, the ability to understand the correct Latin syntax of a given text (*scientia de constructione*) represented only the first step in the scholar's curriculum, the ultimate goal of which consisted in acquiring a mastery that would have permitted him to express something of his own.[195] This was the primary difference between the *latinantes* and the *non latinantes*, a distinction that Squarcione adopted by dividing his school into two classes: a *studium magnum* designated for beginners and a *studium parvum* for the accomplished painters (see p. 26). What separates the latter from the former is the authority of interpretation in reference to a given text and image respectively, as postulated in ancient rhetoric. Cicero's and Quintilian's advice to Roman writers to remain on equal footing with their Greek predecessors (*non converti ut interpres, sed ut orator*) was to become a maxim in fifteenth-century humanism, respected by Barzizza in Padua and Leonardo Bruni in Florence.[196] It affected the editing of authoritative texts as well as authoritative drawings in that the transfer of knowledge, as their ultimate aim, depended upon professional interpretation and not slavish duplication.[197] Only on this condition could the authenticity of the prototype be guaranteed. In the foreword to his edition of Xenophon's *Cyropaedia* (Florence, Cod. Laur. 45, 16), Poggio Bracciolini (1380–1459) declared that he followed not the individual words of the Greek text (*non verba singula*), but rather its content (*sed historiam sum sequutus*), in order to create a prototype upon which all further editions could rely.[198] Similarly, in the literary debate with Pico della Mirandola, Pietro Bembo stated (1513) that it is insufficient to copy Virgil's *Aeneid* and merely change the names. Instead, the author's task required imitating the *Aeneid* in a way that should incorporate the model and yet differ from it.[199] The same capacity was conceded to the painter, whose range of expression was no longer restricted by the rules of a craft but by evolved aesthetic and poetological norms.[200] Here lies the main distinction with respect to the classical compositions in the drawings of the Gentile-Pisanello circle, which are copies of other works and not invented scenes.[201] Folios 40 and 43, as well as Mantegna's mythological engravings exemplify, on the contrary, the novel spirit of poetic invention, advovcated since Cennini. The overall impression conveyed by the *Triumph of Bacchus* is that of a classical work of art, yet one translated into a modern context.

Folio 43

Folios 40 and 43 form a pair. The monumental horse in the center of the composition helps to emphasize their proximity, and it is tempting to think that the iconographies of both drawings may have been influenced by theatrical representations performed at the Paduan Faculty of Jurisprudence during the carnival season (see p. 62). Regarding content, they focus on the subject of triumph. The epitome of triumph, as shown in the preceding chapter, was the god Bacchus. It was this historical qualification, based as it was on the authority of Pliny, Diodor and Varro, that found particular acceptance in humanist circles at that time. Flavio Biondo's *Roma triumphans* (1453–1459) is a case in point.[202] Mantegna, who possessed this book in his library (*un libro de Biondo Flavio, ligato, in carta bambasina*), had made use of it in his *trionfi* – a series of paintings and engravings dedicated to the subject of Roman triumphs.[203] He might have also been familiar with the book *De re militaria*, written circa. 1460 by the Rimini-native Roberto Valturio (1405–1475) and edited in 1472 by Feliciano, which praised triumph as the highest possible honor for mankind.[204] Another author interested in this subject matter was Mantegna's compatriot Marcanova. In Padua, Marcanova started to assemble materials for a scientific publication examining the military ceremonies of the Romans that was to be finished in Bologna in the 1460s.[205] The text is lost, but it is certain that Marcanova must have been well aware of the tradition of ascribing the invention of the Roman triumph to Bacchus himself.[206]

Once it is understood that the theme of triumph is the subject matter, it then follows that the complement to the *Triumph of Bacchus* is clearly the *Triumph of Cupid* (fig. 32). Bacchus and Cupid – the conqueror of the lands and the conqueror of hearts respectively – are set aside in Ovid's "Elegies of Love" (*Amores* 1. 2, 25ff.) and associated with two different poetical genres: the god of wine representing tragedy, and the god of love, elegy. In *Amores* 1. 2 (47), their respective exaltations connect with the triumph of Emperor Augustus (63 BC–14 AD). Again, one would assume that Marcanova, intent on writing a book on the history of the Roman triumph, was as aware of Ovid's interpretation as he was of the other literary and figurative sources addressing this matter.[207] It seems appropriate to consider that it was thus Marcanova who drew attention to their parallelism and incited Mantegna, as had happened in the case of epigraphy, to make use of this information.[208] One might even speculate that Mantegna had originally been asked to include some of the illustrations in Marcanova's book.[209] Yet, even if committed to the distinction of the two triumphs in a general way, the iconography of folio 43 does not mimic Ovid with regard to defining the nature of triumphant love. The birds pulling Cupid's chariot have been replaced by a gigantic horse on whose back the god of love rides along, as have the tigers, said to belong to Bacchus; the victims of Cupid ("captive young men and girls") are missing and so is the cheering crowd that follows the procession. The references to poetic emulation – personifications of Good Sense, Modesty, Error, and Madness – have been replaced by an allegory of Love versus Vice. Similar to the *Triumph of Bacchus*, the message of the *Triumph of Cupid* is adapted to a moral context.[210]

32 *Folio 43*, Musée du Louvre, Paris

The horse in folio 43, with its webbed and almost fishlike wings at each foot, differs from the horse depicted in the *Triumph of Bacchus*; what is shown here is a supernatural animal. The inscription below calls him Pegasus, fathered by Perseus when he killed Medusa (*Pegasus f[ili] o di Per[seo] che amazo medusa*).[211] The table of contents amplifies this interpretation, making reference, apart from the horse Pegasus (*el caval Pedeseo*), to the winged rider (*uno spiritello*) and the two satyrs (*do fauni*).[212] Taking their lead from the wrong interpretation of the horse and inferring from here the myth of Perseus, both interpretations are, however, mistaken. To begin with, the iconography of Pegasus demands a pair of large wings attached to the horse's shoulders.[213] The two children sitting on lion skins on top of the horse originate from a different story. One is the winged god of love, Cupid (Latin *Amor*, Greek *Eros*), the son of Venus (Greek *Aphrodite*), characterized by his bow and a quiver full of arrows. Wearing spurs and holding the reins, he is identified as the horse's guide. Before Cupid sits a little satyr (Latin *Faunus*), recognizable by his goat legs, horns, and pointed ears.[214] He is a near relative to the company of satyrs in the *Triumph of Bacchus* (folio 40), yet is clearly placed in an inferior position. His hooves are tied to the body of the horse and he is held tight from behind so that he cannot stir. Uncomfortably positioned, the *satyretto* pleads to his companion. The meaning of their antagonism is obvious: celestial love tames sexual desire, as represented by the satyr. Cupid's victory is the precondition for the horse to soar into heaven. Analogous to Bacchus, whose virtuous comportment triumphs over degrading appetites, the victory of genuine love over carnal love requires an ethics of moderation in which divine control overcomes bestial desires.[215]

The *Triumph of Cupid* as shown in folio 43 is unprecedented.[216] Representations such as the illumination in Francesco da Barberino's (1264–1348) *Documenti d'amore* (circa 1315), in which blind Cupid, tossing his arrows at the people assembled below, is depicted standing on the back of a horse flying through the air, denote a different context.[217] Here, the power of love is meant as a warning, not as a promise – similar to the devastating power of death over humankind.[218] Petrarch's *Triumph of Love* (1351), rich in heroic victims from the classical world who are forced to follow Cupid's chariot, is in agreement in its condemnation of the "cruel boy."[219] Central to folio 43 is, on the contrary, not love's universal and therefore fearsome power, but the dialectics of love and sex and the negotiation between their positive and negative aspects for the sake of praising the former. The tone is idealistic, not negative, and the figuration – its style and content – references the exegesis of a classical text, not Christian morals.[220]

The combat between two conflicting forms of love is central to Platonic thought. *Eros* itself is twofold: while common *Pandèmos* turns to lust or lewdness, heavenly *Ouranios* aspires to goodness and beauty.[221] According to Plato (circa 428–348 BC), Eros, when subjugated to the weakness of the body, tends to engage in sex just as with any other uncontrolled desire (drinking, for example).[222] Striving for truth and beauty, on the contrary, ensures the purity of love.[223] Which of the two forces gains the upper hand will define the course of the human soul. In his *Republic*, Socrates tells Glaucon that "the right kind of love has nothing mad or licentious about it [. . .] sexual pleasure mustn't come into it [. . .] if they are to love and be loved in the right way."[224] The same ambivalence is expanded further in Plato's *Phaedrus* from about 400 BC. Socrates' distinction of the lover from the non-lover refers to the battle between the winged *amoretto* and the enchained *satyretto* as illustrated in the Louvre drawing:

> Now, as everyone plainly knows, love is some kind of desire; but we also know that even men who are not in love have a desire for what is beautiful. So how shall we distinguish between a man who is in love and one who is not? We must realize that each of us is ruled by two principles which we follow wherever they lead: one is our inborn desire for pleasures, the other is our acquired judgment that pursues what is best. Sometimes these two are in agreement; but there are times when they quarrel inside us, and then sometimes one of them gains control, sometimes the other. Now when judgment is in control and leads us by reasoning toward what is best, that sort of self-control is called 'being in your right mind'; but when desire takes command in us and drags us without reasoning toward pleasure, then its command is known as 'outrageousness'. Now outrageousness has as many names as the forms it can take, and these are quite diverse. Whichever form stands out in a particular case gives its name to the person who has it – and that is not a pretty name to be called, not worth earning at all. If it is desire for food that overpowers a person's reasoning about what is best and suppresses his other desires, it is called gluttony and it gives him the name of a glutton, while if it is desire for drink that plays the tyrant and leads the man in that direction, we all know what name we'll call him then! And now it should be clear how to describe someone appropriately in the other cases: call the man by that name – sister to these others – that derives from the sister of these desires that controls him at the time. As for the desire that has led us to say all this, it should be obvious already, but I suppose things said are always better understood than things unsaid: the unreasoning desire that overpowers a person's considered impulse to do right and is driven to take pleasure in beauty, its force reinforced by its kindred desires for beauty in human bodies – this desire, all-conquering in its forceful drive, takes its name from the word for force (*rhomè*) and is called *eros*.[225]

Not only do the two riders illustrate the Platonic dichotomy, they also explain the presence of the horse. In his dialogue, Socrates tells Phaedrus that, when confronted with the beauty seen in the beloved, the human soul experiences the supreme vision of *eros* to which it will ascend, while in the opposite case, being corrupted by forbidden desires, he will plummet. This ambiguity is represented by the metaphor of two horses, with the one being bound to heaven while the other crashes down to the earth:

> To describe what the soul actually is would require a very long account, altogether a task for a god in every way; but to say what it is like is humanly possible and takes less time. So let us do the second in our speech. Let us then liken the soul to the natural union of a team of winged horses and their charioteer. The gods have horses and charioteers that are themselves all good and come from good stock besides, while everyone else has a mixture. To begin with, our driver is in charge of a pair of horses; second, one of his horses is beautiful and good and from stock of the same sort, while the other is the opposite and has the opposite sort of bloodline. This means that chariot-driving in our case is inevitably a painfully difficult business. And now I should try to tell you why living things are said to include both mortal and immortal beings. All soul looks after all that lacks a soul, and patrols all of heaven, taking different shapes at different times. So long as its wings are in perfect condition it flies high, and the entire universe is its dominion; but a soul that sheds its wings wanders until it lights on something solid, where it settles and takes on an earthly body, which then, owing to the power of this soul, seems to move itself. The whole combination of soul and body is called a living thing, or animal, and has the designation 'mortal' as well. Such a combination cannot be immortal, not on any reasonable account. In fact, it is pure fiction, based neither on observation nor on adequate reasoning, that a god is an immortal living thing which has a body and a soul, and that these are bound together by nature for all time – but of course we must let this be as it may please the gods, and speak accordingly. Let us turn to what causes the shedding of the wings, what makes them fall away from a soul. It is something of this sort: by their nature wings have the power to lift up heavy things and raise them aloft where the gods all dwell, and so, more than anything that pertains to the body, they are akin to the divine, which has beauty, wisdom, goodness, and everything of that sort. These nourish the soul's wings, which grow best in their presence; but foulness and ugliness make the wings shrink and disappear.[226]

Folio 43 only partially follows the text. Whereas Socrates extends the conflict between pure and impure love to the difference between the two horses – one noble and obedient, the other vulgar and savage – the drawing visualizes this difference in the opposed nature of the two riders. This change has been introduced in order to clarify the content. Eros, that is, permissible love (*licitus*), is fittingly represented by a winged Cupid, the classic symbol of virtue. In contrast, forbidden desire is depicted by a satyr that personifies excess and aims to translate Plato's abstract concept into an image that is immediately understandable: "[…] excess has many names, and many members, and many forms, and any of these forms when very marked gives a name, neither honorable nor creditable, to the bearer of the name."[227] A final dilemma is posed by the aged satyr grabbing the horse's tail from behind while raising his hand in an admonitory gesture.[228] He is to be compared to the satyr on the extreme right in folio 40 who is responsible for controlling the rearing horse. Degenhart and Schmitt suggest identifying him with temperance (*Mässigkeit*). Yet, it is not clear why a brute creature like him should represent virtue at all. Conditioned by base appetites, the satyr obviously disagrees with Cupid's victory and instead attempts to assist the captive *satyretto*, who could well be his son. This does not imply a deviation from the ideal of platonic love in the sense that, despite the aspirations of the soul, man's nature will, in the end, succumb to the temptations of the flesh. Subjugated to the artistic principle of rendering the text more

intelligible by translating its symbols into images, he instead acts as an accomplice to the contradictory principle itself and represents the mundane direction of the collapsing horse *of ignoble breed.*[229]

The status of folio 43 is exceptional for both the art historian and the literary scholar. This is the first and most spectacular modern illustration to Plato's *Phaedrus*, and it is probably based on Leonardo Bruni's partial translation dated to the 1420s.[230] The fact is all the more astonishing as *Phaedrus* was highly disputed in academic circles due to its homosexual content.[231] Homosexuality may have been an issue in the circle of antiquarians and humanists in early Renaissance Padua.[232] A pen drawing ascribed to Squarcione in Munich (Graphische Sammlung) with satyrs in different poses has a scene obviously intended as fellatio (line 3, no. 2).[233] What is worth noting, is that the artist responsible for folio 43 not only engaged in one of the most advanced philosophical debates of the time but also possessed the authority to transfer Plato's text into a visual parable that is strikingly vivid and intelligible. It seems reasonable that he was advised by a humanist, which could well have been Marcanova himself whose authority had already emerged in the antiquarian discussion (see preceding chapter).[234] A detail, observed by Windows, may confirm this hypothesis.[235] The same half-moon pendant that is prominently displayed on the horse's forehead appears on the title page of the Bern sylloge (see fig. 23), framing the date at the bottom.[236] If this was indeed intended as a reference to the author's heraldic device, it follows that folio 43 as well makes allusion to Marcanova himself. The horse's double nature, in this admittedly hazardous interpretation, hints at the bonds of platonic friendship uniting the humanist writer and the humanist painter, which had made a drawing such as this possible.[237]

VIII. Contemporary Chronicle

Another surprising aspect of the Louvre *Book of Drawings* is events relating neither to religion nor myth but referring instead to local sources. Interest in contemporary subject matters dates back to Pisanello and court art in general.[238] Since the fourteenth century, French book illuminations in the form of *Grandes Chroniques* have illustrated the lives of the kings of France.[239] Conversely, the *Louvre Album* focuses on incidents drawn from daily life that occurred in the artist's immediate surroundings, translated into visual terms for the first and only time. Aristotle's advice to poets and artists alike to engage in the "ethics and passions and deeds" of human beings (*Poetics* 1450a 16-7)[240] might have played a part in advancing the acceptability of contemporary subject matter.[241] As opposed to ceremonial events in the lives of kings and queens, for which the iconography can be easily deciphered, analysis of those pieces that oscillate "between the privacy of a diary and the publicity of reporting" (Eisler) poses a serious methodological challenge.[242] Without the reassurance of shared tradition, the interpreter cannot ascertain what must have been obvious to the artist himself and his public, who could identify the context by recognizing the appearances of the participants which are carefully rendered. Not surprisingly, this was already lost on the author of the table of contents, except on one single occasion regarding a drawing no longer extant but, significantly, exhibiting a well-known Venetian personality and which is referred to as an "architectural setting with Doge Francesco Foscari and other people" (*uno caxamento con el doxe foschari et altri*).[243] Today's viewers need the help of reliable details, like an inscription in folio 44 (see fig. 35), in order to ascertain the meaning. When this insight is not available, all that can be done is follow the sequential logic of the narrative itself, in accordance with information provided by the accessories, such as the costumes, gestures, physiognomies and architecture, in the way one might read a text by attempting to deduce the plot from its construction.

An exception is those drawings that only seem to constitute a story but, in fact, do not. This is the case with folio 70, which represents two people striving in opposite directions: a nobleman on his horse, a command baton clenched in his fist; and a man from the working class, leaning on his walking stick with a huge basket perched on his back and a pair of keys grasped in his hand (fig. 33).[244] Their dress codes derive from accurate observation; the same holds true for their physiognomies. The man on the horse displays the authority and determination required of a military leader. His haughtiness is heightened by the nobility of his horse, a steed reminiscent of the famous bronzes on the façade of San Marco in Venice (see p. 103). The workingman's expression, on the other hand, is marked by exhaustion and hardship. Tired from a long day's work, he seems at pains to put one foot before the other. His sluggishness is emphasized by his companion dog, which leaps forward while looking back to his master, as if to encourage him to move faster.

Both characters were common in the Veneto and elsewhere; they can be easily recognized as an officer on his horse and a coal-bearer.[245] The fact that members of opposite social strata are depicted does not necessarily justify an underlying narrative, nor does it reveal the artist's class affiliation.[246] Rather, the two men in folio 70 personify prototypes to be studied and employed in whatever setting deemed appropriate. Peasants working in unison with members of the nobility find their place in scenes illustrating the Labors of the Month

33 *Folio 70*, Musée du Louvre, Paris

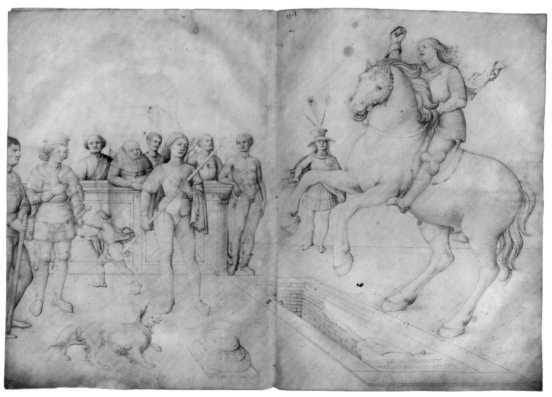

34 *Folio 43v–44*, Musée du Louvre, Paris

around 1400 – with the frescoes of *Torre dell'Aquila* (Trento), the illuminations of the *Très riches heures du Duc de Berry* (Musée Condé, Chantilly), and the tapestries in the Musée des Arts Décoratifs (Paris) serving as examples.[247] These two social opposites, as Aby Warburg has demonstrated in a profound study, are not meant to communicate among each other or tell a story, but are rather intended to define complementary responsibilities in cultivating the land from which economic welfare ensues.[248]

The revenge of Giacomo Loredan

Central to the subject of this chapter is the spectacular drawing in folios 43v – 44 that extends over two pages (fig. 34).[249] It's true meaning was quickly lost; the author of the table of contents limits himself to describing the scene as a "horse in the act of surmounting a hurdle."[250] On the right, a bareheaded knight astride a mounting horse raises his fist heavenward.[251] Next to him stands a man looking up at the rider with fear and loathing; the plumaged hat and the badge on his uniform identify him as an official messenger of the Venetian government – a detail that adds political importance to what is depicted. The cause of their excitement is an open tomb which bears this inscription on the broken slab (fig. 35): "Here lies the noble knight Tommaso Loredano" (HIC IACET NOBILIS VIRI TOMAS/LAVREDANO MILITI). This is the only case in the *Louvre Album* of reference being made to a specific person. Unfortunately, no Tommaso Loredano can be identified between 1316 and 1466.[252] The fact that the coat of arms beneath the inscription, which displays an octagonal star, is not that of the Loredan family has been regarded as proof of the scene's fictitious character.[253] Several authors have thus come to the conclusion that, instead of a contemporary event related to the famous Venetian dynasty, a legend from the time of the Roman Republic is being portrayed, based upon Livy's *Ab urbe condita* (VII, 6).[254] The story goes that a crack had opened in the middle of the Forum Romanum in the year 362 BC. An oracle told the people that they were to throw into the fissure "that what constituted the greatest treasure of the Roman people" and that if they did, the Roman nation would last forever. A young horseman called Marcus Curtius, realizing that it was youth that the Romans held most dear, leaped into the breach astride his horse and fully armed, whereupon the earth closed and Rome was saved. Retold in the medieval *Gesta Romanorum* and elsewhere, this suicide was regarded as a prime example of civic patriotism in ancient Rome.[255]

However, the tomb's inscription, even if fallacious, seems, along with the presence of a representative of the Venetian government, to confirm that this is not a learned recreation of the remote legend of Marcus Curtius in the first place but rather an illustration of a contemporary event. The errors regarding Loredan's forename and his coat of arms may be simply due to the fact that the artist responsible for folio 44 was uninformed about these details, since the focus of his story was less on the earlier cause than its recent aftermath.[256] There is one particular episode referring to admiral Pietro Loredan (1372–1438) that illustrates the point. This officer was one of Venice's most popular heroes, having defeated the fleet of the Ottoman Turks at Gallipoli in 1426 and the Genoese army in the waters near Rapallo in 1432. Venice's military supremacy on water and land had been ensured, to a large degree, by his strategic genius. In politics, he was a partisan of Doge Tommaso Mocenigo (1344–1423), whose successor he failed to become

35 *Folio 44* (det.), Musée du Louvre, Paris

after having been defeated by Francesco Foscari (1373–1457) who was elected the 65th Doge of the *Serenissima* (Most Serene Republic). The subsequent enmity between Pietro Loredan and Francesco Foscari persisted such that the latter is reported to have said that governing had become impossible "as long as this devil of a Loredan was alive." This explains why, after Pietro Loredan's premature death on November 11, 1438, the suspicion was voiced immediately that Doge Foscari himself was responsible for having committed the crime.[257] The chief accuser was Pietro's first-born son, Giacomo Loredan (1396–1471), who was to follow in his father's footsteps. Giacomo Loredan's indignation knew no bounds. Responsible for the execution of Pietro's tomb in the Church of Santa Elena in Venice, he is reported to have added to the inscription the sentence that his father had been poisoned due to the deception of his enemies (*per insidias hostium veneno sublatus*).[258]

The pose of the rider raising his fist in front of his father's tomb adds support to his claim for revenge (*vendetta*), as the expression of the nearby official registers indignation at the doge's side. Yet, one wonders why this would be relevant in the late 1440s when the *Louvre Album* was conceived. As a matter of fact, it is not the antecedents but the continuation of the story, illustrated on the opposite leaf, that is of most interest. Here, Giacomo Loredan appears again, a command baton in his hands, inciting an audience to follow his suggestions by referring to the oath made at his father's tomb. He is no longer a private person exposing personal feelings but a public figure delivering orders. The precision of the individual rendering suggests that the artist knew the subject personally. Giacomo certainly fits a contemporary description that he was "handsome to look at and hot tempered" (*bello di corpo e gagliardo*).[259] The surrounding people are depicted with equal detail. They can be divided into two groups: two men in full figure standing in the foreground on the left are immediately involved in the action, while five people of much smaller size are standing behind a marble screen (*parapetto*) used in municipal halls to separate the public from the governing authorities. Some *genre* elements are included as well: a child running to the left and a dog quite frightened by the mounted horse on the right heighten the story's climax and invite the spectator to let his eyes wander back and forth.

Folio 44 matches what Alberti would have called a *copious historia* in which there is a mixture of men of every age but also children and pet animals, each of them manifesting an individual emotion.[260] It is not possible to verify any of the portraits with any substantial evidence;

fortunately, the interpretation does not depend on it. The following suggestions should, nevertheless, be taken with great caution. The composition itself indicates a clear respect for social hierarchies. The two men in front of the marble screen, similar to Giacomo Loredan himself, are distinguished by their position, stature, dress, and attributes (swords, command batons) as members of the ruling class. They could well represent important *condottieri*, demonstrating Pietro's military achievement. The one in profile on the left, bearing a distinct physiognomy, resembles Erasmo de Narni, called *Gattamelata* (1370–1443), General Commander of the armies of the Republic of Venice since 1438, whose equestrian statue was to be erected by Donatello on the Piazza del Santo in 1453. *Gattamelata* was responsible for Pietro Loredan's election to the title of *generalissimo* of Venice's ground forces in 1438. In the mid or late 1440s when this drawing was made, he was already dead. As a result, he is rendered in strict profile, which may be credited to the use of a terracotta bust model seen today in the Museo Archeologico of Padua.[261] The man next to *Gattamelata*, fully armored with a distinctive headdress characterizing him as feudal warlord, is another ally from earlier times.[262] He may represent Francesco Sforza (1401–1466), a general since 1439 for the league between Venice, Florence, and the Papacy, who departed, together with *Gattamelata*, from Padua for the conquest of Verona on June 23, 1439. The same figure, his position slightly altered, with a cross on his cuirass and a commander's baton (*bastone*) in his hand, reappears in folio 72.[263] This offers a clue that both figures rely upon the same archetype derived perhaps from Paolo Uccello's 1445 cycle of famous men (*uomini famosi*) painted in the Vitelliani family home near the Eremitani Church. Mantegna is reputed to have admired these "giants in chiaroscuro" of which, however, no trace remains.[264]

Five people of minor social ranking relative to the military leaders comment on the outburst of action before them. These spectators are members of the upper-middle class, deliberately assembled to express their qualified judgment on behalf of Giacomo's appeal. From left to right we see: an elderly man with a sash who appears to be related to the two generals in front; a pensive monk, seemingly weighing the arguments *pro et contra*; a young man with a positive smile, a possible student; an armed warrior raising his hand to demonstrate his loyalty; and, most puzzlingly, a fully nude person resting his arm on the balustrade of a classicised pilaster, looking up to Giacomo in front of him.[265] This figure references the heroic nudity of Roman and Greek statues, just as the base of the column in front recalls classical Roman architecture.[266] The man's facial expression, however, indicates that he is a rather contemporary figure, as does his footwear – a mixture of modern and ancient that recalls the man in front of the triumphal arch in Mantegna's *Trial of St. James* and was present in Paduan art since the medals depicting Franesco Novello da Carrara (see p. 60, fn. 353). The very fashion to combine "ideal nudity" (Himmelmann) with the contemporary may well allude to a debate reported by the Milanese humanist Angelo Decembrio (1415–1467) at the court of Ferrara in which the young Margrave Leonello d'Este (1407–1450) stated "that in any picture, it is best for things to be naked […] and this is because it is their [i. e. the poet's and the painter's] duty to conform to the skill of Nature," thereby underlining his preference for the Renaissance instead of the Gothic.[267] A similar modernist and classicist commitment, be it justified on moral or on aesthetic grounds, may have been the reason for distinguishing this protagonist accordingly.

The double appearance of Giacomo Loredan in folios 43v and 44 indicates a shift in time and place. The left page, looking back to the impetus – the year 1438 when Pietro Loredan had died (or was murdered) – depicts Giacomo in the act of swearing eternal vengeance at his father's tomb in Venice. Folio 43v, instead, addresses the present. Thus, the narrative proceeds from the place of crime to the place of justice. That the latter may indeed be identified with the mayor's palace in Padua, is suggested by the fact that Giacomo had assumed this office in the years 1448 to 1451.[268] Upon his becoming the leading politician in Padua, the accusations against the ruling doge were met with increased attention. Pietro Loredan, it was remembered, had been committed to Tommaso Mocenigo, who, contrary to Francesco Foscari, had aimed at maintaining the independence of the *terraferma*. Had Pietro become Mocenigo's successor, events might have unfolded quite differently. It is from this perspective, implying Padua's striving for autonomy, that Giacomo appears no longer simply a rebel but as a public hero and symbol of selfless patriotism, comparable to the Roman Marcus Curtius (see above). If this interpretation were correct, 1448–1450, the years of his mayorship, would offer a reliable date for the *Louvre Album*.

The battle over the pagan past

Folios 46v–47 are organized in a similar way to folios 43v–44 (fig. 36). Due to the nature of the narrative's moral, resulting from the juxtaposition of two distinct events, the draftsman required two pages to contrast the cause, which is seen on the left side, with its consequences, seen on the right. The spectator was invited to combine the two in order to understand the message. For the artist's contemporaries, this reading was facilitated by their recognition of the involved personages via their portraits. With both the visual and oral contexts now lost, a similar approach is no longer possible. No primary references comparable to the inscription in the Loredan case (see p. 75) offer any clues. The table of contents, which describes the scene as an act of vandalism – "a temple with some idols that were being broken by men of arms" (*uno tenpio con alguni idoli che vien roti da zente d'arme*) – is of little help, since it is based upon a mere description without any understanding of the context. A more detailed analysis respecting the dialectics of both representations will reveal the opposite. What the draftsman wanted to ultimately convey is not the destruction but the rescue of an antique monument.

The monument in contention is prominently positioned in the middle of folio 47. It is a pagan altar of presumably Roman origin that would have measured circa four meters in height. Its polygonal base is decorated with four naked male statues, each originally holding a cornucopia in his hand. They surround a fluted column in the middle that is about twice their size, standing atop of which is a naked female statue with long hair, hardly recognizable as Venus.[269] The entire monument is a product of the artist's fantasy. Nothing similar ever existed.[270] Its iconography is composed solely to justify an act of violence from the Christian perspective. A group of soldiers wearing contemporary armor, the *celatura veneziana* as suggested by Degenhart and Schmitt, surround the monument, ready to demolish it. Three footmen on the left have already begun smashing the attributes of the figures in the lower order, while an equestrian on the opposite side gazes up at the statue on top, which is destined to perish as well once the substructure has been destroyed. Yet, the soldiers seem to hesitate in

the midst of their attack. One examines the cornucopia in his hands as if reflecting upon its possible meaning, and the equestrian's expression also communicates astonishment rather than ferociousness.[271] They are but subordinates, after all, dependent on the command of their superiors, who are assembled in folio 46v.

Here, a collision of opposite forces occurs: three people entering from the left encounter obstruction from three people moving from the opposite direction. The former group comprises an armed man with the commander's staff (his pose similar to the presumed portrait of *Gattamelata* in folio 43v), an armed troops commander on horseback, and an elderly man with a long beard viewed in profile. The latter, riding a mule and distinguished as well by a command baton, may represent an ecclesiastic authority.[272] Their opponents, equal in number and coming from the right, are two riders and a footman carrying a shield. They are clearly civilians, and their arrival seems motivated by some urgent request: one man (appearing similar to the second spectator in folio 43v) has jumped off his horse, while his companion salutes the authorities, ready to explain the urgency of their intervention. He may well be a municipal deputy shown in the act of delivering a speech. The arguments this group of dedicated citizens present do no fail to impress the authorities in front of them. From the manner in which the general addresses the representative of the church next to him, his head slightly bent while pointing to the field of action, it is clear that he is willing to reconsider the original agreement. The decision depends upon him, with the outcome being that which seemed concluded and inescapable – namely, the destruction of the pagan monument – has now been halted for reconsideration. This is commented on with relief from the three soldiers to the right. The first, who was about to join his comrades, turns his head back with a smile on his face. Two more soldiers stand next to him, speaking to each other. They have understood that their commander has called off the action and are satisfied with this course of events.

The narrative of folios 46v and 47 juxtaposes the passionate outbreak of action on the one side with its conciliation on the other. The end of the story is not the idol's destruction but its rescue. It is the rational appeal on the right side that matters, not the monument itself – the cause of this conflict – whose shape is as fantastic as the Loredan tomb in folio 44 was with its erroneous inscription and coat of arms. The analysis presented here contradicts recent scholarship that has advocated a representation of the medieval iconography of iconoclasm, where idols are seen toppled from their pedestals.[273] However, no demons are represented here assisting the saints in their efforts to defeat the pagan religion, nor is the idol actually cast to the ground.[274] From the tenor of the *Louvre Album*, with its academic and humanist rather than dogmatic bias, the hypothesis that the battle of faith (*fides*) versus idolatry (*cultura deorum*) is at stake must be strongly doubted.[275] Towards the middle of the fifteenth century, the pagan cult no longer presented as serious a challenge as in the centuries before. To the contrary, it was the fervent zeal of the Christian religion, "destroying all the statues and paintings that had been made until then and, together with these, the knowledge and the rules of such noble art" (Ghiberti), that was being criticized now.[276] It is this modern perspective that found expression in the drawing under discussion.[277] The iconography of iconoclasm is used only to articulate dissent against what was now regarded as a fanatic practice, finding no justification in an educated society.[278]

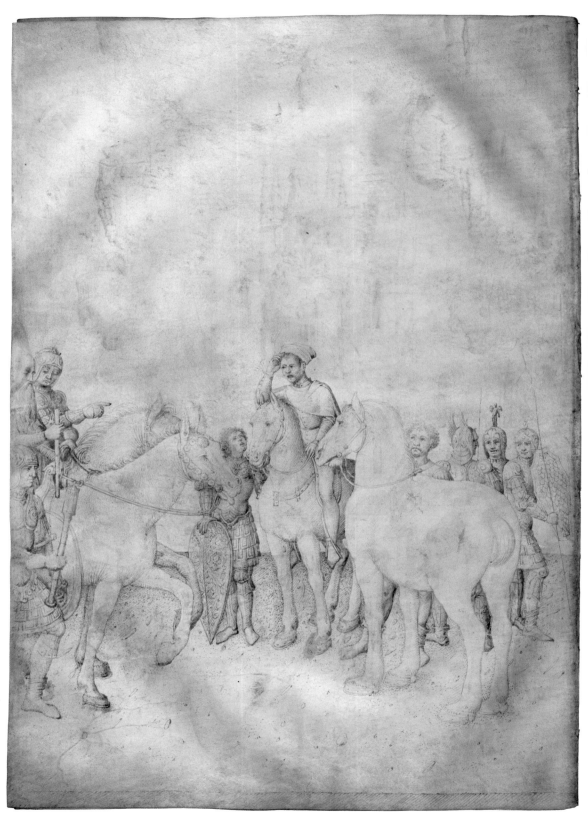

36 *Folio 46v –47*, Musée du Louvre, Paris

1511

47

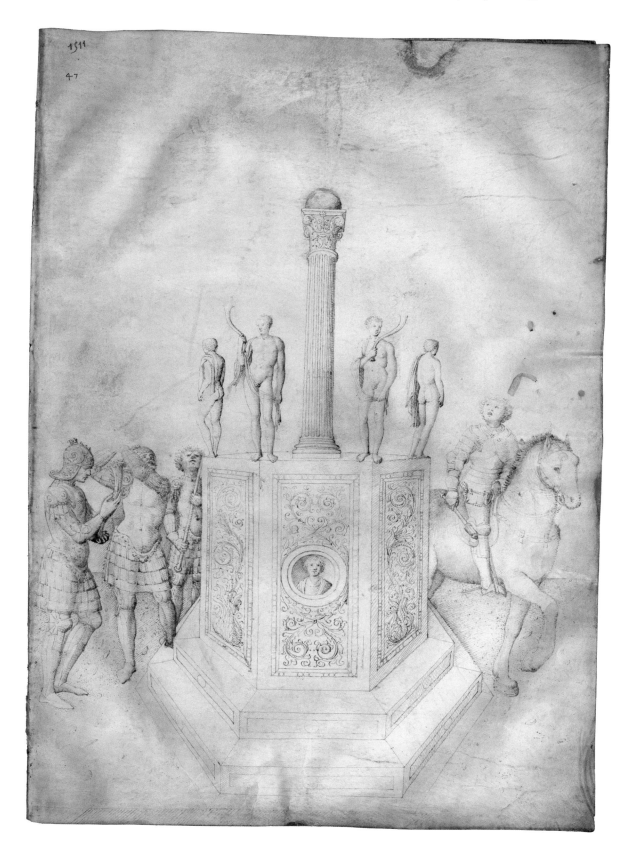

Excursus: Iconoclasm in the Modern Era

Acts of iconoclasm did occur in the Early Modern Era as well, but they were steered less by religious than by ideological zeal. The spark of offense was a political debate in which the pagan statues were manipulated to play an active role in the battle for communal revision. This battle started during the *Renaissance of the Twelfth Century* (Homer Haskins), with the first serious clash occurring during the Capitoline Revolt (1143–1144) when Roman citizens attempted to restore the dignity of their Senate against papal and imperial authority by making use of antique statues and buildings.[279] Nearer to the time of the Louvre drawing, a case in Siena was reported by Ghiberti in his *Commentaries* (circa 1440). An antique statue, ostensibly representing Venus, that was attributed to none other than the Greek sculptor Lysippus (fourth century BC) had been erected in the late 1330s with great fanfare as a public monument in the *Campo* in front of the town hall.[280] It stood as a testament to Siena's glorious past and newly restored authority through the republican government of the *Nove*. In 1357, however, after a return to the old order, the decision was made to destroy the statue and bury its fragments on Florentine territory so as to curse the enemy with bad luck.[281] A third act of iconoclasm occurred in Mantua, which prided itself on being the birthplace of the Roman poet Virgil (70 BC–19 AD). An antique statue, believed to represent the author of the *Aeneid* himself and, at the same time, exemplify the city's present autonomy, was mounted in the *Piazza delle Erbe* in front of the Communal Palace during the first half of the fourteenth century.[282] Mantua's independence, however, was contested by the Pope, whose army, led by General Carlo Malatesta, conquered Mantua in 1397. Malatesta's first act, meant to abolish the city's constitution, was the demolishion of the statue. This act of vandalism provoked an uproar among Italian humanists to a hitherto unheard-of degree. For the first time, they dared to stand up against the Church and its military forces. Pier Paolo Vergerio, a former student from Padua and a professor at that time in Bologna, decried Malatesta as a barbarian, comparing him to the Greek Herostratos, known for having destroyed the Temple of Diana in Ephesos in 356 BC.[283] Vergerio was fully aware that Malatesta's contempt for the statue was compelled by political motives and nurtured by the populist propaganda of the Guelph party, which made it all the more detestable. The scandalous affair continued to appall in the centuries to come. In concordance with the Mantuan humanist Bartolomeo Platina (1421–1481), Leon Battista Alberti launched an initiative for a new monument to Virgil (circa 1460), for which Mantegna is believed to have made the preparatory drawing now in the Louvre.[284]

A last case, similar in fate to the one sketched out above, returns the focus to Padua. As was the case with Siena, Mantua, and many other Italian cities, Padua was proud of its ancient origins and, particularly, its distinction as the birthplace of the Roman historian Titus Livy.[285] An epitaph, believed to have belonged to Livy's tomb, has been kept in his honor in the atrium of Santa Giustina since the Middle Ages.[286] When, in 1413, a container holding human bones was discovered in the same church, the Paduan humanists, under the direction of Sicco Polenton (1376–1447), were convinced of having discovered Livy's remains. They immediately started to plan a mausoleum that was to be erected in the middle of the *Piazza dei Signori*.[287] Polenton was successful in convincing the Venetian *capitano* Zaccaria Trevisan to give his consent for the monument. Due to the firm opposition from the monks

in Santa Giustina and the incredulity of Florentine humanists such as Nicolò Niccoli and Leonardo Bruni, who presented the case to Pope Martin V in 1419, the project was prevented and nothing came of these efforts.[288] The discussion, however, lasted until 1547, when a more modest memorial for Livy was erected in the *Palazzo della Ragione*.[289]

Folio 53: The Temple of Antenor

The cases outlined above – the Sienese Venus, the Mantuan Virgil, and the Paduan Livy – document the enduring battle being waged for the sake of freedom and autonomy by enlightened citizens on the one side and reactionary forces on the other. Folios 46v and 47 illustrate the outcome of this battle from a general perspective, that is, without referring to any monument in particular and by showing the critical moment at which iconoclasm had given way to a better understanding. The final reconciliation of these opposing forces – in a vision where the idol "inspires awe rather than confrontation" (Fortini Brown) – is laid out in folio 53, described in the table of contents as "a polygonal temple on many steps" (*un tenpio in piu faze su molti gradi*).[290] The precision of the architecture in perspective, the variety of ornaments, the accurate hatching, and the use of wash for shading have ensured particular importance be attached to this drawing for its attempt to visualize the antique past (fig. 37).[291]

A classical temple in the round shelters an unspecified male deity standing atop a column.[292] Two groups of worshippers wearing ancient dress yet differently clad ascend the stairs from both sides, while two soldiers within the rotunda, wearing similar armor to the soldiers in folio 47, are placed as guards of honor to protect and, at the same time, provide access to the temple. The one to the right points at the idol and stretches his arm out to a pagan priest as if to explain something. The soldier to the left, bent on his sword, maintains a respectful distance. In front of him stands a high-ranking officer gazing upwards to the statue with a look similar to the equestrian in folio 47. What is represented here is the safeguarding of not just any monument but the pagan cult itself. The same counterforces that had opposed paganity in the drawing discussed previously are transformed into custodians of the monument. Following the humanist perspective, ancients and moderns exist in harmony, with the temple providing shelter for both.

Compared to the non-specificity of the monument displayed in folio 47, its shape in folio 53 bears a resemblance, while fantastic, to something more concrete. The *Tomb of Antenor* in the center of Padua (see fig. 6), juxtaposing the materials of marble and brick, exhibits a similar syncretism of classical and non-classical elements as the one seen in the building of the Louvre drawing with its peristyle below and an almost Gothic cupola above, whose elongated form vaguely alludes to the cone-shaped dome over the crossing of the Santo church (begun 1232).[293] Since the days of Lovato Lovati and Albertino Mussato, local humanists took it for granted that the nearby church of Santa Giustina had been built over a *Temple of Concord*, endowed by Antenor after having founded Padua (*Patavium*) and designing it to become the capital of the tribe of the *Henetians* (Venetians).[294] The legend is confirmed by the authorities of Livy (*Ab urbe condita*, I, 1, 1–3) and Virgil (*Aeneid*, I, 242–249). Nurtured as it was by wishful thinking from the early Middle Ages up to Marcanova himself, apostrophized as *Johannes Antenoreus* (see p. 56), this symbol for the pacification of the adversary

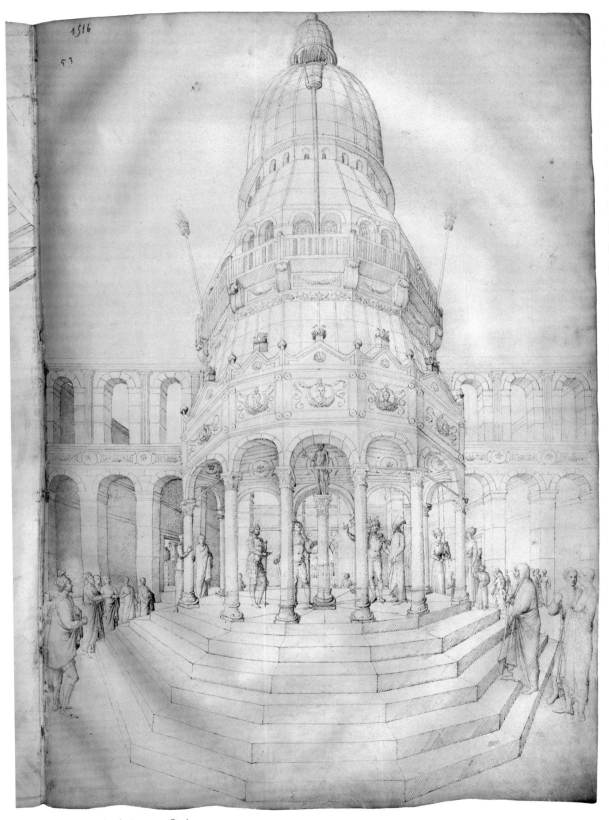

37 *Folio 53*, Musée du Louvre, Paris

populaces of Trojans and Venetians alike could not fail to comment upon the political crisis in the decades following Padua's surrender to Venice in 1405. The different people ascending to the temple and uniting under its roof may well have alluded to a modern reconciliation.[295] There is one further detail that supports the interpretation that the building in the drawing was indeed meant to represent the *Temple of Concord*, with the statue of the Trojan hero in the middle. Behind the temple itself, a colossal piece of architecture rises, distinguished by two superimposed galleries with vaulted radial walls. The building unmistakably references the architecture of the Paduan amphitheater (*arena*), parts of which were still to be seen until the eighteenth century.[296] The addition of this monumental remnant from the times of Emperor Augustus (63 BC–14 AD) was deemed necessary in order to localize the antenorean fiction and render its political implications comprehensible.[297]

Venice, a former trading post founded by Paduan authorities only in the fifth century, could boast of no Roman remains. This is one of the reasons why the archeological material displayed in the *Louvre Album*, important as it was for Padua, was of no relevance here. It is true that evidence of a presumed foothold in the Roman past became desirable over the course of the fifteenth century as soon as the *Serenissima* started to justify its position with respect to cities like Padua and Verona, which had come under its command.[298] What was being requested now, however, was a different and more spectacular kind of antiquity than the monuments connected with Padua's history. In 1486/7, Marco Antonio Coccio (*Sabellico*) published *Historiae rerum Venetiarum*, a book modeled after Livy's *History of Rome*, which resulted in positing Venice as the true heir to the Roman Republic and the Roman Empire.[299] The Arsenale Gate (circa 1457–1461), begun under Doge Pasquale Malipiero (elected in 1457), may be regarded as an attempt to lend visual expression to the "Venetian longing for an ancient Roman presence" (Liebermann).[300] It has long been recognized that the design of its lower storey is based on the architecture of the Arch of the Sergii (circa 30 BC), which was incorporated at that time into the medieval city wall of Pula (Croatia). The question remains, for what reason and via which channels was this remote monument chosen in preference to any of the much more familiar and by far more famous triumphal arches in Rome, Ancona, or Verona. Commercial motives alone – like the fact that much of the stone with which Venice was built came from the Istrian coast – do not suffice.[301] The *Louvre Album* offers a stronger answer. Folio 39 invokes the Arch of the Sergii in a setting where Christ is being led to the palace of Pilate (fig. 38).[302] This is believed to be the earliest rendering of the monument, whose inscription alone had been known to Ciriaco d'Ancona.[303] That Jacopo Bellini should have discovered it by himself is most unlikely. Squarcione, however, is reported to have traveled abroad in his younger years, journeying as far as Greece. The *Louvre Album*, as a matter of fact, exhibits further architectonic details concerning, among others, the cathedral of Sebenico, and even the flag of Dalmatia showing three superimposed lion's heads appears on folio 41.[304] If it was not Squarcione himself, then one of his Dalmatian pupils or even friends could have provided such information.[305] Mantegna was aware of the Arch of the Sergii as well, which he references in the *Triumphs of Cesar* (Hampton Court). Either he or Squarcione, both having been present in Venice at the time when the Arsenale Gate was being erected, could have delivered this particular motif to the Venetian authorities concerned with the planning of the Arsenale Gate.

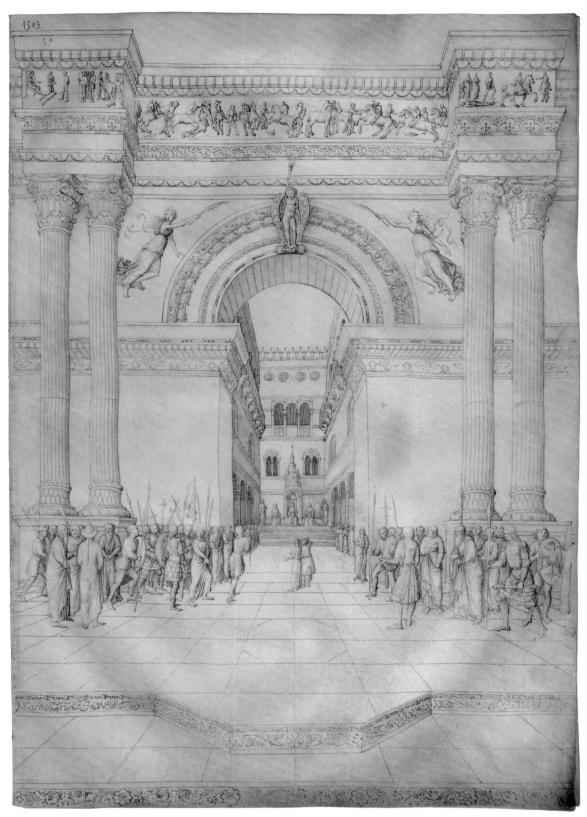

38 *Folio 39*, Musée du Louvre, Paris

IX. Animals

Animals of prey

The *Louvre Album* abounds with the representation of animals of which more than a hundred are shown, be they of secondary importance in small format or as large-scale primary agents.[306] Differences in style and iconography indicate substantial changes in artistic skill and intent due to the fact that the book's completion must have spanned a considerable period of time. Folio 77v, judged by the simplicity of composition, motif, and contouring line, clearly belongs to the initial stage when the responsible artist (possibly Squarcione himself) was still impressed by schematic images and the tradition of textile patterns (fig. 39).[307] The difference in intention becomes evident in comparison with animal drawings of the Lombard painter Giovannino de Grassi (circa 1340–1398) one generation earlier.[308] De Grassi's *taccuino* in Bergamo (Biblioteca Civica, Ms. Cassaf. 1.21), similarly made of parchment but on a much smaller scale, was used as a pocket book to be carried around.[309] Folio 4v, bearing the signature *Johaninus de grassis designavit*, exhibits five animals that are superimposed in a similar fashion to the five lions found in folio 77v: three birds of prey (a buzzard, an eagle, and a falcon) on top, a squirrel and a goat in the middle, and a lion below (fig. 40).[310] They are studies of real animals, dead or alive, not a compendium of symbolic forms.[311] An indicator is that different animals are depicted and rendered according to their respective size, which is why the squirrel requires less space in comparison to the goat. Their poses are to be considered naturalistic insofar as they are typical of their individual species. As far as the drawing technique is concerned, de Grassi did not restrict himself to simple outlines but rendered the animal's bodies livelier through hatches in silverpoint or by adding wash drawing to reproduce fur, skin, feathers, manes or spots, also as a way to increase their plasticity.[312] Even though some of the poses may appear stiff and lifeless, there is reason to believe that these studies were gathered from direct observation at the zoo in Pavia, where the Visconti, Giovannino's patrons, had collected a number of diverse animals.

Instead of presenting a variety of animals, the artist responsible for the Louvre drawing focused on one particular species, shown in different compositions: a lion couple on top, two pacing lions in the middle, and a jumping lioness below. A closer inspection reveals that these animals had been copied not from nature but from models of the late Gothic period. The somewhat slim and elongated bodies of the two pacing lions (lines 2 and 3) recall, for example, the proportions of Jacobello del Fiore's lion at San Marco in Venice, dated 1415 (figs. 41 and 42).[313] Also, the lions' poses, not entirely understood by the artist as can be surmised from hesitations and errors in their outlines, adhere not to zoological observation but to imagination and theory, following specific gender and age concepts. The lioness above (line 1, no. 1) with her raised foreleg, to which the tail gives visual support, is meant to be understood as paying respect to her partner.[314] The same holds true for the physiognomies: the faces of the female and younger animals bear feline traits, contrary to the resting adult lion (line 1, no. 2), seen in profile, that recalls Roman prototypes. The excessiveness of the lions' manes, as opposed to their being restricted to their chest (as in de Grassi's drawing), is meant to express virility and power. A particular case is the lioness below with outstretched fore and hind legs, observed in the act of jumping (line 3). The image, of which there is no

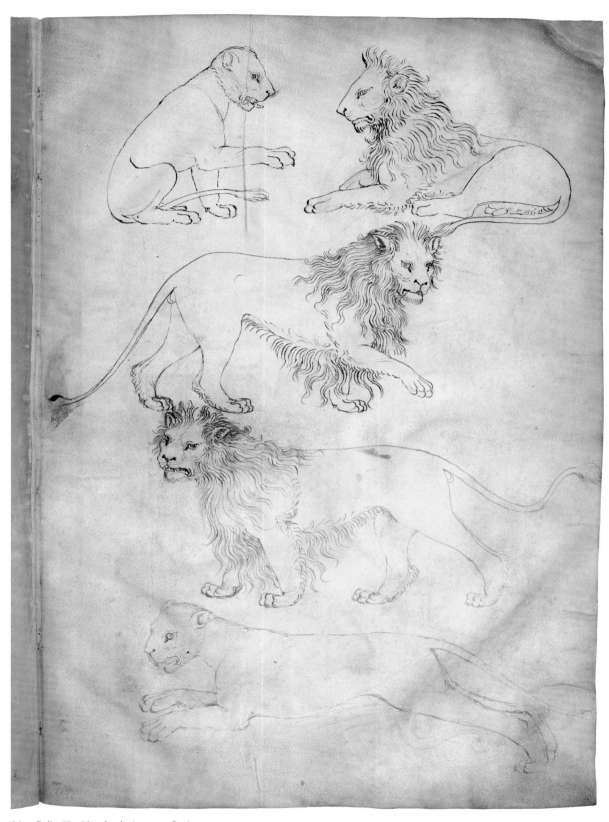

39 *Folio 77v*, Musée du Louvre, Paris

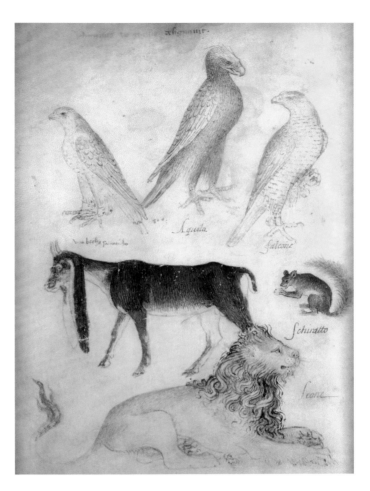

40 Giovannino de Grassi,
taccuino, Biblioteca Civica,
Bergamo, ms.Cassaf. 1.21, Folio 4v

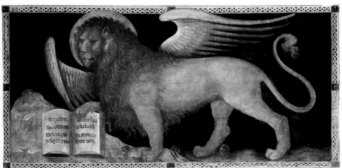

41 Jacobello del Fiore,
Lion of San Marco,
Palazzo Ducale, Venice

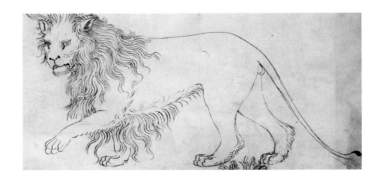

42 *Folio 77v* (det.)

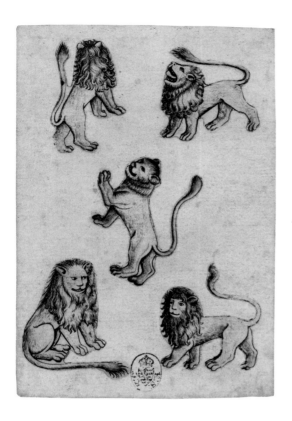

43 Master of the Playing Cards, no. 5 of *Beasts*, Kupferstichkabinett, Dresden

comparison in nature, may have been prompted by a reading of Aristotle's zoology in which the posture of the fleeing lion is described as prolate, similar even to that of a dog.[315]

The principle behind de Grassi's drawing (folio 4v) – its arranging of so many different species of animals – was that of economy. One can imagine him filling in one animal after the other as allowed by the available space. It is not, however, the same reasoning to which the draftsman of the *Louvre Album* adheres. Folio 77v priotizes one species, the amount of which had been determined from the outset. Thus, the artist's task entailed not merely studying animals as such but determining a decorative pattern by combining a variety of characteristic postures. Repetitions that would have lessened the effectiveness of the visual experience needed to be avoided. Closest in comparison are the playing cards by the so-called Master of the Playing Cards (active circa 1430–1450), an artist of Alsatian or Swiss origin whose engravings must have been available at that time. The animals are organized into suits (flowers, birds, deer, animals of prey, and wild men) whereby the value of each card was measured not by an inscribed numeral but the number of figurative symbols (*pips*).[316] The card representing number five in the "animals of prey" suit depicts male and female lions in poses very similar to those found in folio 77v as well as to the pose of the lion in folio 78v (figs. 43 and 44). Squarcione, whose keen interest in both plaster and print reproductions is well known (Antonio Pollaiuolo's *Battle of the Nudes* being part of his collection), may have brought back prints from the Master of the Playing Cards from his travels.[317] It follows that folio 77v, when placed in the context of Italian nature studies, can be misinterpreted. Contrary to the Bergamo booklet, which addresses the *scientific* revival of the late fourteenth

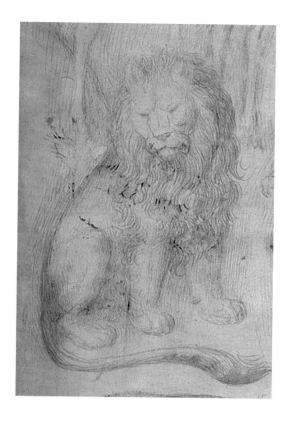

44 *Folio 78v* (det.), Musée du Louvre, Paris

century and the naturalistic style of the International Gothic, the Louvre drawing follows the opposite trend, which was the schematization of nature for the sake of artistic composition. The design's simplicity does not necessarily indicate an early date but rather demonstrates the adherence to a conventionalism also inherent in the trans-alpine model that had been transferred with only slight variations to a modernized Italian idiom. In accordance with the rest of the drawings, a dating to the 1430s is likely.

Folio 78v witnesses a change with respect to folio 77v (fig. 45). The parchment originally contained eleven lions, arranged on four levels and contoured by simple pen lines (partially visible in line 4, no. 1), similar to the ones on the preceding page.[318] While some of the lions' poses (line 1, no. 3; line 3, no. 1) are clearly adopted from folio 77v (line 2, no. 3; line 4, no. 1), there are others (line 2, nos. 1 and 2) that demonstrate an improvement with respect to the more conventional scheme proposed by the Master of the Playing Cards. The all-too simplistic profiles used previously have been abandoned for the use of more ambitious perspectives and bolder foreshortenings, reminiscent of the era of Pisanello and his school rather than a date in the late fourteenth century as has been proposed by Degenhart and Schmitt.[319] The artist who reused folio 78v in the 1440s did something exceptional. He first covered the original lions with a chalky, tinted primer but then decided – instead of replacing them with something on his own – to reproduce seven lions (line 2, 3, 4).[320] He did so, however, with a different and more modern understanding. Layers of subtle parallel hatchings in silverpoint accentuate the roundness and liveliness of the animals as well as their spatial settings.[321] Furthermore, an improvement can be noted consisting in accentuating some of

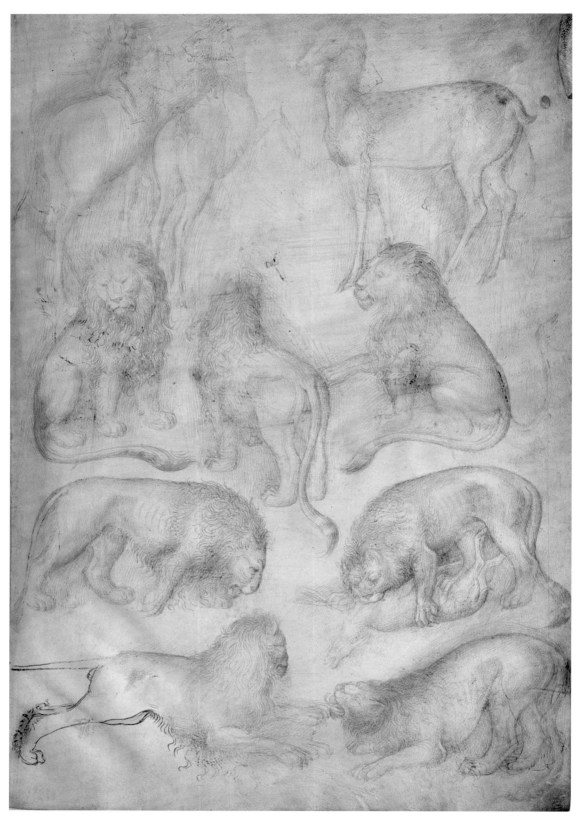

45 *Folio 78v*, Musée du Louvre, Paris

46 *Folio 78v* (det.),
Musée du Louvre, Paris

the physiognomies so as to highlight the different movements. These expressions range from roaring rage (line 4, no. 2) to civilized amiability (line 2, no. 3); they may be indebted to the tradition of Aristotle's *De natura animalium*, which deemed the lion as not only wild and dangerous but also gentle, playful, and dignified.[322]

An exercise like the one described above may well have been part of an academic training that set out to demonstrate both the quality of the model and its value at an advanced stage. Not only does Squarcione's two-class system come to mind but also his method, which consisted of correcting certain figures on a model drawing (*carta d'asenpio*), thereby explaining the errors (*dirge i fali*) one by one (see p. 26). The rigor of this system is proven in the upper quadrant of folio 78v where, instead of correcting the model, the artist decided to replace it altogether. From what can still be seen of the underdrawing, his decision is not difficult to follow (fig. 46). The four lions originally depicted in line 1 (nos. 1 and 2 in particular), reminiscent of emblematic animals in their somewhat rigid and abstract formalism, had obviously been considered far too old-fashioned to be recycled in a more sophisticated context. This is why they have been replaced by two mounting deer depicted from the rear (the one to the left ridden by a putto) and a deer in profile. The drawing technique and foreshortenings are identical to the alternations introduced with the animals below, and the poses reappear throughout the *Louvre Album* (folios 7, 18, 71).

Indebted as they are to the Master of the Playing Cards, folios 77v and 78v are, at the same time, also part of a larger set of lion studies that is continued in the album at the British Museum. Judging from the richness of types assembled in both albums, it becomes evident that serious research has been devoted to this particular topic, which focuses, as it seems, on a Paduan pictorial legacy in particular. Folio 83 (British Museum) shows a cenotaph within a niche (fig. 47).[323] The deceased lies above the *tumba* with three medallions illustrating

47 *Folio 83*, British Museum, London

48 Altichiero, *Memorial of the de Rossi family*, Chapel of San Felice in the Santo, Padua

his deeds, along with a crucifixion placed above, expressing the hope for salvation.[324] What seems to be atypical in this context, is a family of lions positioned in front of the monument; they are meant to be alive, whereas the rest of the tomb is presumably sculpted in stone. A point of comparison is Altichiero's memorial of the de Rossi family in the chapel of San Felice in the Santo in Padua (1376–79) where a large-scale recumbent lion is seen represented on the ground before the tomb (fig. 48). The iconography of the male lion recalling his stillborn cubs as shown in folio 83 (BM) refers, however, to the resurrection of flesh, not to a heraldic animal. This point of reference, the resurrection of the flesh, is explained at length in the classical Physiologus and illustrated in the medieval bestiaries indebted to this source.[325] It makes its reappearance in Padua, quite surprisingly, in one of the decorative bands in Giotto's Arena Chapel (circa 1305) that was probably the point of reference for the Louvre drawing (fig. 49). In addition, the adjustment of this image within a sepulchral context as shown in folio 83 (BM) needed some further research, related in all probability to medieval book illumination, which is known to have interested the Paduan humanists at that time.[326]

The same kind of research would be needed for folio 21 (British Museum) which depicts an armed soldier about to battle a rearing lion, a subject common in late antique consular dyptichs that makes its first reappearance in Villard d'Honnecourts portfolio in the early thirteenth century (figs. 50 and 51).[327] The lion slashing a horse in folio 7v (British Museum) references a model from antiquity as well: a sculpture exhibited on the Capitoline Hill that was believed to symbolize the victory of the Roman Republic (the lion) over the papacy (the horse) (figs. 52 and 53).[328] A similar formula, though translated into a fantasy *all'antica*, may be observed at the core of folio 53 (British Museum) where a lion, mounted by a satyr, is fleeing from a rider

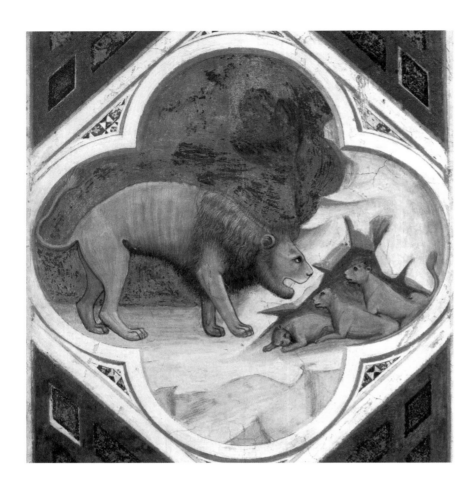

49 Giotto,
The Lion recalls the Cubs to Life,
Arena Chapel, Padua

on horseback (fig. 54).[329] The lion and the satyr signify the pagan world, just as the horse exemplifies the realm of Christianity.[330] The method developed in these studies, consisting in the investigation of valuable local iconographic material from Roman sources, parallels the reuse of archeological material, examined in chapter VI. Similarly, in the case of the animal studies, it was not nature as such but, preferably, classical models which had been explored with the necessary diligence to be reintegrated into Squarcione's academic teaching program.

Domestic animals

While de Grassi's general interest in nature facilitated his assembling of different species on the same page in order to make use of the space at his disposal – in such a way that a squirrel could stand next to a lion – the author of the *Louvre Album* was far more concerned with iconography. He was more an artist than a naturalist, and he might have shared Alberti's opinion who considered horses, dogs, and other things worth seeing an indispensable adornment in painting, since, "without these, no *historia* is worthy of praise."[331] This may explain why, in the *Louvre Album*, dogs and horses compose a prominent group. Beginning with the former, a distinction is worth noting: greyhounds (folios 16, 35, 64v) in the act of running or jumping, similar to Pisanello's *Vision of Saint Eustace* (circa 1440, London, National Gallery), on the one

50 *Folio 21*, British Museum, London

51 Villard de Honnecourt, *Book of Drawings*, Biblio- thèque Nationale de France, Paris, ms.Fr. 19093, Folio 26v

52 *Folio 7v*, British Museum, London

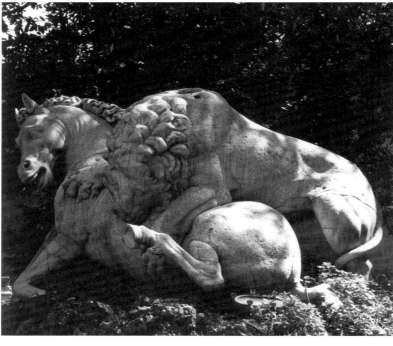

53 Roman sculpture, *Lion Slashing a Horse*, Musei Capitolini, Rome

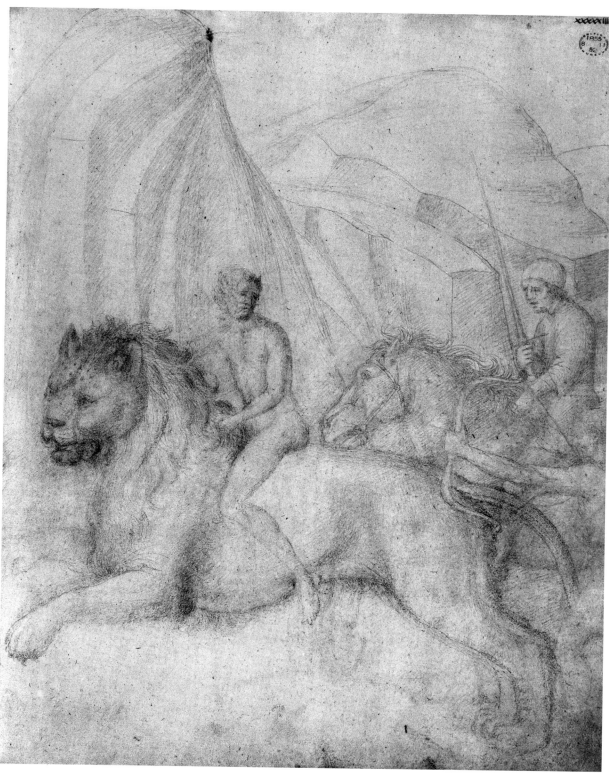

54 *Folio 53*, British Museum, London

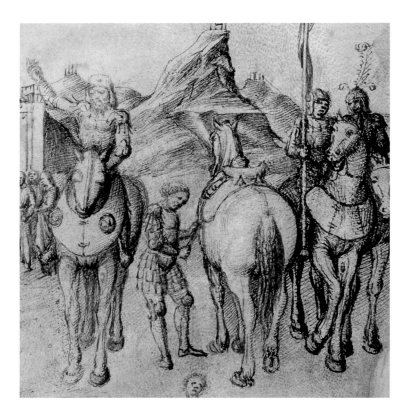

55 *Folio 19*,
Musée du Louvre, Paris

side, and domestic dogs (folios 9, 10, 38, 39, 64, 85) on the other. The former, conveyed with a given outline, seem to adhere rather to a stereotyped attitude, whereas the latter were portrayed realistically, following the animal's individual shape, together with the impression of fur and protruding hair.[332] Contrary to the noble dogs, mongrels and the like were added with no specific iconographic purpose but to enrich the composition and facilitate its reading.[333] The pet dog in the foreground of folio 9, for example, bears no relevance to the monument of St. John the Baptist at whose feet he is laying but has been inserted to emphasize the middle axis and form a bond between the left and the right sides of the composition. A similar function is true for the dog in folio 43v (see p. 76); its recurrence in folios 50, 70 and 92 prompts one to speculate whether this particular animal belonged to the artist's surroundings. For one of Squarcione's pupils, Marco Zoppo, it is verified that he was a dedicated dog owner.[334]

Horses form another important group.[335] Their presence, if not iconographically motivated, as in the Crucifixion of Christ (folios 1, 19, 41) or the story of St. George (folios 14, 15, 67), may again have been prompted by Alberti's advice (see above). Like dogs, they can be divided into different categories. In crowded compositions, horses are rendered with extreme foreshortening from the front and the back so as to draw in the viewer's attention and mark spatial depth. This type of position may refer to Pisanello's fresco of *St. George and the Princess* in Sant'Anastasia (Verona) from about 1438, but it already occurs circa 1380 in Altichiero's *Crucifixion* in the Oratory of Saint George (Padua) (figs. 55 and 56).[336] With the horse joining the action (folios 50, 52, 67, and 90), the preferred equine stance is depicted with both hind legs firmly planted on the ground, the forelegs bent and the horse's head, with its undulating forelock, forcefully

56 Altichiero, *Crucifixion* (det.), Oratorio di
San Giorgio, Padua

turned in profile. The frequently referenced prototype is the mosaic of *St. Isidore* in San Marco in Venice from about 1350 (figs. 57 and 58).[337] The *levade* staged mostly in battle scenes (folios 14, 15, 41, 44, 81, 84) was similarly derived from an early prototype that was known already to Jacopo da Verona (circa 1355–1444) in the Bovi Chapel of San Michele in Padua (circa 1397).[338] A third, equally frequent pose is the horse with one raised foreleg (folios 6, 42, 49, 70). It can be traced back to the famous bronze quadriga from classical antiquity (second or third century AD) on the façade of San Marco in Venice that is referred to as a group in folios 1 and 20 (figs. 59 and 60).[339] The horse to the extreme right, seen from different angles, makes its appearance in several drawings. This indicates the existence of a small-scale model that the artist could turn around at will. One is reminded that Squarcione produced plaster casts and that he had taught Mantegna, as Vasari reports, how to form them after antique statues (*lo esercitò assai in cose di gesso formate da statue antiche*).[340] Since Cennino Cennini had been the first in modern Italy to have systematically operated and written about this technique in late fourteenth-century Padua – referred to in Pliny's *Natural History* (35, 153) – it would be reasonable to assume that his treatise played a role in the formation of Squarcione's academy.[341]

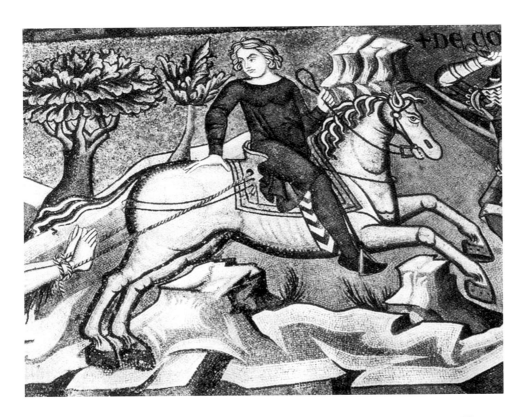

57 *Martyrdom of Saint Isidore* (det.), San Marco, Capella Sant' Isidoro, Venice

58 *Folio 52*

59 *Folio 19 (det.),*
Musée du Louvre, Paris

60 *Horses of San Marco*, Venice

The triumphal gateway of copying from nature (Cennini)

The sequence of animals in the *Louvre Album* has nothing in common with either Jacopo Bellini's painterly interests or Venetian art of that era.[342] Noteworthy *animaliers*, like Cennino Cennini, Giovannino de Grassi, and Pisanello, were court artists, active in cities like Padua, Milan, and Verona. Their patrons' interest in this subject matter was mainly based on ideological rather than artistic reasons. Marsilius (Mainardini) of Padua (circa 1292–1342/3), a former student of the Faculty of Medicine and Philosophy and follower of Pietro d'Abano, referred to Aristotle's *Politics* (I, 1253a18-25) in his tract *The Defender of Peace* (*Defensor Pacis*, 1324) in order to define the desirable *civitas* as an animal-like living organism (*animal bene dispositum secundum naturam*) whose welfare depended – as seen in nature itself – on the faculty of its constituent parts (*bona disposicio civitatis aut regni*). [343] It was owing to this system of empiricism that Marsilius was able to deduce the natural supremacy of King Louis the Bavarian (1282–1347) over the spiritual authority of the papacy.[344] Also the Carraresi in Padua, whose rule extended from 1318 to 1405, were indebted to the theory of supreme rulership (*principatum supremum*) as defined by Marsilio and Aristotle.[345] Since they were self-proclaimed *signori* and possessed neither imperial privileges nor ecclesiastical titles (*ex defectu tituli*), making reference to the law of nature was an effective means to justify their power by being regarded as natural lords (*domini naturales*) and thus dissociated from illegitimate and lawless tyrants (*domini non naturales*).[346]

The hierarchy of the animal world – from the dove to the eagle, and the lamb to the lion – seemed to reflect and confirm existing social orders. Frederick II of Hohenstaufen's (1194–1250) book on falconry *De arte venandi cum avibus* (Vatican, Biblioteca apostolica, Pal. lat. 1071), written and illustrated in an instable political situation with respect to the papacy, was based on Michael Scotus' (1175–1232) translation of Aristotle's zoology from Arab into Latin.[347] In Padua, the Carrara Lords had, as early as 1350, ordered a room in their *reggia*, the *sala bestiarium*, to be decorated entirely with animals.[348] A possible reference to these lost wall paintings may be preserved in Altichiero's allegory of Padua's military victory over Venice at Chioggia (1378/81), in which the bull is meant to personify Francesco il Vecchio da Carrara and the lion the defeated Venetian army (fig. 61).[349] On the occasion of his marriage to Isabella of Valois (1360), Giangeleazzo Visconti asked Lodovico Gonzaga of Mantua to dispatch "four or six painters of figures and of animals" to decorate the rooms of his castle.[350] Similar to the wall paintings in Padua, the animal paintings in Pavia, some executed in gold on a blue background, were intended as mirror images of the court and its members.[351] The same holds true for de Grassi's book of illuminations as well as those of his follower Belbello da Pavia in the *Offiziolo Visconti* (Florence, Biblioteca Nazionale Centrale, Mss. BR 397 and Landau Finaly 22).[352] The various animals sculpted on the reverse of Pisanello's medals, whose front sides portray the members of the Este, the Malatesta, or Gonzaga families, offer further demonstration of this fashion based on political legitimation.[353] The political symbolism did not stop here but could be transferred to plants as well. The re-edition of an eleventh century medical-botany book entitled *The Book of Simple Medicaments* (*Liber aggregatus in medicinis simplicibus*), known as *Erbario Carrarese* (London, British Library, ms. Egerton 2020) since it was commissioned by Francesco Novello da Carrara, testifies to

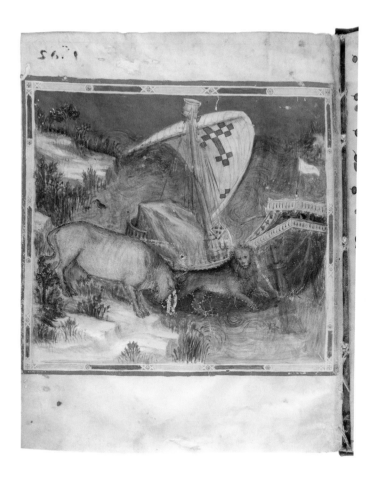

61 Altichiero, *Allegory of the Battle at Chioggia*, in: Franciscus Petrarca, Compendium Virorum Illustrium, cum supplement Lombardi a Serico, Bibliothèque nationale de France, Paris, ms.lat. 6069G, cover

this.[354] For the first time in more than a thousand years, distinct plants were being drawn directly from life instead of by recurring to the traditional and symbolic examples of previously depicted flora – a concept that betrays the same Aristotelian idea of naturalistic equation (*secundum naturam* or *kata physin*) that was to generate the portraiture of animals.[355] The frontispiece (fol. 4) displays the Carrara coat of arms in the border and a lemon tree in the middle of the page (*Citrus medica*), a plant that Pliny recommends as an "ornament to houses" and an "anti-dote against poisons" (fig. 62).[356]

Francesco Novello was also a patron of Cennini, the first artist to reflect theoretically upon the aesthetic consequences of the new demand for naturalistic representation in his *Craftsman's Handbook*.[357] Apart from supplying technical expertise related to the duplication of nature in the final section (ch. 81-89), the treatise issued a strong appeal to contemporary artists that was to be "taken to heart by two generations of North Italian artists who spent considerable time doing precisely what he [Cennini] recommended" (Woods-Marsden).[358]

> Mind you, the most perfect steersman that you can have, and the best helm, lie in the triumphal gateway of copying from nature. And this outdoes all other models; and always rely on this with a stout heart, expecially as you begin to gain some judgement in draftsmanship. Do not fail, as you go on, to draw something every day, for no matter how little it is it will be well worth while, and will do you a world of good.[359]

62 Erbario Carrarese, *Frontispiece*,
British Library, Ms. Egerton 2020, London

Cennini's radical focus on nature was nurtured by his denial of the symbolic representation of nature that had been valid throughout the Middle Ages.[360] A point of comparison is a portfolio of drawings in Paris (Bibliothèque Nationale, Ms. fr. 19093) by the French architect Villard de Honnecourt (circa 1200–125). Folio 24v depicts a male lion from a frontal perspective bearing an inscription that states the artist had been drawing from a live subject (*contrefait al vif*).[361] Yet, his understanding of the term has nothing in common with what Cennini meant by "drawing from nature" (*disegnare dal naturale*), the reason being that Villard's lion is based upon a whole set of theoretical issues and, furthermore, constructed through the use of a circle, which Cennini would not permit.[362] Reorienting the artistic practice towards models (*essempi*) from the phenomenal world that resist idealization, coincided with the *Craftsman's Handbook* general theory that is based upon the preordained hierarchy of the physical world and the difference between ideal and secondary forms of existence.[363] Chapter 70 distinguishes the male body, considered to be perfect (*fatto perfettamente*), from that of the female, which Cennini does not believe to be true to size (*non à perfetta misura*).[364] It follows that, while it is possible to construct the male body in accordance with a system of ideal proportions (conforming to the "pseudo-Varro Canon"), the female body, in the absence of an inner ratio, has to be studied from its physical appearance.[365] The same rule applies to animals. For Cennini, they too fall into the category of irrational beings in that they lack

any ideal measurements (*non hanno misura*), which means that they are subordinate to the happenstance of nature.[366] Yet, this is no longer considered a stigma that demands visual perception be overcome by the intellect. On the contrary – it allows the artist to explore the external world, since what he needs for such representation is a sharp eye and good practice (*buona pratica*). This is why Cennini advises the painter to draw from nature as much as he can (*ritra'ne e disegnia più che puoi dal naturale*).[367]

Cennini's theory offers the basis for the kind of aesthetic naturalism that manifests itself in the simultaneous representation of nude women and animals in the Northern Italian books of drawings.[368] However, over the span of the fifty years separating the *Libro dell'arte* from the *Louvre Album*, an important development occurred in three steps. At the beginning (circa 1400), drawings such as folio 4v in Giovannino de Grassi's *taccuino* document an objective stance, in that the animals portrayed are accurately rendered with respect to their species, if not to their individual appearance. The next step, taken by Pisanello one generation later, was to focus not on timeless images but on a momentary impression that implied movement and spatial environment. Illuminating the uniqueness of perception, it is the artist's eye and hand that capture the image simultaneously. The duality between those images that eliminate all types of anomalies in favor of a reliable format and those that reflect a spontaneous interaction between the viewer and the image reaches a new level of quality in the *Louvre Album*. This happens, on the one hand, by engaging in the dialectics of models that refer to nature and antiquity as the embodiment of naturalistic perfection (see above). On the other hand, it permits an increase in self-referentiality that goes far beyond everything thought of by Cennini. The last pages in the *Louvre Album* and the first ones of the album in the British Museum successively allow a reconstruction of this gain in artistic autonomy.

Folios 65v and 86 (Louvre) exhibit a family of lions, a rare event at that time and one to which Aristotle (*De natura animalium*) had already payed particular attention (figs. 63 and 64).[369] The parading male lion in the foreground of folio 86 emulates the standard poses already seen in Jacobello del Fiore's lion at San Marco in Venice (see p. 97) and in some of the animal studies of folio 77v (line 2). The rest of the pride, partly hidden in the background, was drawn with less attention to detail. It is obvious that they function on a different semantic level: as accompaniment to the primary protagonist rather than models in their own right. No record exists of the preparatory sketches made on the spot.[370] They must have formed the starting point for the versions included in the album of the British Museum.[371] It is here, in the process of editing, that different paradigms of interpretation become apparent. Folios 2v and 3 (British Museum) exhibit the same family of lions yet with a notable exception (figs. 65 and 66). Compared to his self-complacent counterpart in the Louvre (folio 86), the pacing male lion in the foreground of folio 2v looks impatient and enraged, which is obviously due to the limited space of his cage. The same expression is shared by the lion's pride, to which greater importance has now been attached. In the following composition (folio 3), seemingly comprised of various sketches, the hierarchical position of the male is diminished even further in favor of the other animals' interactions. Observation clearly supersedes standardization. The apex of this development can be seen in folios 8v and 20v in which the viewer clearly resides outside the cage, directing his gaze through the grid behind which two lions are seen (figs. 67 and 68). What matters here, is

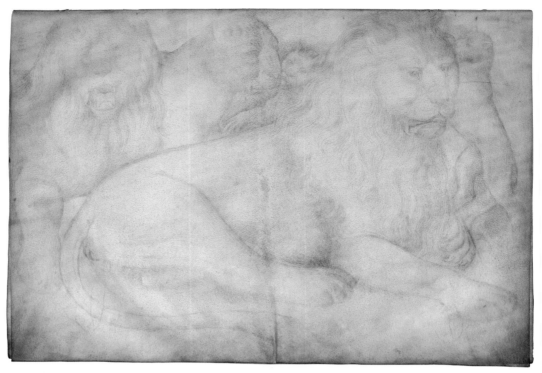

63 *Folio 65v*, Musée du Louvre, Paris

64 *Folio 86*, Musée du Louvre, Paris

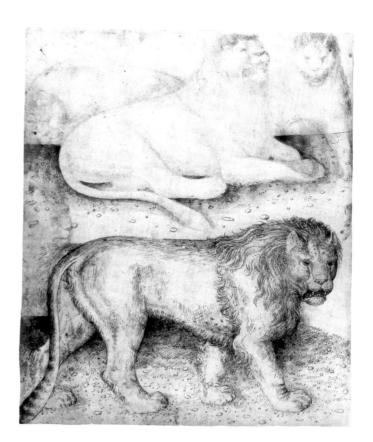

65 *Folio 2v*, British Museum, London

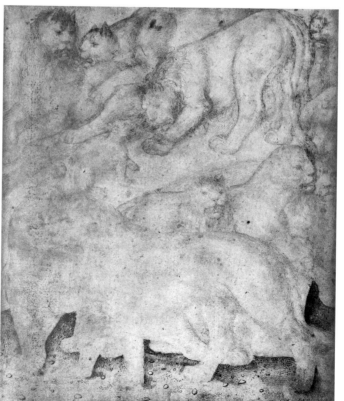

66 *Folio 3*, British Museum, London

67 *Folio 8v*, British Museum, London

68 *Folio 20v, British Museum, London*

the condensing of a momentary visual experience as a way to address the dialectic between observer and observed. This is achieved by scaling down the motif and leaving the rest of the page blank so as to enhance the effect that the space is far too narrow and that these lions are being imprisoned in a dungeon that belongs to some town hall rather than housed in a proper zoo.[372] In folio 8v (British Museum), the most significant within this group, only the head and the back of the animals are visible. It is the immediacy of visual perception that has become central to the representation. Contrary to traditional leonine iconography, which emphasizes the archetypal role of the king of animals for political or religious reasons, here it is the shock of the real that counts. A moment of compassion for the suffering creatures emerges, albeit inadvertently.

The progression to this current example from the beginning of the series (folio 77v) was a long course of evolution: from an early style, bound to the compliance of normative models, towards a personal *maniera* based on the artist's judgment and interpretation. This may be regarded as further proof that the *Louvre Album* clearly predates the drawings in London. Comparable is the progression leading from the dichotomy of specific social types in folio 70 (Louvre) to an almost snapshot-like rendering of scenes from the marketplace (folios 34, 92v British Museum). These subsequent drawings, which are based on pure observation, seem to anticipate Leonardo's advice in his *Book of Painting* to record images from the street immediately, since their infinite variety cannot be easily recalled afterwards.[373]

The same arc from objectivity to subjectivity is also at the heart of *all'antica* motifs, starting with scholarly exercises in archeology (folios 48, 49) and leading to a reinvention of the pagan world in the mythological drawings (folios 40, 43). Donatello's growing presence in Padua, from 1443 onwards, might have fostered this development. In its wake, a new confidence in aesthetic expertise emerged, which necessarily led to a liberation from the dry stricture of rules invented by Master Squarcione.[374] It was left to Mantegna to repudiate his former teacher and stepfather and to surpass him in the ambitious book project. The *Louvre Album*, which he donated to his father-in-law, Jacopo Bellini, in order to possibly serve as basis for a new academy, testifies to the emergence of his genius. So proud of his collection of examples and archetypes, the old *gymnasiarcha* could only counter his pupil's challenge with the claim that, after all, it was he, Squarcione, who "had made the man, Mantegna" – a claim that is immoderate in view of Mantegna's genius, yet not altogether false with regard to the importance of Squarcione's academy.[375]

SUMMARY

The premise of this book was to demonstrate that Jacopo Bellini did not execute the drawings in the Louvre himself (R. F. 1475–1565). Bound together to form a book in the early 1450s, the album was originally intended to attract and educate young students in the art of painting. The idea came from Francesco Squarcione who was devoted to similar projects in humanist Padua, having therefore founded an academy in keeping with the scientific premises established by the Faculty of Medicine and Philosophy at the University (chapter III). Jacopo Bellini, a collector of valuable art objects that were related to his profession (*pertinentia pictorie et ad dipingendum*) and eager to assume a leading position in the Veneto art world, came into possession of the album probably in the late 1450s through mediation of his son-in-law, Andrea Mantegna, Squarcione's most prominent pupil. This information is inferred from the correspondence between the Florentine art dealer Angelo Tovaglia and Lodovico Gonzaga (I). The conclusion of this transaction is all too well known: Jacopo Bellini bequeathed the *Book of Drawings*, together with the rest of his collection, to his wife, Anna Rinversi, who passed it to their son Gentile Bellini in 1471. Gentile and his brother, Giovanni, did not keep Jacopo's possessions, which were of no use from a professional artistic standpoint, but sold them at a high price. The *Louvre Album*, the most precious item, probably passed into the possession of the Sultan Mehmed II in 1479.

The conclusion that Jacopo Bellini was merely the owner and not the author of the drawings is substantiated by a close analysis of the drawings themselves. With respect to style and content, they have little in common with what can be inferred from Jacopo Bellini's painted œuvre.[1] The discrepancy has since been noted, yet, due to Anna Rinversi's testament, seemed unassailable. This fallacy gave birth to the paradox of an artistic personality that, on the one hand, was deeply rooted in the tradition of the late Gothic period (Gentile da Fabriano, Jan van Eyck) but, on the other, due to the ostensible evidence of the drawings, challenged and finally overcame this very tradition. All of the ensuing conclusions are derived from this initial, fallacious presumption, to the point of subordinating Mantegna himself to the Venetian master. Colin Eisler's hypothesis that it was the availability of Jacopo Bellini's drawings that "could, in a sense, have made Andrea Mantegna marry Nicolosia for her father's books" underscores the extent of this factual distortion. What substantiated this theory was, furthermore, the dominant role of Venice. The tremendous success of Venetian Renaissance painting from the late fifteenth century onwards and the characterization of Jacopo Bellini as the "founder of the Serenissima's renaissance" (Eisler) made it difficult to imagine that an object as fundamentally important as the book of drawings in the Louvre could not be his, its having originated from what is still considered a provincial town today. The error, however, lies in a reverse perspective that tended to mitigate Padua's role as an intellectual

and artistic center in the Veneto region since the early Middle Ages. It was only after the city lost its political autonomy in the early fifteenth century that it began to relinquish its cultural leadership as well. The Paduan elite moved to Venice – Squarcione, Mantegna and Marco Zoppo among them – as did the objects of cultural value. Art history, from this perspective, tends to confirm political history.[2]

Five chapters attempt to demonstrate that the lifeblood animating the undertaking of the *Louvre Album* was indeed Paduan and not Venetian. The first chapter (V) addresses perspective in the context of reinvigorated Aristotelian studies. Long before settling in Florence, linear perspective was beginning to manifest in late fourteenth-century Padua, as Michele Savonarola has documented. He understood that this development was part of an artistic revival aimed at elevating painting – still considered a mere craft at that time – to the level of the liberal arts. Altichiero's frescoes in the *Oratorio di S. Giorgio* provide proof of this modern appropriation of science, which was substantiated by the writings of two Paduan exiles, Petrarch and Cennini (chapter II). The method employed to define painterly space and the objects therein, be they figurative or architectural, in accordance with the laws of trigonometry is radically different from Jacopo Bellini's use of aerial perspective, which utilized dark and light colors to denote distances, as was maintained by the physician Giovanni Fontana. It is Squarcione who initiated a systematic study of linear perspective based on the "projection of lines," probably utilizing Biagio Pelacani's research on this matter.[3] The apprentices in his academy, the first of its kind, learned the theory through drawn *archetypes* that demonstrated the procedure step by step. The method, as can be deduced from several of the Louvre drawings, was similar to – yet more antiquated – the one that Leon Battista Alberti published in Florence at approximately the same time.

In addition to perspective, the study of Roman antiquity (chapter VI) was an important topic in Padua. The city's glorious past had been an area of focus since the times of the early humanists such as Lovato Lovati and Albertino Mussato in the thirteenth and fourteenth centuries. However, it was only in Squarcione's academy, where he taught his students with the help of antique sculptures (or plaster duplicates), that archeology became a focus of systematic attention in the artist's workshop at such an early date.[4] Two folios (48 and 49) in the Louvre depicting tomb slabs and their inscriptions (discovered primarily in Padua and its nearby province) testify to the kind of research that both local artists and humanists addressed. This is amply documented in the famous 1464 Lake Garda field trip that Mantegna joined (chapter VI, 2). The trend to compile ancient inscriptions in so-called *sillogeai* dates back to Ciriaco d'Ancona, inciting similar publications by Giovanni Marcanova as well as his assistant Felice Feliciano (chapter VI, 1). The inscriptions in the *Louvre Album* were copied from Marcanova's collection *Antiquitatum quaedam fragmenta*, known to have been available in Padua in the late 1440s. That Mantegna profited from this archeological material as well is documented in the frescoes of the Ovetari Chapel. Both he and the artists of the *Louvre Album*, beyond carefully transcribing the original Latin texts, concurrently incorporated them into a larger, monumental complex *all'antica*, a method reminiscent of Gasparino Barzizza's *De imitatione* wherein he encourages his Latin philology students to transform a given classical text without corrupting its style.

More sophisticated than those drawings that engage perspective and archaeology, the *Triumph of Bacchus* and the *Triumph of Cupid* (folios 40, 43) evidence an artistic personality capable of emancipating itself from the original, didactic purpose of the album by imposing a modern interpretation on classical texts. Similar, so far as size, scaling, stylistic severity, and interpretive liberty are concerned, are Mantegna's large-sized, mythological engravings such as the *Battle of the Sea Gods* – a proximity that may betray the same mastermind's responsibility for the preparatory drawings of the *Louvre Album* (chapter VII). The impetus to create visual equivalents for texts as divergent as Diodor's *Bibliotheca historica* and Plato's *Phaedrus* may have stemmed from Marcanova's research on the subject of Roman triumphs and was perhaps incited by Alberti's demand for artistic erudition. A modern, moral message lies at the heart of the pagan context.

Current, local events emerge as an unexpected subject matter in the *Louvre Album*, which is primarily devoted to Christian and pagan iconography. Of the two subjects commented on in chapter VIII, one refers to Giacomo Loredan's insurgence against Doge Francesco Foscari while Loredan presided as mayor of Padua in 1447–1448 (chapter VIII, 1), and the other to the rescue of a pagan statue as a result of civic intervention within the context of Padua's longstanding battle for the monuments of Antenor and Titus Livy (chapter VIII, 2). Thanks to numerous portraits of local compatriots, probably involving the circle of engaged humanists that surrounded Marcanova and Mantegna, both drawings must have been immediately recognizable to contemporary viewers. Their interpretation poses a serious methodological problem due to the lack of verifiable supporting evidence.

Animals are the subject of this book's last chapter (chapter IX). Their popularity in Northern Italy is attested to by a tradition of combining Aristotle's zoology with a feudal ideology that legitimized the exertion of power by natural law (chapter IX, 1). The hierarchies in the animal world were thus understood to mirror those existing in the social world. Regarding the *Louvre Album*, a distinction can be made between animals drawn from life and those of a superior iconographical category that were included to define specific contents. The latter refer to models as different as the late antique *Physiologus*, German playing cards, and a Roman sculpture on the Capitoline Hill. Drawings from the other category, intended to represent nature as such, demonstrate the steady development from a scientific image, which intended objectivity regarding the species, to the visual experience, which reflected the artist's personal involvement (chapter IX, 2). The realist shift could well have been prompted by Cennini's theory, expounded in his treatise written in Padua at the turn of the fifteenth century, advising the artist to relinquish theoretical issues and focus exclusively on each animal's individual shape and the particularity of its brute condition (chapter IX, 3).

What is true in the case of animals applies to the *Louvre Album* as a whole: a gradual liberation from the book's original purpose of presenting a valid set of academic archetypes towards a freedom of artistic interpretation. Squarcione's idea from the early 1440s to edit a picture book that would serve as a showpiece to his Paduan academy acceded, in the late 1440s, to the manifestation of artistic genius. It remains unclear whether it was Squarcione himself who incited his most gifted pupils to prove their mastery or if he relinquished control of the project, leaving others to steer its course. What emerges from both scenarios is that the once innovative Paduan academy soon lost its prominence. This may well have

been a result of Donatello's commitment and artistic developments in Florence and elsewhere. What's more, Squarcione's former pupils increasingly questioned his authority and denounced his exploitative practices.

While a more profound understanding of the book's authorship may have been attained with the *Louvre Album's* relocation to Padua, thereby resolving contradictions that resulted from the book's erroneous attribution to Jacopo Bellini, the answer regarding who actually executed the drawings has remained unacceptably vague. The hypothesis that the majority of the drawings are master copies transferred from sketches and model drawings provided by pupils more gifted than the master himself has no evidential support, either from documentation or from stylistic content. Based on previous observation, the technical quality of the drawings does not always seem to match that of their concept. This discrepancy is the reason why more scrutiny has been devoted to questions of content and why the intricate problems concerning the relationship between the *Louvre Album* and that of the British Museum have been largely ignored. The many incertitudes that remain can be explained by the fact that these two books of drawings are rather actual documents of a culture on the verge of collapse at the very moment of its inception and not, as commonly believed, the cornerstones of the ascendant era of Venetian Renaissance Painting.

NOTES

Part 1

[1] Colin Eisler, *The Genius of Jacopo Bellini. The Complete Paintings and Drawings* (New York 1989); Bernhard Degenhart and Annegrit Schmitt, *Jacopo Bellini – Der Zeichnungsband des Louvre: Corpus der italienischen Zeichnungen, Teil II: Venedig 1300–1450*, vols. 7 and 8 (Berlin 1990); Peter Windows, *Jacopo Bellini's Drawings and Their Artistic and Intellectual Context, with Particular Reference to Venetian and Paduan Humanism*, 2 vols. (PhD Thesis, University of Central England, Birmingham 2000).

[2] Regarding current debates concerning his year of birth and presence in Padua: Giovanna Baldissin Molli, "In margine al Centenario di Andrea Mantegna: Il problema dell'anno di nascita del pittore," *Il Santo*, XLVII (2007), 481–502; Paola Tosetti Grandi, "Andrea Mantegna, Giovanni Marcanova and Felice Feliciano," *Andrea Mantegna*, L. Signorini et alii, eds., (Florence 2010), 273–361 (316ff., 322ff.); Keith Shaw and Theresa Boccia, "Andrea Mantegna Called Andrea Squarcione," *Encountering the Renaissance: Celebrating Gary M. Radke*, M. Bourne and V. A. Coonin, eds. (Ramsey 2016), 317–23 (320).

[3] Regarding Gentile's role as cultural ambassador for Venice: Alan Chong, "Gentile Bellini in Istanbul: Myths and Misunderstandings," *Bellini and the East*, (exh. cat.), London, National Gallery, C. Campbell and A. Chong, eds. (London 2005), 106–18 (113).

[4] An exception to the rule is: Hans Tietze and Erica Tietze-Conrat, *The Drawings of the Venetian Painters in the Fifteenth and Sixteenth Centuries* (New York 1944), 95. The Tietzes challenged the opinion of Jacopo's exclusive authorship, underlining the "heterogenous character" of the drawings. They were mistaken, however, in believing that Jacopo's sons, Giovanni and Gentile, had been involved. Regarding a different interpretation of the Bellini-related documents, following which Giovanni Bellini was the half-brother of Jacopo and uncle of Gentile (born between circa 1424 and 1428), see: Daniel Wallace Maze, "Giovanni Bellini: Birth, Parentage, and Indipendence," *Renaissance Quarterly*, 66 (2013), 783–823.

This view has been revised in an article by David Alan Brown and Anna Pizzati, "*Meum amatissimum nepotem* – a New Document Concerning Giovanni Bellini," *Burlington Magazine* 156 (2014), 148–52.

[5] Abert J. Elen, "A Codicological Analysis and Reconstruction of Jacopo Bellini's Drawing Books," Eisler, *op. cit.*, 454–507.

[6] These are fols. 56, 76, 77, 78, 82, 83 and 84. See Elen (Eisler, *op. cit.*, 463), Appendix A, Chart 2 (indicated by *m* in the chart of the quire composition).

[7] Eisler, *op. cit.*, 79.

[8] Degenhart and Schmitt, *Corpus*, II, 1, *op. cit.*, 148–50, 168–77. Scenes with hunting animals as displayed in the textile drawing (folio 95v) represent a courtly fashion that was to be replaced by vegetal ornaments in the course of the fifteenth century. A prominent example for the change of taste is Pisanello's post 1448 drawing in the Louvre (inv. no. 2537, Département des Arts Graphiques); the designs for costumes in North Italian *Taccuina sanitatis* from about 1370 represent a much earlier signal for the change of taste. This does not preclude a dating of the drawing here under discussion in the late 1420s. Kathrin Müller, *Musterhaft naturgetreu. Tiere in Seiden, Zeichnungen und Tapisserien des 14. und 15. Jahrhunderts* (Berlin 2020), 257–62; Howard Coutts, "An Early Textile Drawing in the Victoria and Albert Museum," *Burlington Magazine*, 150 (2008), 389–392 (392); Martin Weinberger, "Silk Weaves of Lucca and Venice in Contemporary Painting and Sculpture," *Bulletin of the Needle and Bobin Club* (1941), 20ff.

[9] "Die Textilentwürfe in diesem trecentistischen ‚Musterbestand einer venezianischen Werkstatt' sind zumeist Rapportmuster, und zwar keine Entwurfsskizzen, sondern exakte Werk- und Vorratszeichnungen zur Verwendung in der Textilproduktion." Degenhart and Schmitt, *Corpus*, II-5, *op. cit.*, 240, and II-6, 427.

[10] Eisler, *op. cit.*, 79, n. 6; Degenhart and Schmitt, *Corpus*, II, 1 (1980), *op. cit.*, nos. 652-3.

[11] Regarding Padua's flourishing *lanaiuoli* industry: Benjamin G. Kohl, *Padua under the Carrara, 1318–1405* (Baltimore and London 1998), 30–31. Cf. Silvana Collodo, "La manufattura della seta a Padova durante la signoria dei da Carrara (1365–1405), *Sine Musica nulla disciplina: Studi in onore di Giulio Cattin*. F. Bernabei and A. Lovato, eds. (Padua 2006), 147–71.

[12] Paolo Sambin, "Per la biografia di Francesco Squarcione: briciole documentarie," *Medioevo e Rinascimento: Scritti in onore di Lino Lazzarini* (Padua 1979), 443–69 (451). He is called *sartor et recamator* in a document from December 29, 1423 (Lipton, *op. cit.*, doc. 12, 317) and *magister Franciscus Squarçonus pictor* since April 6, 1426 (Sambin, *ibid*, 447).

[13] "[…] E gli è molti mesi che io con grande deligentia et studio ò cerco et facto cercare d'avere uno libro del ritracto de certe sculture antiche, le quale la più parte sono bataglie di centauri, di fauni et di satiri, cosí ancora d'uomini et di femine accavallo et appié, et altre cose simili. Et maxime desiderrei havere quelle de centauri perché dell'altre c'è di qua qualche notitia: del che cercando, m'è decto da molti che esso libro se ritruova essere di costà nelle mani di Vostra Signoria et di quelli suoi, che certo m'è stato gratissimo non dubitando essene compiaciuto. Priego adunque carissimamente la Signoria Vostra che se degni de commettere sia retrovato et me ne compiacca. Et perché io so che queste cose si tengono care et che gli originali non se mandano atorno, quando cosí fussi, sarei contento quella committesse a Petro Philipo o ad altri me lo facesse copiare et io pagherei la spesa, et per una cosa non potrei havere la più grata." Clifford M. Brown, "Gleanings from the Gonzaga Documents in Mantua: Gian Cristoforo Romano and Andrea Mantegna," *Mitteiliungen des Kunsthistorischen Institutes in Florenz*, 17 (1973), 153–59 (158f.); Luca Leoncini, *Il codice detto del Mantegna: Codice Destailleur OZ 111 della Kunstbibliothek di Berlino* (Rome 1993), 71.

[14] Tovaglia's interest in drawings showing centaurs above all (*Et maxime desiderrei havere quelle de centauri*) finds explanation in early modern art theory where the wedding of man and beast as in the centaur is considered the peak of the artist's poetic imagination (Cennino d'Andrea Cennini, *The Craftsman's Handbook / Il libro dell'arte*, D. V. Thompson, ed. [1933], I, 2 (New York 2019). The occurrence of the centaur in Florentine art is attested to by an antique intaglio that was owned by Lorenzo de Medici (today Naples, Museo Archeologico Nazionale) and had been referred to by Donatello in the bronze statue of *Judith and Holofernes* (1453 to 1457). Francesco Sassetti (1421–1491) had entrusted Giuliano da Sangallo with the frieze around the niche of his tomb including

centaurs, which appear in his Sienese Album as well (Biblioteca Comunale S. IV.8, fols. 11v and 28). Cf. the Munich drawing attributed to Squarcione containing centaurs and fauns, as fn. 233 (Part 2).

[15] "[…] Havendo visto quanto per il pollice vostro ne scriveti de quello libro ne richedeti, respondemo che havendolo facto richedere a Luca, il dice che'l lo dette altre volte ad Andrea Mantegna, quale monstra non sapere quello ne fosse facto, et che'l crede l'andasse in le mane de uno pictore de questa terra, nè fin hora ne trovamo altra certeza. Non stamo per questo de farlo cercare et, possendolo havere, vi ne compiaceremo de la bona voglia." Brown, "Gleanings," *op. cit.*, 159.

[16] The great incertainities in Lodovico's letter to Tovaglia allow for different interpretations. They result from the fact that Mantegna's information had first been assimilated in Fancelli's report, probably oral and not known to us in the original wording, and, furthermore, in what Ludovico had memorized.

[17] As fn. 13. In the *Louvre Album*, however, apart from folio 88 (*tre damixelle nude con tre puttini* / three nude damsels with three infants) there are no *femine accavallo et appié* that, on the contrary, feature in the book of drawings in the British Museum (folios 30v, 31, 31v, 32, 33v, 34, 48, 51v). This could indicate that Tovaglia, his information coming from hearsay, either confused the two books' contents or that more of this subjet matter was shown on the missing folios of the *Louvre Album* (as fn. 19).

[18] Elen / Eisler, *op. cit.*, 470–72. Marcel Röthlisberger, *Studi su Jacopo Bellini* (PhD Thesis, Bern University 1955) (Venice 1960), 13: "Per quanto riguarda la chronologia dei disegni questi sono stati fatti uno dopo l'altro secondo l'ordine che ancor oggi conservano."

[19] Elen, *op. cit.*, 466. The drawings are executed in different techniques: silverpoint, leadoint, pen, brush and watercolour. The number of parchment sheets today is 93, ten more are missing, thirteen folios have been extracted after 1728 (Guérins letter to Abbot Bignon, Bibliothèque Nationale, ms. nouv. franç. 5384). Cf. Seymour de Ricci, "Un album de dessins de Jacopo Bellini au Musée du Louvre," *Revue Archéologique*, 18, (1923), 89–90. Closest in style and subject-matter are: a) The Rosebery Album in the British Museum (inv. nr. 1920.0214.1.23), much smaller in size and content (218 × 158mm, 26 parchment leaves), that has been attributed to the Paduan artist Marco Zoppo and dated around 1460; b) A set of eighteen full-page drawings of the same date in Marcanova's *Antiquitatum quaedam fragmenta* (Cod. alfa,1.5.1.5, Modena, Biblioteca estense universitaria), attributed to Marco Zoppo as well. Patricia Fortini Brown, "The Antiquarianism of

Jacopo Bellini," *Artibus et historiae*, 26 (1992), 65–84 (73ff.). Regarding comparisons with so-called books of travels (*taccuini da viaggio*): Albert J. Elen, *Italian Late-Medieval and Renaissance Drawing-Books from Giovannino de Grassi to Palma Giovane, a Codicological Approach* (PhD Thesis, University Leiden 1995), 31.

[20] "Vielleicht hat Andrea Mantegna es selbst 1459 von Padua nach Mantua aus der Squarcione-Werkstatt mitgebracht." Annegrit Schmitt, "Francesco Squarcione als Zeichner und Stecher," *Münchner Jahrbuch der bildenden Künste* (1974), 205–13 (206). Alberta de Nicolò Salmazo, "Bernardino da Parenzo. Un pittore 'antiquario' di fine Quattrocento," *Quaderni del Seminario di storia d'arte moderna* (Padua 1989), 1–107 (37), points instead to Bernardino da Parenzo (born circa 1450) as the artist to whom Mantegna "aveva prestato" the book of drawings in 1476. This idea goes back to Maria Pia Billanovich, "Bernardino da Parenzo pittore e Bernardino (Lorenzo) da Parenzo eremita," *Italia Medioevale e Umanistica* (1981), 385–404.

[21] The transfer could have taken place following Mantegna's marriage to Nicolosia Bellini, Jacopo' daughter, in 1453. The two painters proably met in Venice in 1447 where Mantegna was renting a house together with Squarcione. It was then that Mantegna left his master. In 1448, he brought his first lawsuit against Squarcione, in 1455 the second. Becoming a member of the Bellini family was probably part of his plan to gain more independence.

[22] Caroline Campbell, Dagmar Korbacher, Neville Rowley, and Sarah Vowles, eds., *Mantegna & Bellini* (exh. cat.), London, National Gallery, and Gemäldegalerie Berlin (Berlin 2018).

[23] Andreas Hauser, "The Griffin's Gaze and the Mask of Medusa," *Art History*, 37 (2014), 334–51 (337); Giovanni Agosti, *Su Mantegna*, Vol. I (Milan 2005), 20.

[24] *Mantegna & Bellini* (exh. cat.), *op. cit.*, fig. 218.

[25] Irene Favaretto, "La raccolta di sculture antiche di Francesco Squarcione tra leggenda e realtà," *Francesco Squarcione* –'Pictorum Gymnasiarcha singularis': *Atti delle giornate di studio* (1998), Alberta De Nicolò Salmazo, ed. (Padua 1999), 233–244; Giuseppe Fiocco, "Il Museo imaginario di Francesco Squarcione," *Atti e Memorie dell'Accademia Patavina di Scienze, Lettere ed Arti*, LXXI, III, (1958/59), 59–72.

[26] Deborah Lipton, *Francesco Squarcione* (PhD Thesis, New York University 1974), doc. 72, 371. Jacopo may as well have bought these items after Squarcione's death in 1468, as he did buy the intarsia from the estate of Jacobello del Fiore (see fn. 46).

[27] "[…] quod magister andreas suprasciptus stetit et cohabitavit cum suprascripto magistro Francisco per annos sex continuos, jn quibus predictus magister andreas se exercuit in commodis et utilitatibus magistri francisci suprascripti quam etiam jn faciendo picturas magni precij et aliarum condictionum pro ut necessitates postulabant." (Lipton, *op. cit.*, doc. 57, 357). Following their separation in 1448, a compromise (*compromissum*) was concluded: Keith Shaw and Theresa Boccia, "Mantegna's pre-1448 Years Reexamined: The S. Sofia Inscription," *The Art Bulletin*, 71, 1 (1989), 47–57 (52, n. 60). The case was moved from the *Giudici delle Vettovaglie* to the *Avogaria di comun* on January 2, 1456. Anne Markham Schulz, "Francesco Squarcione and His School, with an Addendum on the Ovetari Altarpiece," *Ricche minere*, 4 (2017), 23–53 (25).

[28] Lipton, *op. cit.*, doc. 57, 337. This was a high amount indeed, worth the value of a house in Padua at that time. It might be a coincidence that on November 13, 1458, Mantegna could afford to buy the house from Nicola Savonarola (son of Michele), in which he had been living since 1448: Lazzarini, *Documenti relativi alla pittura padovana del secolo XV* [1908] (Bologna 1974), docs. LXV, LXXIV.

[29] When Marco Zoppo sued Squarcione in 1455, the latter was sentenced to compensate him for 3500 pounds of gypsum and for some not specified pictures Zoppo had done for him, worth 20 ducats, with reliefs (*improntis*), medals and other utensils to be used for painting (Lipton, *op. cit.*, doc. 56, 356): "[…] Item volumus […] quod dictus magister Franciscus [Squarzonus] possit et sibi liceat solvere et satisfacere dicto Marco de dicta quantitate ducatorum ducatos viginti auri de picturis, improntis, medaleis et massericijs ad artem pictorie spectantibus, quas dictus Marcus habuerit ab ipso magistro Francisco." In other cases, pupils have apparently helped themselves so as to compensate for their losses. This was the case with Giorgio Schiavone whom Squarcione reproached in 1462 to have stolen several drawings (*quantitates designorum*) from him (Lipton, doc. 73, 372). Squarcione's heirs were still fighting in 1474 to obtain 18 drawings plus a drawing or print by Pollaiuolo (*cartonum cum quibus nudis Poleyuoli*) which Giorgio had apparently taken with him to Croatia (Lipton, doc. 91, 386). For the latter: Hugo Chapman, *Padua in the 1450s. Marco Zoppo and His Contemporaries* (London 1998), 39. Cf. Markham Schulz, "Francesco Squarcione," *op. cit.*, 25–6.

[30] There is a general agreement to date the majority of drawings in the *Louvre Album* to the late 1440s. For a summary of the different positions: Eisler (*op. cit.*, 101–03). A *terminus ante quem* for the *Louvre Album* may be constituted, among other indicators to be re-

vealed in the following chapters, by Jean Fouquet's miniatures from the early 1450s: Otto Pächt, "Jean Fouquet. A Study of his Style," *Journal of the Warburg and Courtauld Institutes*, 4 (1941), 85–101 (92). Regarding the chronology of the two books of drawings, the opinion expressed by Degenhart and Schmitt that the Louvre Album predates the books of drawings in the British Museum (*Corpus*, II-5, *op. cit.*, 238–50), and not vice-versa (Eisler, *op. cit.*, 104), has met with larger acceptance among scholars. Cf. Luigi Grassi, "La 'mano industriosa' di Jacopo Bellini nei disegni dei suoi due libri," *Atti e memorie della R. Accademia Clementina di Bologna*, 30/31 (1992), 9–37 (12f.).

[31] Shaw and Boccia, "Andrea Mantegna," *op. cit.*, 321, n. 19.

[32] Corrado Ricci, *Iacopo Bellini e i suoi libri di disegni*: vol. I, *Il libro del Louvre* (Florence 1908), doc. XXV: "[…] Item dimitte Gentili, filio meo, omnia laborerie de zessio, de marmore et de relevijs quadros dessignatos et omnes libros de dessegnijs et alia omnia pertinentia pictorie et ad dipingendum, que fuerunt prefati quondam magistri Jacobij Bellino viri mej. Et residuum omnium et singulorum bonorum meorum, michi testatrici quovis modo spectantium et pertinendum, et que quomodolibet michi spectaret pertinere posit dimitto prefato Gentilii et Nicolao filijs meis et dicti quondam magistri Iacobj equaliter."

[33] "Ancora vidi in Padova una statua, vi fu condotta per Lombardo della Seta [...]." Lorenzo Ghiberti, *Commentari*, 2 vols., J. von Schlosser, ed. (Berlin 1912), I, 62. Cf. Mandy Richter, "<O> doctissimo, nessuna cosa si vede sanza luce. Darkness, Light and Antiquity in Ghiberti's Third Book," *Ghiberti Teorico. Natura, arte e coscienza storica nel Quattrocento*, F. Jonietz, W.-D. Löhr and A. Nova, eds. (Milan 2019), 183–190 (184). Barbara Hein, "Altichiero e l'antico nell'oratorio di San Giorgio: alcune riflessioni," *Il secolo di Giotto nel Veneto: Istituto veneto di scienze, lettere ed arti*, G. Valenzano and F. Toniolo, eds. (Venice 2007), 437-48 (444f.).

[34] Clifford Malcolm Brown, "*Una testa de Platone antica con la punta dil naso di cera*: Unpublished Negotiations between Isabella d'Este and Niccolò and Giovanni Bellini," *The Art Bulletin*, 51 (1969), 372–77. Patricia Fortini Brown, *Venice and Antiquity. The Venetian Sense of the Past* (London 1999), 118.

[35] Ricci, *op. cit.*, I, 69; Victor Golubew, *Les dessins de Jacopo Bellini au Louvre et au British Museum*, 2 vols. (Brussels 1908), II, plate XVI (*indice*); contrary to the prevailing opinion (Testi, Tietze, Moschini, Eisler and others) is Röthlisberger (*op. cit.*, 14–5). Similar retouchings happened in the case of the lost view of Venice (Eisler, *op. cit.*, 100), to which reference is made in a letter from the Mantuan ambassador in Venice to Francesco Gonzaga (1493): "I talked with Master Gentile Bellini about the view of Venice. He replied that he had one made by his father and offered it to me. Because it is old and, therefore, impossible to decipher, he tells me that it must be reworked in pen, and this task will take at least two months. He begs your Excellency to inform him if you wish to have the view, so that he may have the work begun at one." Whereas no interests in cartography are documented for Jacopo Bellini (Eisler, Appendix F, 3, 533), it is, on the other hand, known that Squarcione, after having settled with his family in Venice in 1463, did receive the commission to draw a plan of Venice (in 1465), probably based on the plan of Padua which he had completed before (preserved in a drawing on parchment, Biblioteca del Museo Civico di Padova). Loredana Olivato Puppi and Lionello Puppi, "Venezia veduta da Francesco Squarcione nel 1465," *Scritti in onore di Maria Cionini Visani* (Turin 1977), 29–32 (30). Melania Zanetti, "Il restauro della mappa di Padova di Francesco Squarcione," *Bollettino del Museo Civico di Padova* (2006), 78–93. Cf. Sergio Marinelli, "Ai confini dell'età media: da Francesco Squarcione a Francesco Benaglio," in *De lapidibus sententiae: scritti in onore per Giovanni Lorenzon*, T. Franco et alii, eds. (Padua 2002), 225–30 (226). It is important to notice that the printer Nicolo di Lorenzo had been a pupil of Squarcione. Concerning his possible involvement in the printing of the first illustrated Italian edition of Ptolemy's *Geographia* (1480/82): Kristen Lippincott, "The Art of Cartography in Fifteenth Century Florence," *Lorenzo the Magnificent. Culture and Politics: Warburg Institute Colloquia*, 3, M. Mallet and N. Mann, eds. (London 1997), 131–43, 142, n. 51. Regarding Alberti's interest in cartography: Leonardo Rombai, "Il progetto della pianta albertiana di Roma e la sua influenza sulla nascita di una cartografia umanistica fatta 'di elevazioni e, soprattutto, di modelli', piuttosto che di 'trucchi prospettici adottati dai pittori'," *Eventi e documenti diacronici delle principali attività geotopografiche in Roma*, A. Cantile, ed. (Florence 2000), 46–67.

[36] René de Mas-Latrie, "Testament de Gentile Bellini," *Gazette des Beaux-Arts*, 2 (1866), 286–88.

[37] Peter Windows, "New Identifications in the Drawings of Gabriele Vendramin," *Master Drawings* (2012), 33–48 (34).

[38] Marcantonio Michiel, *Notizia d'opere del disegno*, Th. Frimmel, ed. (Florence 2000), 157 ("el libro grande in carta bombasina de disegno fu de man de Iacopo Bellino").

[39] Golubew, *op. cit.*, 1: "Les caractères révèlent une main experte en l'art de la minuscola cancelleresca, peut-être celle d'un notaire, ce qui justifierait l'expression un peu cérémonieuse de *messer*." Cf. Emile Galichon and René de Mas-Latrie, "Iacopo, Gentile et Giovanni Bellini, documents inédits," *Gazette des Beaux-Arts*, 2 (1866), 281–88 (283).

[40] Giuseppe Fiocco, *L'arte di Andrea Mantegna* (Venice 1927), 216. Cf. Regarding his presence in Padua in 1430: Erice Rigoni, "Jacopo Bellini a Padova nel 1430," id., *L'arte rinascimentale a Padova* (Padua 1970), 25–46.

[41] In the report of the French ambassador to his king (Eisler, *op. cit.*, 18).

[42] As fn. 32.

[43] Ricci, *Jacopo Bellini, op. cit.*, doc. IX: "[…] fecerunt societatem et mutuam utilitatem de omnibus et singulis picturis et magisterio picturarum cuiuscumque sortis et conditionis quas facient et evenient sorte cuilibet eorum ad apothecas et stationes suas, ita hic Venetiis quam alibi ubicumque extra Venetias. Ita quod quicquid lucrabuntur dictis … ex picturis et lucro picturarum provenientibus sibi hic Venetiis et utrique parti eorum dividatur equaliter sine ulla exceptione et contradictione. Exceptis laboreriis que sibi et cuilibet eorum pervenirent extra Venetias que sint cuiuslibet ipsarum partium specialiter. Et hec Societas duret usque ad annos quinque proxime incipiendos die primo mensis Octubris proxime sequturi. Et convenerunt et pactum fecerunt invicem per totum dictum tempus." Maze, *op. cit.*, 789.

[44] Ricci (*Jacopo Bellini, op. cit.*, doc. IX) remarks that this agreement had been cancelled by the applicant (Venice, Archivio di Stato, sezione notarile, Cancelleria inferiore, Atti Elmis Francesco, Busta 74, Libro 1439–1440, 26).

[45] This is also Giorgio Vasari's opinion, *Vite de' più eccellenti pittori, scultori e architettori* [nelle redazioni del 1550 e 1568], R. Bettarini and P. Barocchi, eds. (Florence 1966–1987), III, 548 [I.488], who connects the breaking up with Squarcione to the success of Jacopo's strategy: "Per questa ed altre opere cominciando Andrea a essere in grande aspettazione, ed a sperarsi che dovesse riuscire quello che riuscì, tenne modo Iacopo Bellino, pittore viniziano, padre di Gentile e di Giovanni e concorrente dello Squarcione, che esso Andrea tolse per moglie una sua figliola, sorella di Gentile. La qual cosa sentendo lo Squarcione, si sdegnò di maniera con Andrea, che furono poi sempre nimici." The betrothal took place in 1452.

[46] Ricci, *Jacopo Bellini, op. cit.*, doc. VIII: "E a dì dito have maistro Iacomo Bellin una tavola intarsiada duc. – D. 1, s. 8."

[47] This item probably figured in Anna Rinversi's testament under the heading of *quadros dessignatos*. Regarding the discussion of this term: Degenhart and Schmitt, *Corpus*, II-56, *op. cit.*, 16, n. 2

[48] André Chastel, "Marqueterie et perspective," *Revue de l'Art* (1953), 141–43; Alessandro Parronchi, "Le fonti di Paolo Uccello," *Paragone* (1957), 89–95; Johannes Grave, "Brunelleschi's Perspective Panels. Rupture and Continuity in the History of the Image," *Renaissance Perceptions of Continuity and Discontinuity in Europe*, H. Schnitker, P. Péporté and C. Lee, eds. (Leiden 2010), 161–81.

[49] Graziano Manni, *I signori della prospettiva. Le tarsie dei Canozi e dei canoziani (1460–1520)*, 2 vols. (Carpi 2001), 11–36.

[50] Antonio Sartori, Archivio Sartori, *Documenti di storia e arte francescana*, vol. I, *Basilica e Convento del Santo*, G. Luisetto, ed. (Padua 1983), 267, doc. 162 [1462, 1st march]: "A maistro Francesco Squarcion, per alguni desegni fé per lo armaro che se vole fare in la sagrestia per le reliquie e paramenti, L. 15, 12. no. 163 – [1462, 13. June]: Ave m. Francesco Squarzon depentore, per suo avere de disigni fati per lo armaro se vole fare da novo, che sono in sagrestia", L. 12. no. 164. – [1462, 26. September]: Ave maestro Squarzon, per resto de sua fadiga de cinque designi fati per mostra de l'armaro se die fare. L. 3." Giancarlo Schizzerotto, *Le incisioni quattrocentesche della Classense* (Ravenna 1971), 135.

[51] Similar is Ghiberti's claim in Florence that young artists should be trained in the *artes liberales* and have knowledge of the *docti maestri*. Lorenzo Ghiberti, *I commentarii* (Biblioteca Nazionale Centrale di Firenze, II, I 333), L. Bartoli, ed. (Florence 1998), III.1, 87. Klaus Bergdolt, *Der dritte Kommentar Lorenzo Ghibertis. Naturwissenschaften und Medizin in der Kunsttheorie der Frührenaissance* (PhD Thesis, University Heidelberg, Weinheim 1988), XL. Cf. Christiane J. Hessler, "Et ancora dissono questo più filosaphii' – Ghiberti und die Philosophen", *Ghiberti teorico, op. cit.*, 103-13 (104).

[52] Claudia Reufer, "Geordnete Unordnung. Ästhetische Evidenzerzeugung im Pariser Zeichnungsbuch Jacopo Bellinis," *Zeigen, Überzeugen, Beweisen. Methoden der Wissensproduktion in Kunstliteratur Kennerschaft und Sammlungspraxis der Frühen Neuzeit*, E. Oy-Marra and I. Scheidel, eds. (Heidelberg 2020), 289–316 (291).

[53] Josph George Rushton Jr., *Italian Renaissance Figurative Sketchbooks 1450–1520* (PhD Thesis, University of Minnesota, Minneapolis/M 1976); Robert W. Scheller, *Exemplum. Model-Book Drawings and*

the Practice of Artistic Transmission in the Middle Ages
(ca. 900–ca. 1470) (Amsterdam 1995).

[54] "Durch die ledernen Einbände werden bereits mit der äusseren Erscheinung Assoziationen hervorgerufen, die im bibliophilen Venedig an die Praxis der Gelehrten, ihr Wissen in Büchern zusammenzustellen, denken lassen," Claudia Reufer, "Eine aus Linien aufgebaute Bildwelt. Die Zeichnungsbücher aus der Werkstatt Jacopo Bellinis," *Wissen in Bewegung: Episteme in Bewegung,* vol. 1, E. Cancik-Kirschbaum and A. Traninger, eds. (Wiesbaden 2015), 393–413 (408). Cf. Albert J. Elen, "Drawing, Evolution or Revolution? From Workshop Model-Book to Personal Sketchbook," *From Pattern to Nature in Italian Renaissance Drawing*, M. W. Kwakkelstein and L. Melli, eds. (Florence 2012), 35–50. Regarding the term *album*: Rushton, *op. cit.,* 63.

[55] Louvre (inv. 2397) and Oxford, Ashmolean Museum (inv. P II, 41): Pisanello. *Le peintre aux sept vertus, op. cit.,* nos. 100v, 102v. Cf. Stefano G. Casu, "Drawings After the Antique in the Early Renaissance: Pisanello and Jacopo Bellini," *In the Light of Apollo. Italian Renaissance and Greece* (exh. cat.), vol. I, Ethnike Pinakotheke, Mouseion Alexandrou Soutsou (Athens 2003), M. Gregori, ed. (Milan 2004), 134–35; Degenhart and Schmitt, *Corpus, op. cit.,* I-1; Francis Ames Lewis, *Drawing in Early Renaissance Italy* (New Haven and London 1981), 71ff.; Keith Christiansen, *Gentile da Fabriano* (Ithaca 1982), 148; Maria Fossi Todorow, "Un taccuino di viaggi del Pisanello e della sua bottega," *Studi di storia d'arte in onore di Mario Salmi*, V. Martinelli and F. M. Aliberti Gaudioso, eds. (Rome 1962), II, 133–61.

[56] "Gerade das, was Jacopo Bellini von Anfang seines Schaffens an beschäftigte, kompositorisches Gestalten, die Verbindung von Figuren und Raum, lag ausserhalb Pisanello's primärer Interessensphäre" (Degenhart and Schmitt, *Corpus,* II-5, *op. cit.,* 55).

[57] "Das Besondere und Neue dieser Zeichnungen ist gerade, daß ihre Enstehung von keinem praktischen Zweck diktiert gewesen zu sein scheint, sondern daß sich in ihnen ein Ringen um Lösungen künstlerischer Probleme dokumentiert, welches sich nicht unmittelbar um praktische Anwendbarkeit kümmert." Otto Pächt, *Venezianische Malerei des 15. Jahrhunderts. Die Bellinis und Mantegna,* M. Vyoral-Tschapka and M. Pächt, eds. (Munich 2002), 42.

[58] "Und obwohl es paradox erscheinen mag, möchte ich diese Zeichnungen als etwas Theoretisches ansehen; sie sind auch eine gedankliche Auseinandersetzung mit den Rätseln des Darstellbaren, und was andere, besonders florentinische Künstler dieser Zeit in geschriebenen Werken niederlegten, scheint mir

hier in Zeichnungen festgehalten." Lili Frölich-Bum, "Bemerkungen zu den Zeichnungen Jacopo Bellini und zu seiner Kunst," *Mitteilungen der Gesellschaft für vervielfältigte Kunst,* 3 (1916), 41–56 (51). Cf. Christiane L. Joost-Gaugier, "The *Sketchbooks* of Jacopo Bellini Reconsidered," *Paragone,* 25 (1974), 24–41 (27ff.).

[59] "Das Potenzial dieser Zeichnungen ist demnach nicht in erster Linie auf das Diktum der 'zeichnenden Denkkraft' (Bredekamp) zurückzuführen, wo die Bewegungen der Hand, die in direkter Verbindung zum Geist gedacht wird, das Denken selbst generieren." (Reufer, "Eine aus Linien aufgebaute Bildwelt," *op. cit.,* 406). Cf. Horst Bredekamp, "Die zeichnende Denkkraft. Überlegungen zur Bildkunst der Naturwissenschaften," *Interventionen,* H. Bredekamp and J. Huber, eds. (Zürich and New York 2005), 155–71 (157).

[60] Eisler, *op. cit.,* 24. Cf. Francis Ames-Lewis, *The Intellectual Life of the Early Renaissance Artist* (New Haven and London 2000), 17–60.

[61] Leon Battista Alberti, *On Painting. A New Translation and Critical Edition* (2010), R. Sinisgalli, Trans. (Cambridge 2013), 18: "Prologue addressed to Filippo Brunelleschi".

[62] Giuseppe Billanovich, *Petrarca e il primo Umanesimo* (Padua 1996); Roberto Weiss, *The Renaissance Discovery of Classical Antiquity* (Oxford 1969).

[63] Petrarch, *Rerum memorandarum libri,* II, 61. Cf. Ronald G. Witt, *In the Footsteps of the Ancients. The Origins of Humanism from Lovato to Bruni: Studies in Medieval & Reformation Thought* (Leyden 2000); Roberto Weiss, "Lovato Lovati," *Italian Studies,* VI (1951), 3–28.

[64] Giuseppe Billanovich, *La tradizione del testo di Livio e le origini dell'umanesimo* (Padua 1981). Of similar success was the rediscovery of Seneca's tragedy *Hercules furens* by Albertino Mussato and its adaptation in *Ecerenis* (J. R. Berrigan, ed., Munich 1975).

[65] Giulio Bodon, "Padova e le memorie dell'antichità: Antenore, Tito Livio e i *Viri Illustres,*" *Petrarca e il suo tempo* (exh. cat.), Musei Civici (Padua 2004), S. Collodo, ed. (Milan 2006), 125–41. Cf. Witt, *op. cit.,* 78.

[66] Stefano G. Casu, "Antiquarian Culture in Padua during the Humanistic Age," *In the Light of Apollo* (exh. cat.), *op. cit.,* 245–47.

[67] The two monuments were originally standing next to the entrance of the church of San Lorenzo and have been transferred to today's Piazza Antenore. Bodon, "Petrarca," *op. cit.,* 125–41; Norberto Gramaccini, *Mirabilia. Das Nachleben antiker Statuen vor der Renaissance* (Mainz 1996), 101–02.

[68] This was, however, a misinterpretation, the tomb being related to a freedman of probably Thrakian ori-

gin named Halys. Giulio Bodon, *Tito Livio fra arte e storia nella Padova del Cinquecento* (Padua 2017); Stefano G. Casu, "Antiquarian Culture in Padua," *op. cit.*, 245–47.

[69] Giulio Bodon, 'Heroum Imagines'. *La Sala dei Giganti a Padova – un monumento della tradizione classica e della cultura antiquaria* (Venice 2009); Theodor E. Mommsen, "Petrarch and the Decoration of the *Sala Virorum Illustrium* in Padua," *Art Bulletin*, XXXIV (1952), 95–116; Pierre De Nolhac, "Le *De viris illustribus* de Pétrarque," *Notice et extraits des Manuscrits de la Bibliothèque Nationale et autres Bibliothèques*, XXXIV (1891). Cf. Annegrit Schmitt, "Die Wiederbelebung der Antike – Petrarcas Rom-Idee in ihrer Wirkung auf die Paduaner Malerei. Die methodische Einbeziehung des römischen Münzbildes in die Ikonographie *berühmter Männer*," *Mitteilungen des Kunsthistorischen Institutes in Florenz*, 18 (1974), 167–218.

[70] This was the opinion of Cristoforo Barzizza, in a speech delivered in Padua in 1435: Ludwig Bertalot, "Eine Sammlung Paduaner Reden des XV Jahrhunderts" [1935/36], *Studien zum italienischen und deutschen Humanismus*, vol. 2, P. O. Kristeller, ed. (Rome 1975), 209–35 (215, n. 3). More modest, in this respect, Bernardino Scardeone, *De antiquitate urbis Patavii et claris civibus Patavinis libri tres* (Basel 1560): "[…] facultas medica ubi a Graeci profecta ad Latinos pertransit, hic primum in hac urbe constitisse, ac domicilium suum posuisse videatur." Paul F. Grendler, "The University of Padua 1405–1600: A Success History," *Books and Schools in the Italian Renaissance* (Aldershot 1995), X–XI.

[71] The primacy of Aristotle is confirmed at the beginning of the fourteenth century by Pietro d'Abano (*Conciliator differentiarum philosopohorum et medicorum*) and will be upheld throughout the fifteenth century by, among others, Michele Savonarola (*Libellus*): Gregorio Piaia, *Vestigia philosophorum: Il Medioeveo e la storiografia filosofica* (Rimini 1983), 16–19. Cf. Antonio Poppi, *Introduzione all'aristotelismo Padovano: Publicazioni del Centro per la tradizione aristotelica nel Veneto, Saggi e testi*, 10 (Padua 1970).

[72] Paul Oskar Kristeller, "Umanesimo e scolastica a Padova fino al Petrarca" (1985), *Studies in Renaissance Thought and Letters*, vol. IV, P. O. Kristeller, ed. (Rome 1996), 11–26; John Hermann Randall, Jr., "The Development of Scientific Method in the School of Padua," *Renaissance Essays*, vol. I, P. O. Kristeller et alii, eds. (Rochester 1993), X, 215–51; Bergdolt, *op. cit.*, XXf.; Carlo Maccagni, "Le scienze nello studio di Padova e nel Veneto," *Storia della Cultura Veneta*, vol. III, G. Arnaldi and M. Pastori

Stocchi, eds. (Vicenza 1981), 135–71 (138f.). It was in Padua where the first edition of Aristotle's works, translated into Latin with the comments of the Arab scholar Averroës, was published from 1472 to 1474 – ten years earlier than Aldo Manutio's famed Venetian edition. The Paduan types had been cut by the same Lorenzo Canozi da Lendinara who had carried out the *intarsie* (inlays) for the sacristy in the Santo that were based on perspectival drawings by Squarcione. Marco Callegari, *Dal torchio del tipografo al banco del libraio. Stampatori, editori e librai a Padova dal XV al XVIII secolo* (Padua 2002), 11–14.

[73] Silvana Collodo and Rémy Simonetti, *Filosofia e scienze dell'esperienza fra Medioevo e Umanesimo* (Treviso 2012), 7 (Preface): "La diffusione, nel XII e XIII secolo, delle opere di Aristotele nelle università e nelle cerchie d'alta cultura dell'Occidente europeo promosse una svolta densa d'implicazioni e di conseguenze nella storia della civiltà del medioevo. Con l'accogliere la nozione di *physis*, come concepita a suo tempo dal filosofo greco, e, cioè, col convenire che le componenti della cosiddetta parte sublunare del cosmo – il pianeta terra e tutti i viventi, umanità compresa – erano conoscibili in modo certo attraverso i sensi e l'intelletto, perché accomunate nella dimensione natura, i dotti d'Occidente crearono le condizioni affinché emergesse la distinzione fra teologia e filosofia e si affermasse l'autonomia dalla teologia dei saperi basati sull'esperienza e sulla ragione. La distinzione, maturata nell'inoltrato Duecento, favorì l'avanzamento di conoscenze della medicina, dell'astronomia e delle matematiche, discipline che nel giro di qualche decennio, sotto il nome di filosofia o filosofia naturale, entrarono a far parte degli insegnamenti impartiti nelle facoltà universitarie delle arti."

[74] Nancy G. Siraisi, *Arts and Sciences at Padua. The Studium of Padua before 1350* (Toronto 1973); Graziella Federici Vescovini, *Astrologia e scienza. La crisi dell'aristotelismo sul cadere del Trecento e Biagio Pelacani da Parma* (Florence 1979); Enrico Berti, "Filosofia, astrologia e vita quotidiana nella Padova del Trecento," *PADVA SIDVS / PRECLARVM. I Dondi dall'Orologio e la Padova dei Carraresi* (exh. cat.), Palazzo della Ragione (Padua 1989), N. Mazzonetto, ed. (Montagnana 1989), 7–28 (21ff.); Diana Norman, "Astrology, Antiquity and Empiricism. Art and Learning," *Siena, Florence and Padua. Art, Society and Religion 1280–1400*, vol. I (New Haven 1995), 197–215.

[75] Andrea Bolland, "Art and Humanism in Early Renaissance Padua: Cennini, Vergerio and Petrarch," *Renaissance Quarterly*, 49 (1996), 469–87.

[76] Berthold L. Ullman, *Studies in the Italian Renaissance* (Rome 1973); Silvana Collodo, "Padova al

tempo di Francesco Petrarca," *Petrarca e il suo tempo* (exh. cat.), Musei Civici agli Eremitani, Padua 2004, D. Banzato and G. Mantovani, eds. (Milan 2006), 15–26.

[77] *In primo gradu liberalium habetur* (Francesco Petrarca, *De remediis utriusque fortunae*, XI, Ed. Basel 1554, I, 50). Cf. Pliny, *Natural History*, XXXV, 77.

[78] See the definition of these two terms, based upon the authorities of Aristotle, Boethius and Thomas Aquinas, in: Robert Brennan, *Painting as Modern Art in Early Renaissance Italy* (Turnhout 2019), 27: "The distinction between 'theory' and 'practice' (*theorica* and *practica*) rested on their respective 'ends' (*fines*): theoretical knowledge pursues truth as an end in itself, whereas the end of practical knowledge is material production. 'Theory' encompassed the three main branches of Aristotelian 'science' (*scientia*) – natural science, mathematics, and metaphysics (i. e. theology) – as well as the seven 'liberal arts': music, arithmetic, geometry, astronomy, grammar, rhetoric and logic."

[79] Cennini, *op. cit.*, I, 1: "[…] and this is an occupation known as painting, which calls for imagination, and skill of hand, in order to discover things not seen, hiding themselves under the shadow of natural objects, and to fix them with the hand, presenting to plain sight what does not actually exist. And it justly deserves to be enthroned next to theory, and to be crowned with poetry. The justice lies in this: that the poet, with his theory, though he have but one, it makes him worthy, is free to compose and bind together, or not, as he pleases, according to his inclination. In the same way, the painter is given freedom to compose a figure, standing, seated, half-man, half-horse, as he pleases, according to his inclination." Peter Seiler, "*trovare cose non vedute*. Naturnachahmung und Phantasie in Cennino Cenninis *Libro dell'arte*," *Imagination, Transformation und die Entstehung des Neuen*, P. Brüllmann et alii, eds. (Berlin 2014), 111–54 (124). For the concept of *fantasia*, Cennini had recurred to Quintilian (*Ars oratoria*, VI, 2 29). Cf. Lionello Venturi, "La critica d'arte alla fine del Trecento. Filippo Villani e Cennino Cennini," *L'Arte*, 28 (1925), 233–44 (239).

[80] Brennan, *op. cit.*, 50-2. Cf. Aeneas Sylvius Piccolomini, *Opera* [c. 1440] (Basel 1571), 646: "Amant se artes hae [*eloquentia et pictura*] ad invicem. Ingenium pictura expetit, ingenium eloquentia cupit non vulgare, sed altum et summum. Mirabile dictu est, dum viguit eloquentia, viguit pictura sicut Demosthenes et Ciceronis tempora docent. Postquam cecidit facundia eloquentiae, iacuit et pictura. Cum illa revixit, haec quoque caput extulit. Videmus picturas ducentorum annorum nulla prorsus arte polita. Scripta illius aetatis rudia erant, inepta, incompta. Post Petrarcham

emerserunt literae; post Iotum surrexere pictorum manus; utramque ad summam iam videmus artem pervenisse." Cicero, *Oratio pro Licinio Archia Poeta*, I, 106–43: "Etenim omnes artes, quae ad humanitatem pertinent, habent quoddam commune vinculum et quasi cognatione quadam inter se continentur." Riccardo Fubini, "Enea Silvio Piccolomini nei rapporti con la cultura umanistica del tempo," *Enea Silvio Piccolomini*, F. Nevola, ed. (Colle Val d'Elsa 2009), 131–50; Brennan, *op. cit.*, 36–42.

[81] Daniele Benati, Jacopo "Avanzi e Altichiero a Padova," *Il secolo di Giotto nel Veneto: Istituto veneto di scienze, lettere ed arti*, G. Valenzano and F. Toniolo, eds. (Venice 2007), 385–98. For Altichiero's cycle of frescoes in the Carrara palace: Giulio Bodon, *Heroum Imagines, op. cit.*

[82] Luca Baggio, *Sperimentazioni spaziali negli affreschi di Altichiero nell'Oratorio di San Giorgio, Il secolo di Giotto nel Veneto: Istituto veneto di scienze, lettere ed arti*, G. Valenzano and F. Toniolo, eds. (Venice 2007), 417–27. Cf. Emma Simmi Varanelli, "La riscoperta medievale della Poetica di Aristotele e la sua suggestione sulle arti figurative tardoduecentesche," *Roma Anno 1300*, A. M. Romanini, ed. (Rome 1983), 833–51 (846f.); id., "Dal Maestro d'Isacco a Giotto. Contributo alla storia della *perspectiva communis* medievale," *Arte Medievale*, 3 (1989), 115–42; John White, T*he Birth and Rebirth of Pictorial Space* (London 1957), 27ff.

[83] Vasco Fassina, *Da Guariento a Giusto de Menabuoi – studi, ricerche e restauri: Atti della giornata di studio* (Padua 2012); Mary Edwards, "Parallelism in the Frescoes in the Oratory of St. George in Padua (1379–1384)," *Zeitschrift für Kunstgeschichte*, 71 (2008), 53–72.

[84] Peter Scholz, *Räume des Sehens – Giusto de Menabuoi und die Wissenskultur des Trecento in Padua* (Berlin 2019), 105–61 and 180–203 (105): "Perspektive ist hierbei die von den mittelalterlichen Autoren benutzte lateinische Übertragung des griechischen *optica* bzw. *optike* und umfasst alle mathematischen, psychologischen, anatomischen und philosophischen Gesichtspunkte, die bei der Wahrnehmung von Sehobjekten eine Rolle spielen." Simone Westermann, *"Oblectant occulos hominum" – Augenfreuden. Altichieros Fresken in Padua und die Bilderzählung im späten 14. Jahrhund*ert (PhD Thesis, Zurich, 2019, unpublished). The dissertation of Judith Claus, *Mittelalterliche Architektur im Bild – die Darstellung von Bauten in den Fresken des oberitalienischen Malers Altichiero*, aiming to define Altichiero as „Traditionalist" (PhD Thesis, TU Berlin, 2006, 65), does not do justice to Altichiero's painterly achievements.

[85] Federici Vescovini, *op. cit.*; Hans Belting, *Florenz und Bagdad – eine westöstliche Geschichte des Blicks* (Munich 2008), 150–69. For a sceptical attitude on behalf of Pelacani's presumed influence: Dominique Raynaud, "Optics and Perspective Prior to Alberti," *The Springtime of the Renaissance –Sculpture and the Arts in Florence 1400–60* (exh. cat.), Palazzo Strozzi (Florence 2013), B. Paolozzi Strozzi and M. Bormand, eds. (Nepi 2013), 165–71 (169f.).

[86] Concerning a copy from 1428 (Biblioteca Laurenziana, Plut. 29, 18): Jack M. Greenstein, "On Alberti's 'Sign': Vision and Composition in Quattrocento Painting," *The Art Bulletin*, LXXXIX, no. 4 (1997), 669–98 (683). In Padua itself, Pelacani's teaching continued to be disseminated through his pupil Prosdocimo de' Beldomandi, whose university career as professor for astrononomy, medicine and mathematics had started in 1422. Antonio Favaro, "Le matematiche nello studio di Padova dal principio del secolo XV alla fine del XVI," *Nuovi saggi della R. Accademia di scienze, lettere ed arti in Padova*, 9, 1880, 1–92. Cf. Remy Simonetti, La formazione di Leon Battista Alberti. Scienze matematiche e filosofia naturale nello Studio di Padova nei primi decenni del Quattrocento, in: Collodo and Simonetti, *Filosofia naturale, op. cit.*, 241–312 (269f.).

[87] Scholz, *op, cit.*, 185–86.

[88] Poppi, *op. cit.*, 21. Paolo Marangoni, *Introduzione all'aristotelismo padovano (sec. XII–XIII)*, Padua 1977.

[89] Scholz, *op. cit.*, 210–11. Graziella Federici-Vescovini, "Il problema delle fonti ottiche medievali del Commentario terzo di Lorenzo Ghiberti," *Lorenzo Ghiberti e il suo tempo: Atti del Convegno internazionale di Studi* [Florence 1978] (Florence 1980), 349–87. Regarding Ghiberti's conservative attitude in this matter and his relation to the Paduan concept of *scientia naturalis*: Bergdolt, *op. cit.*, XXIII. Cf. Richard Krautheimer and Trude Krautheimer-Hess, *Lorenzo Ghiberti* (Princeton N. J. 1956), ch. XVI (*Linear Perspective*), 229–53. Degenhart and Schmitt (*Corpus*, II-5, *op. cit.*, 35–6 and II-6, 358) draw a comparison between Altichiero, Ghiberti and the *Presentation of the Virgin in the Temple* in the *Louvre Album* (folios 24, 30).

[90] Michele Savonarola, "Libellus de magnificis ornamentis regie civitatis Padue," *Rerum Italicarum Scriptores, XXIV*, A. Garizzi, ed. (Città di Castello 1902), 44, 55. A comparison with the related passages in Filippo Villani's *Libellus* and Pietro d'Abano's *Conciliator*: Brennan *op. cit.*, 183, 193, 220–24.

[91] Cf. Creighton E. Gilbert, "Michele Savonarola on the Fine Men of Padua," *Italian Art 1400–1500. Sources and Documents* (Evanston 1992), 210.

[92] The difference between necessity (*uti*), the labour of the body, and enjoyment (*frui*), the life of the contemplative soul, has been explained by Saint Augustine (354–430), *De civitate Dei*, XXII. Cf. Rémy Simonetti, "Filosofia naturale, medicina e pittura nella testimonianza di Michele Savonarola," *Filosofia naturale e scienze dell'esperienza fra Medioevo e Umanesimo*, S. Collodo and R. Simonetti, eds. (Padua 2012), 395–430 (396–95). Regarding a different understanding of science in the writings of Ghiberti and Alberti, cf. Robert Brennan, "Between Pliny and the Trecento: Ghiberti on the History of Painting," *Ghiberti teorico. Natura, arte e coscienza storica nel Quattrocento*, F. Jonietz, W.-D. Löhr and A. Nova, eds. (Milan 2019), 43-60 (47, 51). Regarding Vitruvius deiinition in De architectura (I, 1): Claudia Reufer, "Materia e regionamenti. Wahrnehmung und Materialität der Zeichnung bei Ghiberti und Jacopo Bellini," *Ghiberti teorico, op. cit.* 151–70 (151).

[93] Gilbert, *Italian Art, op. cit.*, 210.

[94] Gilbert, *Italian Art, op. cit.*, 209; Baggio, *op. cit.*, 179–80.

[95] Savonarola, who died in 1461 and must therefore have been aware of the Paduan school of painting even though he lived in Ferrara, fails to mention the former city's artists of his generation. This has been met with surprise ever since: Cesira Gasparotto, "Guide ed illustrazioni della basilica di Sant'Antonio da Padova: Le lodi di Padova di Michele Savonarola," *Il Santo*, II, 1 (1962), 369–87 (385). The reason for his silence might be attributed to political resentment against the generation that successfully worked for the Paduan magistrates under Venetian rule after the expulsion of the Carrara Lords in 1405. There is, indeed, a clue confirming this presumption. In his praise of the local school of painting, Savonarola mentions a young artist from Naples who had made his way to Padua (*ex Neapoli industriosus juvenis ad artem hanc adipiscendam Paduam profectus esset*). This man, with whom he was acquainted, told him that in his opinion "the fame of our city would never have spread any farther than the Venetian lagoon if the illustrious painters named had not illuminated the glorious fame of the study of painting." To him Savonarola replied: "Then you put it [the fame of the study of painting] in great peril, for you put it in the hands of fools, who, if they liked, might destroy their figures by breaking them up, and by this destruction destroy that fame just as they are the cause of it." (Gilbert, *Italian Art, op. cit.*, 210). This verdict is obviously making reference to the threat of the painterly tradition through the contemporary school (qualified as fools), which can only have been that of Squarcione.

96 *Dizionario Biografico Treccani, ad vocem.*

97 Scardeone, *De antiquitate urbis Patavii, op. cit.*, 371. Marco Collareta, "La *vita* di Francesco Squarcione di Bernardino Scardeone," *Francesco Squarcione – 'Pictorum Gymnasiarcha singularis': Atti delle giornate di studio* [1998], A. De Nicolò Salmazo, ed. (Padua 1999), 29–36.

98 Vittorio Lazzarini, "Polizze d'estimo di Francesco Squarzon (I)," *Bollettino del Museo Civico di Padova*, 12, I, 1898, 1–4 (Arch. notarile di Padova, Libro delle imbreviature del notaio Bartolomeo ditto Falivetta de' Falivandi, n. 405, carta 189: 1394, nov. 16). Scardeone, *De antiquitate urbis Patavii* (371) calls Francesco Squarcione the son of the ducal scribe Giovanni ("Joannis curiae principis scribae filius").

99 As translated by Ronald W. Lightbrown, *Mantegna. With a Complete Catalogue of the Paintings, Drawings and Prints* (Oxford 1986), 18. Cf. Scardeone, *op. cit.*, 371: "Quocirca adnavigavit in Graeciam, et totam illam provinciam pervagatus est: unde multa notatu digna, tum mente, tum chartis, quae ad eius artis peritiam facere visa sunt, inde domum secum detulit. Circuivit similiter totam Italiam, et multos nobiles sua sibi affabilitate et virtute fecit amicos."

100 During this period, he is not mentioned in official records. Following Pietro Estense Selvatico, *Il pittore Francesco Squarcione. Studii storico-critici* (Padua 1839), 16), the death of Francesco's father in 1422 marked the beginning of his travels. On April 6, 1426, Squarcione was assigned an altar painting for San Giovanni Battista di Venda (Sambin, "Per la biografia di Francesco Squarcione," *op. cit.*, 451). Apart from Scardeone's report, there are no further documents attesting to Squarcione's travels to Greece. Ciriaco d'Ancona, on the contrary, who departed for Greece in 1435 and visited Athens in 1436, is famed to have been "the only man in thirteen hundred years, since the time of the great Alexandrian geographer Claudius Ptolemy in the age of Hadrian, whose expansive nature and high-born temper gave him the courage to travel all over the world – through Greece, Asia, Egypt, and the Ionian and Aegean islands – to survey and investigate the site and characteristics of its territories and provinces, its mountains, woodlands, springs, rivers, its seas, lakes and noblest cities and towns. Whatever fine monuments of venerable antiquity he found worthy of note in these places, he faithfully recorded, not in Italian, but in Latin and Greek; and, as we have often heard him say himself, his indefatigable resolve, regardless of all discomforts, toils and sleepless nights the task involved, was to inspect and examine whatever ancient remains were to be seen in the world as far as the last rocky heights jutting into the Ocean, to the island of Thule, and any remote parts of the earth." Quoted after Francesco Scalamonti [Felice Feliciano], *Vita viri clarissimi et famosissimi Kyriaci Anconitani*, C. Mitchell and E. W. Bodnar, eds. (Philadelphia 1996), 101. Regarding Cristoforo Buondelmonti's travels to Greece and his *Liber insularum archipelagi* (1420): Fortini Brown, Venice and Antiquity, *op. cit.*, 77–81. Cf. Luigi Beschi, "Antiquarian Research in Greece During the Renaissance: Travellers and Collectors," *In the Light of Apollo* (exh. cat.), *op. cit.*, 46–52.

101 Eisler (*op. cit.*, 195–96) agrees in calling Squarcione's school "the most humanistically oriented in the realm of Venetian art."

102 Differing radically from Squarcione's academic concept in that it is based not on *maniera* but theory is Cennini's advice in chapter 27 (*op. cit.*, 15) to follow only the best master, that is "the one who has the greatest reputation." Peter Seiler, "Giotto – das unerreichte Vorbild? Elemente antiker *imitatio auctorum*-Lehren in Cennino Cennini's *Libro dell'Arte*," *Imitatio als Transformation. Theorie und Praxis der Antikennachahmung in der Frühen Neuzeit*, U. Rombach and P. Seiler, eds. (Petersberg 2012), 44–86 (47).

103 Seiler (*trovare cose non vedute, op. cit.*, 128) rightly points out that Cennini's rhetoric on this point is not substantiated by scientifc knowledge: "Ein Missverhältnis zwischen dem beanspruchten hohen Rang der Malerei und den erfassten Wissensbeständen ist unverkennbar." Here lies a fundamental difference to Squarcione's humanist education.

104 Sarah Blake McHam, "Padua, Treviso, and Bassano," *Venice and the Veneto: Artistic Centers of the Italian Renaissance*, P. Humfrey, ed. (New York 2007), 207–31 (213). Estense Selvatico (*op. cit.*, n. 9) lists the following painters coming from Germany: [1441] *Nicholaus Thetonicus discepulus magist. Franzischi picto: de sa Malgareta. – [1442] Martino da Colonia – [1442] Magistro Rigo todescho intrado in te la fraja per magistro. – Zuhane todescho in te la fraja per magistro. – Zuane Evangelista depentore fiolo de M. Francesco Rigo intrà in la fraja p. m.o sotto la Massaria de m. Piero da Milan. [1445] Bart. De …. D'Alemagna adì 17. Decem. 1445.* Cf. M. Urzi, "I pittori registrati negli statuti dellla fraglia padovana dell'anno 1441," *Archivio Veneto* s. V, 12, (1932), 212, 234.

105 Lazzarini and Moschetti, *op. cit.*, 37–38, doc. XVII; Lipton, *op. cit.*, doc. 19, 321.

106 Vasari, *op. cit.*, III, 548 [I.488]: "[…] il quale Iacopo [Squarcione] se lo tirò in casa, e poco appresso, conosciutolo di bello ingegno, se lo fece figlio adottivo." Lipton, *op. cit.*, doc. 29, 330: "Andrea fiuilo de Maistro Francesco squirzon depentore."

[107] In a document from May 12, 1443, he declares: "Io abito con la mia fameia e bottega … trafego in la mia arte." In a document from May 24, 1455, distinction is made between "unum studium magnum in domo cum relevis, designis et aliis rebus intus and unum studium parvum in domo dita a relevis cum omnibus rebus intus spectantibus ad artem pictorie et picturis existentibus in eis." Cf. Alberta De Nicolò Salmazo, "Presentazione," *Francesco Squarcione – 'Pictorum Gymnasiarcha singularis': Atti delle giornate di studio* 1998 (Padua 1999), 14, 16.

[108] Scardeone (*op. cit.*, 371): "[…] usquadeo, ut (sicut ipse de se in quodam libello asserit) habuerit ex diversis urbibus, centum et triginta septem discipulos, inter quos emicuerunt in primis Andreas Mantinea, vir in ea arte praestantissimus, de quo statim dicemus; et Nicolaus Pizzolus, Andreae ipsius in sacello Eremitarum quod Patavii visitur, compictor et aemulus. Item docuit Mateum Puteum, Marcum Zottum, Darium Tarvisinum, Gregorium Sclavonem, et plerosque alios, qui fuerunt in pingendo excellentissimi."

[109] Laura Cavazzini and Aldo Galli, "Padoue, carrefour artistique," *Mantegna 1431–1506* (exh. cat.), Musée du Louvre, Paris, G. Agosti and D. Thiébaut, eds. (Paris 2008), 55–60. Stefano G. Casu, "Giorgio Schiavone e Carlo Crivelli nella bottega del Squarcione," *Proporzioni*, 1 (2000), 37–54.

[110] This conforms to Luigi Lanzi's judgement, *Storia pittorica della Italia*, 2 vols. (Bassano 1795–1796), II, 18: "Egli [i. e. Squarcione] è quasi lo stipite onde si dirama per via del Mantgena la più grande scuola di Lombardia; e per via di Marco Zoppo Bolognese; ed ha su la Veneta stessa qualche ragione perciocché Jacopo Bellini venuto in Padova ad operare par che in lui si specchiasse come dicemmo."

[111] Paul Kristeller, "Francesco Squarcione e le sue relazioni con Andrea Mantegna," *Rassegna d'Arte*, IX (1909), IV–V (V): "Mi pare che tutto ciò giustifichi il sospetto che lo Squarcione si sia servito più del solito e del lecito dell'opera dei suoi giovani assistenti, e che anzi egli abbia sfruttato le loro forze superiori alle sue." On Dezember 2, 1455, Marco Zoppo from Bologna labeled him as deceitful and sly (*dolose et callide*); on August 21, 1465, Agnolo di Silvestro accuses his former master's fraudulent behaviour as follows: "come e sempremay de so costume che sempremay cercha cum le sue promission laudandose delle cosse lequal non ha et de saver quello chel non sa et promete de far ale persone perfina tanto che li ha reducti e cavado el sugo desi." Rigoni, *op. cit.*, doc. III, 13 and doc. V, 16; Lipton, *op. cit.*, docs. 59 (360), 79 (376).

[112] Markham Schulz, *Francesco Squarcione, op. cit.*, 28.

[113] Mauro Lucco, "Appunti per una rilettura di Francesco Squarcione," *Francesco Squarcione 'Pictorum Gymnasiarcha singularis', op. cit.*, 101–111 (107). Cf. Carmen C. Bambach, *Drawing and Painting in the Italian Renaissance Workshop: Theory and Practice 1300–1600* (Cambridge and New York 1993); Michael Baxandall, *Giotto and the Orators. Humanist Observers of Painting in Italy and the Discovery of Pictorial Composition 1350–1450* (Oxford 1971), 41–43.

[114] Kristeller (*op. cit.*, IV) has drawn attention to the fact that there were two classes of apprentices regarding their age: Those like Mantegna who entered the studio at Pontecorvo at a very young age, and senior students who had already received some training elsewhere, such as Dario da Udine (19 years old), Matteo dal Pozzo (17), Marco Zoppo (22) and Giorgio Chiulinovich (20), "che si manifestano più quale collaboratori che quali apprendisti propriamente detti." There is also a neat difference regarding the period of apprenticeship: Whereas some students conclude a contract for two, four or six years, others (like Uguccione) stay for a crash course in perspective lasting only four months.

[115] Scardeone, *op. cit.* Also Vasari (*op. cit.*, III, 548 [I.488]) had knowledge of a collection consisting of "quadri di pittura, che in tela si fece venire da diversi luoghi e particolarmente di Toscana e di Roma" as well as "cose di gesso formate da statue antiche."

[116] Favaretto, "La raccolta," *op. cit.*, 233–44; Fiocco, "Il Museo," *op. cit.*, 59–72. Lightbrown (*op. cit.*, 19) mentions an icon signed by Emanuel Zarfenari in the Vatican that was believed to have belonged to Squarcione. Markham Schulz (*Francesco Squarcione, op. cit.*, 30) argues that Flemish paintings in the style of Robert Campin also may have formed part of Squarcione's collection.

[117] The 1431 contract with Michele stipulates the study of these models (Lipton, *op. cit.*, doc. 19, 321): "Promitens ipse Squarconus dicto Michaeli dare commoditatem suorum exemplorum ipsi Michaeli et ipsum docere secundum quod facere debent magistri discepulis suis." Regarding Squarcione's criticism of Mantegna's coloristic concept (not the imitation of antique forms as such) in the Ovetari Chapel, see Vasari's statement (*op. cit.*, III, 550 [I.489]), upon the testimony of Girolamo Campagnola: "La qual cosa sentendo lo Squarcione […] sopra tutto biasimò senza rispetto le pitture che Andrea aveva fatte nella detta capella di San Cristofano; dicendo che non erano cosa buona, perché aveva nel farle imitato le cose di marmo antiche, dalle quali non si può imparare la pittura perfettamente; perciocché i sassi hanno sempre la durezza con esso loro, e non mai quella tenera dolcezza

che hanno le carni e le cose naturali, che si piegano e fanno diversi movimenti; aggiungendo che Andrea arebbe fatto molto meglio quelle figure, e sarebbono state più perfette, se avesse fattole di color di marmo, e non di que' tanti colori; perciocchè non avevano quelle pitture somiglianza di vivi, ma di statue antiche di marmo o d'altre cose simili. Quste cotali reprensioni punsero l'animo d'Andrea: ma dall'altro canto gli furono di molto giovamento; perché, conoscendo che egli diceva in gran parte il vero, si diede a ritrarre persone vive; e vi fece tanto acquisto, che in una storia che in detta cappella gli restava a fare, mostrò che sapeva non meno cavare il buono delle cose vive e naturali, che di quelle fatte dall'arte. Ma con tutto ciò ebbe sempre opinione Andrea, che le buone statue fussino più perfette e avessino più belle parti, che non mostra il naturale; attesochè quegli eccellenti maestri, secondo che e' giudicava e gli pareva vedere in quelle statue, avevano da molte persone vive cavato tutta la perfezione della natura, la quale di rado in un corpo solo accozza ed accompagna insieme tutta la bellezza; onde è necessario pigliarne da uno una parte e da un altro un' altra: ed oltre a questo gli parevano le statue più terminate e più tocche in su'muscoli, vene, nervi ed altre particelle, le quali il naturale, coprendo con la tenerezza e morbidezza della carne certe crudezze, mostra talvolta meno; se già non fusse un qualche corpo d'un vecchio o di molto estenuato, i quali corpi però sono per altri rispetti dagli artefici fuggiti. E si conosce di questa opinione essersi molto compiaciuto nell'opere sue; nelle quali si vede invero la maniera un pocchetto tagliente, e che tira talvolta più alla pietra che alla carne viva." In the same vein as Vasari, Scardeone (*op. cit.*, 372) admits the use of ancient statues for contour and relief but demands that the colouring must imitate nature. Regarding the impact of antique sculpture as a model for painting in the case of Alberti and Ghiberti: Leatrice Mendelsohn, "The Transmission of Antique Beauty and Proportion to Renaissance Art: From Sculpture to Painting," *In the Light of Apollo* (exh. cat.), *op. cit.*, 96–103 (97).
[118] Michelangelo Muraro, "Francesco Squarcione pittore umanista," *Da Giotto a Mantegna* (exh. cat.), Palazzo della Ragione, Padua, L. Grossato, ed. (Milan 1974), 68–74 (70); Stephen J. Campbell, "L'agiografia di Andrea Mantegna," *Mantegna e Roma. L'artista davanti all'antico*, T. Calvano et alii, eds. (Rome 2010), 421–49 (425).
[119] R. G. C. Mercer, *The Teaching of Gasparino Barzizza with Special Reference to His Place in Paduan Humanism* (London 1979); Clémence Révest, "Les discours de Gasparino Barzizza et la diffusion du style cicéronien dans la première moitié du XV siècle," *Mélanges de*

l'Ecole française de Rome, 128 (2016), 47–72 (48). Barzizza's importance for Paduan art has been highlightened by Baxandall (*Giotto and the Orators, op. cit.*, 127); Muraro ("Francesco Squarcione," *op. cit.*, 70), Eisler (*op. cit.*, 193), Alberta de Nicolò Salmazo (*Andrea Mantegna*, Cologne 2004, 70), as well as others.
[120] Among these, Vittorino da Feltre is of particular interest. He was a friend of Pelacani's and had gained high reputation within Barzizza's school for teaching geometry in conjunction with drawing, mensuration and surveying. In 1421, Vittorino occupied the chair in rhetorics at the University of Padua. William Harrison Woodward, "Vittorino da Feltre and Other Humanist Educators" [1963], *Renaissance Society of America* (1996); Baxandall, *Giotto and the Orators, op. cit.*, 127.
[121] Silvana Collodo, "L'esperienza e l'opera di Leon Battista Alberti alla luce dei suoi rapporti con la città di Padova," *La vita e il mondo di Leon Battista Alberti*: *Atti dei Convegni internazionali, Centro di Studi Leon Battista Alberti*, 11 (Genua 2004), (Città di Castello 2008), 315–43 (317); Roberto Norbedo, "Considerazioni intorno a Battista Alberti e Gasparino Barzizza a Padova (con un documento su Leonardo Salutati)," ibid., 345–76; Simonetti, "La formazione di Leon Battista Alberti," *op. cit.*, 264.
[122] Muraro, "Francesco Squarcione," *op. cit.*, 70; Randall, *op. cit.*, 177.
[123] Clémence Révest, "Umanesimo, università e chiesa a Padova nei primi anni del dominio veneziano: l'orazione accademica di Gasparino Barzizza per Pietro Donato (1418)," *Quaderni per la storia dell'università di Padova* (2016), 3–34 (18).
[124] Révest, "Les discours de Gasparino Barzizza," *op. cit.*, 48–9.
[125] Michael Baxandall, "Guarino, Pisanello and Manuel Chrysoloras," *Journal of the Warburg and Courtauld Institutes*, 28 (1965), 183–204 (183). In his treatise *De imitatione* (Biblioteca. Marciana, Venice, MS. XI. 34 [4354], fol. 29,) quoted and translated by Baxandall (*Giotto and the Orators, op. cit.*, 34), Barzizza compares the principle of adding: "Adding is, for example, if I have found some short piece of Latin in Cicero or some other learned orator and I add some words to it, so that the piece is seen to take on a form that is new and different from before…This is next proved by similitude: a painter has painted the figure of a man without its right or left hand; I take the brush and add the right or left hand, and also paint some horns on the figure's head. Observe how the figure appears very different from before." Cf. Chrysa Damianaki, "Liceità e pratica dell'imitazione nelle prose. Bembo e il recupero dell'antico nel primo Cinquecento," *Prose della volgar lingua di Pietro Bembo*, S. Morgana et alii,

eds. (Milan 2000), 617–54 (617f.). De Nicolò Salmazo, *Francesco Squarcione* – 'Pictorum Gymnnasiarch singularis', *op. cit.*, 22–3.

[126] Cicero, *Oratio pro Licinio Archia poeta*, I, 106–143: "Etenim omnes artes, quae ad humanitatem pertinent, habent quoddam commune vinculum et quasi cognatione quadam inter se continentur." Pietro d'Abano compared Galen's "balanced complexion" (*complexio aequalis*) to a statue by Polykleitos (Brennan, *op. cit.* 194–97), Pier Paolo Vergerio the imitation of Cicero in present rhetorics with that of Giotto in modern painting (Baxandall, *Giotto and the Orators*, *op. cit.*, 43, Bolland, *op. cit.* 474–75).

[127] A systematic collection of models for academic use is to be distinguished from the artist's personal collection. The difference is similar to that existing between sketchbook and album (see p. 16). Squarcione's idea of collecting was probably inspired not by artists but by humanist collectors like Niccolò Niccoli (1363–1437) and Poggio Bracciolini (1380–1459). Eugène Müntz, "Essai sur l'histoire des collections italiennes d'antiquités depuis les débuts de la Renaissance jusqu'à la mort de Paul II," *Révue archéologique*, 37 (1879), 45–54 and 84–93 (50ff.); Ernst H. Gombrich, "From the Revival of Letters to the Reform of Arts, Niccolo Niccoli and Filippo Brunelleschi," *Essays in the History of Art Presented to Rudolf Wittkower*, D. Fraser et alii, eds. (London 1967), 71–82 (72). A case in between may be Lorenzo Ghiberti whose collection was valued at 1500 florins at his death (Krautheimer and Krautheimer-Hess, *op. cit.*, I, 305). Ghiberti's portfolio of drawings was to be visited by Giorgio Vasari who followed his example in building up his own collection.

[128] Nikolaus Pevsner, *Academies of Past and Present* [1940] (Cambridge 2014), 92.

[129] Vasari, *op. cit.*, VI, 9 [II.718]. A critical, yet not altogether convincing view, in the sense that Vasari, when speaking of Lorenzo's academy, was creating a fictional precedent for his own institution to be sponsored by Cosimo I: Paul Barolsky and William Wallace, "The Strange Case of the Young Michelangelo," *Arion: A Journal of Humanities and the Classics*, 21 (2013), 103–12. The comparison with Squarcione's academy has also been acknowldged by Eisler, *op. cit.*, 195–96; André Chastel, *Art et humanisme à Florence au temps de Laurent le Magnifique. Etudes sur la Renaissance et l'Humanisme Platonicien* (Paris 1958), 19–25.

[130] Luke Syson, "Bertoldo di Giovanni Republican Court Artist," *Artistic Exchange and Cultural Translation in the Italian Renaissance*, S. J. Campbell and S. J. Milner, eds. (Cambridge 2004), 96–133; Laurie Smith Fusco and Gino Corti, *Lorenzo de Medici Collector and Antiquarian* (New York 2006); Cristina Aci-

dini Luchinat, "The Collecting and Commissioning Preferences of the Medici: from Cosimo the Elder to Lorenzo the Magnificent," *In the Light of Apollo* (exh. cat.), *op. cit.*, 271–76.

[131] Scardeone (*op. cit.*, 371). Other visitors were San Bernardino da Siena (d. 1444) as well as Marco Barbo, Patriarch of Aquileia. Cf. Estense Selvatico, *op. cit.*, 22; Michelangelo Muraro, "Donatello e Squarcione. Proposta per un' esposizione sul rinascimento a Padova," *Donatello e il suo tempo: Atti dell'VIII Convegno Internazionale* (Florence 1968), 387–98 (389). As to the terminology: Paula Findlen, "The Museum: its Classical Terminology and Renaissance Genealogy," *Journal of the History of Collections*, I, n. 1 (1989), 59–79, II, (1990), 205–18.

[132] Silvia Rizzo, *Il lessico filologico degli umanisti* (Rome 1973), 314: "L'archetypum inteso come originale è anche il 'primo esemplare', capostipite di tutta la successiva discendenza di manoscritti o stampe."

[133] Hans Tietze, "Mantegna and his Companions in Squarcione's Shop," *Art in America*, XXX (1942), 54–60 (54), has rightly pointed out the sharp contrast between material and artistic property. In a document from October 17, 1466, concerning the decoration of the chapel of the Lazara family in the Santo (Getty Contract, Malibu, J. Paul Getty Research Institute for the Humanities, Special Collections 900255*), the painter Pietro Calzetta was to use a drawing that belonged to Squarcione (*desegno de Maistro Francesco Squarzon*), yet which had been created by Squarcione's former pupil Nicolo Pizolo (*fo de man de Nicolo Pizolo*). Lipton, *op. cit.*, 380, doc. 86. For the attribution of the painting to Bartolomeo Sanvito: Laura Nuvoloni, "Bartolomeo Sanvito e i suoi artisti nella Padova dei primi anni sessanta del Quattrocento," *Il codice miniato in Europa*, G. Mariani Canova and A. Perriccioli Saggese, eds. (Padua 2014), 493–508 (495).

[134] As fn. 107.

[135] From the contract drawn up between himself and Giorgio Schiavone from December 7, 1458 (Lipton, *op. cit.*, doc. 68, 367).

[136] Lipton, *op. cit.*, doc. 87, 383.

[137] Joost-Gaugier, "The Sketchbooks," *op. cit.*, 27–30.

[138] „Die minuziöse Strichführung und die wenigen Korrekturen und *pentimenti* lassen vermuten, dass der Realisierung in den Büchern mehrere Studien, Entwürfe oder zumindest genaue Planungen vorausgegangen sind," (Reufer, „Eine aus Linien aufgebaute Bildwelt," *op. cit.*, 406).

[139] Regarding the importance of the *librarius*: Angelo Camillo Decembrio. *De politia litteraria: Beiträge zur Altertumskunde*, vol. 169, N. Witten, ed. (Munich and Leipzig 2002), 80–1.

140 See on this point: Lorenzo Valla's preamble to *Elegantiarum linguae latinae libri sex*. Marianne Pade, "The Place of Translation in Valla's Thought," *Classica et Medievalia: Revue Danoise de Philologie et d'Histoire*, XXXV (1984), 294–300; Anthony Grafton, "Commerce with the Classics," *The Italian Renaissance. The Essential Readings*, ed. P. Findlen (Ox-

ford 2002), 237–72 (240). Cf. Norberto Gramaccini, "Buch und Bild im Zeitalter ihrer Vervielfältigung durch den Druck," *Die Kunst der Interpretation. Italienische Reproduktionsgraphik 1485–1600*, H. J. Meier and N. Gramaccini, eds. (Berlin and Munich 2009), 9–52 (15).

Part 2

1 *Haec* [lingua Latina] *enim gentes illas populosque omnes omnibus artibus, quae liberales vocantur.* The opinion of Degenhart and Schmitt (*op. cit.*, *Corpus*, II-6, 320) to qualify the body in relation to the fourteenth century iconography of the *Transi* tomb of north Alpine origin is misleading in my opinion. Cf. Erwin Panofsky, *Tomb Sculpture. Four Lectures on Its Changing Aspects from Ancient Egypt to Bernini* (New York 1964), 71–3.

2 A similar room that was reserved for philosophical disputes and separated from the *anatomical theatre* still exists in the Palazzo Bo (Padua).

3 Siraisi, *op. cit.*, 169.

4 Domenico Lauranza, "Art and Anatomy in Renaissance Italy, Images from a Scientific Revolution," The Metropolitan Museum of Art Bulletin, 69, 2012, 5–48 (7); Charles Singer, *The Education of Anatomy* (London 1925), 74–85.

5 This could well be Cristoforo Barzizza, the son of the famous Latinist Gasparino, who held the chair for medicine from 1431–1444. Pearl Kibre, "Cristoforo Barzizza, Professor of Medicine at Padua," *Bulletin of the History of Medicine*, XI (1942), 389–408.

6 Plato, vol. 9, W. R. M. Lamb, Trans. (Cambridge 1925). I am grateful to Guy Claessens for this information.

7 Johannes Thomann, "Pietro d'Abano on Giotto," *Journal of the Warburg and Courtauld Institutes*, 54 (1991), 238–44; Scholz, *op. cit.*, 96–7.

8 *Conciliator differentiarum quae inter philosophos et medicos versantur* (1303, revised in 1310 and published posthumously in 1472). Siraisi, *op. cit.*, 152.

9 Jackie Pigeaud, "Médecine et médecins padouans," *Les Siècles d'Or de la Médecine, Padoue XV – XVIIIème s.* (Milan 1989), 31–35.

10 Loris Premuda, "Giuseppe Ongaro, I primordi della dissezione anatomica in Padova," *Acta medicae historiae patavina*, XII (1965–1966), 117–36.

11 Ghiberti, *I commentarii, op. cit.*, 48: "Ancora bisognia averne conosciuta la disciplina della medicina, et avere veduto notomia, acciò che llo scultore

sappi quante ossa sono nel corpo humano, volendo comporre la statua virile, e sapere e muscoli sono nel corpo dello huomo e così tutti i nervi e legature sono in esso."

12 Savonarola, *Libellus, op. cit.*, 36.

13 Cennini's casting experience (*op. cit.*, ch. 82–86, 127–29) might have been trained within the Paduan medical faculty where gypsum was used for the conservation of the dead body as well as for death masks. This does not mean, however, that he had any knowledge of anatomy as his chapter 70 on human proportions betrays (Cennini, *op. cit.*, 48). Regarding the history of casting: Dominic Olariu, "Körper, die sie hatten – Leiber, die sie waren. Totenmaske und mittelalterliche Grabskulptur," *Quel Corps? Eine Frage der Repräsentation*, H. Belting et alii, eds. (Munich 2002), 85–104 (88); Heinrich Drerup, "Totenmaske und Ahnenbild bei den Römern," *Mitteilungen des Deutschen Archäologischen Institutes in Rom*, 87 (1980), 81–129. Wolfgang Wolters ("Appunti per una storia della scultura padovana del Trecento," *Da Giotto a Mantegna, op. cit.*, 36–42) considers the use of life masks for tomb sculptures of the fourteenth century (cat. nos. 29, 40, 41) a Paduan speciality: "Eine Prüfung ergibt, dass veristische (nach Abguss?) geschaffene Porträts wie in den Grabmälern der Scrovegni, Jacopo da Carrara und Ubertino da Carrara eben doch eine Spezialität von Padua und nicht Venedig waren."

14 "Jacopo was the outstanding master in the Veneto of trompe l'oeil and illusionism" (Eisler, *op. cit.*, 43). Christiane L. Joost-Gaugier, "Considerations Regarding Jacopo Bellini's Place in the Venetian Renaissance," *Arte Veneta*, 28 (1975), 121–38; Keith Christiansen, "Venetian Painting of the Early Quattrocento," *Apollo*, 125, (1987), 168–74; Peter Humfrey, *Painting in Renaissance Venice* (New Haven and London 1995), 37ff.

15 Particularly regretful for understanding Jacopo's style towards the end of his career are the missing panels for the Gattamelata Funerary Chapel in the Paduan Santo church (1459/60), and the scenes from

the *Lives of Christ and the Virgin* painted for the *Scuola Grande di San Giovanni Evangelista* in Venice that had been terminated in 1465 (Eisler, *op. cit.*, Appendix D, 517, 521). For the Gattamelata Chapel, see Giacomo Alberto Calogero, "Il problema della Pala Gattamelata e gli esordi di Giovanni Bellini," *Paragone*, 147 (2019), 3–31; for the Scuola Grande panels: Joseph Hammond, "Five Jacopo Bellini's: The Lives of Christ and the Virgin at the Scuola Grande di S. Giovanni Evangelista," *Burlington Magazine*, 158 (2016), 601–09. The drawings listed in Eisler, *op. cit.*, Appendix E (526) can at best be attributed to the studio and have, furthermore, nothing in common with those of the *Louvre Album*.

[16] The divergence regarding Jacopo's artistic merits was at the core of the famous debate between Giuseppe Fiocco and Roberto Longhi in the late 1920s. Roberto Longhi, "Lettera pittorica a Giuseppe Fiocco," *Vita Artistica*, I, 1926, 127–39, republished by Paola Barocchi, *Storia moderna dell'Arte in Italia: Dal Novecento ai dibattiti sulla figura e sul monumentale, 1925–1945*, III (Turin 1990), 60–69. Cf. Alberta De Nicolò Salmazo, "Dalle 'malefatte' di Francesco Squarcione al 'vero maestro' di Andrea Mantegna: Giuseppe Fiocco e la formazione del Rinascimento Veneto," *Sotto la superficie del visibile: Scritti in onore di Franco Bernabei*, M. Nezzo and G. Tomasella, eds. (Treviso 2013), 129–42.

[17] Eisler, *op. cit.*, 25; Keith Christiansen, *Gentile da Fabriano* (London 1982), LVIII; Enrica Cozzi, *Il gotico internazionale a Venezia: un' introduzione alla cultura figurative nell'Italia nord-orientale* (Verona 2013); Humphrey, *Renaissance Venice, op. cit.*, 40–42.

[18] Eisler, *op. cit.*, 24, 530; Degenhart and Schmitt, *Corpus*, II-5, *op. cit.*, 106–18. The close relationship between the two artists resulted in his naming his oldest son Gentile: Vasari, *op. cit.*, III, 427–28 [I.430]. Regarding a later date (1443) and different hand (Maestro di Ceneda) of the *predella* paintings in Brescia with respect to the *Annunciation*: Andrea de Marchi, "*Lorenzo e Jachomo da Venexia*: un percorso da Zanino a Jacopo Bellini e un enigma da risolvere," *Saggi e memorie di storia dell'arte*, 27 (2004), 71–100 (75).

[19] Eisler, *op. cit.*, 30–1, Appendix D, 517, 525; Degenhart and Schmitt, *Corpus*, II-5, *op. cit.*, 106–07. Cf. Luigi Simeoni, "La Crocifissione di Jacopo Bellini nella Cattedrale di Verona," *Atti e Memorie dell'Accademia di Agricoltura, scienze, lettere, arti e commercio di Verona*, ser. IV, vol. V, fasc. I (Verona), 1904–05.

[20] One wonders whether the reason for the fistfight with Bernardo Silvestro in Gentile da Fabriano's courtyard in 1424 (Gilbert, *Italian Art, op. cit.*, 23–5)

was a quarrel betweeen the ancients and the moderns, in which Jacopo felt obliged to defend his master. For arguments against identifying Jacopo Bellini with the *Jacopus Venetus* mentioned in the documents: Eisler, *op. cit.*, 27.

[21] Lionello Venturi, *Le origini della pittura veneziana, 1300–1500* (Venice 1907), 114, 156, argued that Jacopo Bellini struggled with Squarcione for artistic preeminence in Venice and influence over Andrea Mantegna.

[22] Fontana makes reference to a lost treatise on painting that he had dedicated to Jacopo Bellini in his *Liber de omnibus rebus naturalibus quae continentur in mundo, videlicet coelestibus et terrestribus necnon mathematicis, et de angelis motoribus quae coelorum*, written circa 1454 and in print 1544 under the name of Pompilus Azalus Placentinus. Marshall Clagett, "The Life and Works of Giovanni Fontana," *Annali dell'Istituto e Museo di Storia della Scienza a Firenze*, I (1976), 5–28 (n. 8, 21f.). Cf. Giulia Borea, "Prospettiva lineare e prospettiva *de pedimenti*: un dibattito sullo scorcio del Quattrocento," *Paragone*, 27 (1999), 3–45 (5f., n. 10).

[23] Eisler, *op. cit.*, 38, 44–47, 447; Christiane Joost-Gaugier, "Jacopo Bellini's Interest in Perspective and Its Iconographical Significance," *Zeitschrift für Kunstgeschichte*, 38 (1975), 1–28. Robert Klein, *Form and Meaning: Essays on the Renaissance and Modern Art* [1970] (Princeton 1981), 165, believed that Pelacani's *Quaestiones perspectivae* stood behind Fontana's lost treatise dedicated to Jacopo Bellini.

[24] "Lo sviluppo artistico di Jacopo rimase sempre aderente, nella parte essenziale, al Gotico Intenazionale di Gentile, anche se risentì, in seguito, della forma esteriore dei Fiorentini a Venezia e a Padova, e si dilettò, quasi con ostinazione, del gioco della propsettiva." (Röthlisberger, *op. cit.*, 9).

[25] "[...] lungi dal vertere sulla prospettiva geometrica, formulava invece i principi e dettava i metodi di una diversa *perspettiva* realizzata non già attraverso il disegno ma attraverso la graduazione del colore e della luce." A critical view by Giordana Mariani Canova, "Riflessioni su Jacopo Bellini e sul libro dei disegni del Louvre," *Arte Veneta*, XXVI (1972), 9–30 (21).

[26] For a distinction between *sentire con la vista* or *esperienza sensibile* and *discernere con la vista* in the North Italian *abacus* schools, see Scholz, *op. cit.*, 180. Cf. Filippo Camerota, "*Misurare per perspectiva*. Geometria e prospettiva pingendi," *La prospettiva. Fondamenti teorici ed esperienze figurative dall'antichità al mondo moderno: Atti del Convegno internazionale di studi dell'Istituto Svizzero di Roma*, R. Sinisgalli, ed. (Rome 1998), 293-308. Pelacani called for measure-

ments that defined the objects not in themselves but in relation to a superordinate measure (*cognoscere proportionem illius obiecti quanti ad quantitatem veram*). This is what he called true proportion: "[…] cognoscere […] quantum ipsum sit sub relatione ad aliud notum et hoc non est, nisi cognoscere proportionem huius ad illud." Quoted after Monique Dubois, *Zentralperspektive – in der florentinischen Kunstpraxis des 15. Jahrhunderts* (Petersberg 2010), 13.

27 "Ab hoc naturali experientia ars pictorica canones accepit, ut in libello ad Jacobum Bellinum Venetum pictorem insignem certe descripsi." Quoted after Joost-Gaugier, "Jacopo Bellini's Interest in Perspective," *op. cit.*, 1, n. 2. Regarding analogies between the term *giudizio dell'occhio* (Vasari, *op. cit.*, I, 114 [I.45]) and Cennini's term *inteletto*, both referring to an individual sensual capacity, not imposed numeric measures: David Summers, *Michelangelo and the Language of Art* (Princeton 1981), 375; Bolland, *op. cit.*, 477. Technically speaking, Jacopo Bellini's painterly practice is in accordance with the advice concerning highlighting, shading and relief given in Cennini's *Craftsman's Handbook*.

28 Antonio di Tuccio Manetti, *The Life of Brunelleschi*, H. Saalman, ed. (London 1970), 42–3.

29 With particular reference to Aristotle (*De anima*) and Nicolas Oresme (Questiones): Christopher Lakey, Scholastic Aesthetics and the Medieval 'Origins' of Relief/rilievo, Chiaroscuro als ästhetisches Prinzip. Kunst und Theorie des Helldunkel 1300–1500, C. Lehmann et alii, eds. (Berlin and Boston 2018), 125–40 (134). Peter Marshall, "Two Scholastic Discussions of the Perception of Depth by Shading," *Journal of the Warburg and Courtauld Institutes*, 44 (1981), 170–175; Gérard Simon, "Optique et perspective: Ptolemée, Alhazen, Alberti," *Revue d'histoire des sciences* (2001), LIV, 325–50 [332–333]. Cf. Belting, *op. cit.*, 187–88, 229.

30 The main passages have been translated by Gilbert (*Italian Art, op. cit.*, 174–5): "[…] A certain very noble science of perspective, which pertains to the inquiry into the causes and systems of those things that are seen and felt: […] If there are clouds between us and the sun, that thinner part of them through which the rays come down to us will seem brighter, being imbued with the light oft he rays. The thicker part will seem darker, both because of the density and because of the mixture with smoke. […] Things seen at a distance which partake of more brightness of light, seem nearer than they are, and those that are in blackness seem to be farther than they are. […] From this experience with nature the art of painting has derived excellent rules, as I explained with definite rules in

a little book dedicated to the outstanding Venetian painter Jacopo Bellini, showing in what ways it should be known how to apply bright and dark colors, with a system such that not only the parts of a single image on a painted surface should seem in relief, but also such that when they are looked at they should be believed to be putting a hand or foot outward, or that they might seem miles away from the men and animals and mountains also placed on the same surface. Indeed, the art of painting teaches that near things should be colored with bright colors, the far with dark, and the middle with mixed ones." Cf. Clagett (*op. cit.*, 21): "Ab hac naturali experientia ars pictoria optimos canones accepit, ut in libello ad iacobum bellinum venetum pictorem insignem certe descripsi, quibusque modis colores obscuros et claros apponere sciret, tali cum ratione, quod non solum unius imaginis partes relevatae viderentur in plano depictae, verum extra manum vel pedem porrigere crederentur inspectae, et eorum quae in eadem superficie hominum, animalium vel montium equantur quaedam per miliaria distare apparerent atque eiusmodi. Ars quidem pingendi docet propinqua claris, remota obscuris mediaque permixtis sub coloribus tingi deberi."

31 Jean Paul Richter, *Leonardo da Vinci: The Literary Works* (London 1883), II, 295; Dominique Raynaud, "A hitherto unknown treatise on shadows referred to by Leonardo da Vinci," *Perspective as Practice*, S. Dupré, ed. (Turnhout 2019), 260–77.

32 Pächt, *Venezianische Malerei, op. cit.*, 37 "[…] eine Subordination des Sterblichen unter die Gottesmutter mit dem Jesuskind, die sich in der Diskrepanz der Grössenordnungen ausdrücken soll und die besonders altertümlich wirkt, wenn man dabei an die etliche Jahre früher entstandene Konfrontation von anbetendem Stifter und verehrtem Gottessohn in Jan van Eycks Rolin-Madonna denkt, die sich wie eine Begegnung zweier denselben Existenzraum bewohnender, derselben Existenzart angehörender, äußerlich physisch gleichgestellter Wesen ausnimmt." I have attempted to explain the relative backwardness of the Louvre painting in relation to Pisanello's portrait in Bergamo by the fact that the judge of this competition was not Leonello himself but his father, Niccolo III d'Este (1393–1441). Norberto Gramaccini, "Wie Jacopo Bellini Pisanello besiegte: der Ferrareser Wettbewerb von 1441," *Idea*, I (1982), 27–53.

33 Comparable is Pisanello's painting *The Vision of Saint Eustace* of about the same date (London, National Gallery).

34 "Bellinis Streuung von Goldstaub ist eine Wiederherstellung der ursprünglichen Lichtfunktion,

sozusagen naturalistisch motivierte Goldmusterung"
(Pächt, *Venezianische Malerei, op. cit.*, 37).

35 Alberti, *op. cit.*, III (53), 75.

36 For the *Scuola Grande di S. Marco*, Squarcione had executed two canvases (*teleri*) in 1466, in competition with Jacopo Bellini, who was to paint the rest of the cycle (Lipton, *op. cit.*, doc. 83, 379).

37 Degenhart and Schmitt, *Corpus*, II-5, *op. cit.*, 128–48; Eisler, *op. cit.*, 42–3, 60–2.

38 Alessandro Galli, "L'Annunciazione di Sant'Alessandro e Jacopo Bellini," *Museo Bresciano*, 5 (1995), 104–08.

39 Claus, *op. cit.*, 63, figs. 40 and 43. Equally revealing is the fundamentally different representation of the *Dormition of the Virgin*, presenting, in the case of the Brescia altarpiece, a conventional setting with the Virgin in a horizontal position, whereas in folio 28 and similarly in folio 67 (British Museum) she is shown in a vertical position and in full accordance with a geometrically designed architecture. Cf. Degenhart and Schmitt, *Corpus*, II-5, *op. cit.*, 135–36 and II-6, 341. See Appendix III.

40 Pächt, *Venezianische Malerei, op. cit.*, 17–8: "Wie das Liniengerüst der perspektivischen Konstruktion in bestimmten baulichen Gebilden und Architekturformen festgelegt ist – die Konstruktionslinien sind überall noch zu erkennen –, so ist der im Gerüst der Sehpyramide verankerte Architekturprospekt seinerseits vollkommen ausgebildet da, bevor die Figuren oder besser die Figurinen eingesetzt werden, die auf der vorgegebenen Bühne diese oder jene Szene zu spielen haben. Man könnte es mit einer szenischen Aufführung vergleichen, die für ein Bühnenbild nicht ad hoc gebaut wird, um den speziellen illustrativen Bedürfnissen und Erfordernissen der zu veranschaulichenden Handlung zu genügen, sondern für die eine irgendwo in der Realität existierende und als Schauplatz der betreffenden Legende mögliche Szene gewählt wird. Für den Tempelgang Mariae etwa hatte der Künstler den Vorplatz einer Kirche zu finden, der über eine ausgedehnte Treppenanlage verfügte. Diese einzige Vorbedingung musste erfüllt sein, was das übrige betrifft, hat die Szene ihre eigene topographische Illusionsgesetzlichkeit, ungeachtet dessen, ob ein Detail oder Architekturmotiv im Spiel etwas zu sagen hat oder nicht, ja in zahlreichen Fällen selbst ohne Sorge darum, ob es mit der vom Thema geforderten Milieuillusion vergleichbar ist oder gar gegen sie verstösst."

41 Degenhart and Schmitt, *Corpus*, II-5, *op. cit.*, 37.

42 W. Roger Rearick, "The *Dormitio Virginis* in the Capella de' Mascoli," *De Lapidibus Sententiae. Scritti di Storia dell'Arte per Giovanni Lorenzoni*, T. Franco

and G. Valenzano, eds. (Padua 2002), 343–62; Davide Banzato, "Mantegna a Padova tra il 1445 e il 1460, la prospettiva restituita," *Arte e dossier* (2006), 6–13; Michelangelo Muraro, "Mantegna e Alberti," *Arte, pensiero e cultura a Mantova nel primo rinascimento in rapporto con la Toscana e con il Veneto: Atti del VI Convegno internazionale di studi sul rinascimento* (Florence 1961), 103–32 (117f.); Laudadeo Testi, *La Storia della Pittura Veneziana, Le origini*, vol. 1 (Bergamo 1909), 479–80.

43 Michelangelo Muraro, "Mantegna e Alberti," *op. cit.*, 103–132 (117f.)

44 Eisler, *op. cit.*, 448 Malatini's portrait, which is attributed to Gentile Bellini in the National Gallery (London), shows a man with a pair of dividers (circa 1500). Cf. Sara Menato, "Per la giovinezza di Carpaccio," *Pittura del Rinascimento nell'Italia settentrionale*, Quaderni, 7 (2016), 47–60.

45 References to the Louvre drawings, which may provide a *terminus ante quem* for the transfer of the *Louvre Album* to Jacopo's *bottega*, emerge hesitantly in Jacopo Bellini's design for the three panels of the Gattamelata Altar (1459/60) in the Santo church and in the two full-page illuminations executed for Strabo's *De situ orbis geographia* (Albi, Médiathèque, Centre Pierre Almaric, ms 77, fols. 3v-4r), attributed to Jacopo on good grounds: Giacomo Alberto Calogero, "Il problema della Pala Gattamelata e gli esordi di Giovanni Bellini," *Paragone*, 147 (2019): 3–31; *Mantegna & Bellini* (exh. cat.), *op. cit.*, 106–7; cf. S. Fumian, in *Mantegna a Padova 1445–1460* (exh. cat.), Musei Civici, Padua, D. Banzato et alii, eds. (Milan 2006), 290–95, nos. 69–71. The *Adoration of the Magi* (Ferrara, Pinacoteca Nazionale) is to be compared to the composition in folio 34, similarly the *Descent of Christ into Limbo* (Padua, Musei Civici agli Eremitani) to folio 22v. The soldier's armors in the *Crucifixion* (Venice, Museo Correr) recall the soldier with the winged helmet in folio 90, yet it is interesting to note that no horses appear in this scene as they do in folio 90.

46 Alberti, *op. cit.*, I (19), 39.

47 Christiane Joost-Gaugier (*Jacopo Bellini, Selected Drawings*, New York 1980, XIV) convincingly compares this figure and the setting as such with Ghiberti's composition of *Isaac* in the *Gates of Paradise*.

48 Michele Savonarola, *Speculum physiognomie* (1442), fol. 99, 2 (as quoted by Simonetti, *Filosofia naturale, medicina e pittura nella testimonianza di Michele Savonarola, op. cit.*, 415, n. 52). Regarding the theory of proportion in Padua from Pietro d'Abano up to Cennini: Graziella Federici Vescovini, "La simmetria del corpo umano nella *Physiognomica* di Pietro d'Abano: un canone estetico," in *Concordia Discors:*

Studi su Niccolò Cusano offerti a Giovanni Santinello, G. Piaia, ed. (Padua 1993), 347–60 (349f.).

[49] Michelangelo Muraro, "La ricerca di un ciclo perduto: Gli affreschi dello Squarcione nella chiesa di San Francesco a Padova," *Padova e la sua provincia*, 29 (1983), 3–9. The first to mention mannequins of this type is the architect Filarete in his *Trattato di architettura* (1460/64), A. M. Finoli and L. Grassi, eds. (Milan 1972), fol. 184r – 184v: "figuretta di legname che sia disnodata le braccia e le gambe." Mantegna might recur to the same model in the front figures to the right of the *Martyrdom and Transporting of the Body of St. Christoper* (Ovetari Chapel), whereas neither Jacopo nor his successors made any use of it. I wonder if Squarcione's first experience with wooden mannequins dates back to his profession as a dressmaker (see p. 10). The *terraverde* frescoes in San Francesco (circa 1460), hardly visible any more due to the bad state of preservation, as well as Lorenzo Canozi da Lendinara's *intarsie* in the Santo (1462) were related to Squarcione's discoveries in perspective (Muraro, *Francesco Squarcione, op. cit.*, 69). The nineteenth century engraving *Saint Francis Presenting the Roses to the Pope* (Muraro, 71) shows a cherckerboard system based upon linear perspective similar to the *chaxamento* in folio 45.

[50] Eisler (*op. cit.*, 449) discusses the term *chaxamento*, meaning architectural setting. Vasari used the term in relation to Brunelleschi's perspective panels. For the dating of the *Louvre Album's* index between 1470/71 (the death of Jacopo Bellini) and 1479 (Gentile Bellini's departure for Constantinople): Degenhart and Schmitt, *Corpus*, II-6, *op. cit.*, 427.

[51] Golubew, *op. cit.*, II, 1908, XL.

[52] Livy (*Ab urbe condita*, 39, 51) reports that Hannibal committed suicide by drinking poison after having been betrayed by King Prusias I of Bithynia so as to avoid Roman imprisonment. Cornelius Nepos (*Hannibal* 12) and Iuvenal (10, 163ff.) give a similar interpretation. Following Appian (*Mithridateios* 9–23), Polybios (*Historiai*, 36, 14), and Diodor (*Bibliotheke Historike*, 32, 19–21), Hannibal was stoned to death by the order of Nikomedes in the Temple of Zeus. More to the point is Conrad de Mandach ("Le symbolisme dans les dessins de Jacopo Bellini," *Gazette des Beaux-Arts*, 5 (1922), 39–60, 56), suggesting the illustration of an episode told by Silius Italicus (*Punica*, XV, 807–23) about the killing of Hannibal's brother Hasdrubal at the battle of the Metaurus, where Consul C. Claudius Nero "displays to Hannibal his brother's head fixed on a pike." The poem *Punica* had been rediscovered by Poggio Bracciolini in 1416/7 (Frances Muecke, *Commentary on Silius Italicus*, Geneva 2011), and the killing of Hasdrubal is mentioned in Filarete' *Treatise on Architecture* (fol. 183v) as a model for *storia* (John Spencer, Trans., Yale 1965, I, 313). Degenhart and Schmitt (*Corpus*, II-6, *op. cit.*, 362) rejected de Mandach's interpretation on principle: "Im Gegensatz zu seinem im humanistischen Padua aufgewachsenen Schwiegersohn Andrea Mantegna lässt sich bei Jacopo Bellini kaum Interesse an Themen der römischen Geschichte feststellen." They proposed the illustration of a biblical event instead: Isboseth's head given to King David (2 Samuel, ch. 4), which is shown in the Bible for Borso d'Este (Modena, Biblioteca Estense, Ms. Lat. 429, fol. 129).

[53] Baccio Ziliotto, *Raffaele Zovenzoni: la vita, i carmi* (Trieste 1950), 109, n. 135; Fortini-Brown, *op. cit.*, 118. Zovenzoni also composed lines of praise for Giovanni and Gentile in his poem *Istrias*. Cf. Marzia Pontone, "Giovanni Bellini e Raffaele Zovenzoni. Un sodalizio artistico e letterario nella Venezia del Quattrocento," *Giovanni Bellini. La nascita della pittura devozionale umanistica* (exh. cat.), Pinacoteca Brera, E. Daffra and S. Bandera Bistoletti, eds. (Milan 2014), 91–95 (93) Irene Favaretto, Arte antica e cultura antiquaria nelle collezioni venete al tempo della Serenissima, (Rome 1990), 61.

[54] Frölich-Bum, *op. cit.*, 46. Cf. Creighton Gilbert, "On Subject and Not-Subject in Italian Renaissance Pictures," *The Art Bulletin*, 34 (1952), 202–17 (208f.).

[55] See on this subject matter: Johannes Grave, "Allegorisierung durch Ikonisierung? Architekturen bei Jacopo und Giovanni Bellini," *Die Oberfläche der Zeichen*, G. Tarnow, ed. (Paderborn 2014), 77–95 (79ff.); Christiane L. Joost-Gaugier, "Subject or Non-Subject in a Drawing by Jacopo Bellini," *Commentarii. Rivista di critica e storia dell'arte*, 24 (1973), 148–53.

[56] Gian Paolo Lomazzo, *Trattato dell'arte della Pittura* [Milan 1584] (Hildesheim 1968): "La prospettiva ... universale è quella che mostra come s'ha da collocare una figura secondo il luoco ove si pone, e che circostanze dee havere, come che un Rè si collochi in atto alla maestà reale conveniente, et in un luoco eminente e soprano, che uno non stia in spatio dove non possa stare o tochi quello che non può toccare, ne faccia cosa tale la qual facendo occupi quello che ha da far l'altro."

[57] I agree with Degenhart and Schmitt (*Corpus*, II-5, 34) in assigning particularly pronounced constructions to an early stage: "Outrierte, geschachtelte Raumfluchten sind kennzeichnend für den die perspektivischen Mittel übertrieben einsetzenden Künstler. Gemässigte, nicht so verzerrte, natürlich wirkende Bildräume sind hingegen Ausdruck seines zu beruhigter Grösse und Selbstverständlichkeit gewachsenen Spätstils."

[58] Robert Klein, "Pomponius Gauricus on Perspective," *The Art Bulletin*, 43 (1961), 211–30 (215).

[59] Francesco Divenuto, "La prospettiva nel trattato di Pomponio Gaurico," *Pomponio Gaurico: De sculptura*, P. Cutolo, ed. (Naples 1999), 49–68 (54): "Un apparato grafico, sia pure e temporaneo…giustificherebbe la scarsa chiarezza del solo testo il quale, stampato senza l'ausilio iconografico, risulta incompleto."

[60] Rather than insisting on geometrical figures such as the *mazzocchi* that were Paolo Uccello's preoccupation, Gaurico's main interest is the clarity of any *istoria* that depends on the rule of distances (*intervalla*) between the participants within a given space (ibid., 204). The latin term *perspicuitas*, used for the clarity of language, is derived from Quintilian's *Institutio oratoria* (VIII, 2,3): André Chastel, Robert Klein, *Pomponius Gauricus. De Sculptura* [1504] (Geneva 1969), 166–67.

[61] Gaurico, *op. cit.*, IV, § 4, 1999, 211. Similar diagrams referring to Euclid's *Elements* (XII) accompany the portrait attributed to Jacopo de' Barbari showing the mathematician Luca Pacioli (circa 1495), Museo di Capodimonte (Naples). Cf. Renzo Baldasso, "Portrait of Luca Pacioli and Disciple – a new mathematical look," *The Art Bulletin*, 92 (2010) 83–102.

[62] Alberti, *op. cit.*, I, (19 and 20), 39–42. Rudolf Wittkower, *Architectural Principles in the Age of Humanism* (London 1971), I, 3–13; Howard Collins, "The Decagonal Temples of Jacopo Bellini," *Paragone* (1990), 3–11. Most scholars agree that by the 1430s Belllini must have come to know Leon Battista Alberti (Eisler, *op. cit.*, 445).

[63] Erwin Panofsky, *Perspective as Symbolic Form* [1927] (New York 2011); Cecil Grayson, "L. B. Alberti's 'costruzione legittima'," *Italian Studies*, 14 (1964), 14–28; Pietro Roccasecca, "Pisanello, Alberti and *costruzione legittima*," in *Perspektiva / Perspective*, M. Pasternak and N. Eröss, eds. (Budapest 2000), 67–83.

[64] Christiane Joost-Gaugier, "Jacopo Bellini's Interest in Perspective and Its Iconographical Significance," *Zeitschrift für Kunstgeschichte*, 38 (1975), 1–28.

[65] Regarding Alberti's Paduan formation and his possible knowledge of Pelacani's *Quaestiones*: Simonetti, "La formazione di Leon Battista Alberti," *op. cit.*, 276–92 (285). Regarding his knowledge of the Arab Alhazen's (Ibn Al-Haitham, 965–1040) *De aspectibus*: Pietro Roccasecca, "The Pyramid and the *Intentiones*: Alhacen, Alberti and the Composition of Stories in Paintings," *The Springtime of the Renaissance – Sculpture and the Arts in Florence 1400–60* (exh. cat.), Palazzo Strozzi (Florence 2013), B. Paolozzi Strozzi and M. Bormand, eds. (Nepi 2013), 173–79; Filippo Camer-

ota, *La prospettiva del rinascimento. Arte, architettura, scienza* (Milan 2006), 63.

[66] "Die Art und Weise, wie sich Jacopo mit den perspektivischen Problemen auseinandersetzt, wie er durch Beobachtung fortschreitet und praktisch das Gesetz vom Hauptpunkt findet, zeigt ihn uns als Autodidakten und praktischen Wissenschaftler, d.h. als Künstler, der durch Einzelbeobachtungen zum Allgemeingültigen gelangte. Es hätte seine Bestrebungen gewiss gefördert, wenn er Alberti's klare Ausführungen gekannt hätte." Quoted after Fröhlich-Bum, *op. cit.*, 47–9. Cf. Mariani Canova, *Riflessioni, op. cit.*, 12–13. The opposite view that the "perspective as worked out in architectural complexes is a clear indication of Florentine inspiration" is upheld by Christiane Joost-Gaugier, "The Tuscanisation of Jacopo Bellini. I: The Relation of Jacopo to Problems of the 1420s," *Acta Historiae Artium*, 23 (1977), 95–112 (95).

[67] Alberti, *op. cit.*, I (19), 40.

[68] Degenhart and Schmitt, *Corpus*, II-5, *op. cit.*, 66, 76, 81.

[69] Alberti, *op. cit.*, I (20), 41.

[70] Giulio Carlo Argan, "The Architecture of Brunelleschi and the Origins of Perspective Theory in the 15th Century," *Journal of the Warburg and Courtauld Institutes*, IX (1946), 96–121; Johannes Grave, "Brunelleschi's Perspective Panels: Rupture and Continuity in the History of the Image," *Renaissance?*, A. Lee et alii, eds. (Leiden 2010), 161–80.

[71] Howard F. Collins, "The Cyclopean Vision of Jacopo Bellini," *Pantheon*, XL (1982), 300–04; Testi, *op. cit.*, 483 ("sceglie male il punto di vista, cioé troppo vicino agli oggetti").

[72] Roberto Longhi, *Viatico per cinque secoli di pittura veneziana* (Florence 1946, 11), has underlined the simplicity of the perspective and suggested that, what seems to be likely, the artist had "purchased a magical little box with converging lines at a Padua's stationer's, designed for use of amateurs so that they could play the game of perspective with pieces and figures of wax and cottonwood, which are found throughout so many of his his drawings. They resemble a medium's avocation of a beloved, misunderstood world." Quoted after Eisler, *op. cit.*, 445.

[73] Vasari, *op. cit.*, III, 548 [I.488]. Regarding the content of this letter: Wolfgang Kallab, *Vasaristudien*, ed. J. v. Schlosser (Vienna 1908), 347–54.

[74] Paolo dal Pozzo Toscanelli studied in Padua from 1415 to 1424 when he returned to Florence: Marisa Dalai Emiliani, "Per la prospettiva padana," *Arte Lombarda*, 16 (1971), 117–36. Alberti lived in Padua in the years from 1416 to 1421 when he visited Barzizza's school: Norbedo, *op. cit.*, 346; Bergdolt, *op. cit.*, XXI;

Collodo, "L'esperienza," *op. cit.*, 317; Rémy Simonetti, "La formazione di Leon Battista Alberti," *op. cit.*, 241–312.

[75] Alberti, *op. cit.*, 18.

[76] Leonardo Bruni, *Oratio funebris* (1428), quoted after Hans Baron, *The Crisis of the Early Renaissance* [1955] (Princeton 1996), 556.

[77] The idea of *superatio* is also expressed in the literary debate between the Florentine Pico della Mirandola and the Paduan Pietro Bembo: Luc Hersant, *Giovanni Francesco Pico della Mirandola, Pietro Bembo: De l'imitation* (Paris 1996). Cf. Jörg Robert, "Norm, Kritik, Autorität. Der Briefwechsel *De imitatione* zwischen Gianfrancesco Pico della Mirandola und Pietro Bembo und der Nachahmungsdiskurs in der Frühen Neuzeit," *Pluralisierung und Autorität in der Frühen Neuzeit*, A3 SFB München, *Daphnis* 30 (2001), 597–644.

[78] Vasari, *op. cit.*, III, 63 [I.269].

[79] Ulrich Pfisterer, *Donatello und die Entdeckung der Stile* (Munich 2002), 417, 508. Cf. Serena Romano, "Giotto's O," *Viella History, Art and Humanities*, vol. 1, Rome 2015.

[80] Markham Schulz, *Francesco Squarcione*, *op. cit.*, 44.

[81] Peta Motture, "Donatello a Padova: pratica di bottega e scambio artistico," *Mantegna e Padova 1445–1460* (exh. cat.), Padua Musei Civici, D. Banzato et alii, eds. (Milan 2006), 109–19 (111); Giancarlo Gentilini, "Intorno alla Pala Ovetari: appunti sull'eredità donatelliana a Padova, fra Pizolo, e Mantegna," *Francesco Squarcione – 'Pictorum gymnasiarcha*, *op. cit.*, 195–206. A point of reference for the intrusion of Alberti's treatise in Padua is Michele Savonarola's *Speculum* that makes reference to *De pictura* (Brennan, *op. cit.*, 185). Regarding Savonarola's relationship with the Eremitani church: Silvana Collodo, "La committenza di Andrea Mantegna. Scienza della natura e *studium pictorie* a Padova alla fine del medioevo," *Mantegna e Padova 1445–1460*, *op. cit.*, 29–35 (31f.). Not only does the change in perspective in the Eremitani Chapel evince the presence of Alberti's *legittima costruzione* (see Appendix VIII and IX); also Mantegna's defense towards Squarcione's criticism (following Scardeone), in which he advocates Pliny's legend of Zeuxis and the maidens of Croton, may have been due to the reading of *De pictura* (Alberti, *op. cit.*, III, 78–9).

[82] Significantly, a drawing given to Pisanello in the Louvre (Inv. 2520) that might be of the same date as the early drawings of the *Louvre Album* (circa 1445) pays tribute to the system of perspective and proportion elaborated there. Cf. Samuel Y. Edgerton Jr., *The Renaissance Rediscovery of Linear Perspective* (New York 1975), 50–55; Degenhart and Schmitt, *Corpus*,

II-5, *op. cit.*, 84–90; Pisanello. *Le peintre aux sept vertus*, *op. cit.* no. 71.. The uniqueness of this study and its vicinity to the problems of perspective elaborated in the *Louvre Album* (fols. 28, 45 and in particular fol. 76) is such, that one is tempted to speculate about an immediate linkage with Squarcione's academy.

[83] Lipton, *op. cit.*, doc. 79, 376: "[…] da fede como a cosse false et fititie et facto malitiosamente per lo dicto m. o. francesco contra el dicto m. o agnolo come e sempremay de so costume che sempremay cerca cum le sue promission laudandose delle cosse lequal non ha et de saver quello chel non sa et promette de far ale persone perfina tanto che li ha reducti et cavado el sugo desi […]."

[84] This is an important argument for their later date. Degenhart and Schmitt (*Corpus*, II-5, *op. cit.*, 82): "[…] gegenüber dem Pariser Band sind Vereinfachungen in seinen perspektivischen Methoden eingetreten. Bellini's Hinwendung zu perspektivischen Problemen verlor an Intensität. In den Londoner Zeichnungen wurde, entsprechend ihrem generell spontanen Charakter, auch die Perspektive freier und grosszügiger gehandhabt. Das ging so weit, daß sogar in gewissen Londoner Zeichnungen nicht alle Figuren auf ein und dieselbe Horizonthöhe bezogen wurden, was vorher für Jacopo Bellini geradezu bindende Regel war."

[85] For a close stylistic analysis distinguishing between "a strength and clarity of outline in advance of the master's usual style" (in the idealized head of Emperor Domitian), "more hesitant freehand outlines" (in the ACVTIO monument), and a "cruder draftsmanship": Windows, *op. cit.*, 93-4. Regarding the composition of the images: Degenhart and Schmitt, *Corpus*, *op. cit.*, II-5, 204.

[86] Their alignment has reminded Degenhart and Schmitt, "Jacopo Bellinis Beitrag zur Epigrafik" (*op. cit.*, II-5, 192–213), of the streets of tombs (*Gräberstrassen*) outside of Rome, still to be seen in those days. Regarding the coomparison with Marco Zoppo's drawing in Marcanova's Modena sylloge (Ms. alpha L. 5.15, fol. 39v): Degenhart and Schmitt, *Corpus*, II-5, *op. cit.*, 205. Cf. Annegrit Schmitt, "Antikenkopie und künstlerische Selbstverwirklichung in der römischen Frührenaissance. Jacopo Bellini auf den Spuren römischer Epitaphien," *Antikenzeichnung und Antikenstudium in Renaissance und Frühbarock: Akten des internationalen Symposiums* [1986], R. Harprath and H. Wrede, eds. (Mainz 1989), 1–20.

[87] *Corpus Inscriptionum Latinarum* (CIL) Theodor Mommsen et alii, eds. (Berlin 1872), V, pt. 1 and 2. Cf. Donato Fasolini, "Le iscrizioni dell'album del Louvre di Jacopo Bellini. Una fonte attendibile per epigrafia

e iconografia?," *Antichistica / Storia ed epigrafia 7* [ebook 978-88-6969-374-8/007] (2019), 113–29 (115).

[88] The *Louvre Album* contained altogether five pages showing "circles of medals of Emperors". The originals that were intended to be reproduced may have belonged to the Paduan humanist Giovanni Marcanova who possessed a collection of 250 ancient coins. Marcanova left Padua in 1453, which would explain why the plan never materialized. Another Paduan collector of medals was his close friend, Annibale Maggi da Bassano. Cf. Giulio Bodon, "L'Interesse numismatico ed antiquario nel primo Trecento veneto. Disegni di monete antiche nei codici delle Historiae Imperiales di Giovanni Mansionario," *Xenia Antiqua*, II (1993), 111–24; id., "Studi antiquari tra XV e XVII secolo. La famiglia Maggi di Bassano e la sua collezione di antichità," *Bollettino del Museo Civico di Padova*, LXXX (1991), 23–172; Favaretto, *Arte antica, op. cit.*, 55; Degenhart and Schmitt, *Corpus*, II-5, *op. cit.*, 217–18.

[89] Cf. Windows, *op. cit.*, 94–5.

[90] Rushton (*op. cit.*, 170, 204) names three characteristics that differ from the drawings from classical monuments of the Gentile-Pisanello circle: 1) Topography – the monuments copied are located in Northern Italy rather than in Rome; 2) Accuracy – the tombstones and their inscriptions have been copied faithfully; 3) Combination – the Louvre draftsman has added different elements on his own.

[91] Phyllis Pray Bober and Ruth Rubinstein, *Renaissance Artists and Antique Sculpture. A Handbook of Sources* (London 1986), no. 88, 121. Following Eisler (*op. cit.*, 207), the decoration of the base is derived from a bacchic altar (Venice, Seminario Patriarcale). Giulio Bodon, in his forthcoming article ("Per la fortuna del giardino di antichità nella prima rinascenza veneta: il caso padovano," *Rivista di Archeologia*, XLIII, 2019, 105–14 (106), presents the hypothesis that this cippus formerly belonged to the collection of Alessandro da Bassano (*in hortulo domini Alexandri de Basssano*) as did the Acutius altar itself, which is why they had been combined in one drawing.

[92] Mommsen (*CIL* 2553) refers to it as *corollae cum personis*. Cf. Degenhart and Schmitt, *Corpus*, II-5, *op. cit.*, 204, fig. 212.

[93] Mary Bergstein, "Donatello's Gattamelata and Its Humanist Audience," *Renaissance Quarterly*, 55, 3 (2002), 833–868 (850–853). The competition had been supervised by no less than Leon Battista Alberti who refers to it in his treatise *de eqvo animante*: Leon Battista Alberti, *De eqvo animante*, C. Grayson and F. Furlan, eds. (Pisa 2017). Cf. Degenhart and Schmitt, *Corpus*, II-6, *op. cit.*, 468–70.

[94] Scardeone, *op. cit.*, 82

[95] Regarding alterations of the inscription with respect to the original: Fasolini, *op. cit.*, 119; Schmitt, *Antikenkopie und künstlerische Selbstverwirklichung, op. cit.*, 6.

[96] Much closer in time is Giovanni Dondi (1318-88). In his *Iter Romanum* (1375) and a letter to Fra Guglielmo da Cremona (1381), Dondi makes reference to his passion of copying and measuring ancient inscriptions. Creighton E. Gilbert, "A Letter of Giovanni Dondi dall'Orologio to Fra Guglielmo Centueri," *Viator Medieval and Renaissance Studies*, 8 (1977), 333-36. Dondi also started to compose a sylloge related to the monuments he had studied in Rome, of which two pages have been preserved (Venice, Biblioteca Nazionale Marciana, Lat. XIV, 223, folios 44 and 46, recto and verso).

[97] "[…] suggeriscono non solo la dipendenza da altre fonti, dunque non un controllo di prima mano del monumento, ma anche una maggiore incertezza nell'intendere il senso del testo e nel distribuirlo nello spazio in un modo compatibile all'armonia delle più eleganti iscrizioni romane" (Fasolini, *op. cit.*, 127).

[98] "Aus der Darstellung des Inschriftträgers und der Transskiption des Titulus ist zu schließen, daß Jacopo Bellini dieses römische Einsprengsel innerhalb seiner 'Sammlung' von oberitalienischen, vorwiegend in der Umngebung von Padua und Verona beheimateten Denkmälern nicht aus der Autopsie kannte." (Degenhart and Schmitt, *Corpus*, II-6, *op. cit.*, 373).

[99] *in obelisco apud s. petri. sup lapidem ubi cineres caes* (Giovanni Marcanova, cod. alfa 1.515, Biblioteca estense, Modena, folios 60v and 61r). Regarding the obelisk's place in the context of Angelo Decembrio's *De politia literaria* (circa 1450): Brian Curran and Anthony Grafton, "A Fifteenth-Century Site Report on the Vatican Obelisk," *Journal of the Warburg and Courtauld Institutes*, 58 (1995), 234–48.

[100] Casu, "Drawings after the Antique," *op. cit.*, 134.

101 "[…] l'accuratezza nella riproduzione dei particolari romani … lascia senza parole" (Gallerani, *op. cit.*, 185). For the illustration of the original stele (Vienna, Kunsthistorisches Museum, inv. nr. III 1148): Degenhart and Schmitt, *op. cit.*, 207; Eisler, *op. cit.*, 207; Fasolini, *op. cit.*, 125–26.

102 Pietro Bembo (1470-1547), a defender of Paduan *imitatio* against the Florentine concept of *emulatio*, summarized the matter as follows: "Creativity should possess the precondition that the artist or writer is inspired by models from the classical past, which he should use wisely (*prudenter*) in order to sustain and embellish this heritage rather than erase it." (Hersant, *op. cit.*, 90). Cf. G. W. Pigman, "Versions of Imitation

in the Renaissance," *Renaissance Quarterly*, XXXIII, 30 (1980), 1–32.

103 "[…] fit aut addendo, aut subtrahendo, aut commutando, aut transferendo, aut novando" (Biblioteca Marciana, Venice, MS. XI. 34 [4354], fol. 29), quoted after Baxandall, *Giotto and the Orators, op. cit.* 34.

104 The authoritative text in this matter is: Decembrio, *De politia litteraria* (*op. cit.*, 201). Decembrio lets his teacher Guarino make the following distinction: "Caeterum scriptoris sermo ad operis duntaxat inventionem, librarius autem ad chracterum exarationem pertinet, seu in charta, seu ceratis tabulis, quin etiam in pariete figuras scribi et legi dicitur, ideoque librarius a libris vel libellis dicitur, quorum diversa semper extat compositio." Regarding the *lettera antica*: James Wardrop, *The Script of Humanism. Some Aspects of Humanistic Script 1460–1560* (Oxford 1963), 6–7.

105 Albinia de la Mare, *The Italian Manuscripts in the Library of Major J. R. Abbey*, A. de la Mare and J. G. Alexander, eds. (New York and Washington 1969), xxviii, fn. 4; Elisabetta Barile, "Contributi su Biagio Saraceno, copista dell'Eusebio Marciano Lat. IX.1 (3496) e cancelliere del verscovo di Padova Fantino Dandolo," *Studi di storia religiosa padovana dal medioevo ai nostri giorni: studi in onore di mons. Ireneo Daniele*, F. G. B. Tirolese, ed. (Padua 1997), 141–64.

106 Albinia de la Mare and David Ekserdijan, *La miniatura a Padova da Medioevo al Settecento* (exh. cat.), Palazzo della Ragione (Padua 1999), G. Canova Mariani et alii, eds. (Modena 1999), 123–25; Debra Pincus, "Calligraphy, Epigraphy, and the Paduan-Venetian Culture of Letters in the Early Renaissance," *Padua and Venice. Transcultural Exchange in the Early Modern Age*, B. Blass-Simmen and S. Weppelmann, eds. (Berlin and Boston 2017), 41–60 (49).

107 Sarah Vowles and Dagmar Korbacher, "Jacopo Bellini and the Formation of Giovanni," *Mantegna & Bellini* (exh. cat.), *op. cit.*, 95–107 (107). Andrea Canova, *Mantegna 1431–1506* (exh. cat.), Musée du Louvre (Paris 2008), G. Agosti and D. Thiébaud, eds. (Paris 2008), cat. 10, 78–9. Tosetti Grandi (*Mantegna, op. cit.*, 332–33) believes that it was Marcanova who proposed Mantegna to have the miniature executed, and that Saraceno and Mantegna worked together in the bishop's *scriptorium*.

108 "Sulle orme di Mantegna e delle maiuscole da lui dipinte in iscrizioni negli affreschi della Cappella Ovetari, Sanvito scelse di dare forma epigrafica alle maiuscole dei suoi manoscritti" (Nuvoloni, *op. cit.*, 496–7). Further documents are Mantegna's inscriptions in the *Berlin Madonna* (1449), the monogram that St. Anthony of Padua and St. Bernardino hold in a fresco above the central doorway on the façade of the Santo (dated July 22, 1452), and a painting of *Santa Euphemia* bearing the date of 1454 (Naples, Museo di Capodimonte). Cf. Collodo, "La committenza," *op. cit.*, 29–35. Regarding Feliciano's *Alphabetum Romanum*: Giorgio Montecchi, "Lo spazio del testo scritto nella pagina di Feliciano," *L'Antiquario Felice Feliciano Veronese tra epigrafia antica, letteratura e arti del libro: Atti del Convegno di Studi* (Verona 1993), A. Contò and L. Quaquarelli, eds. (Padua 1995), 251–288 (264ff.). Cf. Millard Meiss, "Toward a More Comprehensive Renaissance Paleography," *The Art Bulletin*, XLII, 1960, 97–112 (106); Geoffrey D. Hargreaves, "Florentine Script, Paduan Script, Roman Type," *Gutenberg Jahrbuch*, 67 (1992), 15–34 (26–8).

109 Paola Isabella Gallerani, "Andrea Mantegna e Jacopo Bellini: Percorsi epigrafici a confronto," *Aquileia Nostra*, LXX (1999) 178–210.

110 He is to be considered the true father of epigraphy. In the words of Jacopo Zeno (1442/3), Cod. Lat. fol. 557, Staatsbibliothek Berlin (fols. 48v – 54r): "Tu enim laboribus et ingenio tuo obscurissima epigrammata et truncatissimas inscriptiones clarissime dilucidasti et quonam modo legerentur primus invenisti et docuisti et in doctrinam quandam et regulam ac in rectam formam atque sententiam redegisti." Quoted after Louis Bertalot and Augusto Campana, "Gli scritti di Iacopo Zeno e il suo elogio di Ciriaco d'Ancona," *La Bibliofilia*, 41 (1939–40), 356–76 (372). Cf. Michail Chatzidakis, *Ciriaco d'Ancona und die Wiederentdeckung Griechenlands im 15. Jahrhundert* (Petersberg 2017); Giorgio Mangani, *Antichità inventate. L'archeologia geopolitica di Ciriaco d'Ancona* (Milan 2017); Carlo Roberto Chiarlo, "*Gli frammenti dilla sancta antiquitate*: studi antiquari e produzione delle immagini da Ciriaco d'Ancona a Francesco Colonna," *Memoria dell'antico nell'arte italiana: L'uso dei classici*, vol. I, S. Settis, ed. (Turin 1984), 271–97 (274).

111 Rita Cappelletto, "Ciriaco d'Ancona nel ricordo di Pietro Ranzano," *Ciriaco d'Ancona e la cultura antiquaria dell'umanesimo: Atti del convegno internazionale di studio* (Ancona 1992), G. Paci and S. Sconocchia, eds. (Reggio Emilia 1998), 71–80. The high esteem Ciriaco earned becomes apparant in that he served as guide to the antiquities of Rome to Emperor Sigismund in 1433. Patrizia Bossi, "L'*Itinerarium* di Ciriaco Anconitano," in *Ciriaco d'Ancona e il suo tempo. Viaggi commerci e avventure fra sponde adriatiche, Egeo e Terra Santa*, L. Minardi, ed. (Ancona 2002), 169–83 (172).

112 The *commentaria* were lost in a fire in the Sforza library at Pesaro in 1514. A fragment related to Ciriaco's trip to the Peloponnese in 1447 has survived (Ms.

Trotti 373, Biblioteca Ambrosiana, Milan). Charles Mitchell, "Ex libris Kiriaci Anconitani," *Italia Medioevale e Umanistica*, V (1962), 283–99.

[113] Ian Holgate, "Paduan Culture in Venetian Care: the Patronage of Bishop Pietro Donato (Padua 1428–47)," *Renaissance Studies*, 16, I (2002), 1–23; Paolo Sambin, "La Bibliotheca di Pietro Donato," *Bollettino del Museo Civico di Padova*, XLVIII (1959), 53–78. Regarding Barzizza's allocution on the occasion of Donato's doctorate in 1418: Révest, "Umanesimo," *op. cit.*, 3–34.

[114] Theodor Mommsen, "Über die Berliner Excerptenhandschrift des Petrus Donatus," *Jahrbuch der Preussischen Kunstsammlungen*, IV (1883), 72–89; Helmut Boese, *Die lateinischen Handschriften der Sammlung Hamilton zu Berlin* (Wiesbaden 1966); Windows, *op. cit.*, 97–99; Pincus, "Calligraphy," *op. cit.*, 44.

[115] Referring to Padua are folios 76, 76v, 78v, 106v, 122, 126.

[116] Daniela Gronta, "Marcanova, Giovanni," *Dizionario Biografico degli Italiani*, 69 (2007), 476–84; Silvia Danesi Squarzina, "Eclisse del gusto cortese e nascita della cultura antiquaria: Ciriaco, Feliciano, Marcanova, Alberti," *Da Pisanello alla nascita deli Musei Capitolini. L'Antico alla vigilia del Rinascimento* (exh. cat.), Musei Capitolini (Rome 1988), A. Cavallaro and E. Parlato, eds. (Milan 1988), 27–37.

[117] Chiarlo, *op. cit.*, 272.

[118] Elisabetta Barile, "La famiglia Marcanova attraverso sette generazioni", *Cittadini Veneziani del Quattrocento. I due Marcanova, il mercante e l'umanista: Istituto veneto di scienze, lettere ed arti, Memorie*, vol. CXVII, E. Barile, P. C. Clarke, G. Nordio, eds. (Venice 2006), 3–248 (195). Following Augusto Campana ("Il codice epigrafico di Faenza, Biblioteca Comunale," *L'Antiquario Felice Feliciano Veronese tra epigrafia antica, letteratura e arti del libro: Atti del Convegno di Studi* (Verona 1993), A. Contò, ed. (Padua 1995), 81–88, a sylloge in Faenza bearing the inscription *Petro Donato Patricio Johannes P*, transcribed by Felice Feliciano, had been dedicated by Marcanova (*Johannes P* = Johannes Patavinus?) to Donato before 1447. Further support for this interpretation is added by Tosetti Grandi (*Andrea Mantegna*, 310–11). Following Irene Favaretto (*Arte antica, op, cit.*, 49), Marcanova had inherited from Pietro Donato Ciriaco's notes and parts of his collection, for which, however, there is no proof.

[119] The first epigraphical museum ever is the one assembled by Alessandro da Bassano in the garden of his Paduan residence and continued by his brother Annibale: Christiane Joost-Gaugier, "The *Casa degli Specchi* a Padova, Its Architect Annibale Bassano, Tito Livio and a Peculiar Historical Connection," *Bolletti-*

no del Museo Civico di Padova, LXXII (1983), 113–24. Bodon, "Studi antiquari" *op. cit.*, and id., "Per la fortuna del giardino," *op. cit.* For the Roman tombstone from Buvolenta, see p. 55. Mention must also be made of the Venetians Ludovico Trevisan and Francesco Contarini (*Areopagita*), known to have been avid collectors of antiquities, who had settled in Padua. Contarini, having received his degree in 1442, embellished his Paduan house with classical inscriptions (Eisler, *op. cit.*, 196).

[120] Transcribed in: Iohannes Marcanova, *Collectio antiquitatum*, Biblioteca estense Modena, alfa 1.5.1.5, folio 6. Bergstein, *op. cit.*, 835, 853; Eugenio and Myriam Billanovich, "Epitafi ed elogi per il Gattamelata," *Italia Medioevale e Umanistica*, 37 (1994), 223–32.

[121] Lightbrown, *op. cit.*, 78, cat. nos. 67, 458. Giacoma's house, situated in the contrada di Santa Lucia, was only a few yards away from the house Mantegna bought in 1458 from Nicolò Savonarola (ibid., 78). The drawing of a funeral monument from the collection His La Salle (RF 428) that was added to the *Louvre Album* in 1878 is perhaps related to Giacoma's commission. Scardeone (1560, 132): "Pinxit thalamum vetustae domus super fornicem prope D. Luciam cum historia Gattamelatae." Regarding the *condottiere Pietà* showing Gianantonio da Narni after falling in battle in 1455: Sarah Blake McHam, "The Eclectic Taste of the Gattamelata Family," *Padua and Venice, op. cit.*, 28–40 (31). Regarding the relationship with a drawing showing the lamentation of a dead by Antonio del Pollaiuolo (London, Wallace Collection, P. 762) and folio 55v (British Museum): Degenhart and Schmitt, *Corpus*, II-6, *op. cit.*, 495.

[122] *Hac et plurima alia require in meo Libro Magno Epitaphiorum* (in Marcanova's own handwriting): Cod. B. 42, folio 149v, Bern, Burgerbibliothek.

[123] Alberta de Nicolò Salmazo, "Giovanni Marcanova, *Quaedam antiquitatum fragmenta studio Iohannis Marchanovae artium et medicinae doctoris patavini collecta*," *La Miniatura a Padova dal Medioeveo al Settecento* (exh. cat.), Palazzo della Ragione (Padua 1999), G. Canova Mariani et alii, eds. (Modena 1999), 255–56; Schmitt, "Antikenkopie und künstlerische Selbstverwirklichung," *op. cit.*, 5.

[124] From the five codices in Bern, Modena, Paris, Princeton, and Genova only those in Modena and Princeton bear illustrations (Tosetti Grandi, *op. cit.*, 290–93). Regarding the manuscripts in Paris (Bibliothèque Nationale, 5825, dated 1465) and Princeton (University, Ms. Garrett 158, believed to be a copy of the Paris manuscript): J. J. G. Alexander, "Giovanni Marcanova, *Collectio antiquitatum*," *The Painted*

Page: Italian Book Illumination, 1450–1550 (London and Munich 1994), 144–45 (cat. no. 67).

[125] In Ciriaco's case, these were executed by amateurs who did not pay much attention to details or proportion. The syllogai before Ciriaco were not illustrated at all. Regarding Giuliano da Sangallo's copies after Ciriaco: Charles Mitchell, "Ciriaco d'Ancona, Fifteenth-Century Drawings and Descriptions of the Parthenon," *The Parthenon [Norton Critical Studies in Art History]*, V. J. Bruno, ed. (New York 1973), 111–23 (120f.). Cf. Fortini Brown, "Antiquarianism," *op. cit.*, 75–6.

[126] Degenhart and Schmitt, *Corpus*, II-5, *op. cit.*, 199, fig. 202.

[127] Susy Marcon, "Vale feliciter," *Lettere Italiane*, XL (1988), 536–56 (544).

[128] Maria Teresa Franco Fiorio, "Marco Zoppo et le livre padouan," *Revue de l'Art*, 53 (1981), 65–73. Regarding convergences between the Modena sylloge and the *Louvre Album*: Fortini Brown, "Antiquarianism," *op. cit.*, 70–1; Susy Marcon, "La miniatura nei codici di Giovanni Marcanova," *La miniatura a Padova dal Medioevo al Settecento* (exh. cat.), Palazzo della Ragione (Padua 1999), G. Canova Mariani, ed. (Modena 1999), 481–93 (490); Windows, *op. cit.*, 278–83.

[129] Giuseppe Fiocco, "Felice Feliciano, amico degli artisti," *Archivio Veneto-Tridentino* (Venice 1926), 188–201. Cf. Charles Mitchell, "Archeology and Romance in Renaissance Italy," *Italian Studies: A Tribute to the Late Cecilia M. Ady* (London 1960), 453–83; id., "Felice Feliciano *Antiquarius*," *Proceedings of the British Academy*, 47 (1961) 197–221; Windows, *op. cit.* 101–02, 231–34, 268–70.

[130] "Collections of classical inscriptions were now regarded as objects of value, suitable pawns of exchange for princes and prelates in the elaborate gift-giving and diplomatic protocols of Renaissance society" (Fortini Brown, "Antiquarianism," *op. cit.*, 77). Cf. Fritz Saxl, "The Classical Inscription in Renaissance Art and Politics," *Journal of the Warburg and Courtauld Institutes*, 2 (1939), 346–67.

[131] Elena Necchi, "Una silloge epigrafica padovana: gli *Epygramata Illustrium Virorum* di Johannes Hasenbeyn" [Epigrafia a Padova, Gilda P. Mantovani, Elena Necchi, Guido e Maria Pia Billanovich], *Italia Medioevale e Umanistica*, XXXV (1992), 123–77. Another German who had been caught by the passion for epigraphy was Johannes Hinderbach, a correspondent of Felice Feliciano, who graduated in the presence of Emperor Frederic III in Padua in 1452 (Calogero, *Non tanto per el guadagno quanto per l'onore*, *op. cit.*, 11). Scardeone's account of local Paduan epigraphy (*De antiqvis notis priscarvm inscriptionum in vrbe & territorio patavino repertis*, Basel 1560, Lib. I, iiii, 57–87) heavily relies on Marcanova's collection.

[132] Eisler (*op. cit.*, 206) quotes Ciriaco d'Ancona's justification: "It is sometimes my business to awaken the dead out of their graves; it is an art I learned from the Pythian oracle of Apollo."

[133] Seen in this perspective, the *Hypnerotomachia Poliphili* by Francesco Colonna (written in 1467 and printed with woodcuts by Aldus Manutius in Venice in 1499) is in line with the humanist's syllogai and their increasingly visionary and fantastic contents: Giovanni Pozzi and Gianni Gianella, "Scienza antiquaria e letteratura, Il Feliciano, Il Colonna," *Storia della cultura veneta dal primo quattrocento al Concilio di Trento*, I–III, G. Arnaldi and M. P. Stocchi, eds. (Vicenza 1980), I, 459–98 (467f.). Mitchell ("Archeology and Romance," *op, cit.*, 461) rightly called the *Hypnerotomachia* an "archaeological rhapsody".

[134] Kathleen Wren Christian, *Empire without End – Antiquities Collections in Renaissance Rome, c. 1350–1527* (New Haven and London 2010).

[135] One is reminded of Andrea Bussi's (1417–1475) remarks concerning the rise of the modern book industry: contrary to the illuminated books of the gothic period, produced exclusively for a wealthy clientele, the editing of printed books was a pedagogic enterprise also including the poor (*ad paupera laboramus*): Gramaccini, "Buch und Bild," *op. cit.*, 14.

[136] In Windows' opinion (*op. cit.* 128), however, Jacopo Bellini was rather "a source of antiquarian subject-matter than a recipient."

[137] The fact that CLODIAE was omitted in the two syllogai from 1460 and 1465 does not exclude that it was to be found in Marcanova's lost notebook, the *librum magnum epitaphium* from the 1440s, which was the master copy used by the draftsman of the *Louvre Album*.

[138] Fasolini, *op. cit.*, 121; Degenhart and Schmitt, *Corpus*, II-5, *op. cit.*, 207–07.

[139] *Quod ioannes marcanova ex buvolera agri q. portare fecit.* Buvolenta is the place where Squarcione's family came from. Elda Zorzi, "Un antiquario padovano del sec. XVI. Alessandro Maggi da Bassano," *Bollettino del Museo Civico di Padova*, LI, 1 (1962), 41–98 (66).

[140] Giordana Mariani Canova, "La dimensione accademica della miniatura del rinascimento padovano," *Paleography, Manuscript Illumination and Humanism in Renaissance Italy*, R. Black et alii, eds. (London 2016), 297–322.

[141] Milena Ricci, "Un tesoro di libro. Il codice Marcanova della Biblioteca Estense universitaria," *Civiltà*

Mantovana: Nel segno di Andrea Mantegna. Arte e cultura a Mantova in età rinascimentale (Modena 2006), 105–15; Fiorio, "Marco Zoppo," op. cit.; Chapman, Padua in the 1450s, op. cit., 34; Giordana Mariani Canova, "Marco Zoppo e la miniatura," Marco Zoppo Cento 1433–1478 Venezia: Atti del Convegno di Studi, B. Giovanucci Vigi, ed. (Bologna 1993), 121–35. Regarding Zoppo's friendship with Felice Feliciano: Stefano Carrari, "La corrispondenza poetica di Feliciano con Giovanni Testa Cillenio" L'Antiquario Felice Feliciano, op. cit., 177–96 (180f.).

[142] David S. Chambers, Jane Martineau and Rodolfo Signorini, "Mantegna and the Men of Letters," Andrea Mantegna (exh. cat.), Royal Academy of Arts, London, J. Martineau, ed. (Milan 1992), 8–31; Tosetti Grandi, Andrea Mantegna, op. cit., 274–77, n. 4.

[143] Elisabetta Barile, "Giovanni Marcanova e i suoi possibili incontri con Andrea Mantegna," Mantegna e Padova 1445–1460 (exh. cat.), op. cit., 37–43.

[144] It has been shown, in one single instance, that Feliciano had access either to the Louvre Album itself or to its preparative designs, probably through Mantegna. His full-page drawing of St. George to be dated before 1463 (Cod. Reg. Lat. 1388, folio 31v, Biblioteca Vaticana) clearly quotes the version of St. George, folio 14: Keith Christiansen, "Early Works: Padua," Andrea Mantegna, op. cit., 94–117 (106f.). Windows, op. cit., 272–75.

[145] MERENTI. Pictorum principi ac unico lumini et cometae magniq. ingenii viro andreae mantegnae patavo amicorum splendori Felix Felicianus salute (Epigrammaton liber, Biblioteca Nazionale Marciana, Lat. X, 196 (=3766), folio 26v (13/I/1464). Feliciano's dedication in the Bologna manuscript (Biblioteca dell'Archiginnasio, A. 186): ΑΓΑΘ ΤΥΧΗ ad andream celeberrimum pictorem nec non amicum incomparabilem. Cf. Mantegna 1431–1506 (exh. cat.), op. cit., no. 67, 194–96; Fiocco, "Felice Feliciano," op. cit., 189f.; Lightbrown, Mantegna, op. cit., 94–5; Mitchell Felice Feliciano Antiquarius, op. cit., 213, no. 1.

[146] Leonardo Quaquarelli, "Felice Feliciano e Francesco Scalamonti (junior?)," Ciriaco d'Ancona e la cultura antiquaria dell'umanesimo, op. cit., 333–347; Myriam Billanovich, "Intorno alla Iubilatio di Felice Feliciano," Italia Medioevale e Umanistica, XXXII (1989), 351–58; Eleonora Caccia, "La Iubilatio di Felice Feliciano," Italia Medioevale e Umanistica, 55 (2014), 167–223; Windows, op. cit., 62–3.

[147] Gilbert, Italian Art, op. cit., 179. Mantegna may well have had his part in organizing this trip since it needed the approval of his patron, Lodovico Gonzaga, and was guided by Samuele da Tradate, who at that time was also working at the Gonzaga court in Mantua and was a friend of Mantegna's.

[148] There are doubts whether, instead of Marcanova, the person in question is the engineer Giovanni da Padova who was employed at the Gonzaga court in Mantua (Chambers, Martineau and Signorini, op. cit., 17); Barile ("Giovanni Marcanova e i suoi possibili incontri," op. cit., 38–9) and Giovanni Rodella (Giovanni da Padova. Un ingegnere gonzaghesco nell'età dell'Umanesimo: Quaderni del Dipartimento di Conservazione delle Risorse Architettoniche e Ambientali, 9, Milan 1988), 26) support this interpretation. It seems unlikely, however, that the epitheton Antenoreo would have suited the latter whose relation to antiquarian studies is not documented. Tosetti Grandi points to an incunabulum containing letters by Iacopo Zaccaria, in which Marcanova (?) is addressed as "venerabili et supra omnes antiquitatis indagatori amatoriq(ue) praecipuo honorando pro patria aliter extra" (Andrea Mantegna, op. cit., 304): "mi pare che un altro Giovanni, amante e indagatore precipuo dell'antichità, degno di onore più di ogni altro nella sua patria, non sia da trovare a Padova in questi anni."

[149] Tosetti Grandi (Mantegna, op. cit., 297) quotes the well-informed Paduan canon Lorenzo Pignoria (1571–1631) calling Mantegna "intimo di Giovanni Marcanova."

[150] Fasolini, op. cit., 122; Gallerani, op. cit., 188; Windows, op. cit., 106–07.

[151] The PVLLIO inscription is quoted again in a miniature painting attributed to the Maestro dei Putti in the lower part of the frontispiece of Titus Livius. Historiae Romanae I II IV decades, J. A. Vindelinus de Spira, ed. (Venice 1470), Vienna Inc. 5.C.9 (Gallerani, op. cit., 186; Fasolini, op. cit., 124, n. 35).

[152] Andrea Moschetti, "Le inscrizioni lapidarie romane negli affreschi del Mantegna agli Eremitani," Atti del R. Istituto Veneto di Scienze, Lettere ed Arti, LXXXIX (1929–1930), 227–37 (233); Eisler, op. cit. 193; Paul D. Knabenshue, "Ancient and Medieval Elements in Mantegna's Trial of St. James," The Art Bulletin, 41 (1959), 59–73.

[153] A point of comparison are two roundels with sculpted portrait busts above Mantegna's inscription which refer to a similar scheme (adding two sides of a coin of emperor Domitian) in the Louvre drawing (see p. 47). Gallerani, op. cit., 186–87; Fasolini, op. cit., 125.

[154] Gallerani, op. cit., 187–88.

[155] It is of interest that Mantegna quotes below the PVLLIO inscription another inscription, avg . p [.o…] / rom [.] io [..] / vman [.] p […], that appears nowhere else. Similarly, in the POMPONENVS inscription, as it

appears in the *Martyrdom of St. Christopher*, Mantegna has added the lines "hi (?) qvi . vi ... / iii xxxviii", which may refer to an inscription from Padua (CIL, V, 2961, inv. 68 Musei Civici, Padua). Gallerani, *op. cit.*, 197.

156 Windows, *op. cit.*, 72–3.

157 See Fasolini's reconstruction (*op. cit.*, fig. 3, 123).

158 Vasari (*op. cit.*, III, 549 [I.488]) mentions explicitly the *Martyrdom of Saint Christopher*. Mantegna did this to appease Squarcione after he had reproached the latter as the Ovetari frescoes "were poorly done because Andrea had imitated ancient marbles," advocating the imitation of living bodies instead. For the identification of ten portraits: Lightbrown, *op. cit.*, 55.

159 Tobia Patetta, "Marmi, pietre e mattoni: città modernamente antiche di Andrea Mantegna conoscitore d'architettura?," *Mantegna e Roma. L'Artista davanti all'antico*, T. Calvano et alii, eds. (Rome 2010), 271-301; Gallerani, *op. cit.*, 185; Robert Eisler, "Mantegnas frühe Werke und die römische Antike," *Monatsberichte über Kunst und Kunstwissenschaft*, 3 (1903), 164ff. Cf. Sandro de Maria, *Giovanna Tosi, L'Arco dei Gavi* [Rome 1983] (review), *Epigraphia*, 46 (1984), 301–08.

160 *Intra fornicem in porta intus*, following Mommsen (quoted by Gallerani, *op. cit.*, 192). The *Arco dei Gavi* had been destroyed in 1805 and reconstructed in the 1930s next to the Castelvecchio. Again, Mantegna presents a less precise version of the inscription by omitting the c in *archite(c)tvs*.

161 The author of the *De architectura* was held to be the architect of the Veronese amphitheater. This was already the opinion of Ciriaco d'Ancona who had visited Verona in 1433 (*arenam augustam ex L. Vitruvio nobilissimo architecto*). Following a local tradition, noted by Marcanova (*CIL*, V, 3464), the *Arco dei Gavi* with its inscription was believed to be part of the amphitheater: "Veronae in porta geminata ex amphiteatro nostro ablata et nunc in arce veteri posta." Cf. Guido Beltramini, "Mantegna e la firma di Vitruvio," *Mantegna e le arti a Verona 1450–1500*, S. Marinelli and P. Marini, eds. (Venice 2006), 139–47 (139). The person in question, however, is Lucius Vitruvius Cerdo (Gallerani, *op. cit.*, 192–93).

162 "Die Veroneser Inschriften waren Felice Felicianos eigener Beitrag zum Inschriften-Corpus des Marcanova" (Degenhart and Schmitt, *Corpus*, II-5, *op. cit.*, 203). The inscription is quoted in the Bern as well as in the Modena sylloge. It also appears in Feliciano's sylloge (Faenza, Biblioteca Manfrediana, cod. 7): Gallerani, *op. cit.*, 195, n. 57; Tosetti Grandi, *Andrea Mantegna*, *op. cit.*, 287, fig. 9.

163 Brigit Blass-Simmen, "Cultural Transfer in Microcosm. Padua and Venice: An Introduction," *Padua and Venice*, *op. cit.*, 1–18 (2).

164 David Landau and Peter Parshall, *The Renaissance Print. 1470–1550* (New Haven and London 1994), 65ff.; *Early Italian Engravings from the National Gallery of Art* (exh. cat.), National Gallery, Washington, J. A. Levenson et alii, eds. (Washington 1973), nos. 71, 72, 75; Patricia Emison, "The Raucousness of Mantegna's Mythological Engravings," *Gazette des Beaux-Arts*, 124 (1994), 159–176.

165 Patricia Anne Emison, *Invention and the Italian Renaissance Print. Mantegna to Parmigianino* (PhD Thesis University of Michigan, Ann Arbor 1985).

166 In circa 1447, Ulisse de Aleotti dedicated a poem in praise of Mantegna (*Ulixis pro Mantegna pictore, dicto Squarsono, pro quondam moniali*), giving testimony that by this date his stylistic maturity had already been fully recognized. Calogero, *Non tanto per el guadagno quanto per l'onore*, *op. cit.*, 3.

167 Gramaccini, "Buch und Bild," *op. cit.*, 21.

168 The table of contents lists the subject as *una Istoria de Bacho con uno caro di trionfo chel tira*. Eisler, *op. cit.*, 508; Fortini Brown, *Venice and Antiquity*, *op. cit.*, 193–95.

169 Windows, *op. cit.*, 150, n. 42 (with a list of references from classical literature).

170 As to Catullus and Giovanni Bellini's painting of Bacchus (Venice, Accademia): Eisler, *op. cit.*, 204.

171 Degenhart and Schmitt, *Corpus*, II-5, *op. cit.*, 223, fig. 278; Pray Bober and Rubinstein, *op. cit.*, figs. 81–83a, 115–19. See also: Bacchic sarcophagus, Rome, Villa Doria Pamphili; Grottaferrata, Abbazia di San Nilo (Census 157851); Rome, Villa Medici (Census 157229) / references are taken from the Website of the CENSUS of Antique Works of Art and Architecture Known in the Renaissance / Humboldt University, Berlin). The similarity between the Satyr holding the reins of the horse and the same motif on the relief of the funeral monument for Lucius Publius (Cologne, Römisch-Germanisches Museum) may be fortituous.

172 The term *bacccchanaliorum vacationes* is quoted under the year 1447 by the lexicographer Jacopo Facciolati, *Fasti Gymnasii Patavini opera collecti ab anno MCCCVI venetae dominationis primo ad justitium anni MDIX* (Padua 1757, 11), when the Senate forbade their duration of ten days. That these *Bacchanalibus diebus* did indeed include theatrical performances related to Bacchus is documented only for the years 1563 and 1573 (Filippo Tomasini, *Gymnasium Patavinum* (Padua 1654), 413 and 416): [1563] *Ex pecunia primae Nivis scholares in Palatio Praefecti comœdiam Baccha-*

nalibus in Palatio Praetoris instruxerunt. [1573] *Quo etiam tempore de pecunia primae Nivis scholares in Palatio Praefecti comœdiam recitant, theatro constituto expensis omnium Nationum collatis.* Cf. Antonio Bonaventura Sberti, *Degli spettacoli e delle feste che si facevano in Padova* (Padua 1818), 44, 105. Eisler (*op. cit.*, 205, n. 46) and Testi (*Storia, op. cit.*, II, 208, no. 3), furthermore, refer to certain Bacchic scenes having decorated the residence in Treviso of the Venetian humanist Ermolao Barbaro (c. 1450), a former student at the University of Padua. Cf. Cornelius von Fabriczy, "Il convento di Porta San Gallo a Firenze," *L'Arte*, 6 (1903), 381–84 (383).

[173] Degenhart and Schmitt, *Corpus*, II-5, *op. cit.*, 229.

[174] Fritz Saxl, "Jacopo Bellini and Andrea Mantegna as Antiquarians," *Lectures* [1957], *A Heritage of Images; A Selection of Essays* (London 1970), 57–70, regarded the capacity to invent "great mental scenes *all' antica* which cannot be related to texts or marbles, but which interpret classical subjects in a new and highly subjective language," as symptomatic of the Venetian humanism. Cf. John W. Pope-Hennessy, "The Italian Plaquette," *Proceedings of the British Academy*, L (1964), 63–85: "Whereas with medals the emblem or allegory on the back refers to status or character of the person who is represented on the front, the imagery of plaquettes is non-specific. In those reliefs in which the subject-matter is not religious, the artist's aim was to establish visual metaphors of the principles of conduct of his time." I do not agree with the current hypothesis that it was the bacchic vocabulary of Donatello and his partner Michelozzo to supply information for Bellini's repertoire (Eisler, *op. cit.*, 201).

[175] Leo Planiscig, *Venezianische Bildhauer der Renaissance* (Vienna 1921), 334–36; id., *Andrea Riccio*, (Vienna 1927), 358, n. 113. Cf. *Rinascimento e passione per l'antico. Andrea Riccio e il suo tempo* (exh. cat.), Castello del Buonconsiglio (Trento 2008), A. Bacchi and L. Giacomelli, eds. (Trento 200), 334–7, no. 45. Millard Meiss, "Sleep in Venice: Ancient Myths and Renaissance Proclivities," *Proceedings of the American Philosophical Society*, 110 (1966), 348–82.

[176] *Museo Archeologico Nazionale di Venezia*, Irene Favaretto, Marcella De Paoli and Maria Cristina Dossi, eds. (Milan 2004), 97, n. III, 23.

[177] Irene Favaretto, "L'immagine e il suo doppio. Le sculture dello statuario e l'artista del Cinquecento: Copie, imitazioni e 'invenzioni' all'antica," *Lo statuario pubblico della Serenissima; due secoli di collezionismo d'antichità, 1596-1797*, (exh. cat.), Biblioteca Marciana, Venice, I. Favaretto and G. L. Ravagnan, eds. (Venice 1997), 107–12 (108): "[…] è da ritenere un pastiche fine 400 o inizi 500, nel quale, pur non mancando

citazioni dotte dall'antico, compaiono certe ingenuità che l'artista antico non avrebbe mai commesso come gli zoccoli di capra e non di cavallo della centauressa dormente e i due centauri compressi in uno scorcio forzato e innaturale entro i brevi limiti della lastra." Cf. Friedrich Matz, *Die Dionysischen Sarkophage, III* (Berlin 1968), nos. 210, 295, fig. 96.

[178] Irene Favaretto, "L'immagine radoppiata: calchi, copie e invenzioni 'all'antica' nelle collezioni venete di antichità," *Les moulages de sculptures antiques et l'histoire de l'archéologie: Actes du colloque international Paris, 24 octobre 1997*, H. Lavargne and F. Queyrel, eds. (Geneva 2000), 13–21 (14); Maria Luisa Bianco, "Saggio di lettura di un museo cinquecentesco. La raccolta di Marco Mantova Benavides," *Iconografia 2001. Studi sull'immagine: Atti del Convegno* (Padua 2002), 495–503; Alessandra Menegazzi, "La Gipsoteca del Museo di Scienze Archeologiche e d'Arte dell'Università di Padova: l'esposizione e la fruizione," *Gipsoteche. Realtà e Storia: Atti del Convegno Internazionale*, M. Guderzo, ed. (Possagno 2008), 17–27; Victoria Avery, "The Production, Display and Reception of Bronze Heads and Busts in Renaissance Venice and Padua: Surrogate Antiques," *Kopf / Bild: Die Büste in Mittelalter und Früher Neuzeit: Italienische Forschungen des Kunsthistorischen Institutes in Florenz*, J. Kohl and R. Müller, eds. (Munich 2007), 75–112.

[179] Marcantonio Michiel, *Notizia d'opere del disegno*, *op. cit.*, 30. Irene Favaretto, "Appunti sulla collezione rinascimentale di Niccolò Leonico Tomeo," *Bollettino del Museo Civico di Padova*, LXVIII (1979), 15–31 (25).

[180] Lucian of Samosata, *Zeuxis and Antiochus*, II, 196. A fourteenth century manuscript of Lucian's text is reported in the collection of the Paduan humanist Raffaele Regio, a correspondant of Tomeo in Gaurico's treatise on sculpture (Pierre de Nolhac, "La Bibliothèque de Fulvio Orsini," *Bibliothèque de l'Ecole des Hautes Etudes*, 74 (1887), 171–72).

[181] Alberti, *op. cit.*, III (53), 76.

[182] Jean-Michel Massing, "A Few More Calumnies: Lucian and the Visual Arts," *Lucian of Samosata Vivus et Redivivus; Warburg Institute Colloquia*, X (London 2007), 129–44.

[183] This regards the copy in plaster as well, which Benavides may have bought after Squarcione's death together with other reproductions from the same collection. Bianca Candida, *I calchi rinascimentali della collezione Mantova Benavides nel museo del Liviano a Padova* (Padua 1967), 94–96; Norberto Gramaccini, "Ideeller Besitz: Paduaner Gipsabgüsse des Quattrocento," *Reproduktion: Techniken und Ideen von der Antike bis heute: eine Einführung*, J. Probst, ed. (Ber-

lin 2011), 58–93. For Squarcione's reproductions in plaster, as fns. 207, 4 (Summary).

[184] Paulus Orosius, *Historiarum adversum paganos septem* (417/18), and, following him, Giovanni Boccaccio, *Genealogia deorum gentilium*: Andreas Emmerling-Skala, *Bacchus in der Renaissance* (Hildesheim 1994), 57.

[185] Pope Nicholas V, in the years following 1447, gave orders to Poggio (lib. I-V), George of Trapezunt (lib. XI–XIV) and Pier Candido Decembrio (lib. XVI–XX) to translate Diodor's text. Passages of his work were known already to Bruni and Salutati. Another Codex (*Cod. Laur LXX* 18), containing *Books I, II, III* and parts of *V*, is reported to have been in the possession of Francesco Filelfo (before 1433). In Padua, Diodor's image of Bacchus was spread through Barzizza's pupil Giovanni Tortelli (circa 1400–1466), probably making use of Poggio's translation. Emmerling-Skala, *op. cit.*, 80–84, 89.

[186] Emmerling-Skala, *op. cit.*, 74–78.

[187] Diodorus Siculus, *The Library of History*, Vol. 4, C. H. Oldfather, Trans. (Cambridge, Loeb Classical Library): "Satyrs also, it is reported, where carried about by him in his company and afforded the god greatest delight and pleasure in connection with their dancings and their goat-songs. And, in general, the Muses who bestowed benefits and delights through the advantages which their education gave them, and the Satyrs by the use of the devices which contribute to mirth, made the life of Dionysios happy and agreable. There is general agreement also, they say, he was the inventor of thymelic contests, and that he introduced places where the spectators could witness the shows and organized musical concerts; furthermore, he freed from any forced contribution to the state those who had cultivated any sort of musical skill during his campaigns, and it is for these reasons that later generations have formed musical associations of the artists of Dionysios and have relieved of taxes the followers of this profession." Renaissance humanists such as Alberti (*De re aedifictoria*) referred to Vitruvius' *De architectura*, where Bacchus is credited with the invention of theater (Eisler, *op. cit.*, 205).

[188] "[…] emere ac vendere instituit Liber pater, idem diadema, regum insigne, et triumphum invenit" (Plinius, *Naturalis historia*, VII, 56, 191).

[189] Horace, *Carmina*, 4, 2, 49; Tibullus, 2, 5, 118.

[190] Diodorus Siculus, 4.5.

[191] Emmerling-Skala, *op. cit.*, 98.

[192] From here originates the attribution of the painting *Hercules and Nessus* characterized by Eisler (*op. cit.*, 526) as being "the only known painting in an early Venetian renaissance style to show classical mythology." Cf. Lionello Venturi, "A Mythological Picture by Jacopo Bellini," *Burlington Magazine*, 49 (1927), 205. The apparent conventionalism emerging from Ulisse Aleotti's sonnets (circa 1412–1468), where Jacopo Bellini is compared to Apelles, Phidias and Polykleitos, has been rightly highlighted by Windows (*op. cit.*, 67).

[193] *Tu, fonte d'ogni inzegno altiero*, as expressed by Filippo Nuvoloni in a sonnet adressed to Mantegna in 1460/65; Feliciano, in a sonnet from December 18, 1461, calls him *speranza antica* (Tosetti Grandi, *Andrea Mantegna*, *op, cit.*, 280, 299). See Battista Fiera's dialogue, *De Iusticia pingenda*, related to Mantegna's presence in Rome (1488/90), which presents the artist as the protagonist of a humanist circle (Lightbrown, *op. cit.*, 198–99).

[194] Campbell, "L'agiografia di Andrea Mantegna," *op. cit.*, 33–59.

[195] Michael Cole and Mary Pardo, "Origins of the Studio," *Invention of the Studio. Renaissance to Romanticism* (Chapel Hill and London 2006), 1–35; Mercer, *op. cit.*, 47.

[196] Leonardo Bruni, *Sulla perfetta traduzione* (Sileni, X), P. Viti, ed. (Naples 2004), 23.

[197] The modern Renaissance appraisal of *disegno* as *fondamento e teorica* of the figurative arts (Ghiberti, *Commentarii I, II,4*) depended on this notion (Reufer, "Materia e Ragionamenti", *op. cit.*, 153–54). Regarding Cennini's combination of drawing and intellect, Brennan, *op. cit.*, 60–1. According to Pier Paolo Vergerio, drawing and writing ranked equally in ancient Greece (*scribere namque est protrahere atque designare*), in: *Petri Pauli Vergerii ad Ubertinum de Carraria de ingenibus moris et liberalibus adulescentiae studiis liber* (earliest dated Ms. 1434, printed 1477), *Humanist Educational Treatises* (*The I Tatti Renaissance Library*), Craig W. Kallendorf, ed. (Cambridge/MA and London 2002), 49–51.

[198] Ernst Walser, *Poggius Florentinus. Leben und Werke* (Leipzig and Berlin 1914), 230.

[199] Hersant, *op. cit.*, 92.

[200] Ernst H. Gombrich, "The Style *all'antica*: Imitation and Assimilation", *Studies in Western Art; Acts of the Twentieth Congress of the History of Art*, vol. II, *The Renaissance and Mannerism* (Princeton 1963), 31–41.

[201] Rushton, *op. cit.*, 166–72. Regarding differences to Jacopo Ripanda, ibid., 205–08.

[202] *The Classical Tradition*, Anthony Grafton, Glenn W. Most, Salvatore Settis, eds. (Cambridge/M and London 2010), 52 ("Antiquarianism"); Anne Raffarin-Dupuis, "*Roma instaurata, Italia illustrata, Roma triumphans*. Flavio Biondo's Encyclopaedic Project for a Dictionary of Antiquities," *Renaissance Encyclopaedism*, W. Scott Blanchard and A. Severi,

eds. (Toronto 2018), 151–84; Emmerling-Skala, *op. cit.*, 796–98.

[203] Rodolfo Signorini, "New Findings about Andrea Mantegna. His Son Ludovico's Post-Mortem Inventory," *Journal of the Warburg and Courtauld Institutes*, 59 (1996), 103–118.

[204] Valturio, XII, 1: "Est enim triumphus omnium militarium rerum honos supremus, maximaque omnis utriusque sexus, aetatis, universae Urbis exultatio, et occursus quidam fiebat honorifica hostium clade duci et victrici turbae redeunti, rerum fortiter ac foeliciter gestarum speciem prae se ferenti" (quoted after Emmerling-Skala, *op. cit.*, 1160). Regarding the printed edition: Agostino Contò, "'Non scripto calamo', Felice Feliciano e la tipografia," *L'Antiquario Felice Feliciano, op. cit.*, 289–312 (290).

[205] The manuscript (*Liber antiquitatum Johannis Marchanove in membranis*) has been recorded in Bologna in 1467. Sandro de Maria, "Künstler, Altertumskenner und Sammler von Altertümern in Bologna des 15. und 16. Jahrhunderts," *Bologna e l'Umanesimo 1490–1510* (exh. cat.), Pinacoteca Nazionale, Bologna 1988, M. Faietti and K. Oberhuber, eds. (Bologna 1988), 17–44 (25). It is possible that the idea for this book derived from the late antique codex *De rebus bellicis*; a copy from the original in Speyer had been ordered in Padua by Bishop Donato (Bodleian Library Oxford, Can. Misc. 37). Mariani Canova, "La miniatura a Padova," *op. cit.*, 25.

[206] The title has been noted by Feliciano (Modena, Biblioteca Estense, *Cod. Alpha L. 5. 15*, fol. 4): "Adverte: Cum in hoc codice saepe fiat mentio de potestate imperatoria et tribunicia, et sic de reliquis, quae ad intelligendum difficilia satis esse videntur, idcirco recurrere ad librum nostrum quem de dignitatibus Romanorum triumpho et rebus bellicis composuimus, in quo plene satis haec tractantur" (quoted after Emmerling-Skala, *op. cit.*, 99, n. 24).

[207] Petrarch's book *Trionfi* (1351–1374) was produced in many lavish manuscript versions and spawned panel paintings for cassoni and the like; in the Scaligeri Palace in Verona, Altichiero and Jacopo Avanzi had frescoed two triumphs of which no trace remains (Vasari, *op. cit.*, III, 620 [I.520]). Regarding Marcanova's library, totalling 521 volumes: Lino Sighinolfi, "La Bibliotheca di Giovanni Marcanova," *Collectanea variae doctrinae: Scritti in onore Leo Olschki* (Munich 1921), 187–222.

[208] Concerning Marcanova's possible influence on Mantegna's *Triumphs of Caesar*: Sarah Vowles and Caroline Campbell, "Mantegna, Bellini and Antiquity," *Mantegna & Bellini* (exh. cat.), *op. cit.*, 232–248 (242). There were originally two more folios (old nos.

3 and 4) in the *Louvre Album* that had been dedicated to the iconography of Roman triumphs. These were, following Jean Guérin (1726), "Deux bas-reliefs, dont l'un est l'entrée d'un empereur avec ses soldats," and "Un triomphe contenant plusieurs bas-reliefs, au milieu duquel une colonne sur laquelle une statue" (quoted after Windows, *op. cit.*, 26).

[209] Cf. Marco Zoppo's illustrations in Marcanova's *Collectio antiquitatum* (Modena): Nicolò Salmazo, *op. cit.*, no. 99, 255–56; Calogero, *Non tanto per el guadagno quanto per l'onore, op. cit.*, 21–23.

[210] This may be indebted partially to a late-medieval tradition of moralizing Ovid's *Metamorphoses* for the sake of learning (*tout est pour notre enseignement*), in the sense of Philippe de Vitry's (1291–1361) *Ovide moralisé*. Jean Seznec, *The Survival of the Pagan Gods: The Mythological Tradition and Its Place in Renaissance Humanism and Art* [1940] (Princeton 1953), 93. Giovanni Caldiera (circa 1400–1474), whose three volumes *De concordantia poetarum, philosorum et theologum* were written between 1447 and 1455, at the time when Caldiera was professor in Padua, may be called a continuator. Margaret L. King, "Personal, Domestic, and Republican Values in the Moral Philosophy of Giovanni Caldiera," *Renaissance Quarterly*, 28 (1975), 535–574. Cf. Windows, *op. cit.*, 162–64, n. 119.

[211] This is a clear misunderstanding, since Medusa had been impregnated by Poseidon; Pegasus was born from Medusa's blood when Perseus cut off her head. Fortini Brown, *Venice and Antiquity, op. cit.*, 193. Cf. Eisler, *op. cit.*, 204.

[212] *El caval Pedeseo con uno spiritello suxo con do fauni.*

[213] Eisler, *op. cit.* 204: "This sea- or sky-worthy horse suggests the mermen and hippocamps by Mantegna and Jacopo de' Barbari."

[214] Reinhard Herbig, *Der griechische Bockesgott. Versuch einer Monographie* (Frankfurt/M 1949), 72–3.

[215] Aristotle, *Nicom. Ethics*, Book 8, 9.

[216] Degenhart and Schmitt, *Corpus, op. cit.*, II-6, 447–49; Windows, *op. cit.*, 173–74.

[217] Rome, Bibl. Vat., MS Barb. Lat. 4076 and 4077.

[218] Dieter Blume, "The Experience of Exile and the Allegory of Love," *Images and Words in Exile*, E. Brilli et alii, eds. (Florence 2015), 172–92; Natalino Sapegno, *Storia letteraria d'Italia: Il Trecento* (Padua 1981), 123. Cf. the iconography of Guillaume de Lorris' and Jean de Meung's *Roman de la Rose* in France and its influence on the representations of the *Triumph of Love*: Marie Jacob, "Les premières représentations des *Trionfi* de Pétrarque dans le royaume de France: le triomphe des modèles italiens?," *La France et l'Europe autour de 1500*, G. Bresc-Bautier et alii, eds. (Paris 2015), 193–206 (197, 199).

219 Petrarch, *Trionfi*, I, 22. Victor Massena and Eugène Müntz, "Pétrarque, ses études d'art, son influence sur les artistes, ses portraits et ceux de Laure, l'illustration de ses écrits," *Gazette des Beaux-Arts* (1902), 200–257. The *Triumph of Love* is the first triumph of altogether six; conformingly, the illustrations and miniatures are divised in six different episodes.

220 It was on this basis that the iconography of folio 43 could influence the biased petrarchesque iconography of the *Triumph* of Love. This happened in the orbit of Andrea Mantegna: Girolamo da Cremona's *Triumphs of Petrarch* (Denver Art Museum, circa 1460) show below the triumphant Cupid the captive slave and a person holding the horse's tail. Caterina Furlan, "I *Trionfi* della collezione Kress: una proposta attributiva e divagazioni sul tema," *Arte Veneta*, 27 (1974), 81–90. Girolamo da Cremona is held to be identical with a certain "Girolamo da Padova" attested in Padua in 1456, and the "Jeronimo suo compagno" who followed Mantegna to Florence in 1466: Federica Toniolo, "Girolamo da Cremona – miniatore alla corte dei Gonzaga," *Andrea Mantegna e i Gonzaga. Rinascimento nel castello di San Giorgio* (exh. cat.), Museo del Palazzo Ducale, Mantua 2006, F. Trevisani, ed. (Milan 2006), 94–101 (95).

221 Plato, *Sym.* 180c–185c.

222 Plato, *Sym.* 181b.

223 Plato, *Sym.* 209b–210c. Cf. Alan Soble, *The Structure of Love* (Yale 1990); id., "A History of Erotic Philosophy," *The Journal of Sex Research*, 46 (2009), 104–120.

224 Plato, *R.* 403a-b: "οὐδὲν ἄρα προσοιστέον μανικὸν οὐδὲ συγγενὲς ἀκολασίας τῷ ὀρθῷ ἔρωτι; [...] οὐ προσοιστέον ἄρα αὕτη ἡ ἡδονή [...] ὀρθῶς ἐρῶσί τε καὶ ἐρωμένοις."

225 Plato, *Phdr.* 237d-238c: "ὅτι μὲν οὖν δὴ ἐπιθυμία τις ὁ ἔρως, ἅπαντι δῆλον· ὅτι δ' αὖ καὶ μὴ ἐρῶντες ἐπιθυμοῦσι τῶν καλῶν, ἴσμεν. τῷ δὴ τὸν ἐρῶντά τε καὶ μὴ κρινοῦμεν; δεῖ αὖ νοῆσαι ὅτι ἡμῶν ἐν ἑκάστῳ δύο τινέ ἐστον ἰδέα ἄρχοντε καὶ ἄγοντε, οἷν ἑπόμεθα ᾗ ἂν ἄγητον, ἡ μὲν ἔμφυτος οὖσα ἐπιθυμία ἡδονῶν, ἄλλη δὲ ἐπίκτητος δόξα, ἐφιεμένη τοῦ ἀρίστου. τούτω δὲ ἐν ἡμῖν τοτὲ μὲν ὁμονοεῖτον, ἔστι δὲ ὅτε στασιάζετον· καὶ τοτὲ μὲν ἡ ἑτέρα, ἄλλοτε δὲ ἡ ἑτέρα κρατεῖ. δόξης μὲν οὖν ἐπὶ τὸ ἄριστον λόγῳ ἀγούσης καὶ κρατούσης τῷ κράτει σωφροσύνη ὄνομα· ἐπιθυμίας δὲ ἀλόγως ἑλκούσης ἐπὶ ἡδονὰς καὶ ἀρξάσης ἐν ἡμῖν τῇ ἀρχῇ ὕβρις ἐπωνομάσθη. ὕβρις δὲ δὴ πολυώνυμον — πολυμελὲς γὰρ καὶ πολυμερές—καὶ τούτων τῶν ἰδεῶν ἐκπρεπὴς ᾗ ἂν τύχῃ γενομένη, τὴν αὑτῆς ἐπωνυμίαν ὀνομαζόμενον τὸν ἔχοντα παρέχεται, οὔτε τινὰ καλὴν οὔτ' ἐπαξίαν κεκτῆσθαι. περὶ μὲν γὰρ ἐδωδὴν κρατοῦσα τοῦ λόγου τε τοῦ ἀρίστου καὶ τῶν ἄλλων ἐπιθυμιῶν ἐπιθυμία γαστριμαργία τε καὶ τὸν ἔχοντα ταὐτὸν τοῦτο κεκλημένον παρέξεται· περὶ δ' αὖ μέθας τυραννεύσασα, τὸν κεκτημένον ταύτῃ ἄγουσα, δῆλον οὗ τεύξεται προσρήματος· καὶ τἆλλα δὴ τὰ τούτων ἀδελφὰ καὶ ἀδελφῶν ἐπιθυμιῶν ὀνόματα τῆς ἀεὶ δυναστευούσης ᾗ προσήκει καλεῖσθαι πρόδηλον. ἧς δ' ἕνεκα πάντα τὰ πρόσθεν εἴρηται, σχεδὸν μὲν ἤδη φανερόν, λεχθὲν δὲ ᾖ μὴ λεχθὲν πάντως σαφέστερον· ἡ γὰρ ἄνευ λόγου δόξης ἐπὶ τὸ ὀρθὸν ὁρμώσης κρατήσασα ἐπιθυμὶ πρὸς ἡδονὴν ἀχθεῖσα κάλλους, καὶ ὑπὸ αὖ τῶν ἑαυτῆς συγγενῶν ἐπιθυμιῶν ἐπὶ σωμάτων κάλλος ἐρρωμένως ῥωσθεῖσα νικήσασα ἀγωγῇ, ἀπ' αὐτῆς τῆς ῥώμης ἐπωνυμίαν λαβοῦσα, ἔρως ἐκλήθη." Trans. A. Nehamas and P. Woodruff.

226 Plato, *Phdr.* 246a-e: "οἷον μέν ἐστι, πάντη πάντως θείας εἶναι καὶ μακρᾶς διηγήσεως, ᾧ δὲ ἔοικεν, ἀνθρωπίνης τε καὶ ἐλάττονος· ταύτῃ οὖν λέγωμεν. ἐοικέτω δὴ συμφύτῳ δυνάμει ὑποπτέρου ζεύγους τε καὶ ἡνιόχου. θεῶν μὲν οὖν ἵπποι τε καὶ ἡνίοχοι πάντες αὐτοί τε ἀγαθοὶ καὶ ἐξ ἀγαθῶν, τὸ δὲ τῶν ἄλλων μέμεικται. καὶ πρῶτον μὲν ἡμῶν ὁ ἄρχων συνωρίδος ἡνιοχεῖ, εἶτα τῶν ἵππων ὁ μὲν αὐτῷ καλός τε καὶ ἀγαθὸς καὶ ἐκ τοιούτων, ὁ δ' ἐξ ἐναντίων τε καὶ ἐναντίος· χαλεπὴ δὴ καὶ δύσκολος ἐξ ἀνάγκης ἡ περὶ ἡμᾶς ἡνιόχησις. πῇ δὴ οὖν θνητόν τε καὶ ἀθάνατον ζῷον ἐκλήθη πειρατέον εἰπεῖν. ψυχὴ πᾶσα παντὸς ἐπιμελεῖται τοῦ ἀψύχου, πάντα δὲ οὐρανὸν περιπολεῖ, ἄλλοτ' ἐν ἄλλοις εἴδεσι γιγνομένη. τελέα μὲν οὖν οὖσα καὶ ἐπτερωμένη μετεωροπορεῖ τε καὶ πάντα τὸν κόσμον διοικεῖ, ἡ δὲ πτερορρυήσασα φέρεται ἕως ἂν στερεοῦ τινος ἀντιλάβηται, οὗ κατοικισθεῖσα, σῶμα γήϊνον λαβοῦσα, αὐτὸ αὑτὸ δοκοῦν κινεῖν διὰ τὴν ἐκείνης δύναμιν, ζῷον τὸ σύμπαν ἐκλήθη, ψυχὴ καὶ σῶμα παγέν, θνητόν τ' ἔσχεν ἐπωνυμίαν· ἀθάνατον δὲ οὐδ' ἐξ ἑνὸς λόγου λελογισμένου, ἀλλὰ πλάττομεν οὔτε ἰδόντες οὔτε ἱκανῶς νοήσαντες θεόν, ἀθάνατόν τι ζῷον, ἔχον μὲν ψυχήν, ἔχον δὲ σῶμα, τὸν ἀεὶ δὲ χρόνον ταῦτα συμπεφυκότα. ἀλλὰ ταῦτα μὲν δή, ὅπῃ τῷ θεῷ φίλον, ταύτῃ ἐχέτω τε καὶ λεγέσθω· τὴν δὲ αἰτίαν τῆς τῶν πτερῶν ἀποβολῆς, δι' ἣν ψυχῆς ἀπορρεῖ, λάβωμεν. ἔστι δέ τις τοιάδε. πέφυκεν ἡ πτεροῦ δύναμις τὸ ἐμβριθὲς ἄγειν ἄνω μετεωρίζουσα ᾗ τὸ τῶν θεῶν γένος οἰκεῖ, κεκοινώνηκε δέ πῃ μάλιστα τῶν περὶ τὸ σῶμα τοῦ θείου [ψυχή], τὸ δὲ θεῖον καλόν, σοφόν, ἀγαθόν, καὶ πᾶν ὅτι τοιοῦτον· τούτοις δὴ τρέφεταί τε καὶ αὔξεται μάλιστά γε τὸ τῆς ψυχῆς πτέρωμα, αἰσχρῷ δὲ καὶ κακῷ καὶ τοῖς ἐναντίοις φθίνει τε καὶ διόλλυται." Trans. A. Nehamas and P. Woodruff.

227 Plato, *Phdr.* 238a.

228 The pose itself is similar to the iconography of the *Departure of Hephaestus*, in which the god of blacksmiths is depicted sitting with deformed feet on

the back of a donkey and being followed by a satyr holding the donkey's tale (greek vase painting from c. 530 BC, Martin von Wagner Museum in Würzburg, cat. no. H 4352). Probably more to the point is Light-brown's hint (*Mantegna, op. cit.*, 192, pl. 252b) regarding Petrarch's *Trionfi* (as fns. 207, 219).

229 In the *Battle between Eros and Anteros*, representing the two contradictory aspects of Love wrestling with each other in a sort of sporting competition, an aged satyr may be included acting as a referee: O. Bie, "Ringkampf des Pan und Eros," *Jahrbuch des kaiserlich deutschen archäologischen Institus*, IV (1889), 129–137. Cf. the bacchic sacophagus from the collection Cardinal Casali (Rome, Museo Pio Clementino). Two *erotes*, the one bearing a palm and the other a whip, are shown in the act of abducting a tied-up satyretto looking back to the aged Silen who is holding up a fan as a sign of victory.

230 Bruni, as fn. 196, 4; Alessandro Perosa, *Studi di filologia umanistica: Studi e testi del Rinascimento europeo*, vol. III (Rome 2000), 340–41. Regarding Ficino's commentary, written in the second half of the 1460s: Michael J. B. Allen, *Commentaries on Plato, Volume 1: Phaedrus and Ion* (Cambridge/MA 2008). Hermias' commentary in Greek was available in fourteenth-cent. Italy (Dirk Baltzly and Michael Share, *Hermias: on Plato Phaedrus 227A-245E* (London 2018), 17). Regarding the library of Palla Strozzi and the visit of the Platonic scholar John Argyropoulos in his Paduan home (between 1441 and 1444): Marino Zorzi, "Bessarion, Venice and the Greek Manuscripts," *In the Light of Apollo* (exh. cat.), *op. cit.*, 53–59 (56).

231 Whereas Bruni carefully censored problematic passages, the Greek scholar George of Trebizond (1395–1484), who taught philosophy in Padua, Vicenza, and Venice from 1433 onwards, refers to *Phaedrus* as "Foedrus" (*foedus* = filthy) in his *Comparationes Philosophorum Aristotelis et Platonis*, book III, ch. 1; equally severe is Cardinal Bessarion's letter from around 1468 on the same subject. I am grateful to Guy Claessens (Leuven) for having kindly furnished this information. Guy Claessens, "The 'Phaedrus' in the Renaissance: Poison or Remedy," *The Reception of Plato's 'Phaedrus' from Antiquity to the Renaissance*, S. Delcomminette et alii, eds. (Berlin and Boston 2020), 229–46 (232).

232 This seems to have been the case of Pomponio Leto (1428–1498). His Roman academy (1460) offers many points of comparison to Squarcione's institution. The scribe Bartolomeo Sanvito was a member of both circles. In 1468, before leaving for Greece, Leto, together with 70 of his humanist friends, was accused of heresy as well as sodomy and put into jail. Ulrich Pfisterer, *Lysippus und seine Freunde. Liebesgaben und Gedächtnis im Rom der Renaissance oder: Das erste Jahrhundert der Medaille* (Berlin 2008), 57.

233 The *fellatio* performed by a group of satyrs in a drawing in Munich (Staatliche Graphische Sammlung, inv. 1973:10), tentatively ascribed to Squarcione by Schmitt, "Francesco Squarcione," *op. cit.*, 205. Stefano Gabriele Casu (*In the Light of Apollo*, exh. cat., *op. cit.*, III, 28, 266) rather thinks of Marco Zoppo. A homoerotic scene is displayed in a codex of drawings attributed to Marco Zoppo (British Museum, 1920-1-14-1, folio 18r). Calogero (*Non tanto per el guadagno quanto per l'onore, op. cit.*, 13–16) makes a comparison with the obscenities in Zovenzoni's poem *Istrias* somewhat later (1474).

234 A prominent member at the Paduan University was Giovanni Battista Rosselli, mentioned in the year 1452 as professor of canon law and (on the authority of Francesco Porcellino, active 1444–1453) as a specialist on Plato: "Magnus Platonicus dictus est, quod Platonis philosophiam collaret" (Facciolati, *op. cit.*, 46).

235 Windows, *op. cit.*, n. 126 (190).

236 It appears twice on the title page of the Bern sylloge on the plinth of a fictitious tombstone bearing his inscription: "in hanc formam redigere s[uae] pec[uniae] fec[it] iohannis marchanova artivm et medicine doctor" (Burgerbibliothek, Cod. B. 42, folio 5v). The same device appears as well on the horse's forehead in the so-called *Revenge of Giacomo Loredan* (fol. 44). Since it is also to be seen in a drawing attributed to Pisanello (Louvre. Inv. 2629), one may doubt whether it was not intended as purely decorative.

237 Cf. Pfisterer, *Lysippus und seine Freunde, op. cit.*, 347ff.; Andrea de Marchi, "Mantegna / Bellini: Invention versus Poetry," *Mantegna & Bellini* (exh. cat.), *op. cit.*, 29–40.

238 Regarding Pisanello's attendance during the Council of Ferrara (1438) and his portrtait of the byzantine emperor John VIII Palaeologus: Stavros Lazaris, "L'empereur Jean VIII Paléologue vu par Pisanello lors du concile de Ferrare-Florence," *Byzantinische Forschungen*, 29 (2007), 293–324; Theodore Koutsogiannis, "The Renaissance Metamorphoses of Byzantine Emperor John VIII Palaeologus," *In the Light of Apollo* (exh. cat.), *op. cit.*, 60–70 (61f.). The inclusion of contemporary subjects was a specialty of late Trecento Padua. Eisler, *op. cit.*, 105: "They used an abundance of telling features – crowds of frightened children, fighting dogs, sleeping cats, cheap household goods – whose collective *actes de présence* lent special pathos and immediacy to the workings of the absolute upon

daily life." Whereas Altichiero showed a preference for the portraits of contemporaries in his *Funerals of Saint Lucy* (Capella di San Giorgio) or the *Council of King Ramirez* (Capella di San Felice, Santo), Giusto hightened the realism of his scenes by including architectonic portraits of famous Paduan buidings, particularly in the frescoes of the *Cappella Belludi* in the Santo (Scholz, *op. cit.*, 162–67).

239 Anne D. Hedeman, "Visualizing History in Medieval France," *Histoire de l' Art*, 80 (2017), 25–36.

240 Aristotle, *Poetica* 1450a16-17: "ἡ γὰρ τραγῳδία μίμησίς ἐστιν οὐκ ἀνθρώπων ἀλλὰ πράξεων καὶ βίου." "For Tragedy is an imitation, not of men, but of an action and of life." Trans. S. H. Butcher.

241 Marina Lambraki-Plaka, "Alberti's Treatise *De Pictura* and Its Ancient Sources," *In the Light of Apollo* (exh. cat.), *op. cit.*, 71–78 (73).

242 Eisler, *op. cit.*, 172.

243 Listed as number 61. Cf. Windows, *op. cit.*, 12; Eisler, p, cit. 519f.; Degenhart and Schmitt, *Corpus*, II-6, *op. cit.*, 386–87.

244 Almost the same person with his dog reapppears in folio 14 (British Museum), associated to a falconer and a gardener.

245 *uno omo d'arme a cavalo con uno carbonaro*, as the table of content specifies.

246 Degenhart and Schmitt (*Corpus*, *op. cit.*, 398) rightly underline the difference to the anecdotic rendering in the album of the British Musuem (fol. 13v – 14). Eisler (*op, cit.*, 106) points to the representation of rustic subjects during courtly entertainments (*intermezzi*) and in the context of a revival of Virgil's *Eclogues*.

247 Otto Pächt, "Early Italian Nature Studies and the Early Calendar Landscape," *Journal of the Warburg and Courtauld Institutes*, 13 (1950), 13–47.

248 Aby Warburg, "Arbeitende Bauern auf burgundischen Wandteppichen," *Zeitschrift für bildende Kunst*, 18 (1907), 41–47,

249 It has been noted that Ciriaco d'Ancona (or his copyist), in a drawing of the Trojan Horse (Ms Ottoboniano Lat. 1586, folios 94v-95r, Biblioteca Apostolica Vaticana, Rome), already made use of the double page for the sake of narrative (Fortini Brown, "Antiquarianism," *op. cit.*, 73).

250 *uno cavalo grosso che salta uno molimento.* The horse's pose is reminiscent of the Roman Dioscuri. Regarding the place of these statues in fifteenth-century Italian art: Arnold Nesselrath, "Antico und Montecavallo," *Burlington Magazine*, 124 (1982), 353–57.

251 The same figure surmounting an open grave reappears in the *Crucifixion*, folio 41.

252 Ricci, 1908, *op. cit.*, I, 70. This is only partially true: Marco Barbaro (1511–1570) lists a certain *Tomaso* who married Alba Venier in 1390 (Slaven Bertosa, "Gli orizzonti mediterranei della famiglia veneziana Loredan," *Atti*, 42 (2012), 537–569, 561). It is to be excluded, of course, that this Tomaso was meant to be represented.

253 Degenhart and Schmitt, *Corpus*, *op. cit.*, II-6, 361: "[…] eine phantastische Fiktion des in seiner Zeichnungssammlung frei erfindenden Künstlers, der hier keinem Auftraggeber Rechnung schuldete." The coat of arms has either three roses or a rampant lion instead (Bertosa, *op. cit.*, 539).

254 Eisler, *op. cit.*, 219, Degenhart and Schmitt, *Corpus*, *op. cit.*, II-6, 360.

255 Ernst Kantorowicz, "'Pro Patria Mori' in Medieval Political Thought," *The American Historical Review*, 56, (1951), 472–92; Maria L. Berbara, "Civic Self-Offering: Some Renaissance Representations of Marcus Curtius," *Recreating Ancient History*, K. Enenkel et alii, eds. (Leiden 2001), 147–66.

256 Regarding the lost drawing (folio 61) which showed Doge Francesco Foscari, see above fn. 243.

257 When Pietro's brother Marco died shortly thereafter, the brother-in-law of the ruling doge was held responsible.

258 Giuseppe Giulino, "Loredan, Pietro," *Dizionario Biografico degli Italiani*, Vol. 65 (2017), *ad vocem*. Another testimony of Giacomo's hatred is a note in his personal book of accounts which comments on Francesco Foscari with the words: "for the death of my father and my uncle" (*Francesco Foscari per la morte di mio padre e di mio zio*). The opposite page for the paid bills was left blank; after Forscari had died in 1457, Giacomo added the note: "he paid for it" (*l'ha pagata*).

259 Francesco Priuli (1423–1491), *Li pretiosi frutti del Maggior Consiglio*, Venice, Biblioteca del Museo Civico Correr, Cod. Cicogna, II, c. 194. Giacomo Loredan's portrait was inserted in the *Sala del Maggior Consiglio* of the Ducal Palace (destroyed by fire in 1577).

260 Leon Battista Alberti, *De pictura*, *op. cit.*, II, 40: "I will say that the really copious historia is that in which there is a mixture of men of every age, boys, women and girls, small children, pet animals, little dogs and birds, horses, all in their proper place: and I will praise every kind of copiousness so long as it is appropriate to the action of the historia.", quoted after Baxandall, "Guarino," *op. cit.*, 200.

261 Candida, *op. cit.*, 81–84 (dated circa 1450–43).

262 Eisler (*op. cit.*, 220), on the authority of Helmut Nickel, suggests a somewhat later date (circa 1455–1470).

[263] The shape of the helmet displayed at his feet on the left is rendered with the help of a perspectival construction; the artist felt it necessary to add a circle, subdivided into different segments, on the opposite side. Similar grids appear in other drawings as well (cf. fols. 41, 69), illustrating the correct foreshortening of specific objects in a given space "with the help of geometrical figures" (*per figura de isomatria*), as was practiced in Squarcione's academy (Lipton, *op. cit.*, doc. 87, 383).

[264] Vasari, *op. cit.*, III, 69 [I.273]: "Fu condotto Paolo da Donato a Padova quando vi lavorò, e vi dipinse nell'entrata della casa de' Vitali di verde-terra, alcuni giganti che, secondo ho trovato in una lettera latina che scrive Girolamo Campagnola a M. Leonico Tomeo filosofo, sono tanto belli che Andrea Mantegna ne faceva grandissimo conto."

[265] The military man's hand caressing this man's buttocks is probably a later addition.

[266] Eisler (*op. cit.*, 208) compares the figure with the statue of a classical athlete. Cf. the model of a Roman statue or statuette representing a fistfighter in fol. 76v. Degenhart and Schmitt (*Corpus, op. cit.*, II-5, 219 and II-6, 361) have convincingly proved that the Roman column base that is prominently positioned in front of him is derived from the church S. Bartolomeo all'Isola in Rome. A copy in plaster might have been available in Squarcione's atelier. The same column base is reproduced in model-book by Benozzo Gozzoli (Rotterdam, Museum Boymans – van Beuningen).

[267] Michael Baxandall, "A Dialogue on Art from the Court of Leonello d'Este. Angelo Decembrio's *De politia litteraria* Pars LXVIII," *Journal of the Warburg and Courtauld Institutes*, 26 (1963), 304–25 (320). Cf. Nikolaus Himmelmann, *Ideale Nacktheit in der griechischen Kunst*. Jahrbuch des Deutschen Archäologischen Instituts, 26 (Berlin 1990).

[268] Tomasini, *op. cit.*, 390–91.

[269] Fortini and Brown, *Venice and Antiquity, op. cit.*, 134. She is barely visible today due to the fact that her outlines are drawn in silverpoint only, without any reinforcement in pen and ink, as has been the case otherwise. The figure is seen standing on a globe or ball.

[270] Degenhart and Schmitt (*Corpus*, II-6. *op. cit.*, 367, figs. 358, 359) make reference to two polygonal piers in front of the church SS. Maria e Donato in Murano that originally formed part of a Roman funerary altar. Cf. Hanns Gabelmann, "Achteckige Grabaltäre in Oberitalien," *Aquileia Nostra*, 38 (1967), 17–54 (34ff.).

[271] Christian K. Kleinbub, "Jacopo Bellini and the Drawing of Idolatry," *Venetian Painting Matters, 1450–1750*, J. Cranston, ed. (Turnhout 2015), 21–34, 26, arrives at a different interpretation by attributing the cornucopia to the statue atop and concluding that she represents abundance, "celebrating material, rather than spiritual, wellbeing." He believes that Jacopo did not dare to outline the idol because he considered its presentation "to be a rather dangerous thing," thereby revealing "a repressed, even self-reflexive, discomfort with pagan Antiquity," and that, furthermore (27), the artist is "savoring a sort of poetic justice in seeing the artificial idol-image violently treated by living persons," which is difficult to accept.

[272] He has been linked to Pope Gregory the Great (Fortini Brown, *Venice and Antiquity, op. cit.*, 134). In my opinion, the profile head strongly resembles that of Saint Simeon in Mantegna's *Presentation of Christ in the Temple* from circa 1453/43 (Berlin, Gemäldegalerie), repeated in Giovanni Bellini's painting of the same narrative (Venice, Museo della Fondazione Querini Stampalia). Neville Rowley, "When Bellini *Traced* Mantegna: Two Paintings of the Presentation of Christ in the Temple," *Mantegna & Bellini* (exh. cat.), *op. cit.*, 140–47.

[273] Fortini Brown, *Venice and Antiquity, op. cit.*, 134. Degenhart and Schmitt, *Corpus, op. cit.*, II- 6, 367.

[274] Points of reference are the mosaics in San Marco (Venice), *St. Philipp Ordering the Destruction of a Pagan Idol* (c. 1200), and a painting of *Santa Apollonia* of about 1450, attributed to Antonio Vivarini (Washington, National Gallery, Kress collection). Cf. Werner Haftmann, *Das italienische Säulenmonument* (Leipzig and Berlin 1939); Michael Camille, *The Gothic Idol: Ideology and Image Making in Medieval Art* (Cambridge 1989).

[275] Prudentius, *Carmina*, f. 34v, Bern, Burgerbibliothek.

[276] Schlosser, *Ghibertis Denkwürdigkeiten, op. cit.*, 35.

[277] An opposite view is expressed by Kleinbub (*op. cit.*, 23): "Jacopo's treatment of idols corresponds to what we might expect of a more medieval worldview."

[278] Fortini Brown ("Antiquarianism," *op. cit.*, 79), comparing the drawing with the painting, possibly by Antonio Vivarini, *Saint Appolonia Destroys a Pagan Idol* (National Gallery of Art, Washington, D.C.) of about the same date (circa 1450), arrives at a similar conclusion: "The idols are no longer just symbols of heresy and disbelief. They have become objects of aesthetic delight, demanding our interest and even respect."

[279] Norberto Gramaccini, "La prima riedificazione del Campidoglio e la rivoluzione senatoriale del 1144," *Roma, centro della cultura dell'Antico nei secoli XV e XVI*, S. Danesi Squarzina, ed. (Milan 1989), 33–47.

[280] Schlosser, *Ghibertis Denkwürdigkeiten, op. cit.*, I, 65. Julius von Schlosser, "Über einige Antiken Ghi-

bertis," *Jahrhbuch der kunsthistorischen Sammlungen des Allerhöchsten Kaiserhauses*, XXIV (1904), 125–160; Gramaccini, *Mirabilia, op. cit.*, 206–217.

[281] Schlosser, *Ghibertis Denkwürdigkeiten, op. cit.*, I, 65; Gramaccini (*Mirabilia, op. cit.*, 213–217) for a different interpretation.

[282] Antonio Possevino, *Gonzagae* (Mantua 1628), 485. The piazza itself rests upon Mantua's Roman Forum. Gramaccini, *Mirabilia, op. cit.*, 218–222.

[283] Pier Paolo Vergerio, *Epistolario*, L. Smith, ed. (Rome 1934), 192–197; Gramaccini, *Mirabilia, op. cit.*, 221.

[284] E. Marani, "Uno monumento a Virgilio, disegnato da Leon Battista Alberti," *Nel bimillenario della morte di Virgilio* (Mantua 1983), 133; Arturo Bassi, *Ricerche e ipotesi di un Virgilio del Mantegna per Isabella d'Este* (Florence 1983).

[285] Billanovich, *La tradizione, op. cit.*

[286] Maria Pia Billanovich, "Una miniera di epigrafi e di antichità. Il Chiostro Maggiore di S. Giustina a Padova," *Italia Medioevale e Umanistica*, XII (1969), 197–293 (282).

[287] Maria Monica Donato, "Il progetto del mausoleo di Livio agli Uomini Illustri *ad fores renovati iusticii*: celebrazione civica a Padova all'inizio della dominazione veneta," *De Lapidibus Sententiae. Scritti di Storia dell'Arte per Giovanni Lorenzoni*, T. Franco and G. Valenzano, eds. (Padua 2002), 11–129 (111); Fortini Brown, *Venice and Antiquity, op. cit.*, 134.

[288] Casu, "Antiquarian Culture," *op. cit.*, 246.

[289] Giulio Bodon, "Veneranda Antiquitas. Studi sull'eredità dell'antico nella Rinascenza veneta," *Studi sull'eredità dell'antico nella Rinascenza veneta (Studies in Early Modern European Culture)*, P. L. Bernardini and L. Orsi, eds. (Bern 2005), 183–202; Donato, *op. cit.*, 133, 117–125; Dagobert Frey, "Apokryphe Liviusbildnisse der Renaissance," *Wallraf-Richartz-Jahrbuch*, 17 (1955), 132–64.

[290] Fortini Brown, "Antiquarianism," *op. cit.*, 80; Fortini Brown, *Venice and Antiquity, op. cit.*, 134–6; Eisler, *op. cit.*, 509.

[291] Windows, *op. cit.*, 202–03.

[292] Following Degenhart and Schmitt (*Corpus*, II-5, *op. cit.*, 226–27) the model was a coin of Emperor Nero (circa 64–66) showing the *Marcellum magnum*.

[293] It was here, under the "angel's dome," that the tomb of Saint Anthony was originally installed. Giuseppe Fiocco, "Le cupole del Santo," *Rivista Antoniana*, IX (1969), 441–44 (444). Regarding Pisanello's drawing, almost contemporary, of the Santo architecture and its different domes (Musée Bonnat, Bayonne, no. 648): Herbert Dellwing, "Der Santo in Padua – eine baugeschichtliche Untersuchung," *Mitteilungen*

des Kunsthistorischen Institutes in Florenz, 19 (1975), 197–240 (228, fig. 18). Cf. Ruth Wolf, "Le tombe dei dottori al Santo. Considerazioni sulla loro tipologia," *Cultura, arte e committenza nella basilica di S. Antonio di Padova nel Trecento: Atti del Convegno internazionale* [2001], L. Baggio and M. Benetazzo, eds. (Padua 2003), 277–297 (285ff.).

[294] Weiss, "Lovato Lovati," *op. cit.*, 3ff.; Bodon, *Petrarca, op. cit.*, 126; Gramaccini, *Mirabilia, op. cit.*, 101–02.

[295] Giulio Bodon, "Tra Padova e Venezia: Tombe e immagini eroiche nella cultura antiquaria rinascimentale," *Eroi, eroismi, eroisizzazioni: Atti del Convegno Internazionale 2006* (Padua 2007), 45–65.

[296] Parts of it were owned by Ludovico Trevisan (1401–1465), an important member of the Paduan circle of humanists and antiquarians, later to be portrayed by Mantegna (Berlin, Gemädegalerie). Irene Favaretto, *Andrea Mantegna e l'antico. 1. Cultura antiquaria e tradizione umanistica a Padova nel Quattrocento*, *Andrea Mantegna, impronta del genio. Convegno internazionale di studi* (Padua, Verona, Mantua 2006), R. Signorini et alii, eds. (Florence 2010), 45–52 (49).

[297] Alessandra Fardin, "L'anfiteatro romano di Padova: la conoscenza della forma architettonica e nuove ipotesi della configurazione originaria," *Bollettino del Museo Civico di Padova*, 85, 1996 (1998), 21–47.

[298] Barbara Marx, "Venedig 'altera Roma'. Transformationen eines Mythos," *Quellen und Forschungen aus italienischen Archiven und Bibliotheken*, 60 (1980), 325–73.

[299] Achille Olivieri, "Un' enfasi mitologica. Troia a Venezia fra Quattrocento e Cinquecento," *Dall'Adriatico greco all'Adriatico veneziano. Archeologia e leggenda troiana* (Hesperia, 12), L. Braccesi, ed. (Rome 2000), 37–52.

[300] Ralph Liebermann, "Real Architecture, Imaginary History. The Arsenale Gate as Venetian Mythology," *Journal of the Warburg and Courtauld Institutes*, LIV (1991), 117–126. Fortini Brown, *Venice and Antiquity, op. cit.*, 109–10.

[301] Liebermann, *op. cit.*, 121.

[302] Jasenka Gudelj, "Dialoghi quattrocenteschi: Arco dei Sergi nelle interpretazioni di Jacopo Bellini," *Scripta in honorem Igor Fiskovic*, M. Jurkovic, ed. (Zagreb 2015), 283–90 (285ff.); Fortini Brown, "Antiquarianism," *op. cit.*, 74; Lorenzo Pericolo, "Incorporating the Middle Ages: Lazzaro Bastiani, the 'Greek' and 'German' Architecture of Medieval Venice," *Remembering the Middle Ages in Early Modern Italy*, L. Pericolo and J. N. Richardson, eds. (Turnhout 2015), 139–69 (165f.); Degenhart and Schmitt, *Corpus*, II-6, *op. cit.*, 356.

[303] Gudelj, *op. cit.*, 288, n. 23.

[304] Dagobert Frey, "Der Dom von Sebenico und sein Baumeister," *Jahrbuch des kunsthistorischen Institutes der K. K. Zentral-Kommission für Denkmalpflege*, I (1913), 1–169 (120ff.), has convincingly demonstrated that the architecture in folio 30 was influenced by that of the cathedral of Sebenico, at this time under construction. Cf. Igor Fiskovic, "Matijev i Jacopo Bellini," *Radovi Instituta za povijest umjetnosti*, 12–13 (Zagreb 1988–1989), 159–77. Concerning the flag: Anchise Tempestini, *Disegno, giudizio e bella maniera. Studi sul disegno italiano in onore di Catherine Monbeig Goguel* (Milan 2005), no. 2, 25.

[305] A. M. Tamassia, "Jacopo Bellini e Francesco Schiavone: due cultori di antichità classica," *Il mondo antico nel Rinascimento: Atti del convegno internazionale* (Florence 1958), 159–165. Meliaduse d'Este, stepbrother of Lionello and a friend of Alberti, had visited Pula in 1440 (Gudelj, *op. cit.*, 289).

[306] Degenhart and Schmitt, *Corpus, op. cit.*, II-5, 234–237; Eisler, *op. cit.*, 78–93 and 136–155.

[307] Degenhart and Schmitt (*Corpus*, II-5, *op. cit.* 240 and II-6, 413–14) and Eisler and Elen (*op. cit.* 79, 470), however, believed that folios 77v and 78v belonged to a late fourteenth-century portfolio, possibly inherited from his master, Gentile da Fabriano, that Jacopo Bellini wanted to include for "reasons of economy" in his new book. I assume, on the contrary, that Squarcione reused vellums that had originally been meant to compose a catalogue of textile designs (see p. 10) – a project that he had given up upon quitting his old profession as *sartor* and *recamator* (Lipton, *op. cit.*, doc. 12, 317) in order to become a painter and teacher of the arts. For an overview of fourteenth- and fifteenth-century animal textile patterns, see Müller, *op. cit.*

[308] Pietro Toesca, *La pittura e la miniatura nella Lombardia: dai più antichi monumenti alla metà del Quattrocento* [1912] (Turin 1987); Monika Dachs, "Zur künstlerischen Herkunft und Entwicklung des Michelino da Besozzo," *Wiener Jahrbuch für Kunstgeschichte*, 45 (1992), 51–81; Victor M. Schmid, "Die Gebrüder Limburg und die italienische Kunst," *Die Brüder van Limburg. Nijmegener Meister am französischen Hof 1400–1416* (exh. cat.), Museum Het Valkhof, Nijmegen, R. Dückers and P. Roelofs, eds. (Amsterdam 2005), 179–190; Andrea Marchi, *Gentile da Fabriano e il gotico internazionale: Jean de Beaumetz, Melchior Broederlam, Jacquemart d'Hesdin, Giovannino de Grassi, Lorenzo Monaco, Michelino da Besozzo, Stefano di Giovanni, Jean Malouel, Herman, Pol e Jean Limbourg, Lorenzo e Jacopo Salimbeni, Giovanni da Modena, Pisanello, Jacopo Bellini, Michele Giambono* (Florence 2008). Regarding possible influences from

Arab sources such as the animal fables of Bidpai and Ibn Bakhtishu: Ernst Kühnel, *Miniaturmalerei im islamischen Orient* (Berlin 1922), figs. 14–16, 20–22.

[309] Rushton, *op. cit.*, 19–51; Scheller, *op. cit.*, 276–91; Elen, *Drawing Books, op. cit.*, 165–69.

[310] Antonio Aldrovandi, "Il *taccuino* di Giovannino de Grassi della Biblioteca Civica di Bergamo. Tecnica di esecuzione e restauro," *I materiali cartacei*, C. Frosini, ed. (Florence 1997), 15–37; Vera Segre Rutz, "Lo studio del mondo animale nella bottega trecentesca di Giovannino de Grassi," *Micrologus*, 8 (2000), 477–88.

[311] Cfr. Müller, *op. cit.*, 210–224.

[312] Pächt, "Early Italian Nature Studies," *op. cit.*, 29f.

[313] Wolfgang Wolters, *Der Dogenpalast in Venedig. Ein Rundgang durch Kunst und Geschichte* (Berlin and Munich 2010), 65. Similar lions drawn in black hematite on white paper are to be seen in the Codex Vallardi (Louvre 2384) and discussed by Eisler in relation to Jacopo Bellini (*op. cit.*, 140–41).

[314] Fröhlich-Bum (*op. cit.*, 51): " […] eine gedankliche Auseinandersetzung mit den Rätseln des Darstellbaren, und was andere florentinische Künstler dieser Zeit in geschriebenen Werken niederlegten, scheint mir hier in Zeichnungen festgehalten."

[315] Aristotle, *Historia animalium*, IX, 44 = 629b8-20: "Καὶ γὰρ ὁ λέων ἐν τῇ βρώσει μὲν χαλεπώτατός ἐστι, μὴ πεινῶν δὲ καὶ βεβρωκὼς πραότατος. Ἔστι δὲ τὸ ἦθος οὐχ ὑπόπτης οὐδενὸς οὐδ' ὑφορώμενος οὐδέν, πρός τε τὰ σύντροφα καὶ συνήθη σφόδρα φιλοπαίγμων καὶ στερκτικός. Ἐν δὲ ταῖς θήραις ὁρώμενος μὲν οὐδέποτε φεύγει οὐδὲ πτήσσει, ἀλλ' ἐὰν καὶ διὰ πλῆθος ἀναγκασθῇ τῶν θηρευόντων ὑπαγαγεῖν βάδην ὑποχωρεῖ καὶ κατὰ σκέλος, κατὰ βραχὺ ἐπιστρεφόμενος· ἐὰν μέντοι ἐπιλάβηται δασέος, φεύγει ταχέως, ἕως ἂν καταστῇ εἰς φανερόν· τότε δὲ πάλιν ὑπάγει βάδην. Ἐν δὲ τοῖς ψιλοῖς ἐάν ποτ' ἀναγκασθῇ εἰς φανερὸν διὰ τὸ πλῆθος φεύγειν, τρέχει κατατείνας καὶ οὐ πηδᾷ. Τὸ δὲ δρόμημα συνεχὲς ὥσπερ κυνός ἐστι κατατεταμένον· διώκων μέντοι ἐπιρρίπτει ἑαυτόν, ὅταν ᾖ πλησίον." / "The lion, while he is eating, is most ferocious; but when he is not hungry and has had a good meal, he is quite gentle. He is totally devoid of suspicion or nervous fear, is fond of romping with animals that have been reared along with him and to whom he is accustomed, and manifests great affection towards them. In the chase, as long as he is in view, he makes no attempt to run and shows no fear, but even if he be compelled by the multitude of the hunters to retreat, he withdraws deliberately, step by step, every now and then turning his head to regard his pursuers. If, however, he reaches wooded cover, then he runs at full speed, until he comes to open ground, when he resumes his leisurely

retreat. When, in the open, he is forced by the number of the hunters to run while in full view, he does run at the top of his speed, but without leaping and bounding. This running of his is evenly and continuously kept up like the running of a dog; but when he is in pursuit of his prey and is close behind, he makes a sudden pounce upon it." Trans. D'Arcy Wentworth Thompson.

[316] Martha A. Wolff, *The Master of the Playing Cards. An Early Engraver and His Relationship to Traditional Media* (PhD Thesis, Yale University, New Haven/CT 1979); Hellmut Rosenfeld, *Der Meister der Spielkarten und die Spielkartentradition und Gutenbergs typographische Pläne* (Frankfurt/M 1964).

[317] The *cartonum cum quibusdam nudis Poleyoli* that Squarcione tried to recuperate in 1468 from his former pupil Giorgio Schiavone (Casu, "Giorgio Schiavone", *op. cit.*, 37ff.) might refer to the engraving *Battle of the Nudes*. Cf, Patricia Emison, "The World Made Naked in Pollaiuolo's Battle of the Nudes," *Art History*, 13 (1990), 261–75. Or else the engravings of the Master of the Playing Cards were brought to Squarcione's attention by one of the numerous German pupils present in Padua at that time (see fn. 104, part 1).

[318] See the reconstruction in Degenhart and Schmitt, *Corpus*, II-6, *op. cit.*, 414, figs. 399 and 400.

[319] Cf. the lion in a painting *Saint Gerome in the Wilderness* by Bono da Ferrara (active 1442–1461) in the National Gallery (London). Luke Syson and Dillian Gordon, *Pisanello. Painter to the Renaissance Court* (exh. cat.), National Gallery, London (London 2001), 203; Bernhard Degenhart, *Pisanello und Bono da Ferrara* (Munich 1995).

[320] "Es ist eine Ausnahme, daß Jacopo Bellini in einer Zeichnung, die er über einer mit Kreidegrund überdeckten Trecento-Zeichnung ausführte, nicht eine letzterer gegenüber heteromorphe eigene Erfindung vortrug, sondern ältere Motive der anderen Hand in sein Repertoire aufnahm." (Degenhart and Schmitt, *Corpus*, II-5, *op. cit.*, 240).

[321] Joanna Woods-Marsden ("*Draw the irrational animals as often as you can from life*: Cennino Cennini, Giovannino de Grassi and Antonio Pisanello," *Studi di Storia dell'arte*, 3 (1992), 67–78, 70) relating to Pisanello's technique: "The sketchy mode thus suggests rapid movement on the part of both artist and model, impolying an apparent matching reaction on paper of the former to the apparent action in life of the latter."

[322] Aristotle, *Historia animalium*, 629b8-20 (as fn. 315).

[323] Eisler (*op. cit.*, 253) calls it a *Scholar's Tomb*, the professor's skull resting on a book that he had published.

[324] Altichiero's memorial of the de Rossi family in the chapel of San Felice in the Santo in Padua (1376–1379) exhibiting a monumental recumbent lion may well have made an impression on the artist of the *Louvre Album*. I am grateful to Simone Westermann for this suggestion.

[325] Eds. Xénia Muratova and Daniel Poirion, *Le Bestiaire. Reproduction en fac-similé des miniatures du manuscrit du Bestiaire Ashmole 1511 de la Bodleian Library d'Oxford* (Lebaud 1988), 41–46. Cf. the drawings in the album of Villard d'Honnecourt: Hans Robert Hahnloser, *Villard de Honnecourt. Kritische Gesamtausgabe des Bauhüttenbuches ms. fr. 19093 der Pariser Nationalbibliothek* [1935] (Graz 1972), nos. 76, 120, pl. 52, 53, 153, 376 (traced back to late roman ivory diptychs). A similar adaptation occurrs in the drawing of the collapsing rider in folio 20 (*Christ Leaving Jerusalem for Calvary*) that shows close affinities with Villard's drawing fol. 3v (Hahnloser, *op. cit.*, 19f., fig. 51) concerning the allegory of broken pride (*orgueil comme il trébuche*). Degenhart and Schmitt, *Corpus*, II-6, *op. cit.*, 329.

[326] For the role of Pietro Donato and Pietro Bembo: Giordana Canova Mariani, *La miniatura a Padova dal Medioevo al Settecento* (exh. cat.), Palazzo della Ragione, Padua 1999, eds. G. Canova Mariani et alii (Modena 1999), 25–27.

[327] Hahnloser *op. cit.*, nos. 76, 120, plates 52, 53, S. 153, 376.

[328] Francis Haskell and Nicholas Penny, *Taste and the Antique. The Lure of Classical Sculpture, 1500–1900* (London 1982), 250; Gramaccini, *Mirabilia*, *op. cit.*, 176. It is of interest that Altichiero, in his fresco *The Council of Charles the Great* (Padua, Oratorio di San Giorgio), was aware of this sculpture and its meaning without being able to reproduce it accurately. Cf. Peter Meller, "Physiognomical Theory in Renaissance Heroic Portraits," *The Renaissance and Mannerism, Studies in Western Art: Acts of the Twentieth International Congress of History of Art* (New York 1963), 53–69 (64).

[329] Degenhart and Schmitt, *Corpus*, II-6, *op. cit.*, 491–92.

[330] One wonders whether this implies an allusion to the endangered condition of the Paduan humanists in the face of Venetian authorities. Regarding contempt of the latter against secular tendencies: Silvio Tramontin, "La cultura monastica del Quattrocento dal primo patriarca Lorenzo Giustiniani ai camaldolesi Paolo Giustiniani e Pietro Quirini," *Storia della cultura veneta*, G. Arnaldi and M. Pastore Stocchi, eds. (Vicenza 1980), III, 431–57; Margaret L. King, *Ve-

netian Humanism in an Age of Patrician Dominance (Princeton1986), 31–36.

[331] Alberti, op. cit., III [60], 81. Cf. Muraro, "Mantegna e Alberti," op. cit., 113. The earlier generation of Italian humanists, from Pier Paolo Vergerio to Bartolomeo Platina (1421–1481), recommended the study of natural history for purposes of education, as intellectui humano consona atque conformis, whereas Vittorino da Feltre regarded an instruction in natural phenomena (de meteoris, de plantis, de animalibus) as fit for young children, recommending the use of pictures in particular: Harrison Woodward, op. cit., 238.

[332] This distinction has been made by Pächt ("Early Italian Nature Studies," op. cit., 29) with regard to the carnets lombards: "[…] so long as they [i. e. dogs] are depicted at rest, standing or sitting, the rendering is true to nature. But as soon as the artist has to show them walking or running he retreats again into the medieval formula." Rushton, op. cit., 183. Cf. Pisanello's drawing of a wild boar in the Louvre Paris, Musée du Louvre, Département des Arts graphiques, Codex Vallardi, inv. no. 2417; Dominque Cordellier, Pisanello. Le peintre aux sept vertus (exh. cat.), Musée du Louvre, C. Cordellier and P. Marini, eds. (Paris 1996), no. 228.

[333] An earlier appearance of similar dogs are "i bei cani maculati" in Giusto de Menabuoi's Wedding at Cana in the Paduan Baptistry (1377/78), as pointed out by Francesca Flores d'Arcais, Giusto de Menabuoi nel Battistero di Padova (Trieste 1989), 137.

[334] Feliciano describes his favourite dog, called Balugante, and compares Zoppo to the legendary Numidian king Massinissa – a lover of dogs, following Pliny and Valerius Maximus (Fiocco, op. cit., 1926, 194; Calogero, Non tanto per el guadagno quanto per l'onore, op. cit., 6). The same is true for Alberti who wrote a funerary oration for his dog. Cf. Eisler, op. cit., 140, n. 33.

[335] Eisler, op. cit., 141–51.

[336] Claudio Bismara, "La cappella Pellegrini e Pisanello civis originarius di Verona nel 1438," Verona illustrata, 26 (2013), 5–13; Annegrit Schmitt, "Pisanello's Georgswandbild in Sant'Anastasia, Verona," Pisanello und Bono da Ferrara, B. Degenhart et alii, eds. (Munich 1995), 119–79. Cf. Paris, Musée du Louvre, Département des Arts graphiques, Codex Vallardi, nos. 2444, 2468; Cordellier (op. cit.), nos. 116, 207, and nos. 145, 241.

[337] Enzo de Franceschini, "I mosaici della cappella di Sant'Isidoro nella basilica di San Marco tra la tradizione bizantina e la novità di Paolo Veneziano," Zograf, 31 [2008] (2009), 123–30; Marco Bortoletto, Nuove ipotesi sulla fondazione della cappella di Sant'Isidoro (Venice 2019). Degenhart and Schmitt, Corpus, II-6, op. cit., 374, fig. 361.

[338] Represented to the right of the Adoration of the Magi (1397), Padua, San Michele, Capella Bovi.

[339] Maria Visonà, "The Models: The Horses of Saint Marc's," In the Light of Apollo, op. cit., 119–26; George Szabó, "Notes on XV-Century Italian Drawings of Equestrian Figures: Giambono, Pollaiuolo and the Horses of San Marco," Drawing, 3 (1981), 34–7. Regarding Petrarch's appraisal (Sen. V, 1): Marilyn Perry, "Saint Marc's Trophies. Legend, Superstition and Archeology in Renaissance Venice," Journal of the Warburg and Courtauld Institutes, 40 (1977), 27–49 (30f.).

[340] Vasari, op. cit., III, 548 [I.488].

[341] In dealing with the technique of casting whole figures, Cennini (op. cit., ch. 185, 127) realized that the naturalness of antique statues was possibly conditioned by this practice. It might well be that Squarcione's idea to reproduce antique sculptures was also influenced from this insight. The relationship between the two artists has been underlined by Baldissin Molli, Cennino Cennini, op. cit., 145. Cf. Norberto Gramaccini, "Das genaue Abbild der Natur – Riccios Tiere und die Theorie des Naturabgusses seit Cennini," Natur und Antike in der Renaissance (exh. cat.), Liebighaus, Frankfurt/M 1985/86, H. Beck, ed. (Frankfurt/M 1985), 198–225 (214); Seiler, "Giotto," op. cit., 58-9. Following Pliny, the sculptor Lysistratos was the first to cast life masks. Regarding casts after statues: Rune Frederiksen, "Plaster Casts in Antiquity," Plaster Casts. Making, Collecting and Displaying from Classical Antiquity to the Present, R. Frederiksen and E. Marchand, eds. (Berlin and New York 2010), 13–34 (21f.).

[342] The only instance Jacopo recurred to animals in his paintings, are the Saint Gerome (circa 1440, Verona, Museo di Castevecchio) and the Louvre Madonna. Their accessory and emblematic character offers no comparison to the animal drawings in the Louvre Album (Degenhart and Schmitt, Corpus, II-5, op. cit., 235).

[343] Marsilii de Padua Defensor pacis: Fontes iuris germanici antiqui in usum scholarum, R. Scholz, ed. (Hannover 1932–1933), § 3 (11); Collodo, Filosofia naturale, op. cit., 75, 152. The reference is to Aristotle, Pol. I, 1253a18-25: "ἡ δὲ τούτων κοινωνία ποιεῖ οἰκίαν καὶ πόλιν. καὶ πρότερον δὲ τῇ φύσει πόλις ἢ οἰκία καὶ ἕκαστος ἡμῶν ἐστιν. τὸ γὰρ ὅλον πρότερον ἀναγκαῖον εἶναι τοῦ μέρους· ἀναιρουμένου γὰρ τοῦ ὅλου οὐκ ἔσται ποὺς οὐδὲ χείρ, εἰ μὴ ὁμωνύμως, ὥσπερ εἴ τις λέγοι τὴν λιθίνην (διαφθαρεῖσα γὰρ ἔσται τοιαύτη), πάντα δὲ τῷ ἔργῳ ὥρισται καὶ τῇ δυνάμει, ὥστε μηκέτι τοιαῦτα ὄντα οὐ λεκτέον τὰ αὐτὰ εἶναι ἀλλ'

ὁμώνυμα." / "Thus also the city-state is prior in nature to the household and to each of us individually. For the whole must necessarily be prior to the part; since when the whole body is destroyed, foot or hand will not exist except in an equivocal sense, like the sense in which one speaks of a hand sculptured in stone as a hand; because a hand in those circumstances will be a hand spoiled, and all things are defined by their function and capacity, so that when they are no longer such as to perform their function they must not be said to be the same things, but to bear their names in an equivocal sense." Trans. H. Rackham.

[344] Gregorio Piaia, *Marsilio da Padova nella Riforma e nella Controriforma. Fortuna e interpretazione* (Padua 1977), 7.

[345] Collodo, *Filosofia naturale, op. cit.*, 212–22.

[346] The distinction goes back to the medieval jurist Bartolus de Saxoferrato, *De Tyrannia* (c. 1300): Diego Quaglioni, *Politica e diritto nel Trecento italiano. Il "De tyranno" di Bartolo da Sassoferrato (1314–1357). Con l'edizione critica dei trattati "De Guelphis et Gebellinis", "De regimine civitatis" e "De tyranno"*, Florence 1983, 177–78, 196–99. Francesco Maiolo, *Medieval Sovereignty. Marsilius of Padua and Bartolus of Saxoferrato. A Study on the Medieval Origin of the Idea of Popular Sovereignty* [1999] (Delft 2007), 231–94. Scholz (*op. cit.*, 86–95) refers to the definition of *charismatische Herrschaft,* as introduced by Max Weber, *Wirtschaft und Gesellschaft. Grundriss der Sozialökonomie*, 3 (Tübingen 1922), 603ff. Kohl, *op. cit.*, 245ff.

[347] Peter Herde, "Friedrich II. und das Papsttum," *Kaiser Friedrich II. 1194–1250. Welt und Kultur des Mittelmeerraumes* (exh. cat). Oldenburg, Landesmuseum (Mainz 2008), 52–65; Gundula Grebner, "Das *Liber Introductorius* des Michael Scotus und die Aristotelesrezeption. Der Hof Friedrichs II. als Drehscheibe des Kulturtransfers," *Kaiser Friedrich II.* (ibid.), 251–57. Charles Homer Haskins, "The *De arte venandi cum avibus* of Frederick II," *Studies in the History of Medieval Science* [1924] (New York 1960), 300–26.

[348] Cesira Gasparotto, "La Reggia dei da Carrara. Il palazzo di Ubertino e le nuove stanze dell'Accademia Patavina," *Atti e Memorie dell'Accademia Patavina di Scienze, Lettere ed Arti*, 79 (1966–1967) 73–116 (97).

[349] Francesco Petrarca, *De viris illustribus* (1380/81), Paris, Bibliothèque nationale de France, Ms. lat. 6069 G. Cf. François Avril (ed.), *Dix siècles d'enluminure italienne VIe–XVIe siècles* (cat. exh.), Bibliothèque Nationale (Paris 1984), fig. XIII, cat. 75; Federica Toniolo, "Il libro miniato a Padova nel Trecento," *Il secolo di Giotto nel Veneto: Studi di arte veneta*, vol. 14, G. Valenzano (ed.), Venice 2007, 107–51 (123).

[350] Rodolfo Majocchi, *Codice Diplomatico artistico di Pavia dall'anno 1330 all'anno 1550* (Pavia 1937), I, no. 14, 5.

[351] Stefano Breventano, *Istoria delle antichità, nobiltà et delle cose notabili della città di Pavia* (Pavia 1570), ch. 1, 7: "Le sale e camere, tanto di sopra quanto di sotto, sono tutte in volto e quasi tutte dipinte a vaghe e varie istorie e lavori; i cui cieli erano colorati di finissimo azzurro, ne' quali campeggiavano diverse sorti d'animali fatti d'oro, come leoni, leopardi, tigri, levrieri, bracchi, cervi cinghiali et altri, e specialmente in quella facciata che rimirava il parco ... nella quale, come a giorni miei io l'ho veduta intera, si vedeva un gran salone lungo da 60 braccia e largo 20, tutto istoriato con bellissime figure, le quali rappresentavano caccie e pescagioni et giostre, con altri vari diporti dei duchi e duchesse di questo stato." Marco Rossi, *Giovannino de Grassi. La corte e la cattedrale* (Milan 1955), 14.

[352] Edith W. Kirsch, *Five Illuminated Manuscripts of Giangaleazzo Visconti* (University Park and London 1991).

[353] Again, it was in Padua, where the medals of Francesco and Francesco Novello da Carrara (circa 1390) had created the prototype for this fashion. Cf. Irving Lavin, "Pisanello and the Invention of the Renaissance Medal," *Italienische Frührenaissance und nordeuropäisches Spätmittelalter. Kunst der frühen Neuzeit im europäischen Zusammenhang*, J. Poeschke, ed. (Munich 1993), 67–84 (68); Mina Gregori, "The Medal and Some of Its Implications," *In the Light of Apollo* (exh. cat.), *op. cit.*, 150–65 (150).

[354] The text was the Latin translation from the Arabic 11th century *Kitab al-adwiya al-mufrada*. Giovanna Baldissin Molli, *La miniatura a Padova dal Medioevo al Settecento* (exh. cat.), Palazzo della Ragione, Padua, G. Mariani Canova and F. Toniolo, eds. (Modena 1999), nos. 54, 154–157; Felix Andreas Baumann, *Das* Erbario Carrarese *und die Bildtradition des* Tractatus de herbis. *Ein Beitrag zur Geschichte der Pflanzendarstellung im Übergang von Spätmittelalter zu Frührenaissance* [Berner Schriften zur Kunst, 12] (Bern 1974). Cf. Giordana Mariani Canova, "La miniatura a Padova nel tempo dei Carraresi," *Guariento e la Padova carrarese* (exh. cat.), Musei Civici di Padova, Padua 2011, D. Banzato et alii, eds. (Venice 2011), 63–71.

[355] Gramaccini, "Das genaue Abbild der Natur," *op. cit.*, 210–16.

[356] Pliny, *Naturalis historia*, XXI, 56. Degenhart and Schmitt (*Corpus*, II-6, *op. cit.*, 387–91) draw a parallel from the *Erbario Carrarese* to the watercolor drawing of an iris in folio 62.

[357] Scholz (*op. cit.*, 87) uses the term "mediale Selbstrepräsentation." Cf. Giovanna Baldissin Molli, "Cennino Cennini im Kontext des paduanischen Hofes," *Fantasia und Handwerk* (exh. cat.), Gemäldegalerie Staatliche Museen (Berlin 2008), W.-D. Löhr and S. Weppelmann, eds. (Munich 2008), 142–45; Fabio Frezzato, "Wege der Forschung zu Cennino Cennini: von den biographischen Daten zur Bedeutung des Libro dell'Arte," *Fantasia und Handwerk*, ibid., 133–39.

[358] Woods-Marsden, *op. cit.*, 67. A point of view to the contrary is expressed by Alexander Perrig, "Vom Zeichnen und von der künstlerischen Grundausbildung im 13. bis 16. Jahrhundert," *Die Kunst der italienischen Renaissance. Architektur – Skulptur – Malerei – Zeichnung*, R. Toman, ed. (Cologne 1994), 416–40 (435); Seiler, *trovare cose non vedute, op. cit.* 128.

[359] Cennini, *op. cit.*, 15.

[360] Erwin Panofsky, *Idea. Ein Beitrag zur Begriffsgeschichte der älteren Kunstgeschichte* [1924] (Berlin 1975), 23; Seiler, *trovare cose non vedute, op. cit.*, 116–17.

[361] Hahnloser, *op. cit.*, n. 45, Pl. 36.

[362] Norberto Gramaccini, "Was bedeutet das Schwein neben dem Löwen in Villard de Honnecourts Zeichnung?," *Re-Visionen. Zur Aktualität von Kunstgeschichte: Festschrift für Alexander Perrig*, B. Hüttel et alii (Berlin 2002), 33–48.

[363] Petrarch was indeed "the first modern man" (Ernest Renan) in that he attested in his letters of old age (*rerum senilium libri*, XV) to have felt superior for having been left out of the traditional hierarchies. See the profound analysis of this relationship by Jakob Burckhardt, *Die Kultur der Renaissance in Italien. Ein Versuch* [1860] (Leipzig 1885), 8: "Die Illegitimität, von dauernden Gefahren umschwebt, vereinsamt den Herrscher; das ehrenvollste Bündnis, welches er nur irgend schliessen kann, ist das mit der höheren geistigen Begabung, ohne Rücksicht auf die Herkunft. Die Liberalität (Mildekeit) der nordischen Fürsten des 13. Jahrhunderts hatte sich auf die Ritter, auf das dienende und singende Adelsvolk beschränkt. Anders der monumental gesinnte, ruhmesbegierige Tyrann. Mit dem Dichter oder Gelehrten zusammen fühlt er sich auf einem neuen Boden, ja fast im Besitz einer neuen Legitimität."

[364] Cennini, *op. cit.*, cf. 70, 48,

[365] Brennan (*op. cit.*, 190–91) regarding a possible congruence between Cennini's *Canon* and the different individual proportional values in Savonarola's *Speculum* (Appendix 3).

[366] Cennini shares the medieval opinion of animals as *bruta animalia* following Thomas Aquinas, *Summa Theologiae*, 38, 19:21. Benjamin Arbel, "The Renaissance Transformation of Animal Meaning – from Petrarch to Montaigne," *Making Animal Meaning*, L. Kalof and G. Montgomery, eds. (East Lansing 2011), 59–80 (63).

[367] Eric Achermann, "Das Prinzip des Vorrangs. Zur Bedeutung des Paragone für die Entwicklung der Künste," *Diskurse der Gelehrtenkultur in der Frühen Neuzeit. Ein Handbuch*, H. Jaumann, ed. (Berlin and New York 2011), 179–209 (197); Woods-Marsden, *op. cit.*, 67.

[368] Pisanello's drawing in Vienna (Albertina n. 24018), the so-called *Luxuria*, showing a naked woman and a rabbit, is probably connected to this ambivalence (Pisanello. *Le peintre aux sept vertus, op. cit.*, no. 42). Drawings of nude women are contained in the *Louvre Album* (tre damixelle nude con tre puttini, folio 88) and in the book of drawings in the British Museum (folios 30v, 31, 31v, 32, 33v, 34, 48, 51v).

[369] Aristoteles, *De natura animalium, op. cit.*, 6, 31; Eisler, *op. cit.*, 154.

[370] Reufer, "Eine aus Linien aufgebaute Bilderwelt," *op. cit.*, 406.

[371] "Ausgehend von seinem heute verlorenen Vorrat an Einzelstudien und Musterblättern, baute Bellini in seiner reifen Zeit groß komponierte, räumlich gestaffelt, in die Wesensart der Tiere eindringende Gruppen auf, selbstgültige Kunstwerke, die eine Abkehr von der überkommenen Musterfunktion der Tierzeichnung bedeuten." (Degenhart and Schmitt, *Corpus*, II-6, *op. cit.*, 444).

[372] Lions were occasionally kept in town halls, as on the Capitoline Hill in Rome or in the *Palazzo dei Priori* in Perugia, in order to sysmbolize the power of the executive authority. When this was not possible, a painting would be exhibited showing a prostrated man before a lion bearing the inscription (as was the case in Padua): *parcere prostratis sit nobilis ira leonis / tu quoque fac simile quisquis regnabis* (Marcanova, Bern Cod. B. 42, f. 79).

[373] *Codex Urbinas*, Biblioteca Apostolica Vaticana, folios 58v–59. Regarding the primacy of sight: David Summers, *The Judgement of Sense. Renaissance Naturalism and the Rise of Aesthetics* [1987] (Cambridge 2007), 38–9.

[374] Martha L. Dunkelmann, "Donatello's Influence on Mantegna's 'early narrative scenes,'" Art Bulletin 62, 1980, 226–35. Martin Warnke, "Die Handschrift des Künstlers – Andrea Mantegna," *Künstlerlegenden – Kritische Ansichten* (Göttingen 2019), 47–55 (49). Martha L. Dunkelmann, Donatello's influence on Mantegna's 'early narrative scenes', Art Bulletin, 62, 1980, 226–35. Martin Warnke, "Die Handschrift des Künstlers – Andrea Mantegna," Künstlerlegenden – Kritische Ansichten (Göttingen 2019), 47–55 (49).

375 *Jo ho facto uno homo andrea mantegna el quale stete cum mi* (Lipton, *op. cit.*, doc. 79, 376). Casu, "Giorgio Schiavone e Carlo Crivelli," *op. cit.*, 38: "[…] se Mantegna aveva a lungo utilizzato il nome del capobottega, anche dopo le liti che assai per tempo avevano caratterizzato i rapporti tra i due, tanto da esser conosciuto a Milano e in Toscana come Andrea Squarcione, ora [1465] è il maestro a farsi pubblicità col nome del più dotato allievo."

Summary

1 Leo Planiscig, "Jacopo und Gentile Bellini. Neue Beiträge zu ihrem Werk," *Jahrbuch der kunsthistorischen Sammlungen in Wien*, NF 12, (1928), 1–22, argued that, without the drawings, Jacopo's importance is difficult to establish (1): "ohne die Skizzenbücher vermöchten wir die wahre Bedeutung dieses Künstlers kaum zu erkennen."

2 Gian Maria Varanini, "La terraferma veneta nel Quattrocento e le tendenze recenti della storiografia", *Ateneo Veneto: Atti del Convegno internazionale di studi* [Venezia 2009], 197, 2010, 13–67.

3 Squarcione, who certainly did not know Pelacani personally, may have been in touch with his pupil and successor on the Paduan chair (since 1422), Prosdocimo de' Beldomandi. Cf. Antonio Favaro, "Intorno alla vita e alle opere di Prosdocimo de' Beldomandi, matematico padovano del secolo XV," *Bullettino di bibliografia e storia delle scienze matematiche e fisiche*, 12 (1879), 1–74, 115–251.

4 Eckart Marchand, "Image and Thing: the Distribution and Impact of Plaster Casts in Renaissance Europe," The *Sculpture Journal*, 26 (2017), 83–91 (83). Regarding a large delivery of gypsum from Marco Zoppo's father in Bologna, on May 24, 1455, for making figures and images (*pro zeso pro aptando figuras et jmagines*): Lipton, *op. cit.*, doc. 54, 353. On October 9, 1455, the amount of gypsum is calculated as weighing 3500 pounds (*librarum trium millium quingentarum de dicto zesso*), ibid., doc. 56, 355. Regarding the *domus dita a relevis*, Salmazo, 'Francesco Squarcione Gymnasiarcha', *op. cit.*, 14. There is no doubt, however, that Squarcione had acquired casts and learnt how to produce them by himself on his travels, at a much earlier date.

APPENDICES

I

Louvre Book, R. F. 1509 (folio 45): *Enthroned Ruler Presented with Severed Head* (see also figs. 18 and 19 in the text)

II

Leon Battista Alberti, *De pictura:* Book One, paragraphs 19, 20

III

Louvre Book, R. F. 1495 (folio 28): *Death of the Virgin*

IV

Louvre Book, R. F. 1496 (folio 30): *Presentation of the Virgin in the Temple*

V

Louvre Book, R. F. 1498 (folio 32): *Adoration of the Magi*

VI

Louvre Book, R. F. 1499 (folio 34): *Adoration of the Magi*

VII

Louvre Book, R. F. 1501 (folio 37): *Adoration of the Shepherds*

VIII

Comparison Louvre Book, R. F. 427 (folio 29): *Flagellation* – Andrea Mantegna, Chiesa degli Eremitani (Padua): *Baptism of Hermogenes by Saint James the Elder*

IX

Andrea Mantegna, Chiesa degli Eremitani (Padua): *Saint James the Elder before Herodes Agrippa*

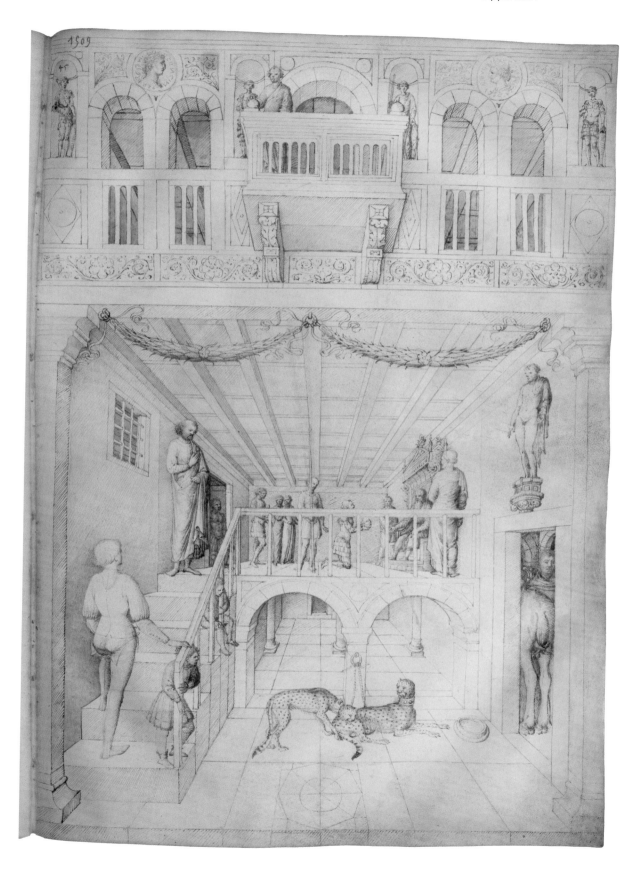

Beginning
Define the framing square with its diagonals. The
intersection of the diagonals establishes the center
point. Draw the horizon line passing through the
center point and parallel to the base line; also
draw the vertical midline through the center point.

Beginning
Define the framing square with its diagonals. The
intersection of the diagonals establishes the center
point. Draw the horizon line passing through the
center point and parallel to the base line; also
draw the vertical midline through the center point.

Pavement
Divide the base line with equidistant points into six
parts and connect these points of division with the
center point; the resulting lines are perspective
lines of the pavement.

Beginning
Define the framing square with its diagonals. The intersection of the diagonals establishes the center point. Draw the horizon line passing through the center point and parallel to the base line; also draw the vertical midline through the center point.

Pavement
Divide the base line with equidistant points into six parts and connect these points of division with the center point; the resulting lines are perspective lines of the pavement.
Choose one of the vanishing points of pavement's diagonals [in this case, the left intersection of the frame and the horizon line]. Connect this vanishing point with the frame corner at the bottom right. This connecting line has six points of intersection with the perspective lines.

Beginning
Define the framing square with its diagonals. The intersection of the diagonals establishes the center point. Draw the horizon line passing through the center point and parallel to the base line; also draw the vertical midline through the center point.

Pavement
Divide the base line with equidistant points into six parts and connect these points of division with the center point; the resulting lines are perspective lines of the pavement.
Choose one of the vanishing points of pavement's diagonals [in this case, the left intersection of the frame and the horizon line]. Connect this vanishing point with the frame corner at the bottom right. This connecting line has six points of intersection with the perspective lines.
Draw lines parallel to the base line through these six points of intersection; these are the transversals 1 to 6 of the pavement.

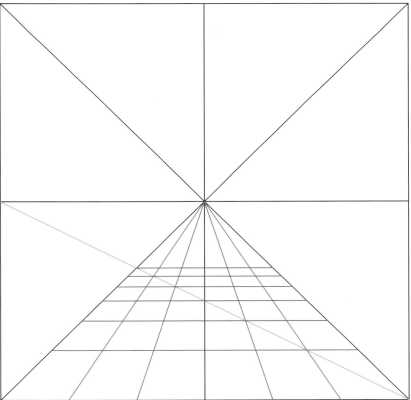

Beginning
Define the framing square with its diagonals. The intersection of the diagonals establishes the center point. Draw the horizon line passing through the center point and parallel to the base line; also draw the vertical midline through the center point.

Pavement
Divide the base line with equidistant points into six parts and connect these points of division with the center point; the resulting lines are perspective lines of the pavement.
Choose one of the vanishing points of pavement's diagonals [in this case, the left intersection of the frame and the horizon line]. Connect this vanishing point with the frame corner at the bottom right. This connecting line has six points of intersection with the perspective lines.
Draw lines parallel to the base line through these six points of intersection; these are the transversals 1 to 6 of the pavement. With the help of a second diagonal, establish transversals 7, 8, and 9.

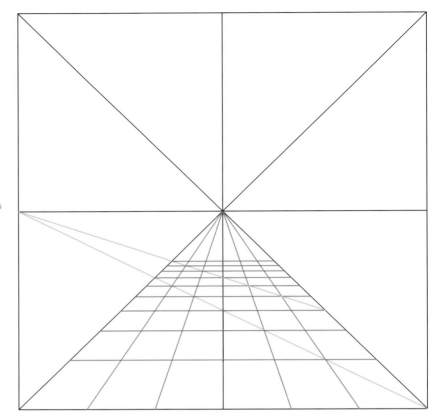

Beginning
Define the framing square with its diagonals. The intersection of the diagonals establishes the center point. Draw the horizon line passing through the center point and parallel to the base line; also draw the vertical midline through the center point.

Pavement
Divide the base line with equidistant points into six parts and connect these points of division with the center point; the resulting lines are perspective lines of the pavement.
Choose one of the vanishing points of pavement's diagonals [in this case, the left intersection of the frame and the horizon line]. Connect this vanishing point with the frame corner at the bottom right. This connecting line has six points of intersection with the perspective lines.
Draw lines parallel to the base line through these six points of intersection; these are the transversals 1 to 6 of the pavement. With the help of a second diagonal, establish transversals 7, 8, and 9.

Rear Wall & Upper Floor
Draw the rear wall.

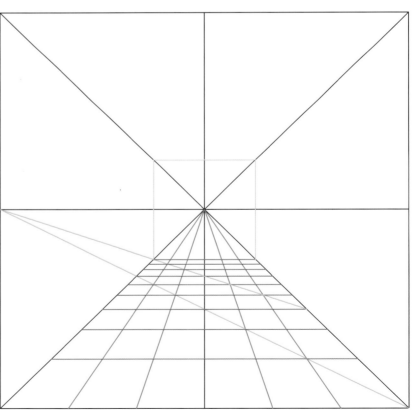

Beginning
Define the framing square with its diagonals. The intersection of the diagonals establishes the center point. Draw the horizon line passing through the center point and parallel to the base line; also draw the vertical midline through the center point.

Pavement
Divide the base line with equidistant points into six parts and connect these points of division with the center point; the resulting lines are perspective lines of the pavement.
Choose one of the vanishing points of pavement's diagonals [in this case, the left intersection of the frame and the horizon line]. Connect this vanishing point with the frame corner at the bottom right. This connecting line has six points of intersection with the perspective lines.
Draw lines parallel to the base line through these six points of intersection; these are the transversals 1 to 6 of the pavement. With the help of a second diagonal, establish transversals 7, 8, and 9.

Rear Wall & Upper Floor
Draw the rear wall.
Draw the front plane, the perspective lines and the back edge of the upper floor.

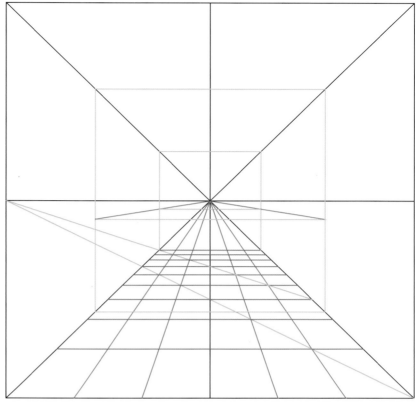

Beginning
Define the framing square with its diagonals. The intersection of the diagonals establishes the center point. Draw the horizon line passing through the center point and parallel to the base line; also draw the vertical midline through the center point.

Pavement
Divide the base line with equidistant points into six parts and connect these points of division with the center point; the resulting lines are perspective lines of the pavement.
Choose one of the vanishing points of pavement's diagonals [in this case, the left intersection of the frame and the horizon line]. Connect this vanishing point with the frame corner at the bottom right. This connecting line has six points of intersection with the perspective lines.
Draw lines parallel to the base line through these six points of intersection; these are the transversals 1 to 6 of the pavement. With the help of a second diagonal, establish transversals 7, 8, and 9.

Rear Wall & Upper Floor
Draw the rear wall.
Draw the front plane, the perspective lines and the back edge of the upper floor.

Staircase
Draw the perspective line in the floor, a vertical line in the front plane of the upper room and one in the rear wall.

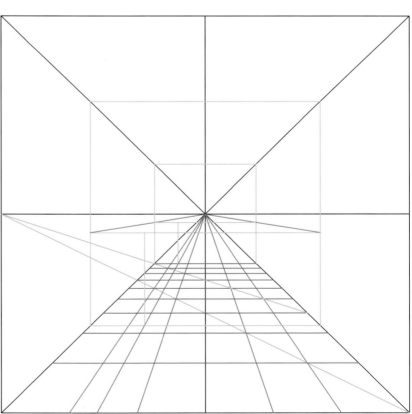

Beginning

Define the framing square with its diagonals. The intersection of the diagonals establishes the center point. Draw the horizon line passing through the center point and parallel to the base line; also draw the vertical midline through the center point.

Pavement

Divide the base line with equidistant points into six parts and connect these points of division with the center point; the resulting lines are perspective lines of the pavement.

Choose one of the vanishing points of pavement's diagonals [in this case, the left intersection of the frame and the horizon line]. Connect this vanishing point with the frame corner at the bottom right. This connecting line has six points of intersection with the perspective lines.

Draw lines parallel to the base line through these six points of intersection; these are the transversals 1 to 6 of the pavement. With the help of a second diagonal, establish transversals 7, 8, and 9.

Rear Wall & Upper Floor

Draw the rear wall.

Draw the front plane, the perspective lines and the back edge of the upper floor.

Staircase

Draw the perspective line in the floor, a vertical line in the front plane of the upper room and one in the rear wall.

Draw the staircase's slope.

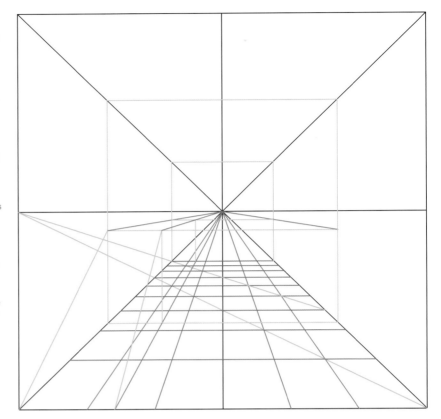

Beginning

Define the framing square with its diagonals. The intersection of the diagonals establishes the center point. Draw the horizon line passing through the center point and parallel to the base line; also draw the vertical midline through the center point.

Pavement

Divide the base line with equidistant points into six parts and connect these points of division with the center point; the resulting lines are perspective lines of the pavement.

Choose one of the vanishing points of pavement's diagonals [in this case, the left intersection of the frame and the horizon line]. Connect this vanishing point with the frame corner at the bottom right. This connecting line has six points of intersection with the perspective lines.

Draw lines parallel to the base line through these six points of intersection; these are the transversals 1 to 6 of the pavement. With the help of a second diagonal, establish transversals 7, 8, and 9.

Rear Wall & Upper Floor

Draw the rear wall.

Draw the front plane, the perspective lines and the back edge of the upper floor.

Staircase

Draw the perspective line in the floor, a vertical line in the front plane of the upper room and one in the rear wall.

Draw the staircase's slope.

Octagon

Draw the original octagon

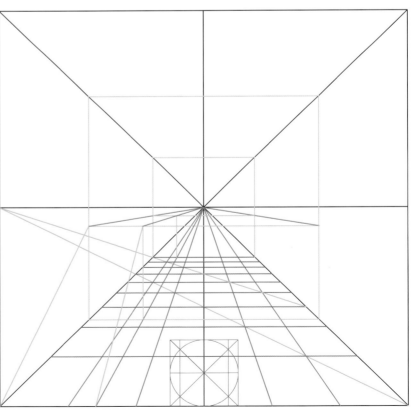

Beginning
Define the framing square with its diagonals. The intersection of the diagonals establishes the center point. Draw the horizon line passing through the center point and parallel to the base line; also draw the vertical midline through the center point.

Pavement
Divide the base line with equidistant points into six parts and connect these points of division with the center point; the resulting lines are perspective lines of the pavement.
Choose one of the vanishing points of pavement's diagonals [in this case, the left intersection of the frame and the horizon line]. Connect this vanishing point with the frame corner at the bottom right. This connecting line has six points of intersection with the perspective lines.
Draw lines parallel to the base line through these six points of intersection; these are the transversals 1 to 6 of the pavement. With the help of a second diagonal, establish transversals 7, 8, and 9.

Rear Wall & Upper Floor
Draw the rear wall.
Draw the front plane, the perspective lines and the back edge of the upper floor.

Staircase
Draw the perspective line in the floor, a vertical line in the front plane of the upper room and one in the rear wall.
Draw the staircase's slope.

Octagon
Draw the original octagon and construct its perspective image in the middle of the pavement's first strip.

Finally
Erase the construction lines

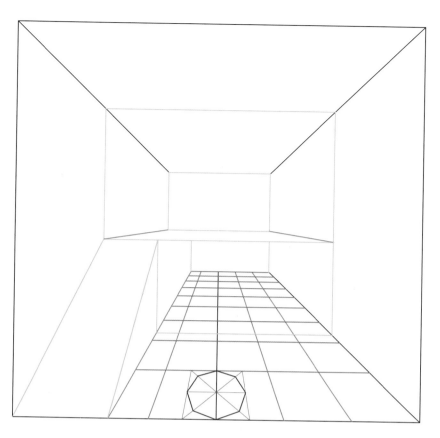

linearum ductionem ad singulas iacentis lineæ diuisiones prosequor · Sed in successiuis quantitatibus transuersis hunc modum seruo ·

Ars Positionis plani peroptima

QVADRAN GVLVS ·

pyramis

distantia

punctus Centricus

perpendicularis

Iacens linea

Habeo Areolam in qua describo lineam unam rectam hanc diuido p eius partis in qua iacens linea quadranguli diuisa est · Dehinc pono sursu ab hac linea punctum unicu ad alteræ lineæ caput perpendicularem tam alte q est in qua drangulo centricus punctus a iacente linea diuisa quadra guli distans abhocq puncto ad singulas huius ipius lineæ diuisiones singulas lineas duco tum quanta uelim distatia

23 · s· centricus

Leon Battista Alberti, *De pictura* [1435], 1518, Lucca, Biblioteca Governativa, Ms. 1448, fol. 23r

sequence: _____

sequence: ================

quadrangulus (mihi pro fenestra)

quadrangulus (mihi pro fenestra)

quam magni homines

sequence: ================

sequence: ================

quadrangulus (mihi pro fenestra)

quadrangulus (mihi pro fenestra)

quam magni homines

quam magni homines

tres partes

tres partes

partes infimae lineae quadranguli

sequence: ================

sequence: ================

quadrangulus (mihi pro fenestra)

quadrangulus (mihi pro fenestra)

centricus punctus

centricus punctus

lineae ad divisiones

quam magni homines

quam magni homines

tres partes

tres partes

partes infimae lineae quadranguli

partes infimae lineae quadranguli

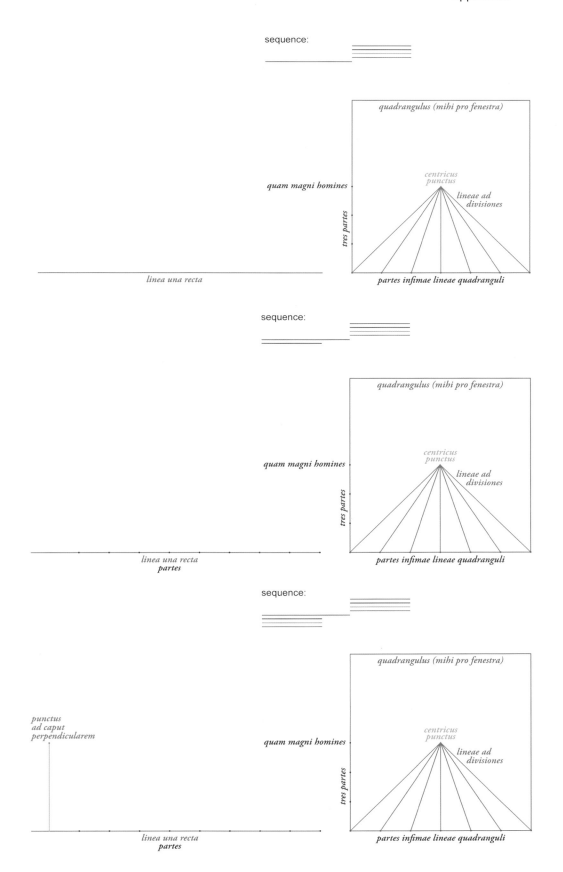

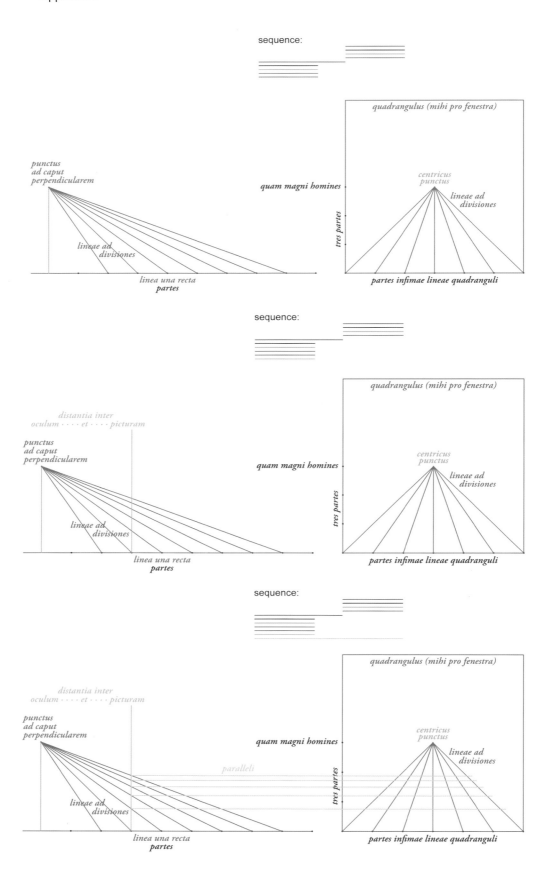

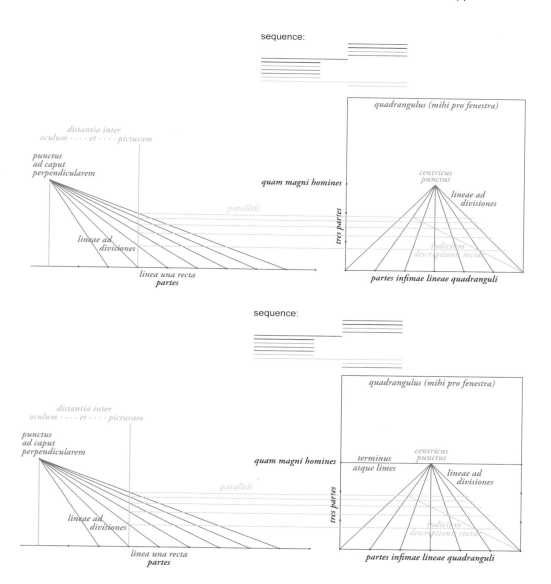

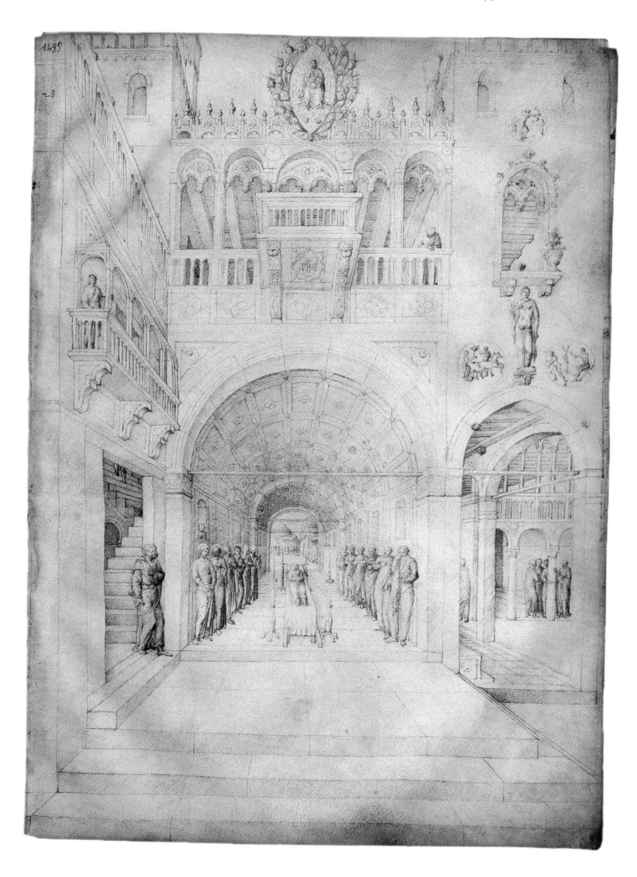

LOUVRE BOOK, R. F. 1495
Folio 28: Death of the Virgin

The Steps of Reconstruction

Beginning
Draw the horizon, the central point and the main front.

The Steps of Reconstruction

Beginning
Draw the horizon, the central point and the main front.

Interior
Draw the perspective lines,

The Steps of Reconstruction

Beginning
Draw the horizon, the central point and the main front.

Interior
Draw the perspective lines,
Draw the cross sections 1 and 5.

The Steps of Reconstruction

Beginning
Draw the horizon, the central point and the main front.

Interior
Draw the perspective lines,
Draw the cross sections 1 and 5.
Draw (with the help of bisections) the cross sections 2, 3 and 4.

The Steps of Reconstruction

Beginning
Draw the horizon, the central point and the main front.

Interior
Draw the perspective lines,
Draw the cross sections 1 and 5.
Draw (with the help of bisections) the cross sections 2, 3 and 4.

Barrel Vault
Draw the arch in the main front and an arch for each cross section.

The Steps of Reconstruction

Beginning
Draw the horizon, the central point and the main front.

Interior
Draw the perspective lines,
Draw the cross sections 1 and 5.
Draw (with the help of bisections) the cross sections 2, 3 and 4.

Barrel Vault
Draw the arch in the main front and an arch for each cross section.

Forecourt
Draw the floor and the step on the left with their perspective lines.

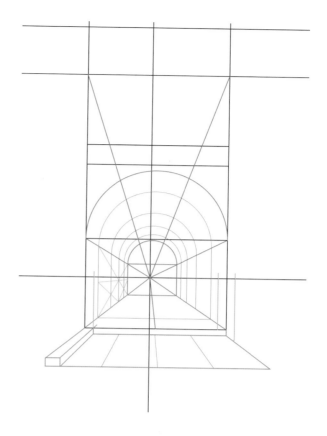

The Steps of Reconstruction

Beginning
Draw the horizon, the central point and the main front.

Interior
Draw the perspective lines,
Draw the cross sections 1 and 5.
Draw (with the help of bisections) the cross sections 2, 3 and 4.

Barrel Vault
Draw the arch in the main front and an arch for each cross section.

Forecourt
Draw the floor and the step on the left with their perspective lines.
Draw some of the vertical bounds of the main front.

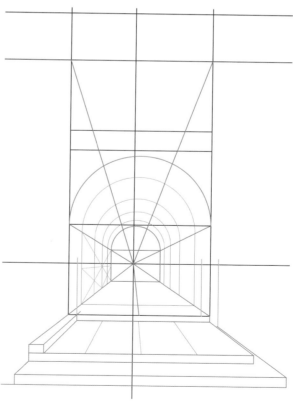

The Steps of Reconstruction

Beginning
Draw the horizon, the central point and the main front.

Interior
Draw the perspective lines,
Draw the cross sections 1 and 5.
Draw (with the help of bisections) the cross sections 2, 3 and 4.

Barrel Vault
Draw the arch in the main front and an arch for each cross section.

Forecourt
Draw the floor and the step on the left with their perspective lines.
Draw some of the vertical bounds of the main front.
Draw the steps in front and on the right.

The Steps of Reconstruction

Beginning
Draw the horizon, the central point and the main front.

Interior
Draw the perspective lines,
Draw the cross sections 1 and 5.
Draw (with the help of bisections) the cross sections 2, 3 and 4.

Barrel Vault
Draw the arch in the main front and an arch for each cross section.

Forecourt
Draw the floor and the step on the left with their perspective lines.
Draw some of the vertical bounds of the main front.
Draw the steps in front and on the right.

Side Face
Draw the frame of the door.

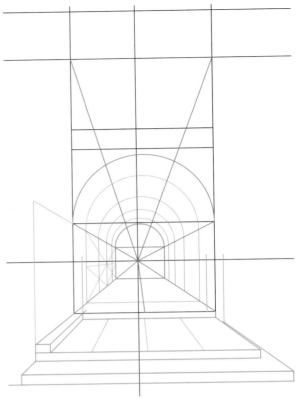

The Steps of Reconstruction

Beginning
Draw the horizon, the central point and the main front.

Interior
Draw the perspective lines,
Draw the cross sections 1 and 5.
Draw (with the help of bisections) the cross sections 2, 3 and 4.

Barrel Vault
Draw the arch in the main front and an arch for each cross section.

Forecourt
Draw the floor and the step on the left with their perspective lines.
Draw some of the vertical bounds of the main front.
Draw the steps in front and on the right.

Side Face
Draw the frame of the door,
the house corner and the perspective lines.

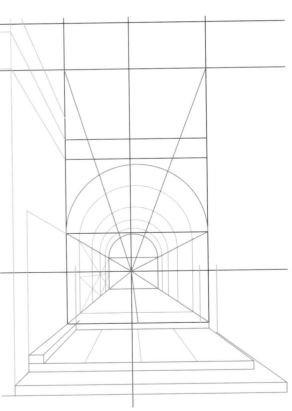

The Steps of Reconstruction

Beginning
Draw the horizon, the central point and the main front.

Interior
Draw the perspective lines,
Draw the cross sections 1 and 5.
Draw (with the help of bisections) the cross sections 2, 3 and 4.

Barrel Vault
Draw the arch in the main front and an arch for each cross section.

Forecourt
Draw the floor and the step on the left with their perspective lines.
Draw some of the vertical bounds of the main front.
Draw the steps in front and on the right.

Side Face
Draw the frame of the door,
the house corner and the perspective lines.

Finally
Erase the construction lines

The Steps of Reconstruction

Beginning
Draw the horizon, the central point and the main front.

Interior
Draw the perspective lines,
Draw the cross sections 1 and 5.
Draw (with the help of bisections) the cross sections 2, 3 and 4.

Barrel Vault
Draw the arch in the main front and an arch for each cross section.

Forecourt
Draw the floor and the step on the left with their perspective lines.
Draw some of the vertical bounds of the main front.
Draw the steps in front and on the right.

Side Face
Draw the frame of the door,
the house corner and the perspective lines.

Finally
Erase the construction lines
and
show the folio as background.

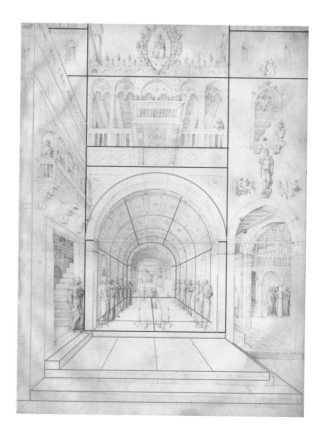

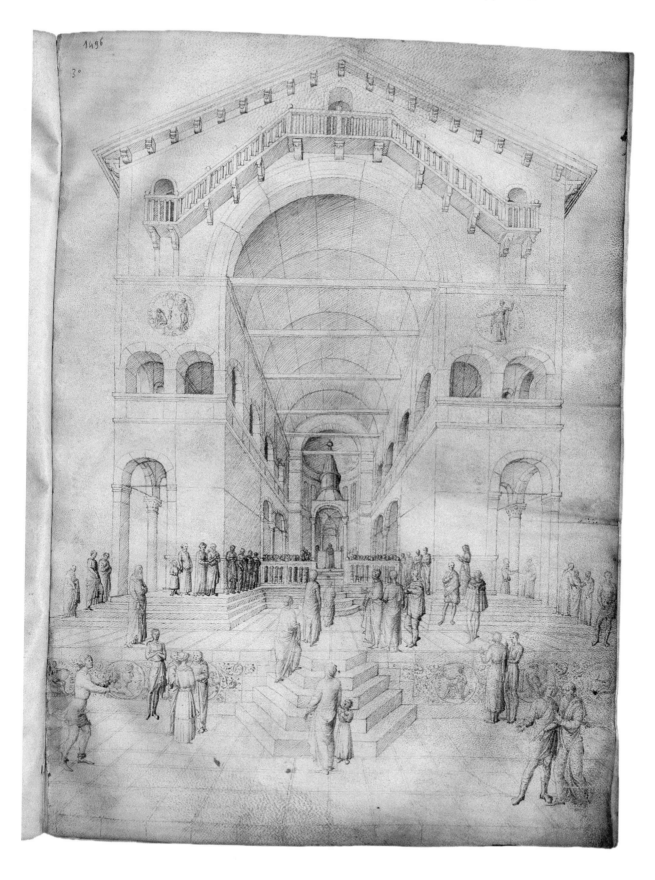

1496

3°

LOUVRE BOOK, R. F. 1496
Folio 30: Presentation of the Virgin in the Temple

The Steps of Reconstruction

Beginning
Draw the horizon, the central point and the hole in the main front.

The Steps of Reconstruction

Beginning
Draw the horizon, the central point and the hole in the main front.

Interior
Draw the perspective lines and a first cross section.

The Steps of Reconstruction

Beginning
Draw the horizon, the central point and the hole in the main front.

Interior
Draw the perspective lines and a first cross section.
Draw a second cross section, the end of the nave.

The Steps of Reconstruction

Beginning
Draw the horizon, the central point and the hole in the main front.

Interior
Draw the perspective lines and a first cross section.
Draw a second cross section, the end of the nave.

Forecourt
Draw the front wall (divided by four horizontal lines).

The Steps of Reconstruction

Beginning
Draw the horizon, the central point and the hole in the main front.

Interior
Draw the perspective lines and a first cross section.
Draw a second cross section, the end of the nave.

Forecourt
Draw the front wall (divided by four horizontal lines).

Protruding staircase
Draw the pyramidal covering

The Steps of Reconstruction

Beginning
Draw the horizon, the central point and the hole in the main front.

Interior
Draw the perspective lines and a first cross section.
Draw a second cross section, the end of the nave.

Forecourt
Draw the front wall (divided by four horizontal lines).

Protruding staircase
Draw the pyramidal covering with the edges of the steps.

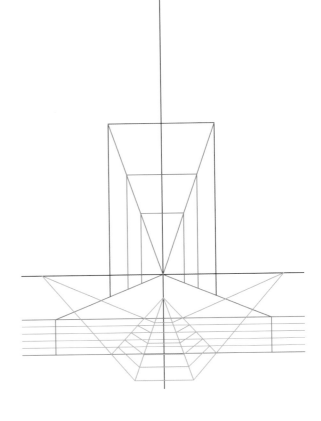

The Steps of Reconstruction

Beginning
Draw the horizon, the central point and the hole in the main front.

Interior
Draw the perspective lines and a first cross section.
Draw a second cross section, the end of the nave.

Forecourt
Draw the front wall (divided by four horizontal lines).

Protruding staircase
Draw the pyramidal covering with the edges of the steps.

Mezzanine floor with stairs
Draw the mezzanine floor (asymmetric)

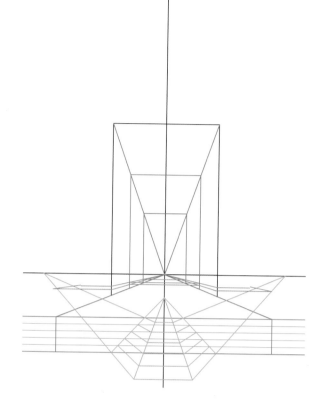

The Steps of Reconstruction

Beginning
Draw the horizon, the central point and the hole in the main front.

Interior
Draw the perspective lines and a first cross section.
Draw a second cross section, the end of the nave.

Forecourt
Draw the front wall (divided by four horizontal lines).

Protruding staircase
Draw the pyramidal covering with the edges of the steps.

Mezzanine floor with stairs
Draw the mezzanine floor (asymmetric) **and**
the pyramidal covering of its stairs (asymmetric).

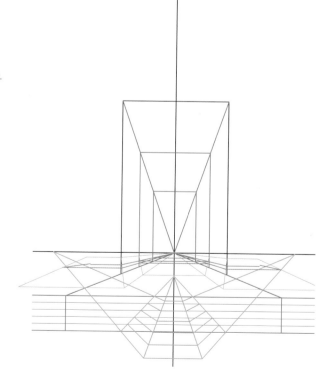

The Steps of Reconstruction

Beginning
Draw the horizon, the central point and the hole in the main front.

Interior
Draw the perspective lines and a first cross section.
Draw a second cross section, the end of the nave.

Forecourt
Draw the front wall (divided by four horizontal lines).

Protruding staircase
Draw the pyramidal covering with the edges of the steps.

Mezzanine floor with stairs
Draw the mezzanine floor (asymmetric) and
the pyramidal covering of its stairs (asymmetric).

Further Contour-Lines
Draw the bounds of the main front (asymmetric).

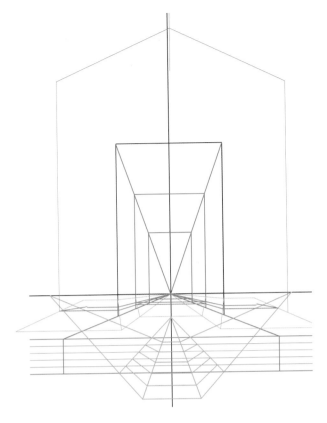

The Steps of Reconstruction

Beginning
Draw the horizon, the central point and the hole in the main front.

Interior
Draw the perspective lines and a first cross section.
Draw a second cross section, the end of the nave.

Forecourt
Draw the front wall (divided by four horizontal lines).

Protruding staircase
Draw the pyramidal covering with the edges of the steps.

Mezzanine floor with stairs
Draw the mezzanine floor (asymmetric) and
the pyramidal covering of its stairs (asymmetric).

Further Contour-Lines
Draw the bounds of the main front (asymmetric).
Draw the front arch and the rear arch of the barrel vault.

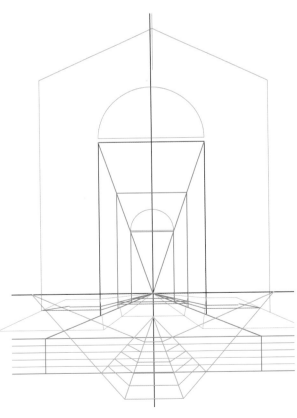

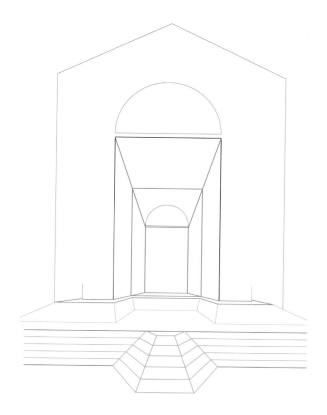

The Steps of Reconstruction

Beginning
Draw the horizon, the central point and the hole in the main front.

Interior
Draw the perspective lines and a first cross section.
Draw a second cross section, the end of the nave.

Forecourt
Draw the front wall (divided by four horizontal lines).

Protruding staircase
Draw the pyramidal covering with the edges of the steps.

Mezzanine floor with stairs
Draw the mezzanine floor (asymmetric) and
the pyramidal covering of its stairs (asymmetric).

Further Contour-Lines
Draw the bounds of the main front (asymmetric).
Draw the front arch and the rear arch of the barrel vault.

Finally
Erase the construction lines

The Steps of Reconstruction

Beginning
Draw the horizon, the central point and the hole in the main front.

Interior
Draw the perspective lines and a first cross section.
Draw a second cross section, the end of the nave.

Forecourt
Draw the front wall (divided by four horizontal lines).

Protruding staircase
Draw the pyramidal covering with the edges of the steps.

Mezzanine floor with stairs
Draw the mezzanine floor (asymmetric) and
the pyramidal covering of its stairs (asymmetric).

Further Contour-Lines
Draw the bounds of the main front (asymmetric).
Draw the front arch and the rear arch of the barrel vault.

Finally
Erase the construction lines
and
show the folio as background.

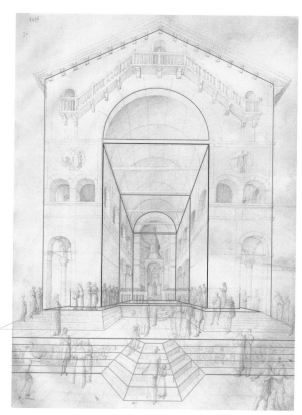

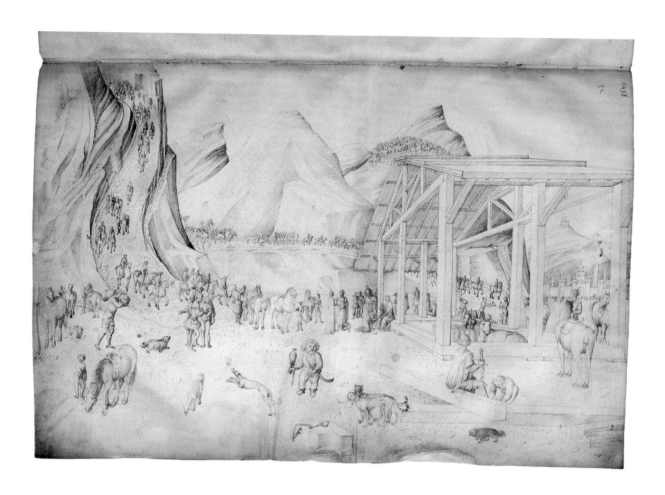

LOUVRE BOOK, R. F. 1498
Folio 32: Adoration of the Magi

The Steps of Reconstruction

Beginning
Draw the horizon and the central point.

The Steps of Reconstruction

Beginning
Draw the horizon and the central point.

Stable
Draw the front wall,

The Steps of Reconstruction

Beginning
Draw the horizon and the central point.

Stable
Draw the front wall,
the perspective lines

The Steps of Reconstruction

Beginning
Draw the horizon and the central point.

Stable
Draw the front wall,
the perspective lines and the rear wall

The Steps of Reconstruction

Beginning
Draw the horizon and the central point.

Stable
Draw the front wall,
the perspective lines and the rear wall
With the help of diagonals define
the middle of the left-side front.

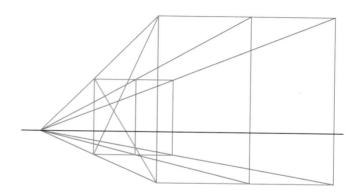

The Steps of Reconstruction

Beginning
Draw the horizon and the central point.

Stable
Draw the front wall,
the perspective lines and the rear wall
With the help of diagonals define
the middle of the left-side front.
Draw the middle cross section.

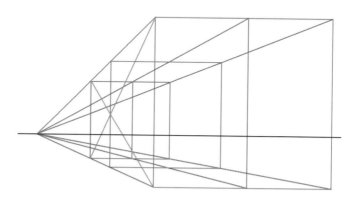

The Steps of Reconstruction

Beginning
Draw the horizon and the central point.

Stable
Draw the front wall,
the perspective lines and the rear wall
With the help of diagonals define
the middle of the left-side front.
Draw the middle cross section.

Finally
Erase the construction lines

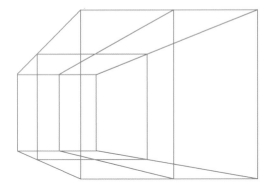

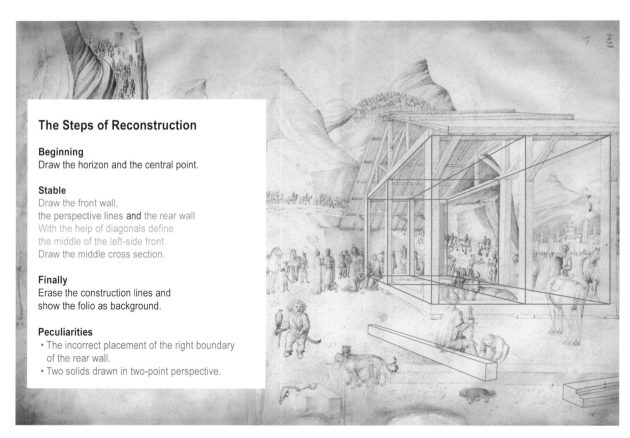

The Steps of Reconstruction

Beginning
Draw the horizon and the central point.

Stable
Draw the front wall,
the perspective lines and the rear wall
With the help of diagonals define
the middle of the left-side front.
Draw the middle cross section.

Finally
Erase the construction lines and
show the folio as background.

Peculiarities
• The incorrect placement of the right boundary
 of the rear wall.
• Two solids drawn in two-point perspective.

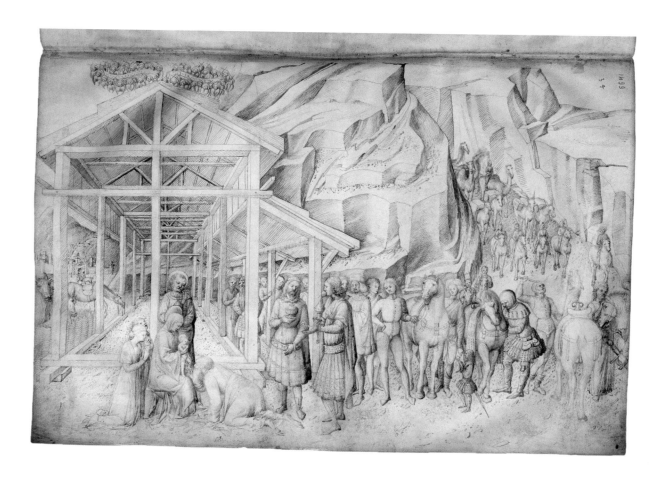

LOUVRE BOOK, R. F. 1499
Folio 34: Adoration of the Magi

The Steps of Reconstruction

Beginning
Draw the horizon and the central point.

The Steps of Reconstruction

Beginning
Draw the horizon and the central point.

Stable (cover)
Draw the front wall,

The Steps of Reconstruction

Beginning
Draw the horizon and the central point.

Stable (cover)
Draw the front wall,
the perspective lines

The Steps of Reconstruction

Beginning
Draw the horizon and the central point.

Stable (cover)
Draw the front wall,
the perspective lines and the rear wall.

The Steps of Reconstruction

Beginning
Draw the horizon and the central point.

Stable (cover)
Draw the front wall,
the perspective lines and the rear wall.

Stable (interior)
With the help of diagonals

The Steps of Reconstruction

Beginning
Draw the horizon and the central point.

Stable (cover)
Draw the front wall,
the perspective lines and the rear wall.

Stable (interior)
With the help of diagonals
draw the middle (second) cross section.

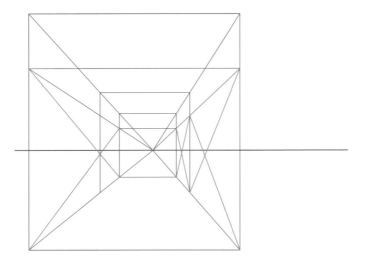

The Steps of Reconstruction

Beginning
Draw the horizon and the central point.

Stable (cover)
Draw the front wall,
the perspective lines **and** the rear wall.

Stable (interior)
With the help of diagonals
draw the middle (second) cross section.
With the help of diagonals

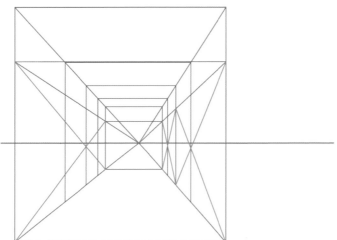

The Steps of Reconstruction

Beginning
Draw the horizon and the central point.

Stable (cover)
Draw the front wall,
the perspective lines **and** the rear wall.

Stable (interior)
With the help of diagonals
draw the middle (second) cross section.
With the help of diagonals
draw the first and the third cross section.

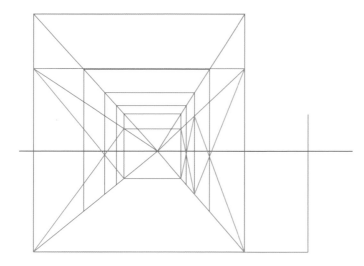

The Steps of Reconstruction

Beginning
Draw the horizon and the central point.

Stable (cover)
Draw the front wall,
the perspective lines **and** the rear wall.

Stable (interior)
With the help of diagonals
draw the middle (second) cross section.
With the help of diagonals
draw the first and the third cross section.

Stable (annex)
Draw the front wall,

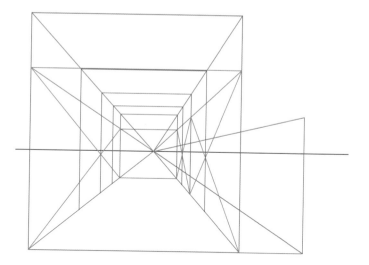

The Steps of Reconstruction

Beginning
Draw the horizon and the central point.

Stable (cover)
Draw the front wall,
the perspective lines **and** the rear wall.

Stable (interior)
With the help of diagonals
draw the middle (second) cross section.
With the help of diagonals
draw the first and the third cross section.

Stable (annex)
Draw the front wall,
the perspective lines

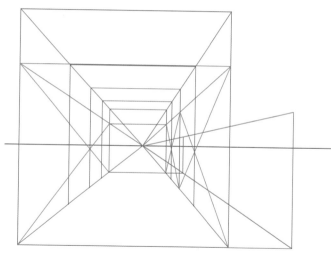

The Steps of Reconstruction

Beginning
Draw the horizon and the central point.

Stable (cover)
Draw the front wall,
the perspective lines **and** the rear wall.

Stable (interior)
With the help of diagonals
draw the middle (second) cross section.
With the help of diagonals
draw the first and the third cross section.

Stable (annex)
Draw the front wall,
the perspective lines **and** the rear wall.

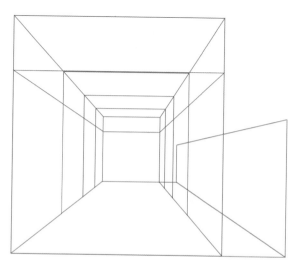

The Steps of Reconstruction

Beginning
Draw the horizon and the central point.

Stable (cover)
Draw the front wall,
the perspective lines **and** the rear wall.

Stable (interior)
With the help of diagonals
draw the middle (second) cross section.
With the help of diagonals
draw the first and the third cross section.

Stable (annex)
Draw the front wall,
the perspective lines **and** the rear wall.

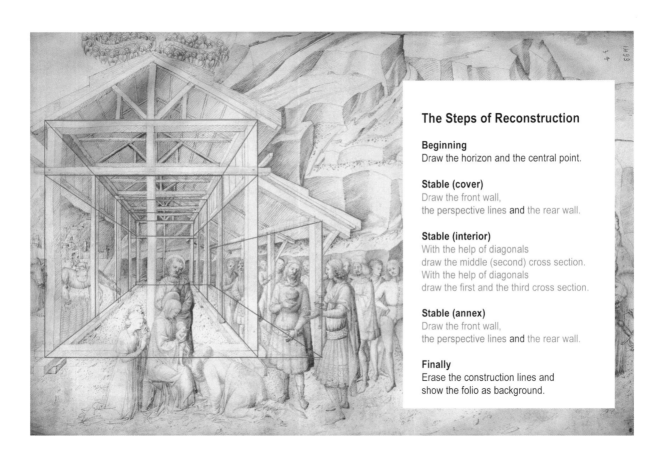

The Steps of Reconstruction

Beginning
Draw the horizon and the central point.

Stable (cover)
Draw the front wall,
the perspective lines and the rear wall.

Stable (interior)
With the help of diagonals
draw the middle (second) cross section.
With the help of diagonals
draw the first and the third cross section.

Stable (annex)
Draw the front wall,
the perspective lines and the rear wall.

Finally
Erase the construction lines and
show the folio as background.

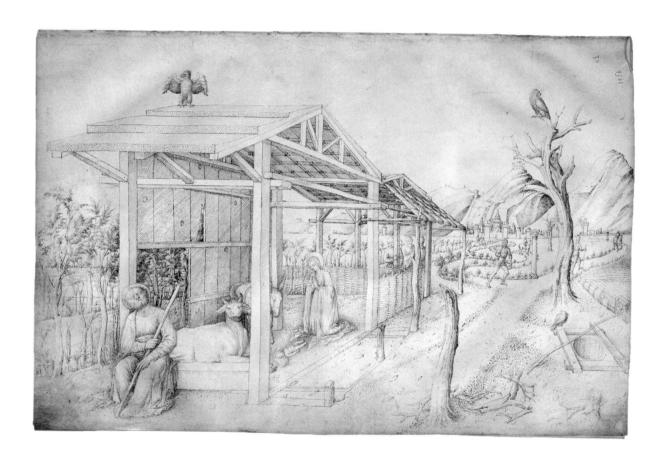

LOUVRE BOOK, R. F. 1501
Folio 37: Adoration of the Shepherds

The Steps of Reconstruction

Beginning
Draw the horizon and the central point.

The Steps of Reconstruction

Beginning
Draw the horizon and the central point.

Stable (main building)
Draw the rear wall.

The Steps of Reconstruction

Beginning
Draw the horizon and the central point.

Stable (main building)
Draw the rear wall,
the perspective lines

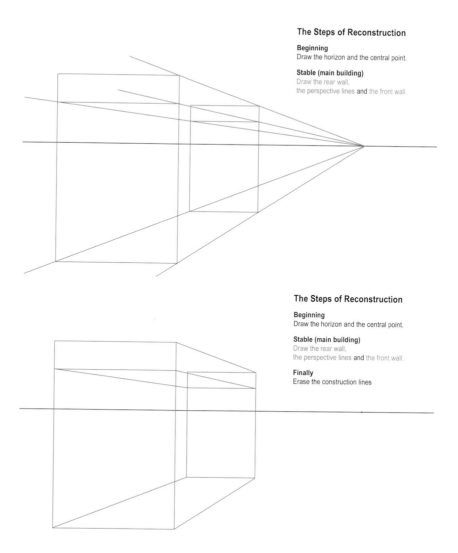

The Steps of Reconstruction

Beginning
Draw the horizon and the central point.

Stable (main building)
Draw the rear wall,
the perspective lines and the front wall.

The Steps of Reconstruction

Beginning
Draw the horizon and the central point.

Stable (main building)
Draw the rear wall,
the perspective lines and the front wall.

Finally
Erase the construction lines

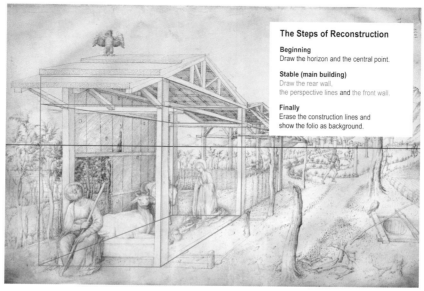

The Steps of Reconstruction

Beginning
Draw the horizon and the central point.

Stable (main building)
Draw the rear wall,
the perspective lines and the front wall.

Finally
Erase the construction lines and
show the folio as background.

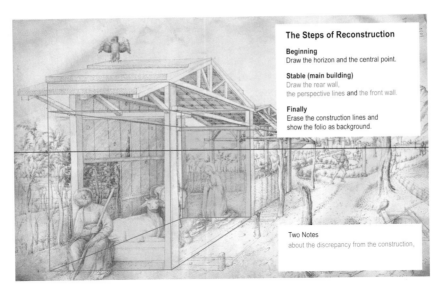

The Steps of Reconstruction

Beginning
Draw the horizon and the central point.

Stable (main building)
Draw the rear wall,
the perspective lines and the front wall.

Finally
Erase the construction lines and
show the folio as background.

Two Notes
about the discrepancy from the construction,

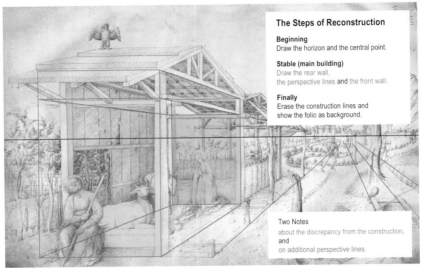

The Steps of Reconstruction

Beginning
Draw the horizon and the central point.

Stable (main building)
Draw the rear wall,
the perspective lines and the front wall.

Finally
Erase the construction lines and
show the folio as background.

Two Notes
about the discrepancy from the construction,
and
on additional perspective lines.

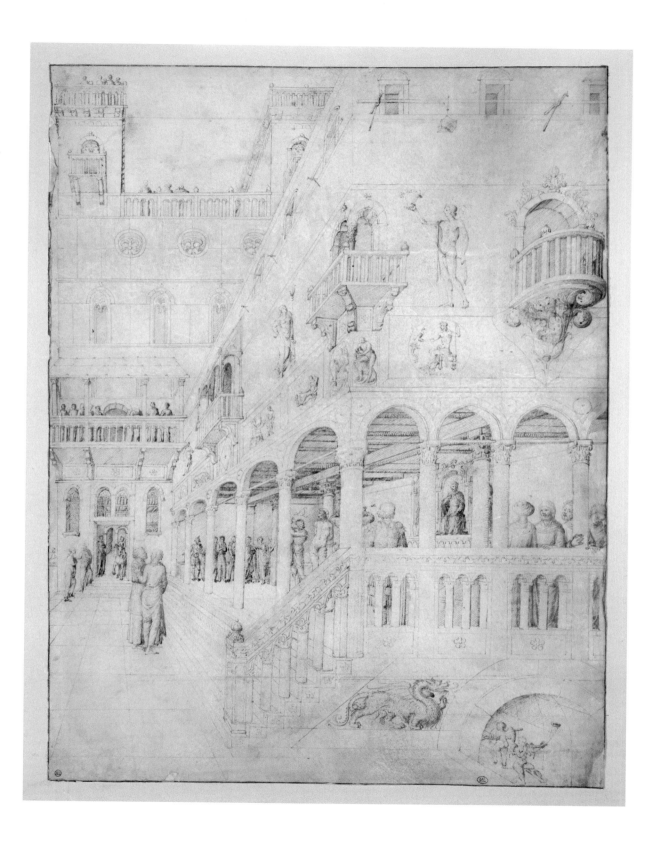

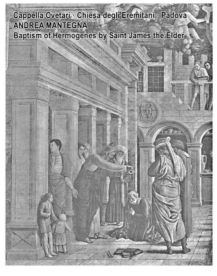

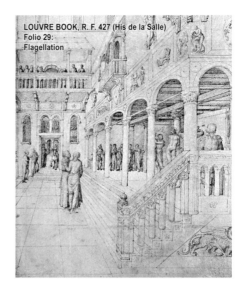

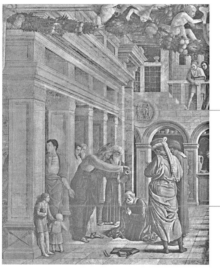

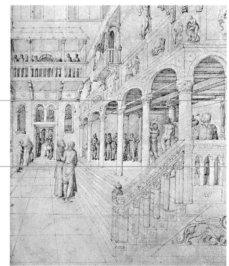

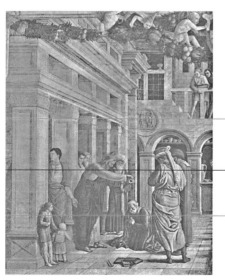

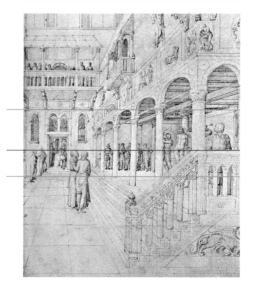

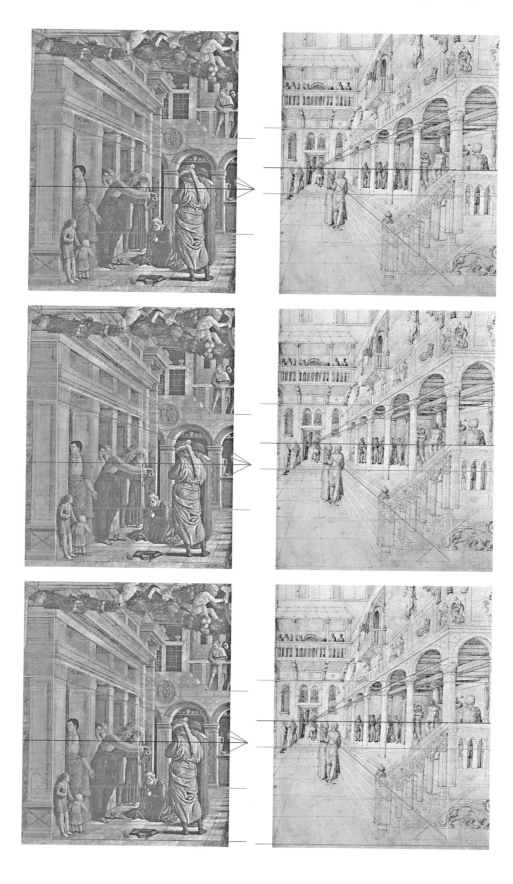

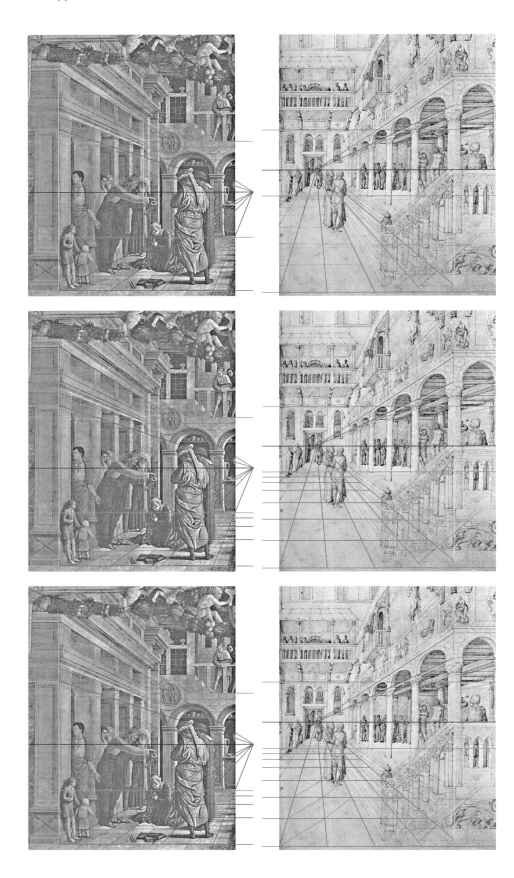

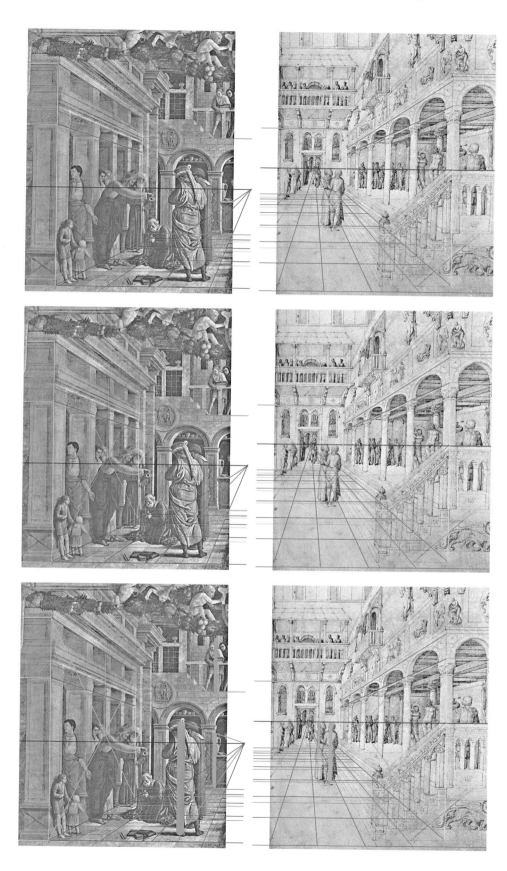

COMPARISION OF TWO ARTWORKS WITH THE HELP OF RECONSTRUCTIONS OF PROBABLE PERSPECTIVE DESIGNS			
01	Cappella Ovetari · Chiesa degli Eremitani · Padova **ANDREA MANTEGNA** **Baptism of Hermogenes by Saint James the Elder**	LOUVRE BOOK, R. F. 427 (His de la Salle) Folio 29: Flagellation	01
02	Define the rear wall by the floor line and a parallel of it.		02
03	Choose the horizon line and the central point.		03
04	Mark the side face of the side wing by perspective lines (especially with the floor line of the side face).		04
05	For the side wing: Mark the vertical bounds of the side face		05
05	and determining horizontal lines of the front face.		05
06	Draw the front bound of the floor.		06
	Choose – from the front bound to the rear wall – a grid of the pavement with		
	3 x 4 fields (each field with several tiles).	3 x 7 fields (each field with one tile).	
07	Draw the perspective lines of the pavement.		07
08	Draw the transversals of the pavement.		08
09	Draw diagonals in the grid's fields and check the collinearity.		09
	Diagnosis: not accurate.	Diagnosis: not accurate.	
10	Compare with the correct placement of the transversals.		10
	Diagnosis: displaced a little backward.	Diagnosis: displaced a lot forward.	
11	For the side face of the side wing: Determine in the reconstruction the middle with the face's diagonals, look at the middle in the original work and check how much this middles differ.		11
	Diagnosis: a little difference. The middle in the original work is a little too close to the central point.	Diagnosis: a great difference. The middle in the original work is much too far away from the central point.	
12	Compare the height of human figures. Remove the reference figure to the balcony.		12
	Diagnosis: almost the same height like figures on the balcony. (The children – left in front – have turned out much too small.)	Diagnosis: significantly higher than figures on the balcony	

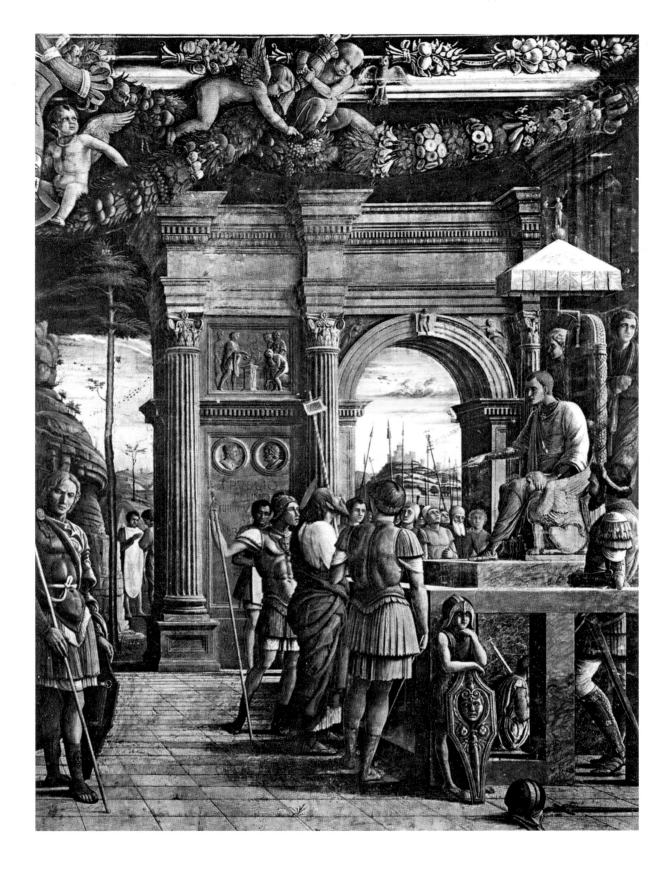

Cappella Ovetari · Chiesa degli Eremitani · Padova
ANDREA MANTEGNA
Saint James the Elder before Herodes Agrippa I

The Steps of Reconstruction

Beginning
Draw the horizon and the central point
Draw the front and rear boundaries of the floor,
the front boundary with points of division.

The Steps of Reconstruction

Beginning
Draw the horizon and the central point
Draw the front and rear boundaries of the floor,
the front boundary with points of division.

Pavement
Draw the perspective lines.
(For the placement of the transversals, no construction
and no numerical method is recognizable.)

The Steps of Reconstruction

Beginning
Draw the horizon and the central point
Draw the front and rear boundaries of the floor,
the front boundary with points of division.

Pavement
Draw the perspective lines.
(For the placement of the transversals, no construction
and no numerical method is recognizable.)

Throne
Draw the faces that are in frontal position.

The Steps of Reconstruction

Beginning
Draw the horizon and the central point
Draw the front and rear boundaries of the floor,
the front boundary with points of division.

Pavement
Draw the perspective lines.
(For the placement of the transversals, no construction
and no numerical method is recognizable.)

Throne
Draw the faces that are in frontal position.
Draw the perspective lines

The Steps of Reconstruction

Beginning
Draw the horizon and the central point
Draw the front and rear boundaries of the floor,
the front boundary with points of division.

Pavement
Draw the perspective lines.
(For the placement of the transversals, no construction
and no numerical method is recognizable.)

Throne
Draw the faces that are in frontal position.
Draw the perspective lines and
the remaining edges.

The Steps of Reconstruction

Beginning
Draw the horizon and the central point
Draw the front and rear boundaries of the floor,
the front boundary with points of division.

Pavement
Draw the perspective lines.
(For the placement of the transversals, no construction
and no numerical method is recognizable.)

Throne
Draw the faces that are in frontal position.
Draw the perspective lines and
the remaining edges.

Triumphal Arch
Draw the front with the first arch of the barrel vault.

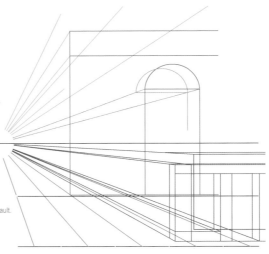

The Steps of Reconstruction

Beginning
Draw the horizon and the central point
Draw the front and rear boundaries of the floor,
the front boundary with points of division.

Pavement
Draw the perspective lines.
(For the placement of the transversals, no construction
and no numerical method is recognizable.)

Throne
Draw the faces that are in frontal position.
Draw the perspective lines and
the remaining edges.

Triumphal Arch
Draw the front with the first arch of the barrel vault.
Draw the perspective lines and the last arch.

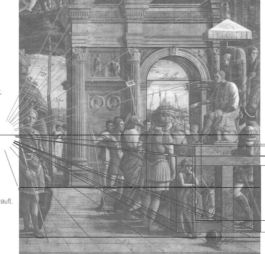

The Steps of Reconstruction

Beginning
Draw the horizon and the central point
Draw the front and rear boundaries of the floor,
the front boundary with points of division.

Pavement
Draw the perspective lines.
(For the placement of the transversals, no construction
and no numerical method is recognizable.)

Throne
Draw the faces that are in frontal position.
Draw the perspective lines and
the remaining edges.

Triumphal Arch
Draw the front with the first arch of the barrel vault.
Draw the perspective lines and the last arch.

Finally
Show the folio as background

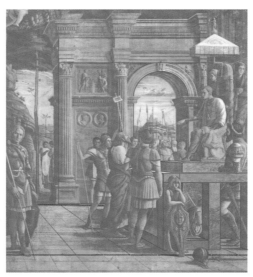

The Steps of Reconstruction

Beginning
Draw the horizon and the central point
Draw the front and rear boundaries of the floor,
the front boundary with points of division.

Pavement
Draw the perspective lines.
(For the placement of the transversals, no construction
and no numerical method is recognizable.)

Throne
Draw the faces that are in frontal position.
Draw the perspective lines and
the remaining edges.

Triumphal Arch
Draw the front with the first arch of the barrel vault.
Draw the perspective lines and the last arch.

Finally
Show the folio as background and
erase the construction lines.

The Height of Figures

(Note well: The eyes of all figures – standing on the pavement – are above the horizon. Therefore, the pavement is higher than the painter's base floor. This is also indicated by the step at the front boundary of the floor.)

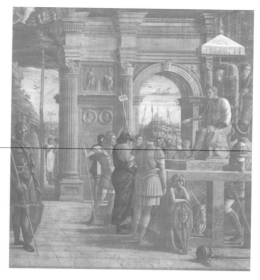

The Height of Figures

(Note well: The eyes of all figures – standing on the pavement – are above the horizon. Therefore, the pavement is higher than the painter's base floor. This is also indicated by the step at the front boundary of the floor.)

Reference Figure • Saint James • Spectators

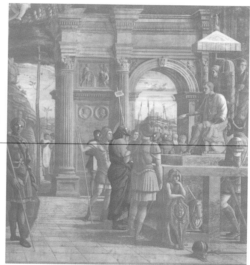

The Height of Figures

(Note well: The eyes of all figures – standing on the pavement – are above the horizon. Therefore, the pavement is higher than the painter's base floor. This is also indicated by the step at the front boundary of the floor.)

Reference Figure • Saint James • Spectators

Displacement of the Reference Figure
• in its own frontal plane.

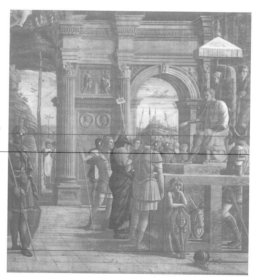

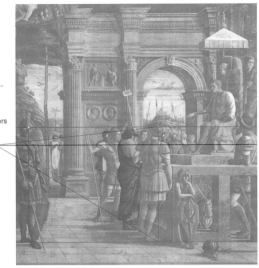

The Height of Figures

(Note well: The eyes of all figures – standing on the pavement – are above the horizon. Therefore, the pavement is higher than the painter's base floor. This is also indicated by the step at the front boundary of the floor.)

Reference Figure • Saint James • Spectators

Displacement of the Reference Figure
• in its own frontal plane.
• in Saint James's perspective plane.

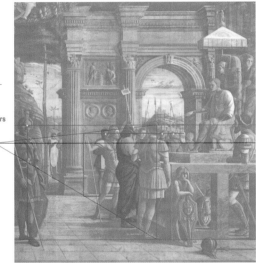

The Height of Figures

(Note well: The eyes of all figures – standing on the pavement – are above the horizon. Therefore, the pavement is higher than the painter's base floor. This is also indicated by the step at the front boundary of the floor.)

Reference Figure • Saint James • Spectators

Displacement of the Reference Figure
• in its own frontal plane.
• in Saint James's perspective plane.
• in the frontal plane of the spectators.

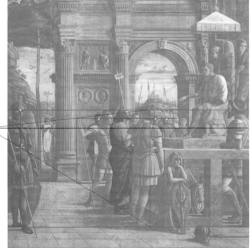

The Height of Figures

(Note well: The eyes of all figures – standing on the pavement – are above the horizon. Therefore, the pavement is higher than the painter's base floor. This is also indicated by the step at the front boundary of the floor.)

Reference Figure • Saint James • Spectators

Displacement of the Reference Figure
• in its own frontal plane.
• in Saint James's perspective plane.
• in the frontal plane of the spectators.

Conclusions from these comparisons
The height of the figures correspond very exactly. The painter probably used a constructive transfer.

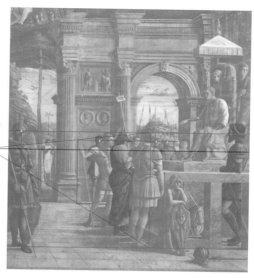

The Height of Figures

(Note well: The eyes of all figures – standing on the pavement –
are above the horizon. Therefore, the pavement is higher than
the painter's base floor. This is also indicated by the step at
the front boundary of the floor.)

Reference Figure • Saint James • Spectators

Displacement of the Reference Figure
• in its own frontal plane.
• in Saint James's perspective plane.
• in the frontal plane of the spectators.

Conclusions from these comparisons
The height of the figures correspond very exactly.
The painter probably used a constructive
transfer.

Exceptions:
The soldier at the right boundary is standing behind the frontal
plane of the reference figure. Therefore, he is too big.

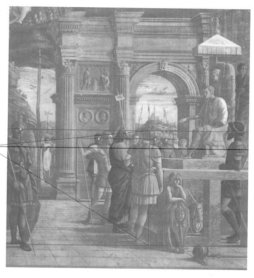

The Height of Figures

(Note well: The eyes of all figures – standing on the pavement –
are above the horizon. Therefore, the pavement is higher than
the painter's base floor. This is also indicated by the step at
the front boundary of the floor.)

Reference Figure • Saint James • Spectators

Displacement of the Reference Figure
• in its own frontal plane.
• in Saint James's perspective plane.
• in the frontal plane of the spectators.

Conclusions from these comparisons
The height of the figures correspond very exactly.
The painter probably used a constructive
transfer.

Exceptions:
The soldier at the right boundary is standing behind the frontal
plane of the reference figure. Therefore, he is too big.
The man behind the seat of judgment is standing approximatly
in Saint James's frontal plane. Therefore, he is too small.

BIBLIOGRAPHY

ACHERMANN, Eric, „Das Prinzip des Vorrangs. Zur Bedeutung des Paragone für die Entwicklung der Künste," *Diskurse der Gelehrtenkultur in der Frühen Neuzeit. Ein Handbuch*, H. Jaumann, ed. (Berlin and New York 2011), 179–209.

ACIDINI LUCHINAT, Cristina, "The Collecting and Commissioning Preferences of the Medici: from Cosimo the Elder to Lorenzo the Magnificent," see CAT. EXH., *In the Light of Apollo* (Athens 2003), 271–76.

AGOSTI, Giovanni, *Su Mantegna*, I (Milan 2005).

AGOSTI, Giovanni, see CAT. EXH., *Mantegna* (Louvre, Paris 2008).

ALBERTI, Leon Battista, *On Painting: A New Translation and Critical Edition* (2010), R. Sinisgalli, Trans. (Cambridge 2013).

ALBERTI, Leon Battista, *De eqvo animante*, C. Grayson and F. Furlan, eds. (Pisa 2017).

ALDOVRANDI, Antonio, "Il taccuino di Giovannino de Grassi della Biblioteca Civica di Bergamo. Tecnica di esecuzione e restauro," *I materiali cartacei*, C. Frosinini, ed. (Florence 1997), 15–37.

ALEXANDER, Jonathan J. G. (ed.), *The Painted Page: Italian Renaissance Book Illumination, 1450–1550* (CAT. EXH.), Royal Academy of Arts, London (London and Munich 1994).

AMES-LEWIS, Francis, *Drawing in Early Renaissance Italy* (New Haven and London 1981).

AMES-LEWIS, Francis, *The Intellectual Life of the Early Renaissance Artist* (New Haven and London 2000).

D' ANCONA, Ciriaco, *Codex Hamilton* (1442/43), Staatsbibliothek Ms. Ham. 254.

ARBEL, Benjamin, "The Renaissance Transformation of Animal Meaning – from Petrarch to Montaigne," *Making Animal Meaning*, L. Kalof and G. Montgomery, eds. (East Lansing 2011), 59–80.

ARGAN, Giulio Carlo, "The Achitecture of Brunelleschi and the Origins of Perspective Theory in the 15th Century," *Journal of the Warburg and Courtauld Institutes*, IX (1946), 96–121.

ARISTOTLE, *Historia animalium*, D'Arcy Westworth Thompson, Trans. (London 1910).

ARISTOTLE, *The Poetics*, S. H. Butcher, Trans. (London 1902).

ARISTOTLE, *Politics*, H. Rackham, Trans. [Loeb Classical Library, 264] (Cambridge/MA 1932).

AVERY, Victoria, "The Production, Display and Reception of Bronze Heads and Busts in Renaissance Venice and Padua: Surrogate Antiques," *Kopf / Bild: Die Büste in Mittelalter und Früher Neuzeit: Italienische Forschungen des Kunsthistorischen Institutes in Florenz*, J. Kohl and R. Müller, eds. (Munich 2007), 75–112.

AVRIL, François (ed.), *Dix siècles d'enluminure italienne VIe–XVIe siècles* (CAT. EXH.), Bibliothèque Nationale (Paris 1984).

BACCHI, Andrea, and GIACOMELLI, Luciana (eds.), *Rinascimento e passione per l'antico. Andrea Riccio e il suo tempo* (CAT. EXH.), Castello del Buonconsiglio (Trento 2008).

BAGGIO, Luca, "Sperimentazioni spaziali negli affreschi di Altichiero nell'Oratorio di San Giorgio," *Il secolo di Giotto nel Veneto: Istituto veneto di scienze, lettere ed arti*, G. Valenzano and F. Toniolo, eds. (Venice 2007), 417–27.

BALDASSO, Renzo, "Portrait of Luca Pacioli and Disciple – a New Mathematical Look," *The Art Bulletin*, 92 (2010), 83–102.

BALDISSIN MOLLI, Giovanna, MARIANI CANOVA, Giordana, and TONIOLO, Federica (eds.), *La miniatura a Padova dal Medioevo al Settecento* (CAT. EXH.), Palazzo della Ragione, Padua (Modena 1999).

BALDISSIN MOLLI, Giovanna, "In margine al Centenario di Andrea Mantegna: Il problema dell'anno di nascita del pittore," *Il Santo*, XLVII (2007), 481–502.

BALDISSIN MOLLI, Giovanna, "Cennino Cennini im Kontext des paduanischen Hofes," see CAT. EXH., *Fantasia und Handwerk*, (Staatliche Museen, Berlin 2008) 142–45.

BAMBACH, Carmen C., *Drawing and Painting in the Italian Renaissance Workshop: Theory and Practice 1300–1600* (Cambridge and New York 1993).

BANZATO, Davide, "Mantegna a Padova tra il 1445 e il 1460, la prospettiva restituita," *Art e dossier* (2006), 6–13.

BANZATO, Davide, see CAT. EXH., *Guariento* (Musei Civici, Padua 2011).

BANZATO, Davide, see CAT. EXH., *Mantegna e Padova* (Musei Civici, Padua 2006).

BARILE, Elisabetta, "Contributi su Biagio Saraceno, copista dell'Eusebio Marciano Lat. IX.1 (3496) e cancelliere del verscovo di Padova Fantino Dandolo," *Studi di storia religiosa padovana dal medioeveo ai nostri giorni: Studi in onore di mons. Ireneo Daniele*, F. G. B. Tirolese, ed. (Padua 1997), 141–64.

BARILE, Elisabetta, "La famiglia Marcanova attraverso sette generazioni," *Cittadini Veneziani del Quattrocento. I due Marcanova, il mercante e l'umanista: Istituto veneto di scienze, lettere ed arti, Memorie*, vol. CXVII, E. Barile, P. C. Clarke, G. Nordio, eds. (Venice 2006), 3–248.

BARILE, Elisabetta, "Giovanni Marcanova e i suoi possibili incontri con Andrea Mantegna," see CAT. EXH., *Mantegna e Padova 1445-1460* (Musei Civici, Padua 2006) 37–43.

BAROLSKY, Paul, and WALLACE, William, "The Strange Case of the Young Michelangelo," Arion: A Journal of Humanities and the Classics, 21 (2013), 103–12.

BARON, Hans, The *Crisis of the Early Renaissance* [1955] (Princeton 1996).

BASSI, Arturo, *Ricerche e ipotesi di un Virgilio del Mantegna per Isabella d'Este* (Florence 1983).

BAUMANN, Felix Andreas, *Das Erbario Carrarese und die Bildtradition des* Tractatus de herbis. *Ein Beitrag zur Geschichte der Pflanzendarstellung im Übergang von Spätmittelalter zu Frührenaissance: Berner Schriften zur Kunst*, 12 (Bern 1974).

BAXANDALL, Michael, "A Dialogue on Art from the Court of Leonello d'Este. Angelo Decembrio's *De politia letteraria* Pars LXVIII," *Journal of the Warburg and Courtuld Institutes*, 26 (1963), 304–25.

BAXANDALL, Michael, "Guarino, Pisanello and Manuel Chrysoloras," *Journal of the Warburg and Courtauld Institutes*, 28 (1965), 183–204.

BAXANDALL, Michael, *Giotto and the Orators. Humanist Observers of Painting in Italy and the Discovery of Pictorial Composition 1350–1450* (Oxford 1971).

BECK, Herbert, see CAT. EXH., *Natur und Antike* (Liebieghaus, Frankfurt/M 1985)).

BELTING, Hans, *Florenz und Bagdad – eine westöstliche Geschichte des Blicks* (München 2008).

BELTRAMINI, Guido, "Mantegna e la firma di Vitruvio," *Mantegna e le arti a Verona 1450-1500*, S. Marinelli and P. Marini, eds. (Venice 2006), 139–47.

BENATI, Daniele, "Jacopo Avanzi e Altichiero a Padova," *Il secolo di Giotto nel Veneto: Istituto veneto di scienze, lettere ed arti*, G. Valenzano and F. Toniolo, eds. (Venice 2007), 385–398.

BERBARA, Maria L., "Civic Self-Offering: Some Renaissance Representations of Marcus Curtius," *Recreating Ancient History*, K. Enenkel et alii, eds. (Leyden 2001), 147–66.

BERGDOLT, Klaus, *Der dritte Kommentar Lorenzo Ghibertis. Naturwissenschaften und Medizin in der Kunsttheorie der Frührenaissance* (= PhD Thesis, University Heidelberg, Weinheim 1988).

BERGSTEIN, Mary, "Donatello's Gattamelata and Its Humanist Audience," *Renaissance Quarterly*, 55, 3 (2002), 833–68.

BERTALOT, Ludwig, "Eine Sammlung Paduaner Reden des XV Jahrhunderts" [1935/36], *Studien zum italienischen und deutschen Humanismus*, P. O. Kristeller, ed., vol. 2 (Rome 1975), 209–35.

BERTI, Enrico, "Filosofia, astrologia e vita quotidiana nella Padova del Trecento," *PADVA SIDVS / PRECLARVM. I Dondi dall'Orologio e la Padova dei Carraresi* (CAT. EXH.), Palazzo della Ragione, Padua 1989, N. Mazzonetto ed. (Montagnana 1989), 7–28.

BERTOSA, Slaven, "Gli orizzonti mediterranei della famiglia veneziana Loredan," *Atti*, 42 (2012), 537–69.

BESCHI, Luigi, "Antiquarian Research in Greece During the Renaissance: Travellers and Collectors," see CAT. EXH., *In the Light of Apollo* (Athens 2003), 46–52.

BIANCO, Maria Luisa, "Saggio di lettura di un museo cinquecentesco. La raccolta di Marco Mantova Benavides," *Iconografia 2001. Studi sull' immagine: Atti del Convegno* (Padua 2002), 495–503.

BIE, O., "Ringkampf des Pan und Eros," *Jahrbuch des Kaiserlich Deutschen Archäologischen Instituts*, IV (1889), 129–37.

BILLANOVICH, Eugenio and Myriam, "Epitafi ed elogi per il Gattamelata," *Italia Medioevale e Umanistica*, 37 (1994), 223–32.

BILLANOVICH, Giuseppe, *La tradizione del testo di Livio e le origini dell'umanesimo* (Padua 1981).

BILLANOVICH, Giuseppe, *Petrarca e il primo Umanesimo* (Padua 1996).

BILLANOVICH, Maria Pia, "Una miniera di epigrafi e di antichità. Il Chiostro Maggiore di S. Giustina a Padova," *Italia Medioevale e Umanistica*, XII (1969), 197–293.

BILLANOVICH, Maria Pia, "Bernardino da Parenzo pittore e Bernardino (Lorenzo) da Parenzo eremita," *Italia Medioevale e Umanistica* (1981), 385–404.

BILLANOVICH, Myriam, "Intorno alla *Iubilatio* di Felice Feliciano," *Italia Medioevale e Umanistica*, XXXII (1989), 351–58.

BILLANOVICH, Myriam, see BILLANOVICH, Eugenio.

BISMARA, Claudio, "La cappella Pellegrini e Pisanello *civis originarius* di Verona nel 1438," *Verona illustrata*, 26 (2013), 5–13.

BLAKE MCHAM, Sarah, "Padua, Treviso, and Bassano," *Venice and the Veneto: Artistic Centers of the Italian Renaissance*, P. Humfrey, ed. (New York 2007), 207–31.

BLAKE MCHAM, Sarah, "The Eclectic Taste of the Gattamelata Family," *Padua and Venice. Transcultural Exchange in the Early Modern Age*, B. Blass-Simmen and S. Weppelmann, eds. (Berlin and Boston 2017), 28–40.

BLASS-SIMMEN, Brigit, "Cultural Transfer in Microcosm. Padua and Venice: An Introduction," *Padua and Venice. Transcultural Exchange in the Early Modern Age*, B. Blass-Simmen and S. Weppelmann, eds. (Berlin and Boston 2017), 1–18.

BLUME, Dieter, "The Experience of Exile and the Allegory of Love," *Images and Words in Exile*, E. Brilli et alii, eds. (Florence 2015), 172–92.

BOCCIA, Theresa, see SHAW.

BODON, Giulio, "Studi antiquari tra XV e XVII secolo. La famiglia Maggi di Bassano e la sua collezione di antichità," *Bollettino del Museo Civico di Padova*, LXXX (1991), 23–172.

BODON, Giulio, "L'Interesse numismatico ed antiquario nel primo Trecento veneto. Disegni di monete antiche nei codici delle *Historiae Imperiales* di Giovanni Mansionario," *Xenia Antiqua*, II (1993), 111–24.

BODON, Giulio, "*Veneranda Antiquitas*. Studi sull'eredità dell'antico nella Rinascenza veneta," *Studi sull'eredità dell'antico nella Rinascenza veneta: Studies in Early Modern European Culture*, P. L. Bernardini and L. Orsi, eds. (Bern 2005), 183–202.

BODON, Giulio, "Petrarca, Padova e le memorie dell'antichità: Antenore, Tito Livio e i *Viri Illustres*," *Petrarca e il suo tempo* (CAT. EXH.), Musei Civici, Padua, S. Collodo, ed. (Milan 2006), 125–41.

BODON, Giulio, "Tra Padova e Venezia: Tombe e immagini eroiche nella cultura antiquaria rinascimentale," *Eroi, eroismi, eroizizzaioni: Atti del Convegno Internazionale* [2006] (Padua 2007), 45–65.

BODON, Giulio, 'Heroum Imagines'. *La Sala dei Giganti a Padova – un monumento della tradizione classica e della cultura antiquaria* (Venice 2009).

BODON, Giulio, *Tito Livio fra arte e storia nella Padova del Cinquecento* (Padua 2017).

BODON, Giulio, "Per la fortuna del giardino di antichità nella prima rinascenza veneta: il caso padovano," *Rivista di Archeolgia* (2021), XLIII (2019), 105–114.

BOESE, Helmut, *Die lateinischen Handschriften der Sammlung Hamilton zu Berlin* (Wiesbaden 1966).

BOLLAND, Andrea, "Art and Humanism in Early Renaissance Padua: Cennini, Vergerio and Petrarch," *Renaissance Quarterly*, 49 (1996), 469–87.

BONAVENTURA SBERTI, Antonio, see SBERTI, Antonio Bonaventura.

BOREA, Giulia, "Prospettiva lineare e prospettiva *de pedimenti*: un dibattito sullo scorcio del Quattrocento," *Paragone*, 27 (1999), 3–45.

BOSSI, Patrizia, "L'*Itinerarium* di Ciriaco Anconitano," *Ciriaco d'Ancona e il suo tempo, Viaggi, commerci e avventure fra sponde adriatiche, Egeo e Terra Santa*, L. Minardi, ed. (Ancona 2002), 169–83.

BRENNAN, Robert, "Between Pliny and the Trecento: Ghiberti on the History of Painting," *Ghiberti teorico. Natura, arte e coscienza storica nel Quattrocento*, F. Jonietz, W.-D. Löhr and A. Nova, eds. (Milan 2019), 43–60.

BRENNAN, Robert, *Painting as Modern Art in Early Renaissance Italy* (Turnhout 2019).

BREVENTANO, Stefano, *Istoria delle antichità, nobiltà et delle cose notabili della città di Pavia* (Pavia 1570).

BROWN, David Alan and PIZZATI, Anna, "*Meum amatissimum nepotem* – a New Document Concerning Giovanni Bellini," *Burlington Magazine*, 156 (2014), 148–52.

BROWN, Clifford Malcolm, "Gleanings from the Gonzaga Documents in Mantua: Gian Cristoforo Romano and Andrea Mantegna," *Mitteilungen des Kunsthistorischen Institutes in Florenz*, 17 (1973), 153–59.

BROWN, Clifford Malcolm, "*Una testa de Platone antica con la punta dil naso di cera*: Unpublished Negotiations between Isabella d'Este and Niccolò and Giovanni Bellini," *The Art Bulletin*, 51 (1969), 372–77.

BRUNI, Leonardo, *Sulla perfetta traduzione: Sileni*, vol. 10, P. Viti, ed. (Naples 2004).

BURCKHARDT, Jakob*, Die Kultur der Renaissance in Italien. Ein Versuch* [1860] (Leipzig 1885).

CACCIA, Eleonora. "La *Iubilatio* di Felice Feliciano," *Italia Medioevale e Umanistica*, 55 (2014), 167–223.

CALLEGARI, Marco, *Dal torchio del tipografo al banco del libraio. Stampatori, editori e librai a Padova dal XV al XVIII secolo* (Padua 2002).

CALOGERO, Giacomo Alberto, "Il problema della Pala Gattamelata e gli esordi di Giovanni Bellini," *Paragone*, 147 (2019), 3–31.

CAMEROTA, Filippo, "Misurare *per perspectiva*: geometria e prospettiva pingendi," *La prospettiva. Fondamenti teorici ed esperienze figurative dall'antichità al mondo moderno: Atti del Convegno internazionale di studi dell'Istituto Svizzero di Roma*, R. Sinisgalli ed. (Rome 1998), 293–308.

CAMEROTA, Filippo, *La prospettiva del rinascimento. Arte, architettura, scienza* (Milan 2006).

CAMILLE, Michael, *The Gothic Idol: Ideology and Image Making in Medieval Art* (Cambridge 1989).

CAMPANA, Augusto, "Gli scritti di Iacopo Zeno e il suo elogio di Ciriaco d'Ancona," *La Bibliofilia*, 41 (1939–40).

CAMPANA, Augusto, "Il codice epigrafico di Faenza, Biblioteca Comunale," *L' Antiquario Felice Feliciano Veronese tra epigrafia antica, letteratura e arti del libro: Atti del Convegno di Studi, Verona* [1993] (Padua 1995), 81–88.

CAMPBELL, Caroline, KORBACHER, Dagmar, ROWLEY, Neville, and VOWLES, Sarah, *Mantegna & Bellini*, (CAT. EXH.) National Gallery, London, and Gemäldegalerie Staatliche Museen, Berlin (London 2019).

CAMPBELL, Caroline, see VOWLES, Sarah.

CAMPBELL, Caroline, see CAT. EXH., *Bellini and the East*, (London, National Gallery, 2005)

CAMPBELL, Caroline, see CAT. EXH, *Mantegna & Bellini* (London, National Gallery 2018)

CAMPBELL, Stephen J., "L'agiografia di Andrea Mantegna," *Mantegna e Roma. L'artista davanti all'antico*, T. Calvano et alii, eds. (Rome 2010), 421–49.

CANDIDA, Bianca, *I calchi rinascimentali della collezione Mantova Benavides nel museo del Liviano a Padova* (Padua 1967).

CANOVA, Andrea, cat. nos. 10, 78–9, see CAT. EXH., *Mantegna 1431–1506* (Musée du Louvre, Paris 2008).

CANOVA MARIANI, see MARIANI CANOVA.

CAPPELETTO, Rita, "Ciriaco d'Ancona nel ricordo di Pietro Ranzano," *Ciriaco d'Ancona e la cultura antiquaria dell'umanesimo: Atti del convegno internazionale di studio, Ancona* [1992], G. Paci and S. Sconocchia, eds. (Reggio Emilia 1998), 71–80.

CARRARI, Stefano, "La corrispondenza poetica di Feliciano con Giovanni Testa Cillenio," *L'Antiquario Felice Feliciano Veronese tra epigrafia antica, letteratura e arti del libro: Atti del Convegno di Studi, Verona* [1993], A. Contò and L. Quaquarelli, eds. (Padua 1995), 177–196.

CASU, Stefano G., "Giorgio Schiavone e Carlo Crivelli nella bottega del Squarcione," *Proporzioni*, 1 (2000), 37–54.

CASU, Stefano G., "Drawings after the Antique in the Early Renaissance: Pisanello and Jacopo Bellini," see CAT. EXH., *In the Light of Apollo* (Athens 2003), 134–35.

CASU, Stefano G., "Antiquarian Culture in Padua during the Humanistic Age," see CAT. EXH., *In the Light of Apollo* (Athens 2003), 245–47.

CAT. EXH., *Early Italian Engravings From The National Gallery Of Art*, National Gallery, Washington, J. A. Levenson, ed. (Washington 1973).

CAT. EXH., *Da Giotto A Mantegna*, Palazzo della Ragione, Padua, L. Grossato, ed. (Milan 1974).

CAT. EXH., *Natur und Antike in der Renaissance*, Liebighaus, Frankfurt/M, H. Beck and P. C. Bol, eds. (Frankfurt/M 1985).

CAT. EXH., *Bologna e l'Umanesimo 1490–1510*, Pinacoteca Nazionale, Bologna, and Graphische Sammlung Albertina, Vienna, M. Faietti and K. Oberhuber, eds. (Bologna 1988).

CAT. EXH., *Da Pisanello alla Nascita dei Musei Capitolini. L'antico alla Vigilia del Rinascimento*, Musei Capitolini, Rome, A. Cavallaro and E. Parlato, eds. (Milan 1988).

CAT. EXH., *Andrea Mantegna*, Royal Academy of Arts, London, J. Martineau, ed. (Milan 1992).

CAT. EXH., *Pisanello. Le peintre aux sept vertus*, Musée du Louvre, Paris, C. Cordellier and P. Marini, eds. (Paris 1996).

CAT. EXH., *La Miniatura a Padova dal Medioevo al Settecento*, Palazzo della Ragione, Padua, G. Mariani Canova, ed. (Modena 1999).

CAT. EXH., *Pisanello. Painter to the Renaissance Court*, National Gallery, London, L. Syson and D. Gordon, eds. (London 2001).

CAT. EXH., *In the Light of Apollo. Italian Renaissance and Greece*, vol. I, Ethnike Pinakotheke, Mouseion Alexandrou Soutsou, Athens 2003, M. Gregori, ed. (Milan 2004).

CAT. EXH., *Bellini and the East*, National Gallery, London, C. Campbell and A. Chong, eds. (London 2005).

CAT. EXH., *Die Brüder van Limburg. Nijmegener Meister am Französischen Hof 1400–1416*, Museum Het Valkhof, Nijmegen, R. Dückers and P. Roelofs, eds. (Amsterdam 2005).

CAT. EXH., *Andrea Mantegna e i Gonzaga. Rinascimento nel Castello di San Giorgio*, Museo del Palazzo Ducale, Mantua, F. Trevisani, ed. (Milan 2006).

CAT. EXH., *Mantegna e Padova 1445–1460*, Padua Musei Civici, D. Banzato et alii, eds. (Milan 2006).

CAT. EXH., *Mantegna 1431–1506*, Musée du Louvre, Paris, G. Agosti and D. Thiébaut, eds. (Paris 2008).

CAT. EXH., *Fantasia und Handwerk*, Gemäldegalerie Staatliche Museen, Berlin, W.-D. Löhr and S. Weppelmann, eds. (Munich 2008).

CAT. EXH., *Fra Angelico to Leonardo. Italian Renaissance Drawings*, British Museum, London, H. Chapman and M. Faietti, eds. (London 2010).

CAT. EXH., *Guariento e la Padova Carrarese*, Musei Civici, Padua, D. Banzato et alii, eds. (Venice 2011).

CAT. EXH., *The Springtime of the Renaissance –Sculpture and the Arts in Florence 1400-60*, Palazzo Strozzi, Florence, B. Paolozzi Strozzi and M. Bormand, eds. (Nepi 2013).

CAT. EXH., *Giovanni Bellini. La nascita della pittura devozionale umanistica*, Pinacoteca Brera, Milan, E. Daffra and S. Bandera Bistoletti, eds. (Milan 2014).

CAT. EXH., *Mantegna & Bellini*, National Gallery, London, C. Campbell et alii, eds. (London 2018).

CAVALLARO, Anna, see CAT. EXH., *Pisanello* (Musei Capitolini, Rome 1988).

CAVAZZINI, Laura, and GALLI, Aldo, "Padoue, carrefour artistique," see CAT. EXH., *Mantegna 1431–1506* (Musée du Louvre, Paris 2008), 55–60.

CENNINI, Cennino, *The Craftsman's Handbook / Il libro dell'arte*, D. V. Thompson, Trans. [1933] (New York 2019).

CHAMBERS, David S., MARTINEAU, Jane, and SIGNORINI, Rodolfo, "Mantegna and the Men of Letters," see CAT. EXH., *Andrea Mantegna* (Royal Academy of Arts, London 1992), 8–31.

CHAPMAN, Hugo, *Padua in the 1450s. Marco Zoppo and His Contemporaries* (London 1998).

CHAPMAN, Hugo, see CAT. EXH., *Fra Angelico to Leonardo* (British Museum, London 2010).

CHASTEL, André, "Marqueterie et perspective," *Revue de l'Art*, 3 (1953), 141–54.

CHASTEL, André, *Art et humanisme à Florence au temps de Laurent le Magnifique. Etudes sur la Renaissance et l'Humanisme platonicien* (Paris 1958).

CHASTEL, André, and KLEIN, Robert, *Pomponius Gauricus. De Sculptura* [1504] (Geneva 1969).

CHATZIDAKIS, Michail, *Ciriaco d'Ancona und die Wiederentdeckung Griechenlands im 15. Jahrhundert* (Petersberg 2017).

CHIARLO, Carlo Roberto, "*Gli frammenti dilla sancta antiquitate*: studi antiquari e produzione delle immagini da Ciriaco d'Ancona a Francesco Colonna," *Memoria dell'antico nell'arte italiana*, S. Settis (ed.), vol. I (Turin 1984), 271–97.

CHONG, Alan, "Gentile Bellini in Istanbul: Myths and Misunderstandings," see CAT. EXH., *Bellini and the East* (National Gallery, London 2005), 106–18.

CHRISTIANSEN, Keith, "Early Works: Padua," see CAT. EXH. *Andrea Mantegna* (Royal Academy of Arts, London 1992), 94–117.

CHRISTIANSEN, Keith, "Venetian Painting of the Early Quattrocento," *Apollo*, 125 (1987), 168–74.

CHRISTIANSEN, Keith, *Gentile da Fabriano* (Ithaca 1982).

CLAESSENS, Guy, "The *Phaedrus* in the Renaissance: Poison or Remedy," *The Reception of Plato's 'Phaedrus' from Antiquity to the Renaissance*, S. Delcomminette et alii, eds. (Berlin and Boston 2020), 229–46.

CLAGETT, Marshall, "The Life and Works of Giovanni Fontana," *Annali dell'Istituto e Museo di Storia della Scienza a Firenze*, I (1976), 5–28.

CLAUS, Judith, *Mittelalterliche Architektur im Bild – die Darstellung von Bauten in den Fresken des oberitalienischen Malers Altichiero* (PhD Thesis, TU Berlin, 2006).

COLE, Michael, and PARDO, Mary, "Origins of the Studio," *Invention of the Studio. Renaissance to Romanticism* (Chapel Hill and London 2006).

COLLARETA, Marco, "La *vita* di Francesco Squarcione di Bernardino Scardeone," *Francesco Squarcione –* 'Pictorum Gymnasiarcha singularis': *Atti delle giornate di studio* [1998], A. De Nicolò Salmazo, ed. (Padua 1999), 29–36.

COLLINS, Howard F., "The Cyclopean Vision of Jacopo Bellini," *Pantheon*, XL (1982), 300–304.

COLLINS, Howard F., "The Decagonal Temples of Jacopo Bellini," *Paragone*, 41 (1990), 3–11.

COLLODO, Silvana, "La committenza di Andrea Mantegna. Scienza della natura e *studium pictorie* a Padova alla fine del medioevo," see CAT. EXH., *Mantegna e Padova 1445–1460* (Padua Musei Civici, Padua 2006), 29–35.

COLLODO, Silvana, "Padova al tempo di Francesco Petrarca," *Petrarca e il suo tempo* (CAT. EXH.), Musei Civici, Padua (Milan 2006), 15–26.

COLLODO, Silvana, "La manufattura della seta a Padova durante la signoria dei da Carrara (1365–1405), *Sine musica nulla disciplina: Studi in onore di Giulio Cattin*. F. Bernabei and A. Lovato, eds. (Padua 2006), 147–71.

COLLODO, Silvana, "L'esperienza e l'opera di Leon Battista Alberti alla luce dei suoi rapporti con la città di Padova," *La vita e il mondo di Leon Battista Alberti: Atti dei Convegni internazionali, Centro di Studi Leon Battista Alberti*, vol. 11 [Genua 2004] (Città di Castello 2008), 315–43.

COLLODO, Silvana, and SIMONETTI, Rémy, *Filosofia e scienze dell'esperienza fra Medioevo e uUmanesimo* (Treviso 2012).

CONTÒ, Agostino, "*Non scripto calamo*. Felice Feliciano e la tipografia," *L' Antiquario Felice Feliciano Veronese tra epigrafia antica, letteratura e arti del libro: Atti del Convegno di Studi, Verona* [1993], A. Contò and L. Quaquarelli, eds. (Padua 1995), 289–312.

CORDELLIER, Dominque, see CAT. EXH., *Pisanello. Le peintre aux sept vertus* (Musée du Louvre, Paris 1996).

CORTI, Gino, see SMITH FUSCO, Laurie.

COUTTS, Howard, "An Early Textile Drawing in the Victoria and Albert Museum," *Burlington Magazine*, 150 (2008), 389–92.

COZZI, Enrica. *Il gotico internazionale a Venezia: un' introduzione alla cultura figurative nell'Italia nord-orientale* (Verona 2013).

CURRAN, Brian, and GRAFTON, Anthony, "A Fifteenth-Century Site Report on the Vatican Obelisk," *Journal of the Warburg and Courtauld Institutes*, 58 (1995), 234–48.

DACHS, Monika, "Zur künstlerischen Herkunft und Entwicklung des Michelino da Besozzo," *Wiener Jahrbuch für Kunstgeschichte*, 45 (1992), 51–81.

DAFFRA, Emanuela, see CAT. EXH., *Giovanni Bellini* (Pinacoteca Brera, Milan 2014).

DALAI EMILIANI, Marisa, "Per la prospettiva padana," *Arte Lombarda*, 16 (1971), 117–36.

DAMINIAKI, Chrysa, "Liceità e pratica dell'imitazione nelle prose. Bembo e il recupero dell'antico nel primo Cinquecento," *Prose della volgar lingua di Pietro Bembo*, S. Morgana et alii, eds. (Milan 2000), 617–54.

DANESI SQUARZINA, Silvia, "Eclisse del gusto cortese e nascita della cultura antiquaria: Ciriaco, Feliciano, Marcanova, Alberti," see CAT. EXH., *Da Pisanello alla nascita deli Musei Capitolini.* (Musei Capitolini, Rome 1988), 27–37.

DECEMBRIO, Angelo Camillo, *De politia litteraria*, N. Witten (ed.), *Beiträge zur Altertumskunde*, vol. 169 (Munich and Leipzig 2002).

DEGENHART, Bernhard (ed.), *Pisanello und Bono da Ferrara* (Munich 1995).

DEGENHART, Bernhard and SCHMITT, Annegrit, *Jacopo Bellini – Der Zeichnungsband des Louvre: Corpus der italienischen Zeichnungen, Teil II, Venedig 1300–1450*, vols. 5 and 6 (Berlin 1990).

DELLWING, Herbert, "Der Santo in Padua – eine baugeschichtliche Untersuchung," *Mitteilungen des Kunsthistorischen Institutes in Florenz*, 19 (1975), 197–240.

DIVENUTO, Francesco, "La prospettiva nel trattato di Pomponio Gaurico," *Pomponio Gaurico : De sculptura*, P. Cutolo, ed. (Naples 1999), 49–68.

DONATO, Maria Monica, "Il progetto del mausoleo di Livio agli Uomini illustri *ad fores renovati iusticii*: celebrazione civica a Padova all'inizio della dominazione veneta," De lapidibus sententiae: *Scritti di storia dell'Arte per Giovanni Lorenzoni*, T. Franco and G. Valenzano, eds. (Padua 2002), 11–129.

DOSSI, Maria Cristina, see FAVARETTO, Irene.

DRERUP, Heinrich, "Totenmaske und Ahnenbild bei den Römern," *Mitteilungen des Deutschen Archäologischen Institutes in Rom*, 87 (1980), 81–129.

DUBOIS, Monique, *Zentralperspektive – in der florentinischen Kunstpraxis des 15. Jahrhunderts* (Petersberg 2010).

DÜCKERS, Rob, see CAT. EXH., *Die Brüder van Limburg* (Museum Het Valkhof, Nijmegen 2005).

DUNKELMANN, Martha L., "Donatello's Influence on Mantegna's 'early narrative scenes'," *Art Bulletin*, 62, 1980, 226–35.

EDGERTON JR., Samuel Y., *The Renaissance Rediscovery of Linear Perspective* (New York 1975).

EDWARDS, Mary, "Parallelism in the Frescoes in the Oratory of St. George in Padua (1379–84)," *Zeitschrift für Kunstgeschichte*, 71 (2008), 53–72.

EKSERDIJAN, David, see De la MARE, Albinia.

EISLER, Colin, *The Genius of Jacopo Bellini. The Complete Paintings and Drawings* (New York 1989).

EISLER, Robert, "Mantegnas frühe Werke und die römische Antike," *Monatsberichte über Kunst und Kunstwissenschaft*, 3 (1903), 164–175.

ELEN, Albert J., *Italian Late-Medieval and Renaissance Drawing-Books from Giovannino de Grassi to Palma Giovane, a Codicological Approach* (PhD Thesis, University Leiden 1995).

ELEN, Albert J., "Drawing, Evolution or Revolution? From Workshop Model-Book to Personal Sketchbook, *From Pattern to Nature in Italian Renaissance Drawing*, M. W. Kwakkelstein and L. Melli, eds. (Florence 2012).

ELEN, Abert J., *A Codicological Analysis and Reconstruction of Jacopo Bellini's Drawing Books*, see EISLER, Colin.

EMISON, Patricia Anne, *Invention and the Italian Renaissance Print, Mantegna to Parmigianino* (Ann Arbor 1985).

EMISON, Patricia Anne, "The World Made Naked in Pollaiuolo's Battle of the Nudes," *Art History*, 13 (1990), 261–75.

EMISON, Patricia Anne, "The Raucousness of Mantegna's Mythological Engravings," *Gazette des Beaux-Arts*, 124 (1994), 159–76.

EMMERLING-SKALA, Andreas, *Bacchus in der Renaissance* (Hildesheim 1994).

ESTENSE SELVATICO, Pietro, *Il pittore Francesco Squarcione. Studii storico-critici* (Padua 1839).

FACCIOLATI, Jacopo, *Fasti Gymnasii Patavini opera collecti ab anno MCCCVI venetae dominationis primo ad justitium anni MDIX* (Padua 1757).

FAIETTI, Marzia, see CAT. EXH., *Bologna e l'Umanesimo* (Pinacoteca Nazionale, Bologna 1988).

FAIETTI, Marzia, see CAT. EXH., *Fra Angelico to Leonardo* (British Museum, London 2010).

FARDIN, Alessandra, "L'anfiteatro romano di Padova: la conoscenza della forma architettonica e nuove ipotesi della configurazione originaria," *Bollettino del Museo Civico di Padova*, 85 (1998), 21–47.

FASOLINI, Donato, "Le iscrizioni dell'album del Louvre di Jacopo Bellini. Una fonte attendibile per epigrafia e iconografia?," *Antichistica / Storia ed epigrafia*, 7 (2019), 113–29.

FASSINA, Vasco (ed.), *Da Guariento a Giusto de Menabuoi. Studi, ricerche e restauri: Atti della giornata di studio* (Padua 2012).

FAVARETTO, Irene, "Appunti sulla collezione rinascimentale di Niccolò Leonico Tomeo," *Bollettino del Museo Civico di Padova*, LXVIII (1979), 15–31.

FAVARETTO, Irene (ed.), *Arte antica e cultura antiquaria nelle collezioni venete al tempo della Serenissima*: Studia archaeologica, 55 (Rome 1990).

FAVARETTO, Irene, "L'immagine e il suo doppio. Le sculture dello statuario e l'artista del Cinquecento: Copie, imitazioni e 'invenzioni' all'antica," *Lo statuario pubblico della Serenissima; due secoli di collezionismo d'antichità*, 1596–1797, (CAT. EXH.), Biblioteca Marciana, Venice, I. Favaretto and G. L. Ravagnan, eds. (Venice 1997), 107–12.

FAVARETTO, Irene (ed.), "La raccolta di sculture antiche di Francesco Squarcione tra leggenda e realtà," *Francesco Squarcione – 'Pictorum Gymnasiarcha singularis': Atti delle giornate di studio* [1998], Alberta De Nicolò Salmazo, ed. (Padua 1999), 233–44.

FAVARETTO, Irene, "L'immagine radoppiata: calchi, copie e invenzioni 'all'antica' nelle collezioni venete di antichità," *Les moulages de sculptures antiques et l'histoire de l'archéologie: Actes du colloque international Paris* [1997], H. Lavargne and F. Queyrel, eds. (Geneva 2000), 13–21.

FAVARETTO, Irene, DE PAOLI, Marcella, DOSSI, Maria Cristina (eds.), *Museo Archeologico Nazionale di Venezia* (Milan 2004).

FAVARETTO, Irene, "Andrea Mantegna e l'antico. 1. Cultura antiquaria e tradizione umanistica a Padova nel Quattrocento," *Andrea Mantegna, impronta del genio: Convegno internazionale di studi, Padua, Verona, Mantua* [2006], R. Signorini et alii, eds. (Florence 2010), 45–52.

FAVARO, Antonio, "Intorno all vita e alle opera di Prosdocimo de' Beldomandi matematico padovano del secolo XV," *Bullettino di bibliografia e di storia delle scienze matematiche e fisiche*, 12 (1879), 1–74, 115–251.

FAVARO, Antonio, "Le matematiche nello studio di Padova dal principio del secolo XV alla fine del XVI," *Nuovi saggi della R. Accademia di scienze, lettere ed arti in Padova*, 9 (1880), 1–92.

FEDERICI VESCOVINI, Graziella, "Il problema delle fonti ottiche medievali del Commentario terzo di Lorenzo Ghiberti," *Lorenzo Ghiberti e il suo tempo: Atti del Convegno internazionale di Studi, Florence* [1978] (Florence 1980), 349–87.

FEDERICI VESCOVINI, Graziella, "La simmetria nel corpo umano nella *Physiognomica* di Pietro d'Abano: Un canone estetico," *Concordia discors: Studi su Niccolò Cusano offerti a Giovanni Santinello*, G. Piaia, ed. (Padua 1993), 347–60.

FEDERICI VESCOVINI, Graziella, *Astrologia e scienza. La crisi dell'aristotelismo sul cadere del Trecento e Biagio Pelacani da Parma* (Florence 1979).

FELICIANO, Felice, see SCALAMONTI, Francesco.

FILARETE (called), Antonio Averlino, *Treatise on Architecture*, John Spencer, Trans. (Yale 1965).

FILARETE (called), Antonio Averlino, *Trattato di architettura* [1460/64], A. M. Finoli and L. Grassi, eds. (Milan 1972).

FINDLEN, Paula, "The Museum: Its Classical Terminology and Renaissance Genealogy," *Journal of the History of Collections*, I, n. 1 (1989), 59–79, II (1990), 205–18.

FIOCCO, Giuseppe, "Felice Feliciano, amico degli artisti," *Archivio Veneto-Tridentino* (Venice 1926), 188–201.

FIOCCO, Giuseppe, *L'Arte di Andrea Mantegna* (Venice 1927).

FIOCCO, Giuseppe, "Il museo imaginario di Francesco Squarcione," *Atti e Memorie dell'Accademia Patavina di Scienze, Lettere ed Arti*, LXXI (1958/59), III, 59–72.

FIOCCO, Giuseppe, "Le cupole del Santo," *Rivista Antoniana*, IX (1969), 441–44.

FISCOVIC, Igor, and MATIJEV, Juraj, "Jacopo Bellini," *Radovi Instituta za povijest umjetnosti*, 12–13 (Zagreb 1988–1989), 159–77.

FLORES D'ARCAIS, Francesca, *Giusto de Menabuoi nel Battistero di Padova* (Trieste 1989).

FORTINI BROWN, Patricia, "The Antiquarianism of Jacopo Bellini," *Artibus et historiae*, 26 (1992), 65–84.

FORTINI BROWN, Patricia, *Venice and Antiquity. The Venetian Sense of the Past* (London 1999).

FOSSI TODOROW, Maria, "Un taccuino di viaggi del Pisanello e della sua bottega," *Studi di storia d'arte in onore di Mario Salmi*, vol. 2, V. Martinelli and F. M. Aliberti Gaudioso, eds. (Rome 1962), 133–61.

DE FRANCESCHINI, Enzo, "I mosaici della cappella di Sant'Isidoro nella basilica di San Marco tra la tradizione bizantina e la novità di Paolo Veneziano," *Zograf*, 31 (2009), 123–30.

FRANCO FIORIO, Maria Teresa, "Marco Zoppo et le livre padouan," *Revue de l'Art*, 53 (1981), 65–73.

FREDERIKSEN, Rune, "Plaster Casts in Antiquity," *Plaster Casts. Making, Collecting and Displaying from Classical Antiquity to the Present*, R. Frederiksen and E. Marchand, eds. (Berlin and New York 2010), 13–34.

FREY, Dagobert, "Der Dom von Sebenico und sein Baumeister," *Jahrbuch des kunsthistorischen Institutes der K. K. Zentral-Kommission für Denkmalpflege*, I, 1913, 1–169.

FREY, Dagobert, "Apokryphe Liviusbildnisse der Renaissance," *Wallraf-Richartz-Jahrbuch*, 17 (1955), 132–64.

FREZZATO, Fabio, "Wege der Forschung zu Cennino Cennini: von den biographischen Daten zur Bedeutung des *Libro dell'Arte*," *Fantasia und Handwerk* (CAT. EXH.), Gemäldegalerie Staatliche Museen, Berlin, W.-D. Löhr and S. Weppelmann, eds. (Munich 2008), 133–39.

FRÖLICH-BUM, Lili, "Bemerkungen zu den Zeichnungen Jacopo Bellinis und zu seiner Kunst," *Mitteilungen der Gesellschaft für vervielfältigte Kunst*, 3 (1916), 41–56.

FUBINI, Riccardo, "Enea Silvio Piccolomini nei rapporti con la cultura umanistica del tempo," *Enea Silvio Piccolomini*, F. Nevola, ed. (Colle Val d'Elsa 2009), 131–150.

FUMIAN, Silvia, cat. nos. 69–71, see CAT. EXH., *Mantegna a Padova 1445–1460* (Musei Civici, Padua Milan 2006), 290–95.

FURLAN, Caterina, "I *Trionfi* della collezione Kress: una proposta attributiva e divagazioni sul tema," *Arte Veneta*, 27 (1974), 81–90.

GABELMANN, Hanns, "Achteckige Grabaltäre in Oberitalien," *Aquilea Nostra*, 38 (1967), 17–54.

GALICHON, Emile, and De Mas-Latrie, René, "Iacopo, Gentile et Giovanni Bellini, documents inédits," *Gazette des Beaux-Arts*, 2 (1866), 281–88.

GALLERANI, Paola Isabella, "Andrea Mantegna e Jacopo Bellini: Percorsi epigrafici a confronto," *Aquileia Nostra*, LXX (1999), 178–210.

GALLI, Alessandro, "L'Annunciazione di Sant'Alessandro e Jacopo Bellini," *Museo Bresciano*, 5 (1995), 104–108.

GALLI, Aldo, see CAVAZZINI, Laura.

GASPAROTTO, Cesira, "Guide ed illustrazioni della basilica di Sant'Antonio da Padova: le lodi di Padova di Michele Savonarola," *Il Santo*, II, 1 (1962), 369–87.

GASPAROTTO, Cesira, "La Reggia dei da Carrara. Il palazzo di Ubertino e le nuove stanze dell'Accademia Patavina," *Atti e Memorie dell'Accademia Patavina di Scienze, Lettere ed Arti*, 79 (1966–67), 73–116.

GAURICO, Pomponio, *De sculptura* [1504], P. Cutolo, ed. (Naples 1999).

GENTILINI, Giancarlo. "Intorno alla Pala Ovetari: appunti sull'eredità donatelliana a Padova, fra Pizolo, e Mantegna," *Francesco Squarcione – 'Pictorum Gymnasiarcha singularis': Atti delle giornate di studio* [1998], A. De Nicolò Salmazo, ed. (Padua 1999), 195–206.

GHIBERTI, Lorenzo, *I commentarii* (Biblioteca Nazionale Centrale di Firenze, II, I, 333), L. Bartoli, ed. (Florence 1998).

GHIBERTI, Lorenzo, see BERGDOLT, Klaus.

GHIBERTI, Lorenzo, see SCHLOSSER, Julius von.

GIACOMELLI, Luciana, see BACCHI, Andrea.

GILBERT, Creighton, E., "On Subject and Not-Subject in Italian Renaissance Pictures," *The Art Bulletin*, 34 (1952), 202–17.

GILBERT, Creighton E., "A Letter of Giovanni Dondi dall'Orologio to Fra Guglielmo Centueri," *Viator: Medieval and Renaissance Studies*, 8 (1977), 333–36.

GILBERT, Creighton E., *Italian Art 1400–1500. Sources and Documents* [1980] (Evanston 1992).

GOLUBEW, Victor, *Les dessins de Jacopo Bellini au Louvre et au British Museum*, vol. I (Brüssel 1908).

GOMBRICH, Ernst H., "The style *all'antica*: Imitation and Assimilation," *Studies in Western Art: Acts of the Twentieth Congress of the History of Art*, vol. II, *The Renaissance and Mannerism* (Princeton 1963), 31–41.

GOMBRICH, Ernst H., "From the Revival of Letters to the Reform of Arts, Niccolo Niccoli and Filippo Brunelleschi," *Essays in the History of Art Presented to Rudolf Wittkower*, D. Fraser et alii, eds. (London 1967), 71–82.

GORDON, Dillian, see SYSON, Luke.

GRAFTON, Anthony, "Commerce with the Classics," *The Italian Renaissance. The Essential Readings*, P. Findlen, ed. (Oxford 2002), 237–72.

GRAFTON, Anthony (ed), *The Classical Tradition* (Cambridge/M and London 2010).

GRAFTON, Anthony, see CURRAN, Brian.

GRAMACCINI, Norberto, "Wie Jacopo Bellini Pisanello besiegte: der Ferrareser Wettbewerb von 1441," *Idea*, I (1982), 27–53.

GRAMACCINI, Norberto, "Das genaue Abbild der Natur – Riccios Tiere und die Theorie des Naturabgusses seit Cennini," see CAT. EXH., *Natur und Antike in der Renaissance* (Liebighaus, Frankfurt/M 1985), 198–225.

GRAMACCINI, Norberto, "La prima riedificazione del Campidoglio e la rivoluzione senatoriale del 1144," *Roma, centro della cultura dell'Antico nei secoli XV e XVI*, S. Danesi Squarzina, ed. (Milan 1989), 33–47.

GRAMACCINI, Norberto, *Mirabilia. Das Nachleben antiker Statuen vor der Renaissance* (Mainz 1996).

GRAMACCINI, Norberto, "Was bedeutet das Schwein neben dem Löwen in Villard de Honnecourts Zeichnung?," *Re-Visionen. Zur Aktualität von Kunstgeschichte: Festschrift für Alexander Perrig*, B. Hüttel et alii, eds. (Berlin 2002), 33–48.

GRAMACCINI, Norberto, "Buch und Bild im Zeitalter ihrer Vervielfätigung durch den Druck," *Die Kunst der Interpretation. Italienische Reproduktionsgraphik 1485–1600*, N. Gramaccini and H. J. Meier, eds. (Berlin and Munich 2009), 9–52.

GRAMACCINI, Norberto, "Ideeller Besitz: Paduaner Gipsabgüsse des Quattrocento," *Reproduktion: Techniken und Ideen von der Antike bis heute: eine Einführung*, J. Probst, ed. (Berlin 2011), 58–93.

GRASSI, Luigi, "La 'mano industriosa' di Jacopo Bellini nei disegni dei suoi due libri," *Atti e memorie della R. Accademia Clementina di Bologna*, 30/31 (1992), 9–37.

GRAVE, Johannes, "Brunelleschi's Perspective Panels. Rupture and Continuity in the History of the Image," *Renaissance? Perceptions of Continuity and Discontinuity in Europe*, H. Schnitker, P. Péporté and A. Lee, eds. (Leyden 2010), 161–81.

GRAVE, Johannes, "Allegorisierung durch Ikonisierung? Architekturen bei Jacopo und Giovanni Bellini," *Die Oberfläche der Zeichen*, G. Tarnow, ed. (Paderborn 2014), 77–95.

GRAYSON, Cecil, "L. B. Alberti's 'costruzione legittima'," *Italian Studies*, 14 (1964), 14–28.

GREBNER, Gundula, "Das *Liber Introductorius* des Michael Scotus und die Aristotelesrezeption. Der Hof Friedrichs II. als Drehscheibe des Kulturtransfers," *Kaiser Friedrich II. 1194–1250. Welt und Kultur des Mittelmeerraumes* (CAT. EXH.). Oldenburg, Landesmuseum (Mainz 2008), 251–57.

GREENSTEIN, Jack M., "On Alberti's 'Sign': Vision and Composition in Quattrocento Painting," *The Art Bulletin*, LXXXIX, 4 (1997), 669–98.

GREGORI, Mina, "The Medal and Some of Its Implications," see CAT. EXH., *In the Light of Apollo* (Mouseion Alexandrou Sotsou, Athens 2003), 150–65.

GRENDLER, Paul F., "The University of Padua 1405–1600: A Success History," *Books and Schools in the Italian Renaissance* (Adlershot 1995), X–XI.

GRONTA, Daniela, "Marcanova, Giovanni," *Dizionario Biografico degli Italiani*, 69 (2007), 476–484.

GROSSATO, Lucio, see CAT. EXH., *Da Giotto a Mantegna* (Palazzo della Ragione, Padua 1974).

GUDELJ, Jasenka, "Dialoghi quattrocenteschi: Arco dei Sergi nelle interpretazioni di Jacopo Bellini," *Scripta in honorem Igor Fiskovic*, M. Jurkovic ed. (Zagreb 2015), 283–90.

HAFTMANN, Werner, *Das italienische Säulenmonument* (Leipzig and Berlin 1939).

HAHNLOSER, Hans Robert, *Villard de Honnecourt. Kritische Gesamtausgabe des Bauhüttenbuches ms. fr. 19093 der Pariser Nationalbibliothek* [1935] (Graz 1972).

HAMMOND, Joseph, "Five Jacopo Bellini's: the Lives of Christ and the Virgin at the Scuola Grande di S. Giovanni Evangelista," *Burlington Magazine*, 158 (2016), 601–09.

HARGREAVES, Geoffrey D., "Florentine Script, Paduan Script, Roman Type," *Gutenberg Jahrbuch*, 67 (1992), 15–34.

HARRISON WOODWARD, William, *Vittorino da Feltre and Other Humanist Educators* [1963], *Renaissance Society of America* (1996).

HASKELL, Francis, and PENNY, Nicholas, *Taste and the Antique. The Lure of Classical Sculpture, 1500–1900* (London 1982).

HAUSER, Andreas, "The Griffin's Gaze and the Mask of Medusa," *Art History*, 37 (2014), 334–51.

HEDEMAN, Anne D., "Visualizing History in Medieval France," *Histoire de l' Art*, 80 (2017), 25–36.

HEIN, Barbara, "Altichiero e l'antico nell'oratorio di San Giorgio: alcune riflessioni," *Il secolo di Giotto nel Veneto: Istituto veneto di scienze, lettere ed arti*, G. Valenzano and F. Toniolo, eds. (Venice 2007), 437–48.

HERBIG, Reinhard, *Der griechische Bockesgott. Versuch einer Monographie* (Frankfurt/M 1949).

HERDE, Peter, "Friedrich II. und das Papsttum," *Kaiser Friedrich II. 1194–1250. Welt und Kultur des Mittelmeerraumes* (CAT. EXH.). Oldenburg, Landesmuseum (Mainz 2008), 52–65.

HERSANT, Luc, *Giovanni Francesco Pico della Mirandola, Pietro Bembo: De l'imitation* (Paris 1996).

HESSLER, Christiane J., 'Et ancora dissono questo più filosaphii' – Ghiberti und die Philosophen, *Ghiberti teorico. Natura, arte e coscienza storica nel Quattrocento*, F. Jonietz, W.-D. Löhr and A. Nova, eds. (Milan 2019), 103-13 (104).

HOLGATE, Ian, "Paduan Culture in Venetian Care: The Patronage of Bishop Pietro Donato (Padua 1428–47)," *Renaissance Studies*, 16, I (2002), 1–23.

HOMER HASKINS, Charles, "The *De arte venandi cum avibus* of Frederick II," *Studies in the History of Medieval Science* [1924] (New York 1960).

HUMFREY, Peter, *Painting in Renaissance Venice* (New Haven and London 1995).

JACOB, Marie, "Les premières représentations des *Trionfi* de Pétrarque dans le royaume de France: Le triomphe des modèles italiens?," *La France et l'Europe autour de 1500*, G. Bresc-Bautier et alii, eds. (Paris 2015), 193–206.

JOOST-GAUGIER, Christiane, L., "Subject or Non-Subject in a Drawing by Jacopo Bellini," *Commentarii. Rivista di critica e storia dell'arte*, 24 (1973), 148–53.

JOOST-GAUGIER, Christiane L., "The *Sketchbooks* of Jacopo Bellini Reconsidered," *Paragone*, 25 (1974), 24–41.

JOOST-GAUGIER, Christiane L., "Considerations Regarding Jacopo Bellini's Place in the Venetian Renaissance," *Arte Veneta*, 28 (1975), 121–38.

JOOST-GAUGIER, Christiane L, "Jacopo Bellini's Interest in Perspective and Its Iconographical Significance," *Zeitschrift für Kunstgeschichte*, 38 (1975), 1–28.

JOOST-GAUGIER, Christiane L., "The Tuscanisation of Jacopo Bellini. I: The Relation of Jacopo to Problems of the 1420s," *Acta Historiae Artium*, 23 (1977), 95–112.

JOOST-GAUGIER, Christiane L, *Jacopo Bellini, Selected Drawings*, New York 1980.

JOOST-GAUGIER, Christiane L, "The *Casa degli Specchi* a Padova, Its Architect Annibale Bassano, Tito Livio and a Peculiar Historical Connection," *Bollettino del Museo Civico di Padova*, LXXII (1983), 113–24.

KALLAB, Wolfgang, *Vasaristudien*, J. v. Schlosser, ed. (Vienna 1908).

KALLENDORF, Craig W. (ed.), *Humanist Educational Treatises: The I Tatti Renaissance Library* (Cambridge/M. and London 2002).

KANTOROWICZ, Ernst, "'Pro Patria Mori' in Medieval Politial Thought," *The American Historical Review*, 56 (1951), 472–92.

KIBRE, Pearl, "Cristoforo Barzizza, Professor of Medicine at Padua," *Bulletin of the History of Medicine*, XI (1942), 389–408.

KING, Margaret L., "Personal, Domestic, and Republican Values in the Moral Philosophy of Giovanni Caldiera," *Renaissance Quarterly*, 28 (1975), 535–74.

KING, Margaret L., *Venetian Humanism in an Age of Patrician Dominance* (Princeton 1986).

KIRSCH, Edith W., *Five Illuminated Manuscripts of Giangaleazzo Visconti* (London 1991).

KLEIN, Robert, "Pomponius Gauricus on Perspective," *The Art Bulletin*, 43 (1961), 211–30.

KLEIN, Robert, *Form and Meaning: Essays on the Renaissance and Modern Art* [1970] (Princeton 1981).

KLEIN, Robert, see CHASTEL, André.

KLEINBUB, Christian K., "Jacopo Bellini and the Drawing of Idolatry," *Venetian Painting Matters, 1450–1750*, J. Cranston, ed. (Turnhout 2015), 21–34.

KNABENSHUE, Paul D., "Ancient and Medieval Elements in Mantegna's Trial of St. James," *The Art Bulletin*, 41 (1959), 59–73.

KOHL, Benjamin G., *Padua under the Carrara, 1318–1405* (Baltimore and London 1998).

KORBACHER, Dagmar, see CAMPBELL, Caroline.

KORBACHER, Dagmar, see VOWLES, Sarah.

KOUTSOGIANNIS, Theodore, "The Renaissance Metamorphoses of Byzantine Emperor John VIII Palaeologus," see CAT. EXH., *In the Light of Apollo* (Mouseion Alexandrou Sotsou, Athens 2003), 60–70.

KRAUTHEIMER, Richard, and KRAUTHEIMER-HESS, Trude, *Lorenzo Ghiberti* (Princeton/NJ 1956).

KRISTELLER, Paul, "Francesco Squarcione e le sue relazioni con Andrea Mantegna," *Rassegna d'Arte*, IX (1909), IV–V.

KRISTELLER, Paul Oskar, "Umanesimo e scolastica a Padova fino al Petrarca" [1985], *P. O. Kristeller, Studies in Renaissance Thought and Letters*, IV (Rome 1996).

KÜHNEL, Ernst, *Miniaturmalerei im islamischen Orient*, Berlin 1922.

LAKEY, Christopher, "Scholastic Aesthetics and the Medieval 'Origins' of Relief/rilievo," *Chiaroscuro als ästhetisches Prinzip. Kunst und Theorie des Helldunkel 1300–1500*, C. Lehmann et alii, eds. (Berlin and Boston 2018), 125–40.

LAMBRAKI-PLAKA, Marina, "Alberti's Treatise *De Pictura* and its Ancient Sources," see CAT. EXH., *In the Light of Apollo* (Mouseion Alexandrou Sotsou, Athens 2003), 71–78.

LANDAU, David, and PARSHALL, Peter, *The Renaissance Print. 1470–1550* (New Haven und London 1994).

LANZI, Luigi, *Storia pittorica della Italia*, 2 vols. (Bassano 1795–1796).

LAURANZA, Domenico, "Art and Anatomy in Renaissance Italy. Images from a Scientific Revolution," The Metropolitan Museum of Art Bulletin, 69, 2012, 5–48.

LAVIN, Irving, "Pisanello and the Invention of the Renaissance Medal," *Italienische Frührenaissance und nordeuropäisches Spätmittelalter. Kunst der frühen Neuzeit im europäischen Zusammenhang*, J. Poeschke, ed. (Munich 1993), 67–84.

LAZARIS, Stavros, "L'empereur Jean VIII Paléologue vu par Pisanello lors du concile de Ferrare-Florence," *Byzantinische Forschungen*, 29 (2007), 293–324.

LAZZARINI, Vittorio, "Polizze d'estimo di Francesco Squarzon (I)," *Bollettino del Museo Civico di Padova*, 12, I (1898).

LAZZARINI, Vittorio, and MOSCHETTI, Andrea, *Documenti relativi alla pittura padovana del secolo XV* [1908] (Bologna 1974).

LEONCINI, Luca, *Il codice detto del Mantegna: Codice Destailleur OZ 111 della Kunstbibliothek di Berlino*, Rome 1993.

LEVENSON, J. A. (ed.), *Early Italian Engravings from the National Gallery of Art* (CAT. EXH.), National Gallery, Washington (Washington 1973).

LIEBERMANN, Ralph, "Real Architecture, Imaginary History. The Arsenale Gate as Venetian Mythology," *Journal of the Warburg and Courtauld Institutes*, LIV (1991), 117–126.

LIGHTBROWN, Ronald W., *Mantegna. With a Complete Catalogue of the Paintings, Drawings and Prints* (Oxford 1986).

LIPPINCOTT, Kristen, "The Art of Cartography in Fifteenth Century Florence," *Lorenzo the Magnificent. Culture and Politics: Warburg Institute Colloquia*, 3, M. Mallet and N. Mann, eds. (London 1997), 131–143.

LIPTON, Deborah, *Francesco Squarcione* (= PhD Thesis, New York University 1974).

LOMAZZO, Gian Paolo, *Trattato dell'arte della Pittura* [1584] (Hildesheim 1968).

LONGHI, Roberto, "Lettera pittorica a Giuseppe Fiocco," *Vita Artistica*, I (1926), 127–139, republished by Paola BAROCCHI, *Storia moderna dell'Arte in Italia: Dal Novecento ai dibattiti sulla figura e sul monumentale, 1925-1945*, III (Turin 1990), 60–69.

LONGHI, Roberto, *Viatico per cinque secoli di pittura veneziana* (Florence 1946).

LUCCO, Mauro, "Appunti per una rilettura di Francesco Squarcione," *Francesco Squarcione – 'Pictorum Gymnasiarcha singularis': Atti delle giornate di studio* [1998], A. De Nicolò Salmazo, ed. (Padua 1999), 101–11.

MACCAGNI, Carlo, "Le scienze nello studio di Padova e nel Veneto," *Storia della Cultura Veneta*, vol. III, G. Arnaldi and M. Pastori Stocchi, eds. (Vicenza 1981), 135–71.

MAJOCCHI, Rodolfo, *Codice Diplomatico artistico di Pavia dall'anno 1330 all'anno 1550* (Pavia 1937).

MAIOLO, Francesco, *Medieval Sovereignty. Marsilius of Padua and Bartolus of Saxoferrato. A Study on the Medieval Origin of the Idea of Popular Sovereignty* [1999] (Delft 2007).

DE MANDACH, Conrad, "Le symbolisme dans les dessins de Jacopo Bellini," *Gazette des Beaux-Arts*, 5 (1922), 39–60.

MANETTI, Antonio di Tuccio, *The Life of Brunelleschi*, H. Saalman, Trans. (London 1970).

MANGANI, Giorgio, *Antichità inventate. L'archeologia geopolitica di Ciriaco d'Ancona* (Milan 2017).

MANNI, Graziano, *I signori della prospettiva. Le tarsie dei Canozi e dei canoziani (1460–1520)*, 2 vols. (Carpi 2001).

MARANGONI, Paolo, *Introduzione all'aristotelismo padovano (sec. XII–XIII)* (Padua 1977).

MARANI, E., "Uno monumento a Virgilio, disegnato da Leon Battista Alberti," *Nel bimillenario della morte di Virgilio: Accademia Nazionale Virgiliana di Scienze, Lettere e d'Arti* (Mantua 1983).

MARCON, Susy, "Vale feliciter," *Lettere Italiane*, XL (1988), 536–556.

MARCON, Susy, "La miniatura nei Codici di Giovanni Marcanova," see CAT. EXH., *La miniatura a Padova dal Medioevo al Settecento* (Palazzo della Ragione, Padua 1999), 481–493.

MARCANOVA, Giovanni, *Antiquitatum quaedam fragmenta* [1460], Cod. B. 42, Bern, Burgerbibliothek.

MARCANOVA, Giovanni, *Antiquitatum quaedam fragmenta* [1465], Cod., alfa 1.5.1.5, Modena, Biblioteca estense.

MARCHAND, Eckart, "Image and Thing: The Distribution and Impact of Plaster Casts in Renaissance Europe," *The Sculpture Journal*, 26 (2017), 83–91.

DE MARCHI, Andrea, "*Lorenzo e Jachomo da Venexia*; un percorso da Zanino a Jacopo Bellini e un enigma da risolvere," *Saggi e memorie di storia dell'arte*, 27 (2004), 71–100.

DE MARCHI, Andrea, "Mantegna / Bellini: Invention Versus Poetry," see CAT. EXH., *Mantegna & Bellini* (National Gallery, London 2018), 29–40.

DE MARCHI, *Andrea, Gentile da Fabriano e il gotico internazionale: Jean de Beaumetz, Melchior Broederlam, Jacquemart d'Hesdin, Giovannino de Grassi, Lorenzo Monaco, Michelino da Besozzo, Stefano di Giovanni, Jean Malouel, Herman, Pol e Jean Limbourg, Lorenzo e Jacopo Salimbeni, Giovanni da Modena, Pisanello, Jacopo Bellini, Michele Giambono* (Florence 2008).

DE LA MARE, Albinia, *The Italian Manuscripts in the Library of Major J. R. Abbey*, A. de la Mare and J. G. Alexander, eds. (New York and Washington 1969).

DE LA MARE, Albinia, and EKSERDIJAN, David, see CAT. EXH., *La miniatura a Padova dal Medioeveo al Settecento* (Palazzo della Ragione, Padua 1999), 123–25.

DE MARIA, Sandro, "Giovanna Tosi: L'Arco dei Gavi, Rome 1983" (review), *Epigraphia*, 46 (1984), 301–08.

DE MARIA, Sandro, "Künstler, Altertumskenner und Sammler von Altertümern in Bologna des 15. und 16. Jahrhunderts," see CAT. EXH., *Bologna e l'Umanesimo 1490–1510* (Pinacoteca Nazionale, Bologna 1988), 17–44.

MARIANI CANOVA, Giordana, "Riflessioni su Jacopo Bellini e sul libro dei disegni del Louvre," *Arte Veneta*, XXVI (1972), 9–30.

MARIANI CANOVA, Giordana, "Marco Zoppo e la miniatura," *Marco Zoppo, Cento 1433–1478: Atti del Convegno di Studi, Venezia*, B. Giovanucci Vigi, ed. (Bologna 1993), 121–35.

MARIANI CANOVA, Giordana, "La miniatura a Padova dal Medioevo al Settecento" (Palazzo della Ragione, Modena 1999), 25–27.

MARIANI CANOVA, Giordana, "La miniatura a Padova nel tempo dei Carraresi," see CAT. EXH., *Guariento e la Padova carrarese* (Musei Civici di Padova, Venice 2011), 63–71.

MARIANI CANOVA, Giordana, "La dimensione accademica della miniatura del rinascimento padovano," *Paleography, Manuscript Illumination and Humanism in Renaissance Italy*, R. Black et alii, eds. (London 2016), 297–322.

MARIANI CANOVA, Giordana, see BALDISSIN MOLLI, Giovanna.

MARINELLI, Sergio, "Ai confini dell'età media: da Francesco Squarcione a Francesco Benaglio," *De lapidibus sententiae: Scritti in onore per Giovanni Lorenzoni*, T. Franco et alii, eds. (Padua 2002), 225–30.

MARSHALL, Peter, "Two Scholastic Discussions of the Perception of Depth by Shading," *Journal of the Warburg and Courtauld Institutes*, 44 (1981), 170–75.

MARTINEAU, Jane, see CHAMBERS, David, S.

MARTINEAU, Jane, see CAT. EXH., *Andrea Mantegna* (Royal Academy, London 1992).

MARX, Barbara, "Venedig 'altera Roma'. Transformationen eines Mythos," *Quellen und Forschungen aus italienischen Archiven und Bibliotheken*, 60 (1980), 325–73.

DE MAS-LATRIE, René, "Testament de Gentile Bellini," *Gazette des Beaux-Arts*, 2 (1866), 286–88.

DE MAS-LATRIE, René, see GALICHON, Emile.

MASSENA, Victor, and MÜNTZ, Eugène, "Pétrarque, ses études d'art, son influence sur les artistes, ses portraits et ceux de Laure, l'illustration de ses écrits," *Gazette des Beaux-Arts* (1902), 200–57.

MASSING, Jean-Michel, "A Few More Calumnies: Lucian and the Visual Arts," *Lucian of Samosata Vivus et Redivivus: Warburg Institute colloquia*, X (London 2007), 129–44.

MATIJEV, Juraj, see FISCOVIC, Igor.

MATZ, Friedrich, *Die Dionysischen Sarkophage: Deutsches Archäologisches Institut*, vol. IV: "Die antiken Sarkophagreliefs," (Berlin 1968).

MEISS, Millard, "Toward a More Comprehensive Renaissance Paleography," *The Art Bulletin*, XLII (1960), 97–112.

MEISS, Millard, "Sleep in Venice: Ancient Myths and Renaissance Proclivities," *Proceedings of the American Philosophical Society*, 110 (1966), 348–82.

MELLER, Peter, "Physiognomical Theory in Renaissance Heroic Portraits," *The Renaissance and Mannerism, Studies in Western Art: Acts of the Twentieth International Congress of History of Art* (New York 1963), 53–69.

MENEGAZZI, Alessandra, "La Gipsoteca del Museo di Scienze Archeologiche e d'Arte dell'Università di Padova: l'esposizione e la fruizione," *Gipsoteche. Realtà e Storia: Atti del Convegno Internazionale*, M. Guderzo ed. (Possagno 2008), 17–27.

MENATO, Sara, "Per la giovinezza di Carpaccio," *Pittura del Rinascimento nell'Italia settentrionale, Quaderni*, 7 (2016), 47–60.

MENDELSOHN, Leatrice, "The Transmission of Antique Beauty and Proportion to Renaissance Art: From Sculpture to Painting," see CAT. EXH., *In the Light of Apollo* (Mouseion Alexandrou Sotsou, Athens 2003), 96–103.

MERCER, R. G. C., *The Teaching of Gasparino Barzizza with Special Reference to His Place in Paduan Humanism* (London 1979).

MICHIEL, Marcantonio, *Notizia d'opere del disegno*, Th. Frimmel, ed. (Florence 2000).

MITCHELL, Charles, "Archeology and Romance in Renaissance Italy," *Italian Studies: A Tribute to the Late Cecilia M. Ady* (London 1960), 453–83.

MITCHELL, Charles, "Felice Feliciano *Antiquarius*," *Proceedings of the British Academy*, 47 (1961), 197–221.

MITCHELL, Charles, "Ex libris Kiriaci Anconitani," *Italia Medioevale e Umanistica*, V (1962), 283–299.

MITCHELL, Charles, "Ciriaco d'Ancona: Fifteenth-Century Drawings and Descriptions of the Parthenon," *The Parthenon: Norton Critical Studies in Art History*, Vincent J. Bruno, ed. (New York 1973), 111–23.

MOMMSEN, Theodor (ed.), *Corpus Inscriptionum Latinarum* (CIL), V (Berlin 1872), pts. 1 and 2.

MOMMSEN, Theodor, "Über die Berliner Excerptenhandschrift des Petrus Donatus," *Jahrbuch der Preussischen Kunstsammlungen*, IV (1883), 72–89.

MOMMSEN, Theodor E., "Petrarch and the Decoration of the *Sala Virorum Illustrium* in Padua," *Art Bulletin*, XXXIV (1952), 95–116.

MONTECCHI, Giorgio, "Lo spazio del testo scritto nella pagina di Feliciano," *L' Antiquario Felice Feliciano Veronese tra epigrafia antica, letteratura e arti del libro: Atti del Convegno di Studi, Verona* [1993], A. Contò and L. Quaquarelli, eds. (Padua 1995), 251–88.

MOSCHETTI, Andrea, "Le inscrizioni lapidarie romane negli affreschi del Mantegna agli Eremitani," *Atti del R. Istituto Veneto di Scienze, Lettere ed Arti*, LXXXIX (1929–1930), 227–37.

MOSCHETTI, Andrea, see LAZZARINI, Vittorio.

MOTTURE, Peta, "Donatello a Padova: pratica di bottega e scambio artistico," see CAT. EXH., *Mantegna e Padova, 1445–1460* (Padua Musei Civici, Padua 2006), 109–19.

MUECKE, Frances, *Commentary on Silius Italicus* (Geneva 2011).

MÜLLER, Kathrin, *Musterhaft naturgetreu. Tiere in Seiden, Zeichnungen und Tapisserien des 14. und 15. Jahrhunderts* (Berlin 2020).

MÜNTZ, Eugène, "Essai sur l'histoire des collections italiennes d'antiquités depuis les débuts de la Renaissance jusqu'à la mort de Paul II," *Révue archéologique*, 37 (1879), 45–54 and 84–93.

MÜNTZ, Eugène, see MASSENA, Victor.

MURARO, Michelangelo, "Mantegna e Alberti," *Arte, pensiero e cultura a Mantova nel primo rinascimento in rapporto con la Toscana e con il Veneto: VI Convegno internazionale di studi sul rinascimento* (Florence 1961), 103–132.

MURARO, Michelangelo, "Donatello e Squarcione. Proposta per un' esposizione sul rinascimento a Padova," *Donatello e il suo tempo: Atti dell'VIII Convegno Internazionale* (Florence 1968), 387–98.

MURARO, Michelangelo, "Francesco Squarcione pittore umanista," see CAT. EXH., *Da Giotto a Mantegna* (Palazzo della Ragione, Padua 1974), 68–74.

MURARO, Michelangelo, "La ricerca di un ciclo perduto: gli affreschi dello Squarcione nella chiesa di San Francesco a Padova," *Padova e la sua provincia*, 29 (1983), 3–9.

MURATOVA, Xénia, and POIRION, Daniel (eds.), *Le Bestiaire. Reproduction en fac-similé des miniatures du manuscrit du Bestiaire Ashmole 1511 de la Bodleian Library d'Oxford* (Lebaud 1988).

MUSSATO, Albertino, *Ecerenis*, J, R. Berrigan, Trans. (Munich 1975).

NECCHI, Elena, "Una silloge epigrafica padovana: gli *Epygramata Illustrium Virorum* di Johannes Hasenbeyn [= Epigrafia a Padova, Gilda P. Mantovani, Elena Necchi, Guido e Maria Pia Billanovich]," *Italia Medioevale e Umanistica*, XXXV (1992), 123–77.

NESSELRATH, Arnold, "Antico und Montecavallo," *Burlington Magazine*, 124 (1982), 353–57.

DE NICOLÒ SALMAZO, Alberta, *Bernardino da Parenzo. Un pittore 'antiquario' di fine Quattrocento: Quaderni del Seminario di storia d'arte moderna* (Padua 1989), 1–107.

DE NICOLÒ SALMAZO, Alberta, "Presentazione," *Francesco Squarcione – 'Pictorum Gymnasiarcha singularis': Atti delle giornate di studio* [1998], A. De Nicolò Salmazo, ed. (Padua 1999).

DE NICOLÒ SALMAZO, Alberta, "Giovanni Marcanova, *Quaedam antiquitatum fragmenta studio Iohannis Marchanovae artium et medicinae doctoris patavini collecta*," see CAT. EXH., *La Miniatura a Padova dal Medioeveo al Settecento* (Palazzo della Ragione, Padua 1999), 255–56.

DE NICOLÒ SALMAZO, Alberta, *Andrea Mantegna*, Cologne 2004,

DE NICOLÒ SALMAZO, Alberta, "Dalle 'malefatte' di Francesco Squarcione al 'vero maestro' di Andrea Mantegna: Giuseppe Fiocco e la formazione del Rinascimento Veneto," *Sotto la superficie del visibile: Scritti in onore di Franco Bernabei*, M. Nezzo and G. Tomasella, eds. (Treviso 2013), 129–42.

DE NOLHAC, Pierre, "La Bibliothèque de Fulvio Orsini," *Bibliothèque de l'Ecole des Hautes Etudes*, 74 (1887), 171–72.

DE NOLHAC, Pierre, "Le *De viris illustribus* de Pétrarque," *Notice et Extraits des Manuscrits de la Bibliothèque Nationale et autres Bibliothèques*, XXXIV (1891).

NORBEDO, Roberto, "Considerazioni intorno a Battista Alberti e Gasparino Barzizza a Padova (con un documento su Leonardo Salutati)," *La vita e il mondo di Leon Battista Alberti: Atti dei Convegni internazionali, Centro di Studi Leon Battista Alberti*, 11 [2004] (Città di Castello 2008), 345–76.

NORMAN, Diana, "Astrology, Antiquity and Empiricism. Art and Learning," *Siena, Florence and Padua. Art, Society and Religion 1280–1400*, vol. I (New Haven 1995), 197–215.

NUVOLONI, Laura, "Bartolomeo Sanvito e i suoi artisti nella Padova dei primi anni sessanta del Quattrocento," *Il codice miniato in Europa*, G. Mariani Canova and A. Perriccioli Saggese, eds. (Padua 2014), 493–508.

OLARIU, Dominic, "Körper, die sie hatten – Leiber, die sie waren. Totenmaske und mittelalterliche Grabskulptur," *Quel Corps? Eine Frage der Repräsentation*, H. Belting et alii, eds. (Munich 2002), 85–104.

OLIVATO PUPPI, Loredana, and PUPPI, Lionello, "Venezia veduta da Francesco Squarcione nel 1465," *Scritti in onore di Maria Cionini Visani* (Turin 1977), 29–32.

OLIVIERI, Achille, "Un' enfasi mitologica. Troia a Venezia fra Quattrocento e Cinquecento," *Dall'Adriatico greco all'Adriatico veneziano. Archeologia e leggenda troiana: Hesperia*, 12, L. Braccesi, ed. (Rome 2000), 37–52.

PÄCHT, Otto, "Jean Fouquet. A Study of his Style," *Journal of the Warburg and Courtauld Institutes*, 4 (1941), 85–101.

PÄCHT, Otto, "Early Italian Nature Studies and the Early Calendar Landscape," *Journal of the Warburg and Courtauld Institutes*, 13 (1950), 13–47.

PÄCHT, Otto, *Venezianische Malerei des 15. Jahrhunderts. Die Bellinis und Mantegna*, M. Vyoral-Tschapka and M. Pächt, eds. (Munich 2002).

PADE, Marianne, "The Place of Translation in Valla's Thought," *Classica et Medievalia: Revue Danoise de Philologie et d'Histoire*, XXXV (1984), 294–300.

PANOFSKY, Erwin, *Tomb sculpture. Four Lectures on its Changing Aspects from Ancient Egypt to Bernini* (New York 1964).

PANOFSKY, Erwin, *Idea. Ein Beitrag zur Begriffsgeschichte der älteren Kunstgeschichte* [1924] (Berlin 1975).

PANOFSKY, Erwin, *Perspective as Symbolic Form* [1927] (New York 2011).

DE PAOLI, Marcella, see FAVARETTO, Irene.

PAOLOZZI-STROZZI, Beatrice, see CAT. EXH., *The Springtime of the Renaissance* (Palazzo Strozzi, Florence 2013).

PARDO, Mary, see COLE, Michael.

PARRONCHI, Alessandro, "Le fonti di Paolo Uccello," *Paragone* (1957), 89–95.

PARSHALL, Peter, see LANDAU, David.

PATETTA, Tobia, "Marmi, pietre e mattoni: città modernamente antiche di Andrea Mantegna conoscitore d'architettura?," *Mantegna e Roma. L'artista davanti all'antico*, T. Calvano et alii, eds. (Rome 2010), 271–301.

PENNY, Nicholas, see HASKELL, Francis.

PERICOLO, Lorenzo, "Incorporating the Middle Ages: Lazzaro Bastiani, the 'Greek' and 'German' Architecture of Medieval Venice," *Remembering the Middle Ages in Early Modern Italy*, L. Pericolo and J.N. Richardson, eds. (Turnhout 2015), 139–169.

PEROSA, Alessandro, *Studi di filologia umanistica: Studi e testi del Rinascimento europeo*, vol. III, (Rome 2000).

PERRIG, Alexander, "Vom Zeichnen und von der künstlerischen Grundausbildung im 13. bis 16. Jahrhundert," *Die Kunst der italienischen Renaissance. Architektur – Skulptur – Malerei – Zeichnung*, R. Toman, ed. (Cologne 1994), 416–440.

PERRY, Marilyn, "Saint Marc's Trophies. Legend, Superstition and Archeology in Renaissance Venice," *Journal of the Warburg and Courtauld Institutes*, 40 (1977), 27–49.

PETRARCA, Francesco, *De viris illustribus* (1380/81), Ms. lat. 6069 G, Paris, Bibliothèque nationale de France.

PEVSNER, Nikolaus, *Academies of Past and Present* [1940] (Cambridge 2014).

PFISTERER, Ulrich, *Donatello und die Entdeckung der Stile* (Munich 2002).

PFISTERER, Ulrich, *Lysippus und seine Freunde. Liebesgaben und Gedächtnis im Rom der Renaissance oder: Das erste Jahrhundert der Medaille* (Berlin 2008).

PIAIA, Gregorio, *Marsilio da Padova nella Riforma e nella Controriforma. Fortuna e interpretazione* (Padua 1977).

PIAIA, Gregorio, 'Vestigia philosophorum': *Il Medioevo e la storiografia filosofica* (Rimini 1983).

PICCOLOMINI, Aeneas Sylvius, *Opera* [c. 1440] (Basel 1571).

PIGEAUD, Jackie, "Médecine et médecins padouans," *Les Siècles d'Or de la Médecine, Padoue XV–XVIIIème s.* (Milan 1989), 31–35.

PIGMAN, G. W., "Versions of Imitation in the Renaissance," *Renaissance Quarterly*, XXXIII, 30 (1980), 1–32.

PINCUS, Debra, "Calligraphy, Epigraphy, and the Paduan-Venetian Culture of Letters in the Early Renaissance," *Padua and Venice. Transcultural Exchange in the Early Modern Age*, B. Blass-Simmen and S. Weppelmann, eds. (Berlin and Boston 2017), 41–60.

PIZZATI, Anna, see BROWN.

PLANISCIG, Leo, *Venezianische Bildhauer der Renaissance* (Vienna 1921).

PLANISCIG, Leo, *Andrea Riccio* (Vienna 1927).

PLANISCIG, Leo, "Jacopo und Gentile Bellini. Neue Beiträge zu ihrem Werk," *Jahrbuch der kunsthistorischen Sammlungen in Wien*, NF 12 (1928), 1–22.

PLATO, *Phaedrus*, A. Nehamas and P. Woodruff, Trans. (Indianapolis 1995).

PLATO, *Phaedrus and Ion* [*Commentaries on Plato*], vol. I, Allen, Michael J. B., Trans. (Cambridge/MA 2008).

PLATO, *Timaeus*, W. R. M. Lamb, Trans. (Cambridge/MA 1929).

PLINIUS (PLINY), Gaius Secundus, *Natural History*, vol. IX, Books 33–35, H. Rackham, Trans. [Loeb Classical Library, 394] (Cambridge/MA 1938).

POIRION, Daniel. See MURATOVA, Xénia.

PONTONE, Marzia, "Giovanni Bellini e Raffaele Zovenzoni. Un sodalizio artistico e letterario nella Venezia del Quattrocento," *Giovanni Bellini. La nascita della pittura devozionale umanistica* (CAT. EXH.), Pinacoteca Brera, Milan, E. Daffra and S. Bandera Bistoletti, eds. (Milan 2014), 91–95.

POPE-HENNESSY, John W., "The Italian Plaquette," *Proceedings of the British Academy*, L (1964), 63–85.

POPPI, Antonio, *Introduzione all'aristotelismo padovano: Pubblicazioni del Centro per la tradizione aristotelica nel Veneto, Saggi e testi*, vol. 10 (Padua 1991).

POSSEVINO, Antonio, *Gonzagae* (Mantua 1628).

POZZI, Giovanni, and GIANELLA, Gianni, "Scienza antiquaria e letteratura, Il Feliciano, Il Colonna," *Storia della cultura veneta dal primo Quattrocento al Concilio di Trento*, I–III, G. Arnaldi and M. P. Stocchi, eds. (Vicenza 1980), I, 459–98.

PRAY BOBER, Phyllis, and RUBINSTEIN, Ruth, *Renaissance Artists and Antique Sculpture. A Handbook of Sources* (London 1986).

PREMUDA, Loris, "Giuseppe Ongaro, I primordi della dissezione anatomica in Padova," *Acta medicae historiae patavina*, XII (1965–1966), 117–136.

PRIULI, Francesco, *Li pretiosi frutti del Maggior Consiglio, Cod. Cicogna, II, c. 97*, Archivio di Stato di Venezia (Venice late fifteenth century).

PUPPI, Lionello, see OLIVATO PUPPI.

QUAGLIONI, Diego, *Politica e diritto nel Trecento italiano. Il "De tyranno" di Bartolo da Sassoferrato (1314–1357). Con l'edizione critica dei trattati "De Guelphis et Gebellinis", "De regimine civitatis" e "De tyranno"* (Florence 1983).

QUAQUARELLI, Leonardo, "Felice Feliciano e Francesco Scalamonti (junior?)," *Ciriaco d'Ancona e la cultura antiquaria dell'umanesimo, Atti del convegno internazionale di studio, Ancona* [1992], G. Paci and S. Sconocchia, eds. (Reggio Emilia 1998), 333–47.

RAFFARIN-DUPUIS, Anne, "*Roma instaurata, Italia illustrata, Roma triumphans*. Flavio Biondo's Encyclopaedic Project for a Dictionary of Antiquities," *Renaissance Encyclopaedism*, W. Scott Blanchard and A. Severi, eds. (Toronto 2018), 151–84.

RANDALL JR., John Hermann, "The Development of Scientific Method in the School of Padua," *Renaissance Essays*, P. O. Kristeller et alii, eds. (University of Rochester 1993), X, 215–51.

RAYNAUD, Dominique, "Optics and Perspective Prior to Alberti," see CAT. EXH., *The Springtime of the Renaissance Sculpture and the Arts in Florence 1400–60* (Palazzo Strozzi, Florence 2013), 165–71.

RAYNAUD, Dominique, "A Hitherto Unknown Treatise on Shadows Referred to by Leonardo da Vinci," *Perspective as Practice*, S. Dupré, ed. (Turnhout 2019), 260–77.

REARICK, W. Roger, "The *Dormitio Virginis* in the Capella de' Mascoli," *De Lapidibus Sententiae: Scritti di Storia dell'Arte per Giovanni Lorenzoni*, T. Franco and G. Valenzano, eds. (Padua 2002), 343–62.

REUFER, Claudia, "Eine aus Linien aufgebaute Bildwelt. Die Zeichnungsbücher aus der Werkstatt Jacopo Bellinis," *Wissen in Bewegung: Episteme in Bewegung*, vol. 1, E. Cancik-Kirschbaum and A. Traninger, eds. (Wiesbaden 2015), 393–43.

REUFER, Claudia, "Geordnete Unordnung. Ästhetische Evidenzerzeugung im Pariser Zeichungsbuch Jacopo Bellinis," *Zeigen, Überzeugen, Beweisen. Methoden der Wissensproduktion in Kunstliteratur Kennerschaft und Sammlungspraxis der Frühen Neuzeit*, E. Oy-Marra and I. Scheidel, eds. (Heidelberg 2020), 289–316.

REUFER, Claudia, "Materia e regionamenti. Wahrnehmung und Materialität der Zeichnung bei Ghiberti und Jacopo Bellini," *Ghiberti teorico. Natura, arte e coscienza storica nel Quattrocento*, F. Jonietz, W.-D. Löhr and A. Nova, eds. (Milan 2019), 151–70.

RÉVEST, Clémence, "Les discours de Gasparino Barzizza et la diffusion du style cicéronien dans la première moitié du XVe siècle," *Mélanges de l'Ecole française de Rome*, 128 (2016), 47–72.

RÉVEST, Clémence, "Umanesimo, università e chiesa a Padova nei primi anni del dominio veneziano: l'orazione accademica di Gasparino Barzizza per Pietro Donato (1418)," *Quaderni per la storia dell'università di Padova* (2016), 3–34.

RICCI, Corrado, *Iacopo Bellini e i suoi libri di disegni*, 2 vols., vol. I, *Il libro del Louvre* (Florence 1908).

RICCI, Milena, "Un tesoro di libro. Il codice Marcanova della Biblioteca Estense universitaria," *Civiltà Mantovana: Nel segno di Andrea Mantegna. Arte e cultura a Mantova in età rinascimentale* (Modena 2006), 105–15.

DE RICCI, Seymour, "Un album de dessins de Jacopo Bellini au Musée du Louvre," *Revue Archéologique*, 18 (1923), 89–90.

RICHTER, Jean Paul, *Leonardo da Vinci: The Literary Works*, vol. 1 (London 1883).

RICHTER, Mandy, "'<O> doctissimo, nessuna cosa si vede sanza luce.' Darkness, Light and Antiquity in Ghiberti's Third Book," Ghiberti und die Philosophen, *Ghiberti teorico. Natura, arte e coscienza storica nel Quattrocento*, F. Jonietz, W.-D. Löhr and A. Nova, eds. (Milan 2019), 183–190.

RIGONI, Erice, *L'arte rinascimentale a Padova* (Padua 1970).

RIZZO, Silvia, *Il lessico filologico degli umanisti* (Rome 1973).

ROBERT, Jörg, "Norm, Kritik, Autorität. Der Briefwechsel *De imitatione* zwischen Gianfrancesco Pico della Mirandola und Pietro Bembo und der Nachahmungsdiskurs in der Frühen Neuzeit," *Pluralisierung und Autorität in der Frühen Neuzeit: Daphnis*, 30 (2001), 597–644.

ROCCASECCA, Pietro, "Pisanello, Alberti and *costruzione legittima*," *Perspektiva / Perspective*, M. Pasternak and N. Eröss, eds. (Budapest 2000), 67–83.

ROCCASECCA, Pietro, "The Pyramid and the *Intentiones*: Alhacen, Alberti and the Composition of Stories in Paintings," see CAT. EXH., *The Springtime of the Renaissance* (Palazzo Strozzi, Florence 2013), 173–79.

RODELLA, Giovanni, *Giovanni da Padova. Un ingegnere gonzaghesco nell'età dell'Umanesimo: Quaderni del Dipartimento di Conservazione delle Risorse Architettoniche e Ambientali*, 9 (Milan 1988).

ROMANO, Serena, *Giotto's O: Viella History, Art and Humanities*, vol. 1 (Rome 2015).

ROMBAI, Leonardo, "Il Progetto della pianta albertiana di Roma e la sua influenza sulla nascita di una cartografia umanistica fatta 'di elevazioni e, sopratutto, di modelli', piuttosto che di 'trucchi prospettici adottati dai pittori'," *Eventi e documenti diacronici delle principali attività geotopografiche in Roma*, A. Cantile, ed. (Florence 2000), 46–67.

ROSENFELD, Hellmut, *Der Meister der Spielkarten und die Spielkartentradition und Gutenbergs typographische Pläne* (Frankfurt/M 1964).

RÖTHLISBERGER, Marcel, *Studi su Jacopo Bellini* (PhD Thesis, Bern University 1955, Venice 1960).

ROWLEY, Neville, see CAMPBELL, Caroline.

Rowley, Neville, "When Bellini *Traced* Mantegna: Two Paintings of the Presentation of Christ in the Temple," see Cat. Exh., *Mantegna & Bellini* (National Gallery, London 2018), 140–47.

Rubinstein, Ruth, see, Pray Bober, Phyllis.

Rushton Jr., Joseph George, *Italian Renaissance Figurative Sketchbooks 1450–1520* (PhD Thesis, University of Minnesota/M 1976).

Sambin, Paolo, "La Bibliotheca di Pietro Donato," *Bollettino del Museo Civico di Padova*, XLVIII (1959), 53–78.

Sambin, Paolo, "Per la biografia di Francesco Squarcione: bricciole documentarie," *Medioevo e Rinascimento: Scritti in onore di Lino Lazzarini* (Padua 1979), 443–69.

Sapegno, Natalino, *Storia letteraria d'Italia: Il Trecento* (Padua 1981).

Sartori, Antonio, Archivio Sartori, *Documenti di storia e arte francescana*, vol. I: "Basilica e Convento del Santo," G. Luisetto, ed. (Padua 1983).

Savonarola, Michele, *Libellus de magnificis ornamentis regie civitatis Padue: Rerum Italicarum Scriptores*, XXIV, A. Garizzi, ed. (Città di Castello 1902).

Saxl, Fritz "The Classical Inscription in Renaissance Art and Politics," *Journal of the Warburg and Courtauld Institutes*, 2 (1939), 346–67.

Saxl, Fritz, "Jacopo Bellini and Andrea Mantegna as Antiquarians: Lectures" [1957], *A Heritage of Images. A Selection of Essays* (London 1970), 57–70.

Sberti, Antonio Bonaventura, *Degli spettacoli e delle feste che si facevano in Padova* (Padua 1818).

Scalamonti, Francesco, *Vita viri clarissimi et famosissimi Kyriaci Anconitani*, C. Mitchell and E. W. Bodnar, eds. (Philadelphia 1996).

Scardeone, Bernardino, *De antiquitate urbis Patavii et claris civibus Patavinis libri tres* (Basel 1560).

Scheller, Robert W., *Exemplum. Model-Book Drawings and the Practice of Artistic Transmission in the Middle Ages (ca. 900–ca. 1470)* (Amsterdam 1995).

Schizzerotto, Giancarlo, *Le incisioni quattrocentesche della Classense* (Ravenna 1971). Ghiberti, Lorenzo, *I commentarii*, J. von Schlosser, ed., 2 vols. (Berlin 1912).

von Schlosser, Julius, "Über einige Antiken Ghibertis," *Jahrbuch der kunsthistorischen Sammlungen des Allerhöchsten Kaiserhauses*, XXIV (1904), 125–60.

von Schlosser, Julius (ed.), *Lorenzo Ghibertis Denkwürdigkeiten (I Commentarii). Zum ersten Mal nach der Handschrift der Biblioteca Nazionale in Florenz vollständig herausgegeben und erläutert*, 2 vols. (Berlin 1912).

Schmid, Victor M., Die Gebrüder Limburg und die italienische Kunst," see Cat. Exh., *Die Brüder van Limburg. Nijmegener Meister am französischen Hof 1400–1416* (Museum Het Valkhof, Nijmegen 2005), 179–90.

Schmitt, Annegrit, "Francesco Squarcione als Zeichner und Stecher," *Münchner Jahrbuch der bildenden Künste* (1974), 205–13.

Schmitt, Annegrit, "Die Wiederbelebung der Antike – Petrarcas Rom-Idee in ihrer Wirkung auf die Paduaner Malerei. Die methodische Einbeziehung des römischen Münzbildes in die Ikonographie *berühmter Männer*," *Mitteilungen des Kunsthistorischen Institutes in Florenz*, 18 (1974), 167–218.

Schmitt, Annegrit, "Antikenkopie und künstlerische Selbstverwirklichung in der römischen Frührenaissance. Jacopo Bellini auf den Spuren römischer Epitaphien," *Antikenzeichnung und Antikenstudium in Renaissance und Frühbarock: Akten des internationalen Symposiums* [1986], R. Harprath and H. Wrede, eds. (Mainz 1989), 1–20.

Schmitt, Annegrit, "Pisanellos Georgswandbild in Sant'Anastasia, Verona," *Pisanello und Bono da Ferrara*, B. Degenhart, ed. (Munich 1995), 119–79.

Schmitt, Annegrit, Corpus. see Degenhart.

Scholz, Peter, *Räume des Sehens – Giusto de Menabuoi und die Wissenskultur des Trecento in Padua* (Berlin 2019).

Schulz, Anne Markham, "Francesco Squarcione and His School, with an Addendum on the Ovetari Altarpiece," *Ricche minere*, 4 (2017), 23–53.

Segre Rutz, Vera, "Lo studio del mondo animale nella bottega trecentesca di Giovannino de Grassi," *Micrologus*, 8 (2000), 477–88.

SEILER, Peter, "Giotto – das unerreichte Vorbild? Elemente antiker *imitatio auctorum*-Lehren in Cennino Cennini's *Libro dell'Arte*," *Imitatio als Transformation. Theorie und Praxis der Antikennachahmung in der Frühen Neuzeit*, U. Rombach and P. Seiler, eds. (Petersberg 2012), 44–86.

SEILER, Peter, "*trovare cose non vedute*. Naturnachahmung und Phantasie in Cennino Cenninis *Libro dell'arte*," *Imagination, Transformation und die Entstehung des Neuen*, P. Brüllmann et alii, eds. (Berlin 2014), 111–54.

SEZNEC, Jean, *The Survival of the Pagan Gods. The Mythological Tradition and Its Place in Renaissance Humanism and Art* [1940] (Princeton 1953).

SHAW, Keith, and BOCCIA, Theresa, "Mantegna's pre-1448 Years Reexamined: the S. Sofia Inscription," *The Art Bulletin*, 71, 1 (1989), 47–57.

SHAW, Keith, and BOCCIA, Theresa, "Andrea Mantegna Called Andrea Squarcione," *Encountering the Renaissance: Celebrating Gary M. Radke*, M. Bourne and V. A. Coonin, eds. (Ramsey 2016), 317–23 (320).

SIGHINOLFI, Lino, "La Bibliotheca di Giovanni Marcanova," *Collectanea variae doctrinae: Scritti in onore Leo Olschki* (Munich 1921), 187–222.

SIGNORINI, Rodolfo, "New Findings about Andrea Mantegna. His Son Ludovico's Post-Mortem Inventory," *Journal of the Warburg and Courtauld Institutes*, 59 (1996), 103–18.

SIGNORINI, Rodolfo, see CHAMBERS, David, S.

SIMEONI, Luigi, "La Crocifissione di Jacopo Bellini nella Cattedrale di Verona," *Atti e Memorie dell'Accademia di Agricoltura, scienze, lettere, arti e commercio di Verona*, ser. IV, vol. V, fasc. I (Verona 1904–05).

SIMMI VARANELLI, Emma, "La riscoperta medievale della Poetica di Aristotele e la sua suggestione sulle arti figurative tardoduecentesche," *Roma Anno 1300*, A. M. Romanini, ed. (Rome 1983), 833–51.

SIMMI VARANELLI, Emma, "Dal Maestro d'Isacco a Giotto. Contributo alla storia della *perspectiva communis* medievale," *Arte Medievale*, 3 (1989), 115–42.

SIMON, Gérard, "Optique et perspective: Ptolémée, Alhazen, Alberti," *Revue d'histoire des sciences* (2001), LIV, 325–50.

SIMONETTI, Rémy, "La formazione di Leon Battista Alberti: scienza matematica e filosofia naturale nello Studio di Padova nei primi decenni del Quattrocento," *Filosofia e scienze dell'esperienza fra Medioevo e Umanesimo*, S. Collodo and R. Simonetti, eds. (Treviso 2012), 241–312.

SIMONETTI, Rémy, "Filosofia naturale, medicina e pittura nella testimonianza di Michele Savonarola," *Filosofia naturale e scienze dell'esperienza fra Medioevo e Umanesimo*, S. Collodo and R. Simonetti, eds. (Padua 2012), 395–430.

SIMONETTI, Rémy, see COLLODO, Silvana.

SINGER, Charles, *The Education of Anatomy* (London 1925).

SIRAISI, Nancy G., *Arts and Sciences at Padua. The* studium *of Padua before 1350* (Toronto 1973).

SMITH FUSCO, Laurie, and CORTI, Gino, *Lorenzo de Medici Collector and Antiquarian* (New York 2006).

SOBLE, Alan, *The Structure of Love* (Yale 1990).

SOBLE, Alan, "A History of Erotic Philosophy," *The Journal of Sex Research*, 46 (2009), 104–20.

SUMMERS, David, *The Judgement of Sense. Renaissance Naturalism and the Rise of Aesthetics* [1987] (Cambridge 2007).

SYSON, Luke, and GORDON, Dillian (eds.), *Pisanello. Painter to the Renaissance Court* (CAT. EXH.), National Gallery, London (London 2001).

SYSON, Luke, "Bertoldo di Giovanni, Republican Court Artist," *Artistic Exchange and Cultural Translation in the Italian Renaissance*, S. J. Campbell and S. J. Milner, eds. (Cambridge 2004), 96–133.

SZABO, Georges, "Notes on XV-Century Italian Drawings of Equestrian Figures: Giambono, Pollaiuolo and the Horses of San Marco," *Drawing*, 3 (1981), 34–7.

TAMASSIA, A. M., "Jacopo Bellini e Francesco Schiavone. Due cultori di antichità classica," *Il mondo antico nel Rinascimento: Atti del convegno internazionale* (Florence 1958), 159–165.

TEMPESTINI, Anchise, "Disegno, giudizio e maniera," *Studi sul disegno italiano in onore di Catherine Monbeig Goguel* (Milan 2005).

TESTI, Laudadeo, *La Storia della Pittura Veneziana*, 2 vols. (Bergamo 1909, 1915).

TESTI, Laudadeo, "Dei disegni di Jacopo Bellini," *Rassegna d'Arte*, 9, 1909.

THIÉBAUT, Dominique, see CAT. EXH., *Mantegna 1431–1506* (Louvre, Paris 2008).

THOMANN, Johannes, "Pietro d'Abano on Giotto," *Journal of the Warburg and Courtauld Institutes*, 54 (1991), 238–44.

Tietze, Hans, "Mantegna and His Companions in Squarcione's Shop," *Art in America*, XXX (1942), 54–60.

Tietze, Hans, and Tietze-Conrat, Erica, *The Drawings of the Venetian Painters in the Fifteenth and Sixteenth Centuries* (New York 1944).

Toesca, Pietro *La pittura e la miniatura nella Lombardia: dai piú antichi monumenti alla metà del Quattrocento* [1912] (Turin 1987).

Tomasini, Filippo, *Gymnasium Patavinum* (Padua 1654).

Toniolo, Federica, "Girolamo da Cremona – miniatore alla corte dei Gonzaga," see Cat. Exh., *Andrea Mantegna e i Gonzaga* (Museo del Palazzo Ducale, Mantua 2006), 94–101.

Toniolo, Federica, "Il libro miniato a Padova nel Trecento," *Il secolo di Giotto nel Veneto*: *Studi di arte veneta*, 14, G. Valenzano, ed. (Venice 2007), 107–51.

Toniolo, Federica, see Baldissin Molli, Giovanna.

Tosetti Grandi, Paola, "Andrea Mantegna, Giovanni Marcanova e Felice Feliciano," *Andrea Mantegna*, L. Signorini et alii, eds. (Florence 2010), 273–361.

Tramontin, Silvio, "La cultura monastica del Quattrocento dal primo patriarca Lorenzo Giustiniani ai camaldolesi Paolo Giustiniani e Pietro Quirini," *Storia della cultura veneta*, G. Arnaldi and M. Pastore Stocchi, eds., 3, 1 (Vicenza 1980), 431–57.

Trevisani, Filippo, see Cat. Exh., *Andrea Mantegna e i Gonzaga* (Museo del Palazzo Ducale, Mantua 2006).

Ullman, Berthold L., *Studies in the Italian Renaissance* [1952] (Rome 1973).

Urzi, M., "I pittori registrati negli statuti dellla fraglia padovana dell'anno 1441," *Archivio Veneto*, s. V (1932), 212–34.

Varanini, Gian Maria, "La terraferma veneta nel Quattrocento e le tendenze recenti della storiografia," *Ateneo Veneto: Atti del Convegno internazionale di studi, Venezia* [2009], 197 (2010), 13–67.

Vasari, Giorgio, *Vite de' più eccellenti pittori, scultori e architettori* [nelle redazioni del 1550 e 1568], R. Bettarini and P. Barocchi, eds. (Florence 1966–1987).

Venturi, Lionello, *Le origini della pittura veneziana, 1300–1500* (Venice 1907).

Venturi, Lionello, "La critica d'arte alla fine del Trecento. Filippo Villani e Cennino Cennini," *L'Arte*, 28 (1925), 233–44.

Venturi, Lionello, "A Mythological Picture by Jacopo Bellini," *The Burlington Magazine for Connoisseurs*, 49 (1927), 205.

Vergerio, Pier Paolo, *Epistolario*, L. Smith, ed. (Rome 1934).

Visonà, Maria, "The Models: The Horses of Saint Mark's," see Cat. Exh., *In the Light of Apollo* (Mouseion Alexandrou Sotsou, Athens 2003), 119–26.

Vowles, Sarah, and Korbacher, Dagmar, "Jacopo Bellini and the Formation of Giovanni," see Cat. Exh., *Mantegna & Bellini* (National Gallery, London 2018), 95–107.

Vowles, Sarah, and Campbell, Caroline, "Mantegna, Bellini and Antiquity," see Cat. Exh., *Mantegna & Bellini* (National Gallery, London 2018), 232–48.

Wallace, Williams, see Barolsky, Paul.

Wallace Maze, Daniel, "Giovanni Bellini: Birth, Parentage, and Indipendence," *Renaissance Quarterly*, 66 (2013), 783–823.

Walser, Ernst, *Poggius Florentinus. Leben und Werke* (Leipzig and Berlin 1914).

Warburg, Aby, "Arbeitende Bauern auf burgundischen Wandteppichen," *Zeitschrift für bildende Kunst*, 18 (1907), 41–47.

Wardrop, James, *The Script of Humanism. Some Aspects of Humanistic Script 1460–1560* (Oxford 1963).

Warnke, Martin, "Die Handschrift des Künstlers – Andrea Mantegna," id., *Künstlerlegenden – Kritische Ansichten* (Göttingen 2019).

Weinberger, Martin, "Silk Weaves of Lucca and Venice in Contemporary Painting and Sculpture," *Bulletin of the Needle and Bobin Club* (1941), 20ff.

Weiss, Roberto, "Lovato Lovati," *Italian Studies*, VI (1951), 3–28.

Weiss, Roberto, *The Renaissance Discovery of Classical Antiquity* (Oxford 1969).

White, John, *The Birth and Rebirth of Pictorial Space* (London 1957).

Windows, Peter, *Jacopo Bellini's Drawings and Their Artistic and Intellectual Context, with Particular Reference to Venetian and Paduan Humanism*, 2 vols. (PhD Thesis, University of Central England, Birmingham 2000).

WINDOWS, Peter, "New Identifications in the Drawings of Gabriele Vendramin," *Master Drawings* (2012) 33–48.

WITT, Ronald G., *In the Footsteps of the Ancients. The Origins of Humanism from Lovato to Bruni: Studies in Medieval & Reformation Thought* (Leyden 2000).

WITTKOWER, Rudolf, *Architectural Principles in the Age of Humanism* (London 1971).

WOLF, Ruth, "Le tombe dei dottori al Santo. Considerazioni sulla loro tipologia," *Cultura, arte e commitenza nella basilica di S. Antonio di Padova nel Trecento: Atti del Convegno internazionale* [2001], L. Baggio and M. Benetazzo, eds. (Padua 2003), 277–97.

WOLFF, Martha A., *The Master of the Playing Cards. An Early Engraver and His Relationship to Traditional Media* (PhD Thesis, Yale University, New Haven/C 1979).

WOLTERS, Wolfgang, "Appunti per una storia della scultura padovana del Trecento," see CAT. EXH., *Da Giotto a Mantegna* (Palazzo della Ragione, Padua 1974), 36–42.

WOLTERS, Wolfgang, *Der Dogenpalast in Venedig. Ein Rundgang durch Kunst und Geschichte* (Berlin and Munich 2010).

WOODS-MARSDEN, Joanna, "*Draw the irrational animals as often as you can from life*: Cennino Cennini, Giovannino de Grassi and Antonio Pisanello," *Studi di Storia dell'arte*, 3 (1992), 67–78.

ZANETTI, Melania, "Il restauro della mappa di Padova di Francesco Squarcione," *Bollettino del Museo Civico di Padova* (2006), 78–93.

ZILIOTTO, Baccio, *Rafffaele Zovenzoni: la vita, i carmi* (Trieste 1950).

ZORZI, Elda, "Un antiquario padovano del sec. XVI. Alessandro Maggi da Bassano," *Bollettino del Museo Civico di Padova*, LI, 1 (1962), 41–98.

ZORZI, Marino, "Bessarion, Venice and the Greek Manuscripts," see CAT. EXH., *In the Light of Apollo* (Mouseion Alexandrou Sotsou, Athens 2003), 53–59.

INDEX

PHOTOGRAPHIC CREDITS

Cristina Accidini and Gabriele Morolli (eds.), L'uomo del Rinascimento. Leon Battista Alberti e le arti a Firenze tra ragione e bellezza (Florence 2006): Appendix II.

Giovanni Agosti, Mantegna 1431–1506 (Milan 2008): fig. 26.

Bibliothèque nationale de France, Département des Manuscrits Latins 6069G: fig. 61.

Luca Baggio, Altichiero da Zevio nell'Oratorio di San Giorgio: il restauro degli affreschi (Rome 1999): figs. 9, 13, 54.

Bern, Burgerbibliothek, Cod. B. 42 f. 109r: fig. 25

Dresden, Staatliche Kunstsammlungen, Kupferstichkabinett: fig. 43

Colin Eisler, The Genius of Jacopo Bellini (New York 1989): figs. 12, 14, 47, 50, 52, 54, 65, 66, 67, 68.

Cat. Exh. Mantegna 1431–1506, Musée du Louvre, Paris, G. Agosti and D. Thiébaut, eds. (Paris 2008): fig. 24

Giuseppe Fiocco, Mantegna, La Cappella Ovetari (Milan 1953): fig. 26, 27

Giuliano Pisani, Il capolavoro di Giotto. La Cappella degli Scrovegni (Treviso 2015): fig. 49.

Padua, Museo di Scienze Archeologiche e d'Arte del Dipartimento dei Beni Culturali, nr serie MB76, nr inventario 5953: fig. 31.

Venice, Museo Archeologico: fig. 30.

Paris, Louvre, Département des arts graphiques / Réunion des musées nationaux (RMN): figs. 2, 10, 15, 20, 21, 28, 32, 33, 34, 36, 37, 38, 39, 45, 58, 63, 65.

Photo Author: figs. 1a, 1b, 3, 4, 6, 16, 23, 35, 42, 44, 46, 51, 53, 55, 57, 59.

Photo Federica Toniolo: fig. 17.

Photo Simone Westermann: fig. 48.

Photographs in the public domain: figs. 5, 11, 29, 41, 60, 62.

Marco Rossi, Giovannino de Grassi. La corte e la cattedrale (Milan 1995): fig. 40.

Copyright Georg Wick: figs. 7, 8, 18, 19, Appendix I–IX.

Gedruckt mit freundlicher Unterstützung der
Donation Prof. Maria Bindschedler und der Stiftung Pro Scientia et Arte

ISBN 978-3-11-072595–7
e-ISBN (PDF) 978-3-11-075059-1

Library of Congress Control Number: 2021935736

Bibliographic information published by the Deutsche Nationalbibliothek
The Deutsche Nationalbibliothek lists this publication in the Deutsche Nationalbibliografie;
detailed bibliographic data are available on the Internet at http://dnb.dnb.de.

Cover illustration: Jacopo Bellini, Book of drawing, folio 45, Musée du Louvre,
Département des arts graphiques / Réunion des musées nationaux (RMN), Paris.

Cover, Typesetting: Andreas Eberlein, aromaBerlin
Printing and binding: Beltz Grafische Betriebe GmbH, Bad Langensalza

www.degruyter.com